photographs by ARALDO DE LUCA

text by ALESSIA AMENTA

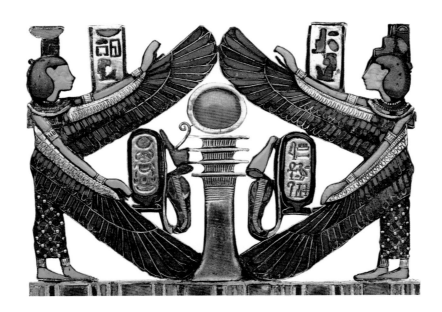

The treasures of
TUTANKHAMUN
and the Egyptian Museum of Cairo

WHITE STAR PUBLISHERS

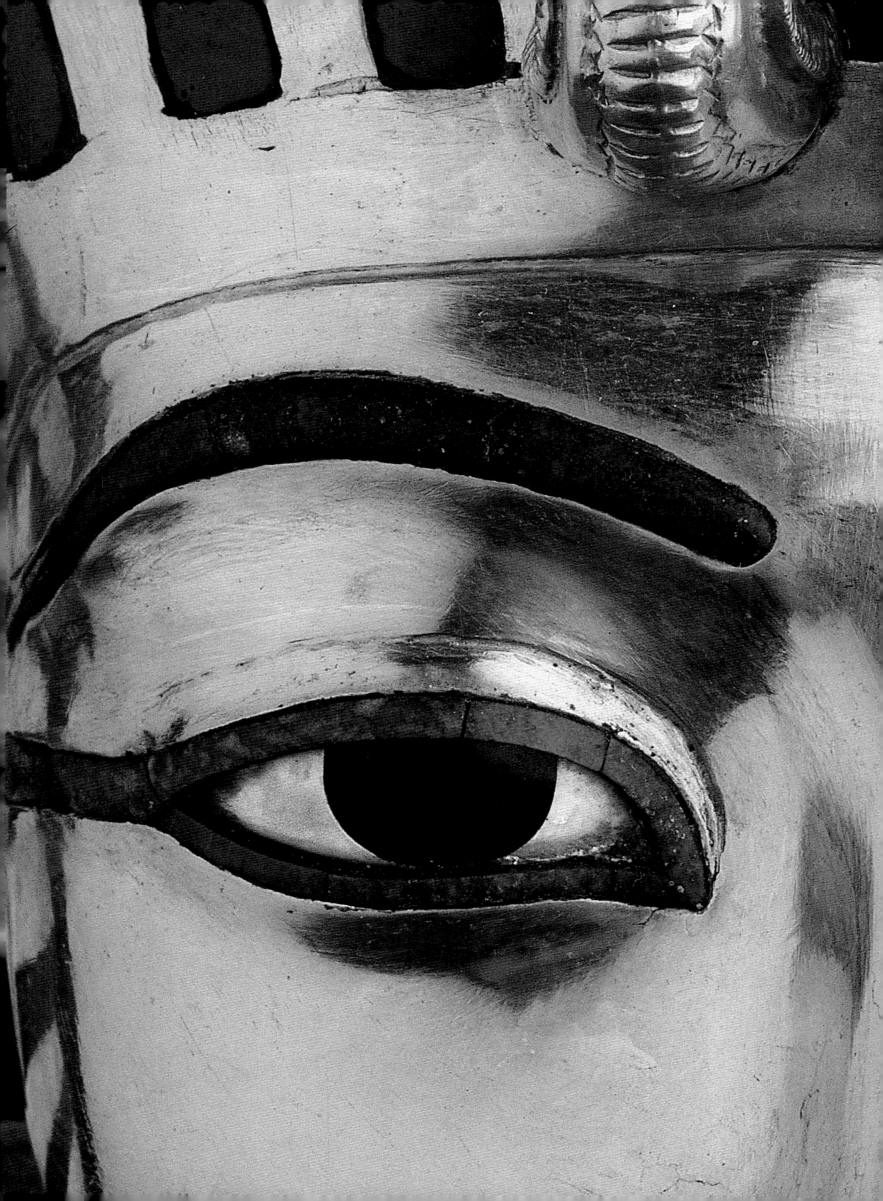

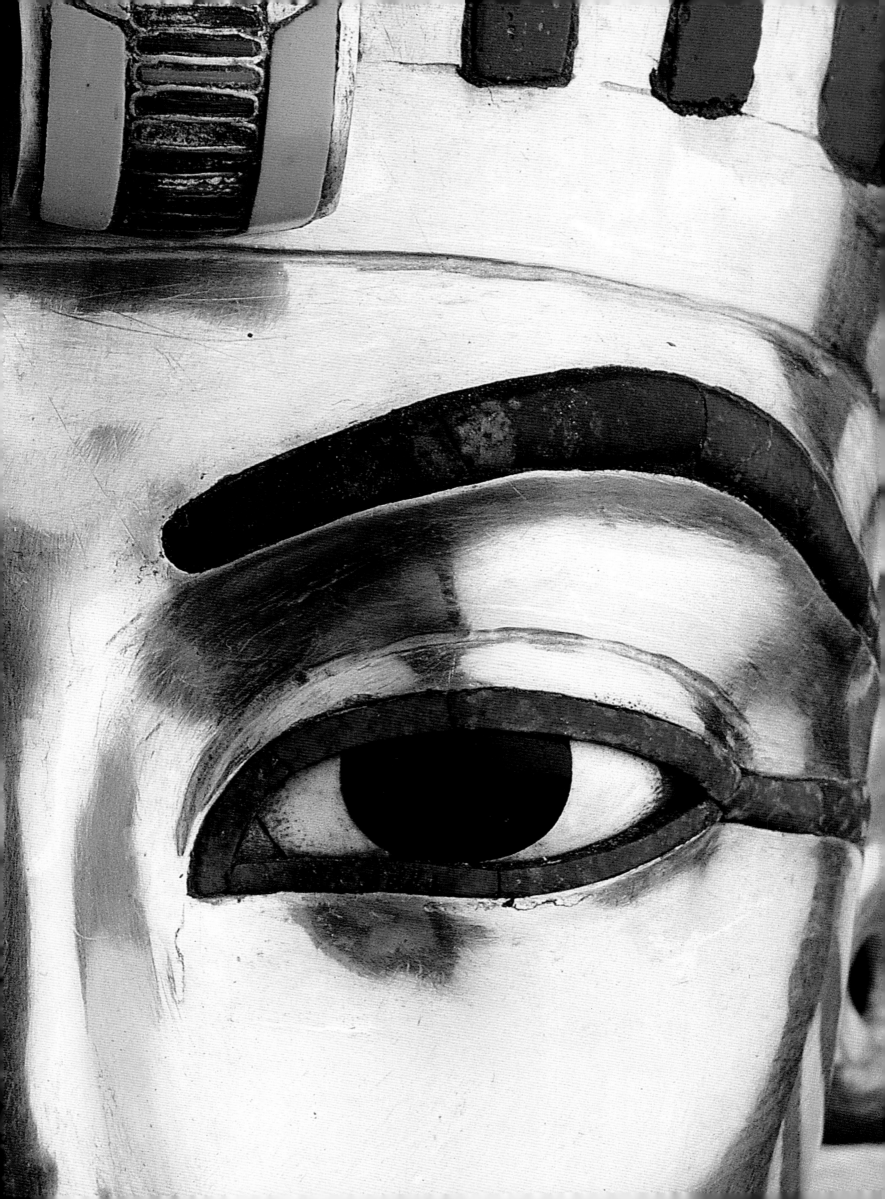

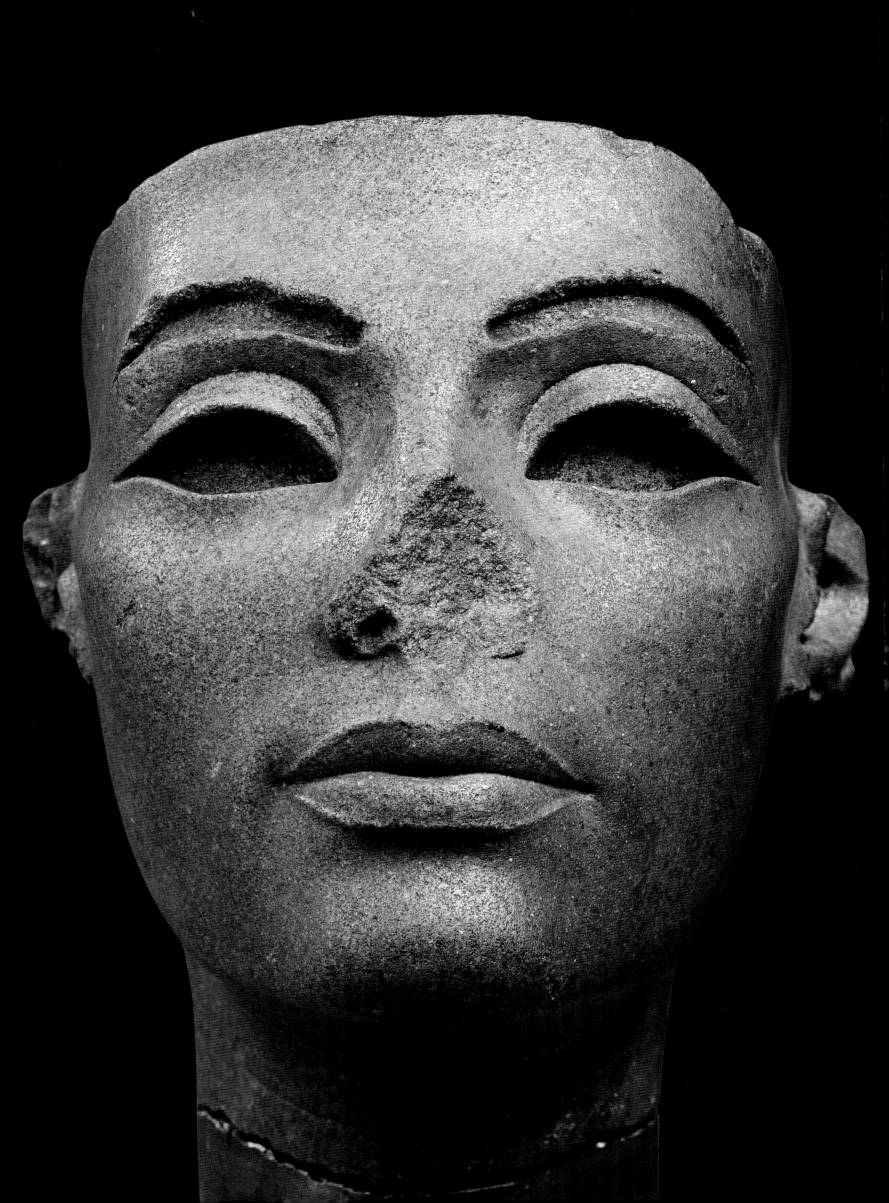

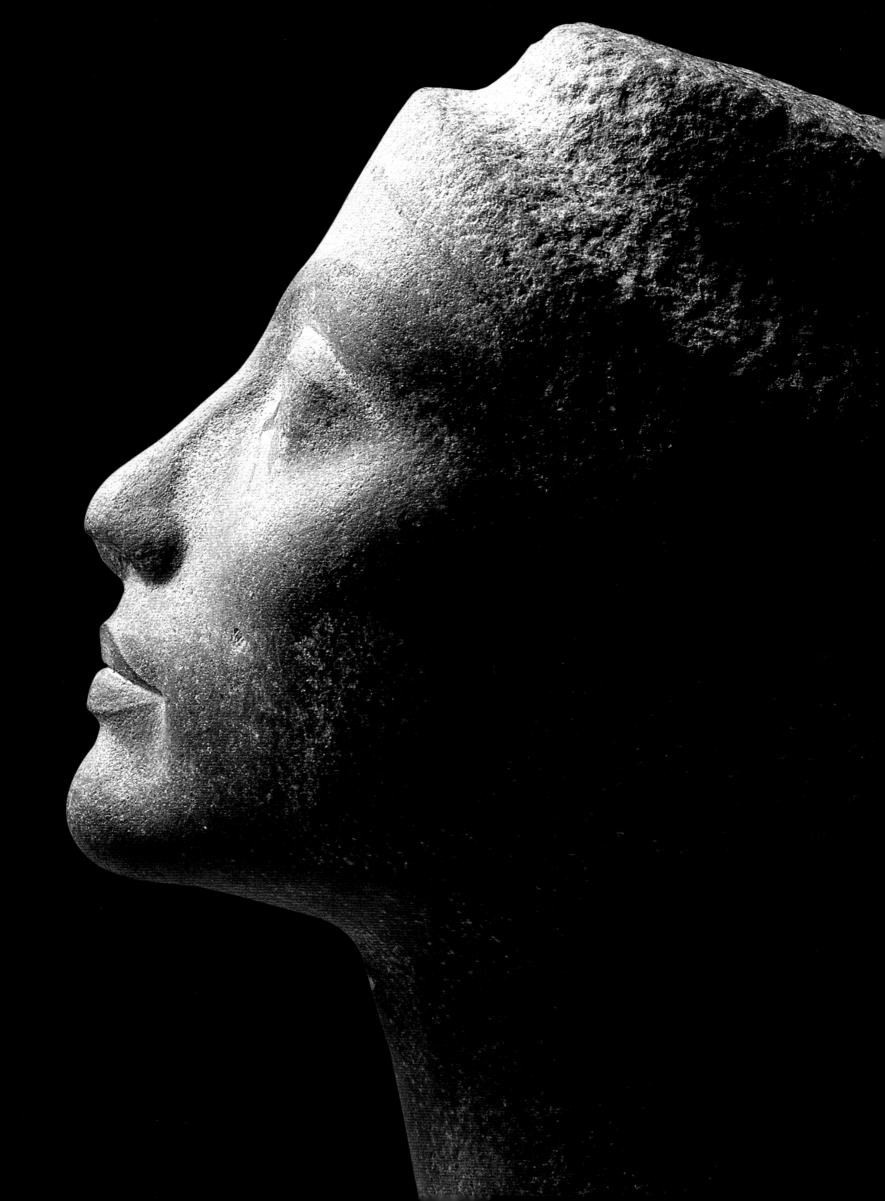

Photographs by
ARALDO DE LUCA

Text by
ALESSIA AMENTA

Editorial Director
VALERIA MANFERTO DE FABIANIS

Project Design
CLARA ZANOTTI

WHITE STAR PUBLISHERS

© 2005 White Star S.p.A.
Via Candido Sassone, 22/24
13100 Vercelli - www.whitestar.it

TRANSLATION: Catherine Bolton

ISBN 88-544-0068-8

REPRINTS:
1 2 3 4 5 6 09 08 07 06 05

Printed in Thailand
Color separation by Fotomec, Turin

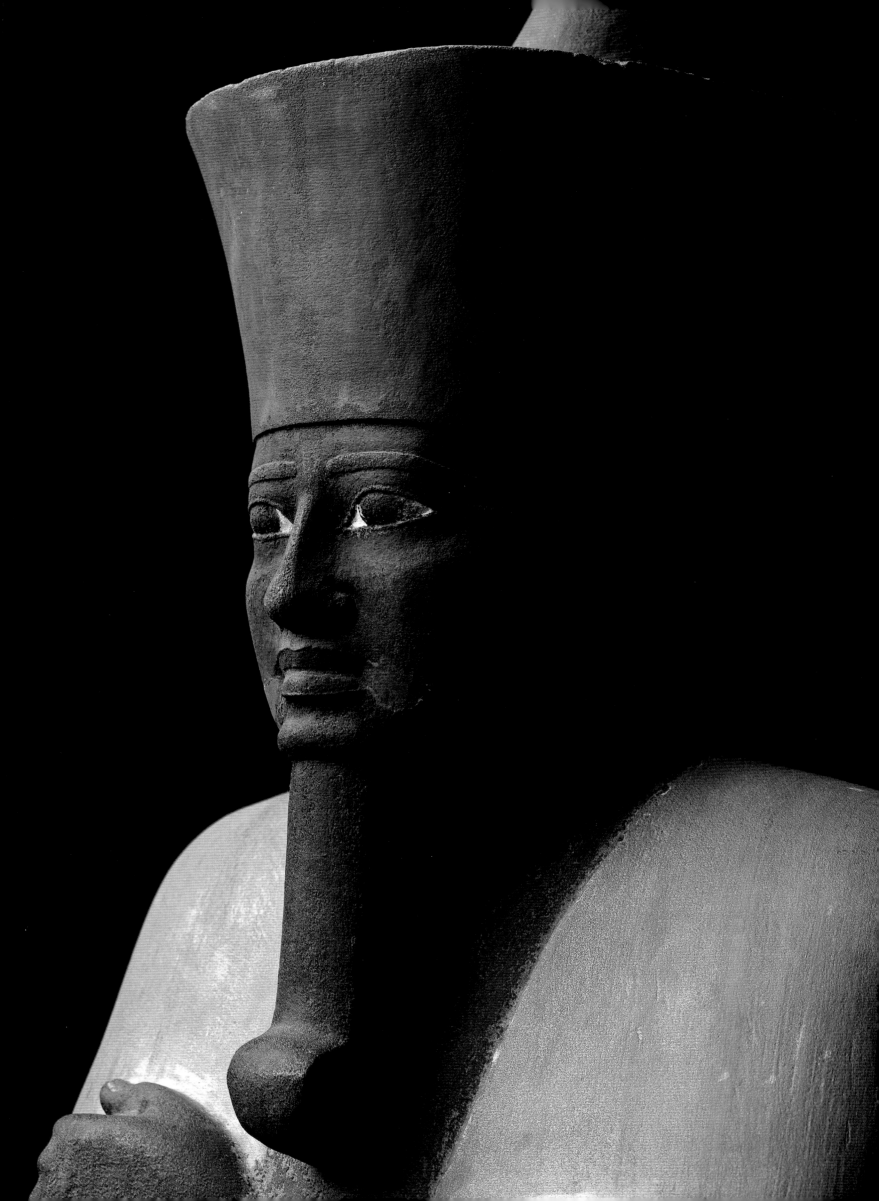

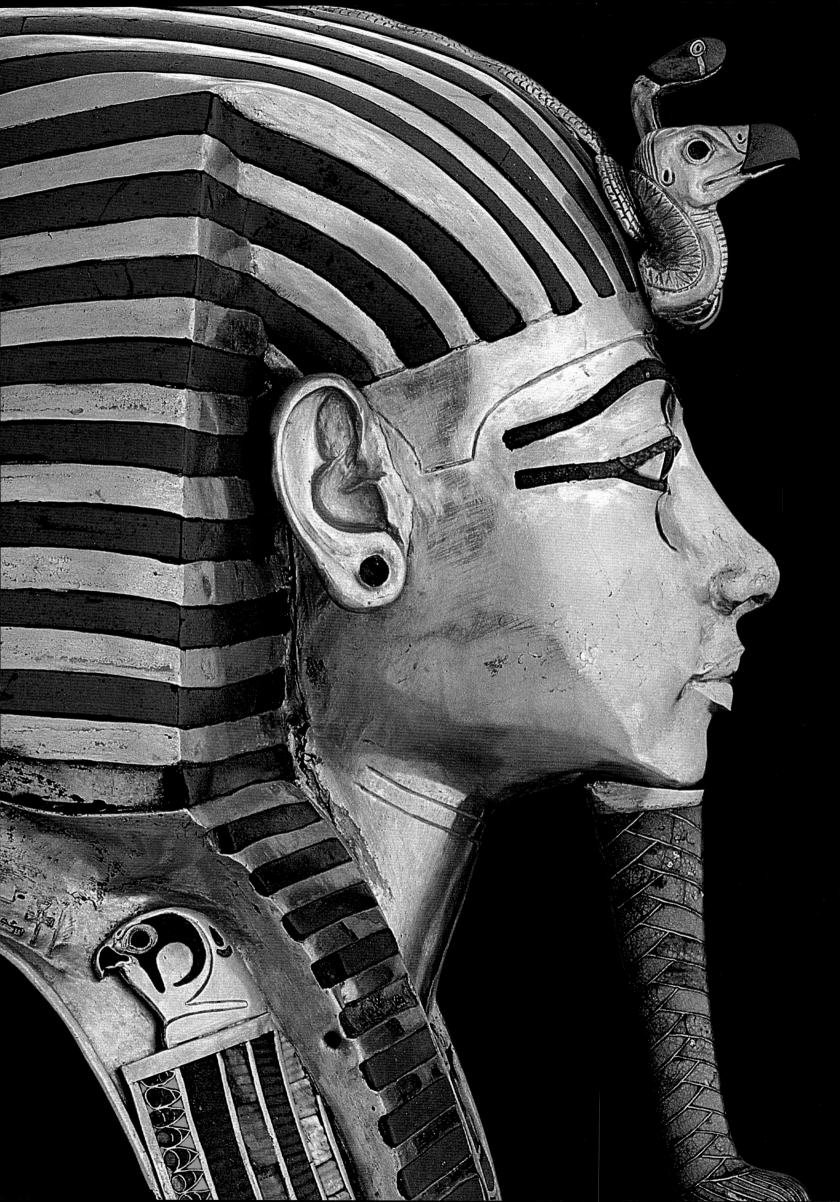

CONTENTS

1	*4*	*6*
Pectoral from the treasure of Tutankhamun.	Head of Amarnan queen.	Tutankhamun's throne.
	5	*7*
2-3 e 8	Unfinished head of Nefertiti.	Statue of Mentuhotep II.
Tutankhamun's burial mask.		

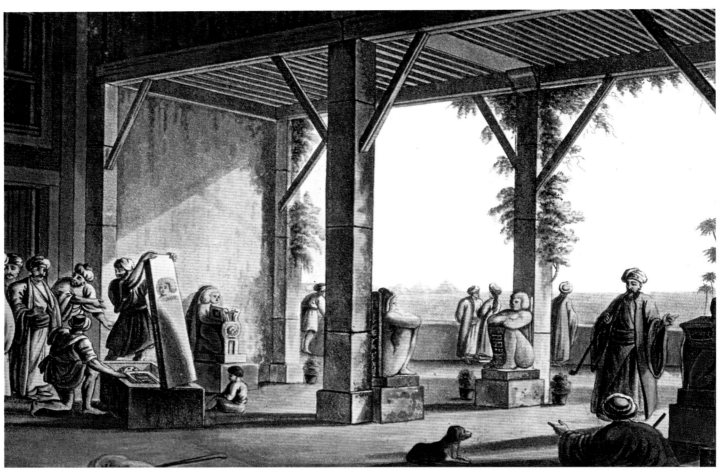

Auguste Mariette (1821–1881), an Egyptologist and curator of of the Louvre, was a decisive figure

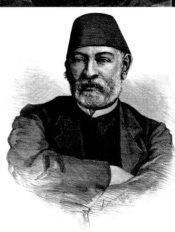

10 top

In 1863, viceroy Ismaïl Pasha inaugurated the first Egyptian Museum in Cairo, illustrated here in a lithograph by Luigi Mayer.

10 bottom

French Egyptologist Auguste Ferdinand Mariette was the first Director of the Antiquities Service and founded the museum at Bulaq.

for the birth of historic awareness in modern-day Egypt. He can be credited with forming an initial core collection of Egyptian antiquities on Egyptian soil, and with establishing the Antiquities Service in order to monitor the uncontrolled market for pharaonic antiquities that various European countries and private collectors were amassing, in many cases irreverently destroying monuments. Napoleon's expedition to Egypt with his savants between 1798 and 1801 paved the way for Egyptology as a science. At the same time, however, in Europe it sparked a massive hunt for Egyptian antiquities. This pursuit soon became a widespread fashion, leading to the establishment of important official collections—not to mention private ones—across Europe that became the pride of the governments of the era.

Mariette was the first director of the Service des Antiquités de l'Égypte, the organization established in 1858 specifically to supervise and promote archaeological excavations across Egypt. This service also trained specialized personnel, oversaw the work of foreign expeditions, and opened independent and highly scientific excavations sites. Moreover, the ancient

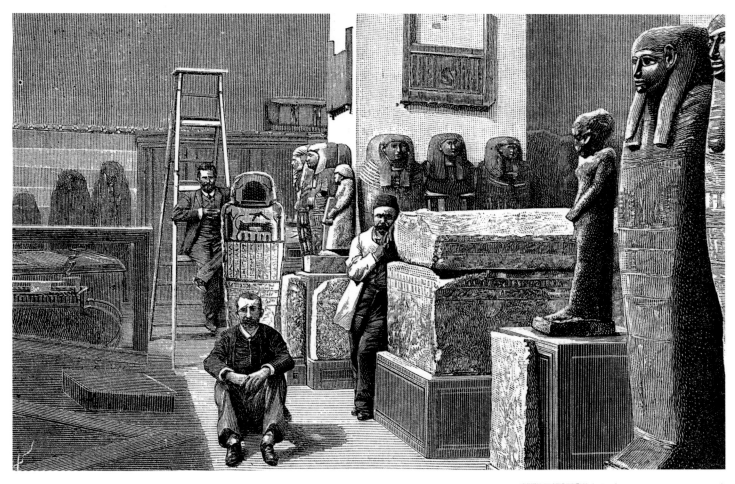

artifacts that were found were monitored constantly, and they could not be taken out of the country without authorization.

A few years later—in 1863—the Egyptian Viceroy Ismaïl Pasha officially inaugurated the Egyptian Museum in Cairo. Mariette energetically promoted the museum; he was also convinced that Egypt should safeguard its vestiges from destruction, preserve them from foreign greed, and protect them from savage plundering. For nearly a century, the director of the Antiquities Service also served as director of the Egyptian Museum.

The museum's first core collection, housed in one of the buildings of the old Fluvial Company in the Bulaq district, soon grew at a dizzying pace, due to both archaeological excavations and attentive protection policies.

However, the Bulaq site faced the constant risk of flooding by the Nile and, at the same time, the number of artifacts continued to increase expo-

11 top

The Bulaq site was abandoned in 1891 because it was subject to flooding by the Nile.

11 bottom

Scientists with Napoleon's expedition at work in an imaginary view of Egypt in this illustration from the early nineteenth century. The results of their work were published in the book *Description de l'Égypte*.

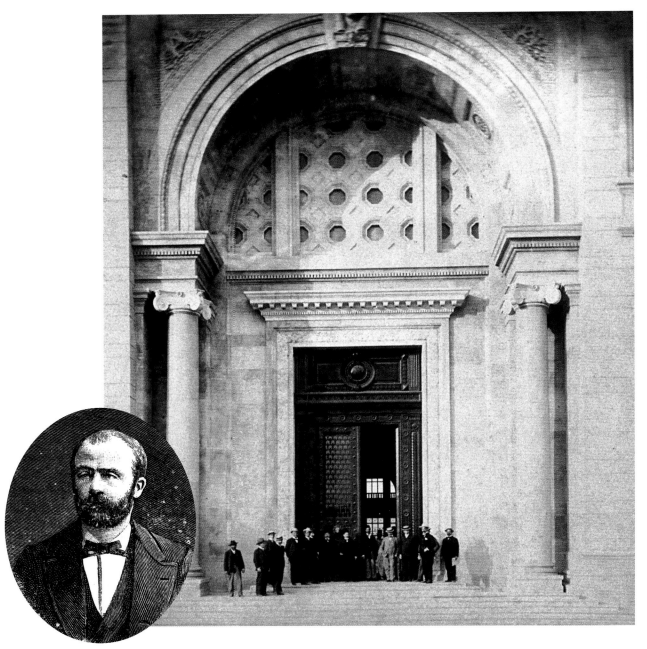

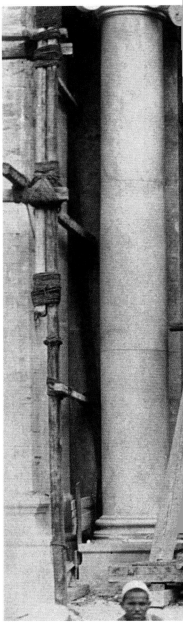

nentially. As a result, in 1890 it was transferred initially to Giza to a building provided by the viceroy. Subsequently, the current building of Qasr al-Nil was designed to house the museum, which was officially inaugurated in 1902 under Mariette's successor, Gaston Maspéro (1846–1916). This new museum, designed in a classical style by Frenchman Marcel Dourgnon, who won a hotly disputed international competition, now houses 150,000 artifacts that are on public display, and it has 30,000 other pieces in its storerooms. The display itinerary, which winds its way around a central hall, is laid out chronologically on the ground floor. In contrast, the upper floor is arranged by subject matter and archaeological context: Tutankhamun's tomb furnishings, those of Yuya and Tuya, the treasures of Tanis, the Fayum portraits, coffins and sarcophagi, deities, everyday life, funerary accouterments, mummies, papyruses, and ostraca. To cater to ongoing discoveries, changes were gradually made in the original layout and new sectors were created. The jewels of the princesses of the Middle Kingdom, discovered in 1894 with additional findings in 1914, the treasure of Tutankhamun, which was brought to the Museum in 1923, the funerary accouterments of Queen Hetepheres discovered in 1925, the royal furnishings of Tanis discovered in 1939, the findings from Tell al-Amarna, Deir al-Medina and Fayum, and the artifacts from expeditions to Nubian territory following the project to construct the Aswan Dam are just a few of the exhibitions that have been added.

12 left

After Auguste Mariette, French Egyptologist Gaston Camille Charles Maspéro became the director of the Egyptian Museum in Cairo and began publishing the catalog.

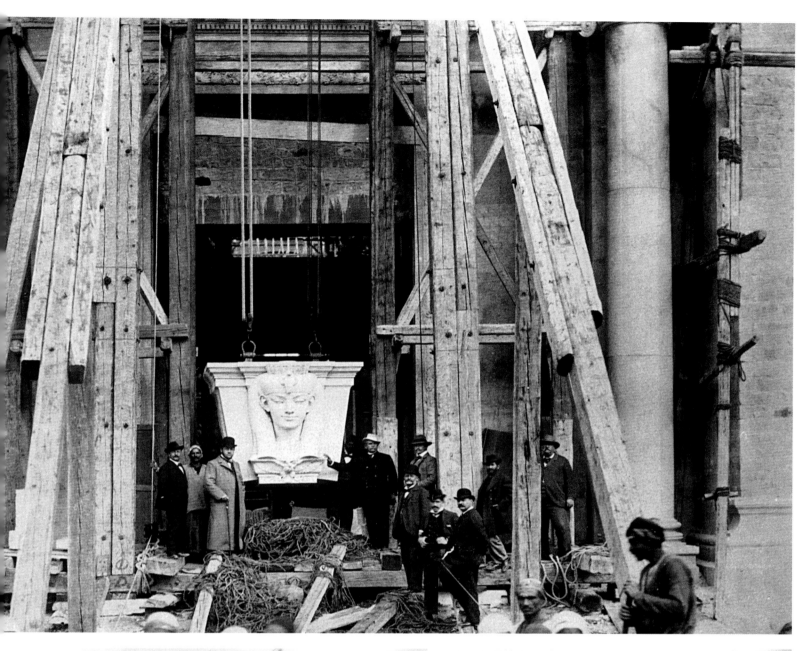

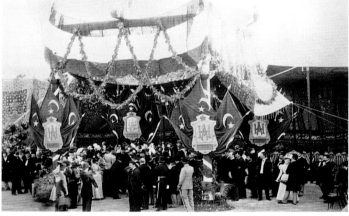

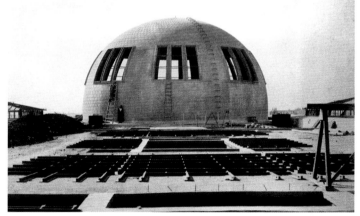

12 right

The year is 1901: executives from the Italian construction company and museum officials pose in front of the main entrance.

12-13

The raising of the keystone, decorated with a head of the goddess Isis, marked a historic moment for the museum.

13 bottom left

The cornerstone of the museum in Midan al-Tahrir was laid on April 1, 1897.

13 bottom right
This photograph of two laborers at work on the structure gives us an idea of the size of the innovative dome over the atrium.

The allure of the Egyptian Museum in Cairo, one of the most popular museums in the world, is due not only to the beauty of the items on display, but also to its nineteenth-century exhibition layout. Its rooms, somewhat chaotic and brimming with artifacts, house extraordinary monuments that look as if they were hastily amassed there, giving the museum a kind of charm found nowhere else in the world. Even the gardens around the building, surrounded by Cairo's frenzied traffic, create a unique 'outdoor museum' where visitors can admire important large-scale findings. This is also where Mariette was buried, amidst the beloved monuments to which he devoted so much attention.

From the very beginning, Maspéro was committed to publishing works on the items at the Egyptian Museum, as he recognized the importance of classifying them and studying them systematically. The outcome was the *Catalogue Général du Musée du Caire*, a work with numerous volumes, all of which were ed-

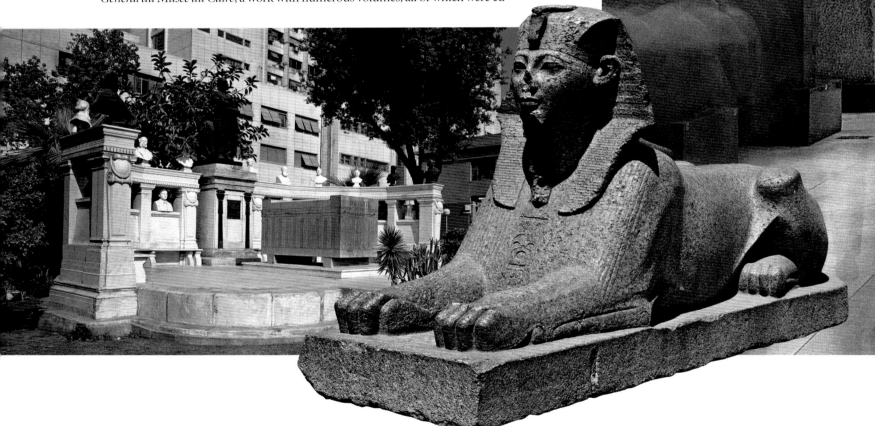

ited by renowned specialists. This publication is a fundamental and boundless source of detailed information about all aspects of the Egyptian civilization. In 1900 Maspéro founded the *Annales du Service des Antiquités,* a scientific periodical publishing articles about excavations, restoration work, and studies being conducted in Egypt. These valuable instruments have long provided significant stimulus and support for Egyptian studies.

Even today, however, modern studies and discoveries continue to yield Egyptian artifacts that literally run the risk of 'overwhelming' the Egyptian Museum in Cairo, detracting from its enjoyment by visitors. As a result, a new museum project is now underway. The Grand Museum of Egypt will be built on 124 acres of land a little over a mile from the Pyramids at Giza. The museum was designed by the Chinese architect Shih Fu Peng, who won an important international competition.

14 left

In the museum garden, a simple mausoleum, with a tomb sculpted to resemble to an ancient sarcophagus, commemorates Mariette.

14 right

The face of the conqueror king Thutmose III stands out on the splendid pink granite sphinx that welcomes visitors outside the museum.

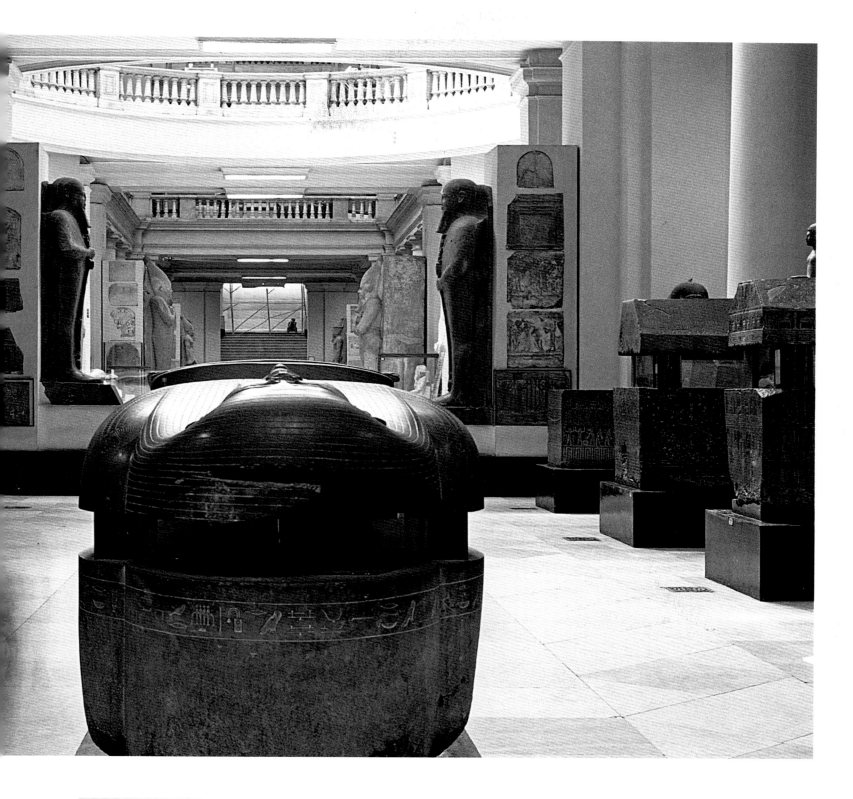

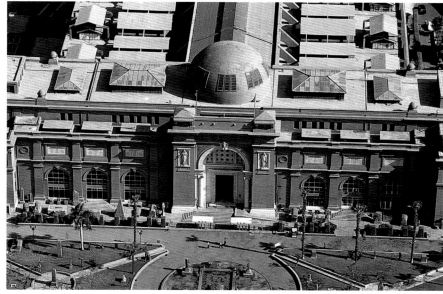

Soft light, filtered through the dome designed by Marcel Dourgnon, pervades the side rooms on the ground floor of the museum, enhancing the extraordinary works displayed there. The atmosphere here evokes the dignified, majestic sacredness of an ancient temple.

The garden, dotted with architectural fragments and sculptures from various eras, is effectively an outdoor museum that introduces visitors to the marvels inside.

The colossal statue of Amenotep III and Teye dominates the central room on the ground floor.

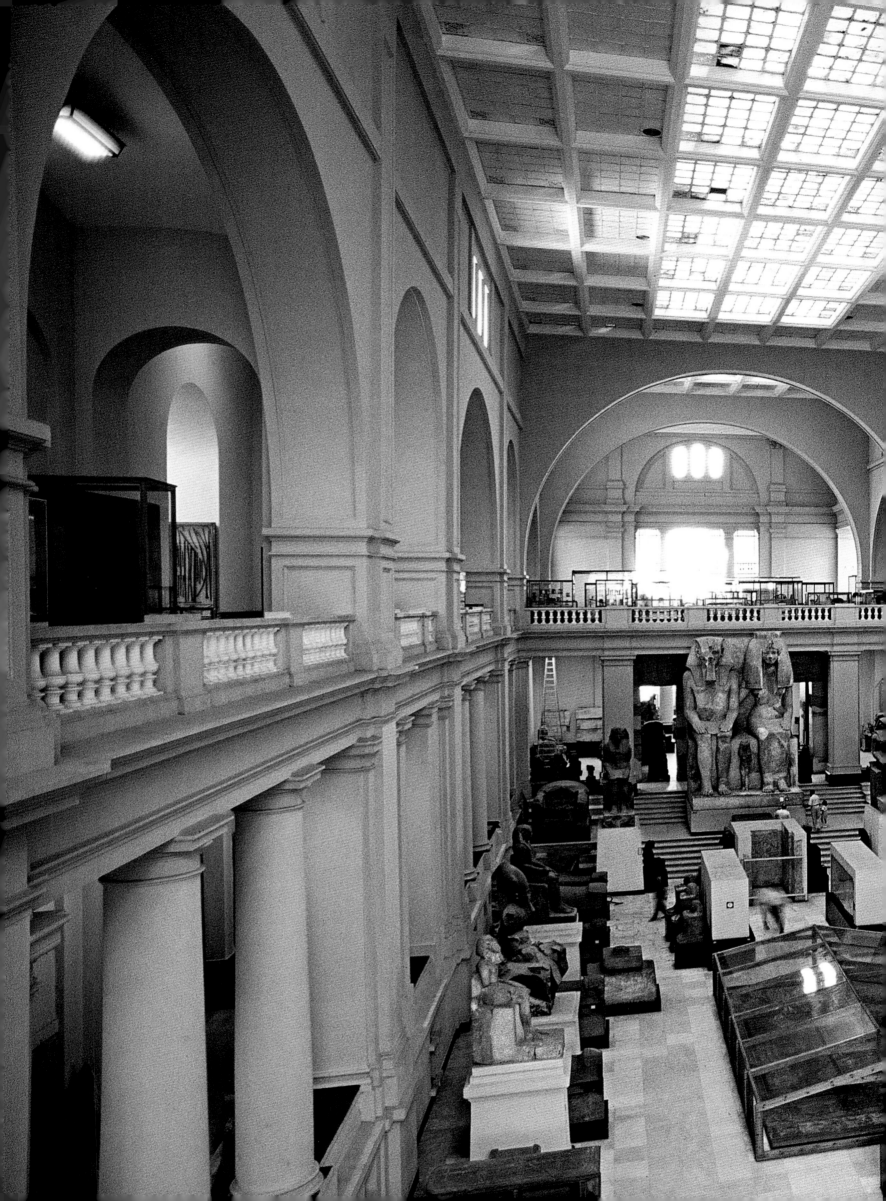

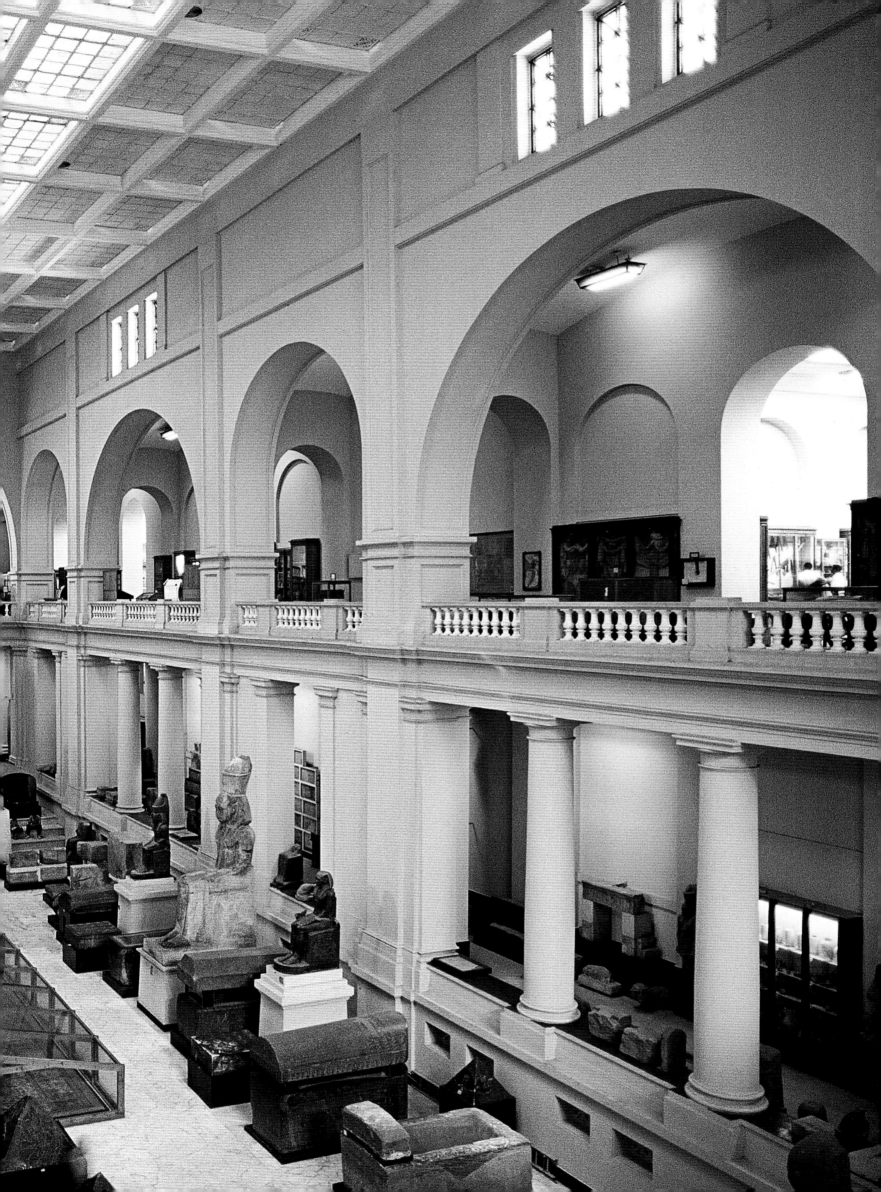

GROUND FLOOR

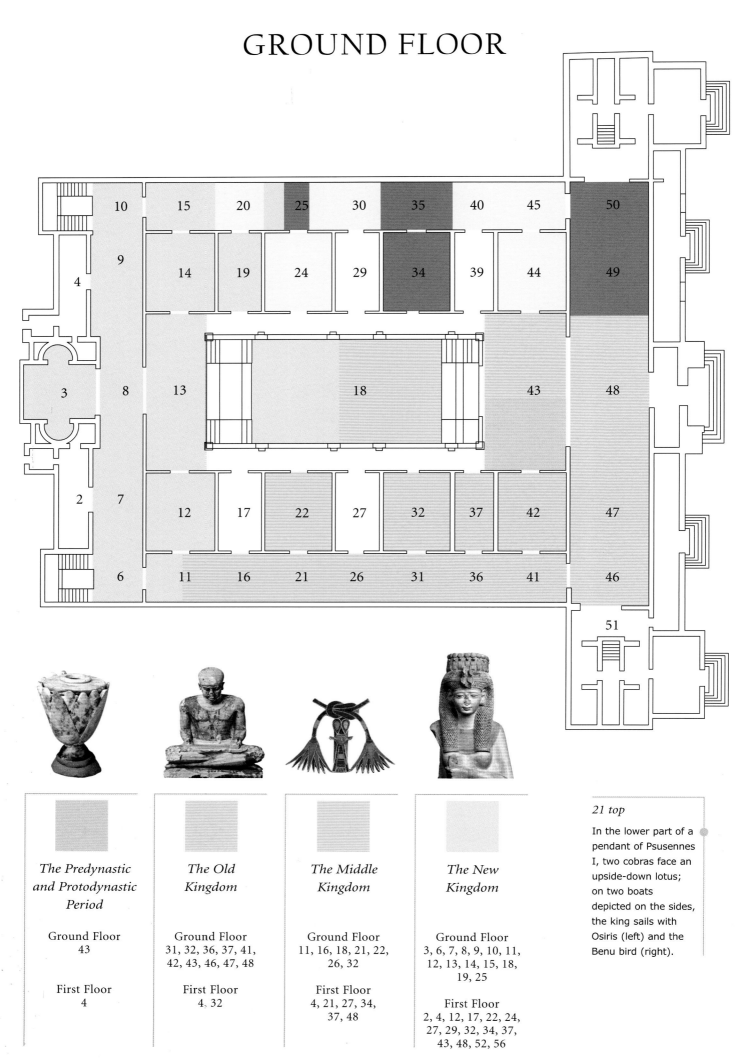

10	15	20	25	30	35	40	45	50	
9	14	19	24	29	34	39	44	49	
4									
3	8	13	18			43	48		
2	7	12	17	22	27	32	37	42	47
6	11	16	21	26	31	36	41	46	

51

The Predynastic and Protodynastic Period

Ground Floor
43

First Floor
4

The Old Kingdom

Ground Floor
31, 32, 36, 37, 41,
42, 43, 46, 47, 48

First Floor
4, 32

The Middle Kingdom

Ground Floor
11, 16, 18, 21, 22,
26, 32

First Floor
4, 21, 27, 34,
37, 48

The New Kingdom

Ground Floor
3, 6, 7, 8, 9, 10, 11,
12, 13, 14, 15, 18,
19, 25

First Floor
2, 4, 12, 17, 22, 24,
27, 29, 32, 34, 37,
43, 48, 52, 56

21 top

In the lower part of a
pendant of Psusennes
I, two cobras face an
upside-down lotus;
on two boats
depicted on the sides,
the king sails with
Osiris (left) and the
Benu bird (right).

FIRST FLOOR

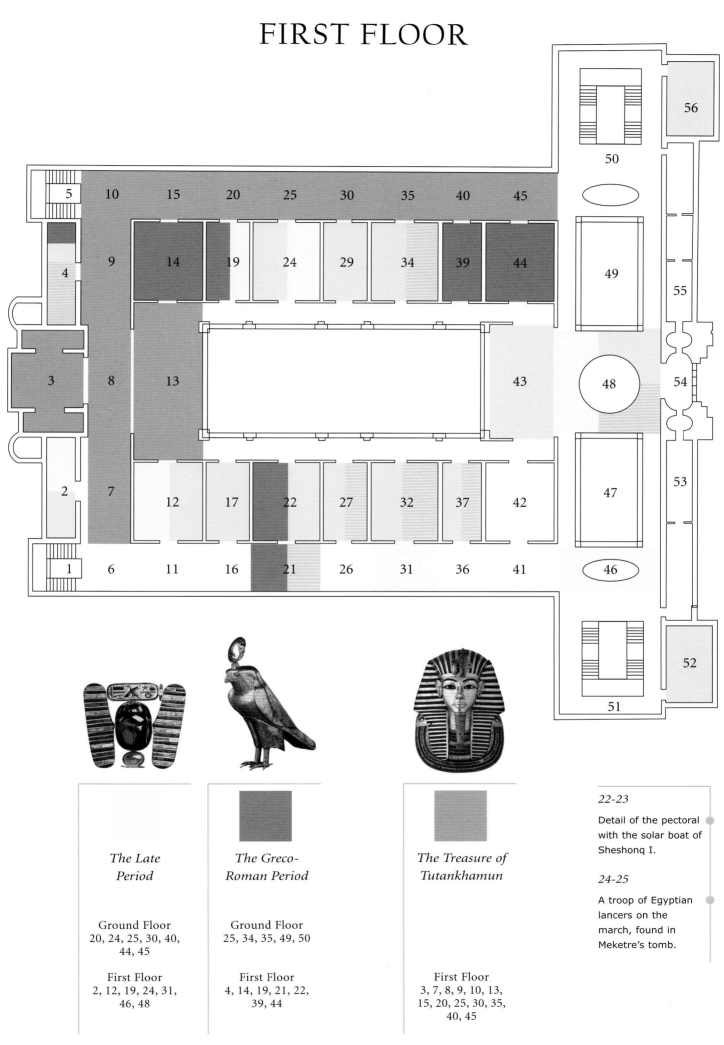

The Late Period

Ground Floor
20, 24, 25, 30, 40, 44, 45

First Floor
2, 12, 19, 24, 31, 46, 48

The Greco-Roman Period

Ground Floor
25, 34, 35, 49, 50

First Floor
4, 14, 19, 21, 22, 39, 44

The Treasure of Tutankhamun

First Floor
3, 7, 8, 9, 10, 13, 15, 20, 25, 30, 35, 40, 45

22-23

Detail of the pectoral with the solar boat of Sheshonq I.

24-25

A troop of Egyptian lancers on the march, found in Meketre's tomb.

CHRONOLOGY

* PREDYNASTIC PERIOD *
(4000 - 3000 BC)

Naqada I	(4000 - 3500)
Naqada II	(3500 - 3100)

Dynasty 0 (circa 3000)
Narmer

* PROTODYNASTIC PERIOD *
(2920 - 2575 BC)

1st Dynasty (2920 - 2770)
Aha (Menes?)
Djer
Djet
Den
Adjib
Semerkhet
Qaa

2nd Dynasty (2770 - 2649)
Hetepsekhemwy
Raneb
Nynetjer
Peribsen
Khasekhem (Khasekhemwy)

* OLD KINGDOM *
(2649 - 2152 BC)

3rd Dynasty (2649 - 2575)

Sanakht	2649 - 2630
Djoser (Netjerkhet)	2630 - 2611
Sekhemkhet	2611 - 2603
Khaba	2603 - 2600
Huni	2600 - 2575

4th Dynasty (2575 - 2465)

Snefru	2575 - 2551
Khufu	2551 - 2528
Djedefra	2528 - 2520
Khafre	2520 - 2494
Menkaure (Mycerinus)	2494 - 2472
Shepseskaf	2472 - 2465

5th Dynasty (2465 - 2323)

Userkaf	2465 - 2458
Sahure	2458 - 2446
Neferirkare Kakai	2446 - 2426
Shepseskare	2426 - 2419
Neferefre	2419 - 2416
Niuserre	2416 - 2392
Menkauhor	2392 - 2388
Djedkare Isesi	2388 - 2356
Unas	2356 - 2323

6th Dynasty (2323 - 2152)

Teti	2323 - 2291
Pepi I	2289 - 2255
Merenre	2255 - 2246
Pepi II	2246 - 2152

* FIRST INTERMEDIATE PERIOD *
(2152 - 2065 BC)

7th Dynasty
Probably inexistent.
Manetho notes: "Seventy kings of Memphis who ruled for 70 days" to indicate the political anarchy and dynastic conflicts that overwhelmed Egypt.

8th Dynasty (2152 - 2135)
The names of approximately 20 Memphis kings are known. The only one documented historically is Qakare Ibi; the pyramid at Saqqara pertained to this ruler.

9th and 10th Dynasties (2135 - 2040)
These were the dynasties of the Heracleopolitan kings who ruled much of Egypt before the return and rise of the Theban dynasty.

11th Dynasty – first part (2135 - 2065)

Mentuhotep I	
Antef I	
Antef II	2123 - 2073
Antef III	2073 - 2065

* MIDDLE KINGDOM *
(2065 - 1781 BC)

11th Dynasty – second part (2065 - 1994)

Mentuhotep II	
Nebhepetra	2065 - 2014
Mentuhotep III	2014 - 2001
Mentuhotep IV	2001 - 1994

12th Dynasty (1994 - 1781)

Amenemhat I	1994 - 1964
Sesostris I	1964 - 1929
Amenemhat II	1929 - 1898
Sesostris II	1898 - 1881
Sesostris III	1881 - 1842
Amenemhat III	1842 - 1794
Amenemhat IV	1793 - 1785
Queen Nefrusobek	1785 - 1781

* SECOND INTERMEDIATE PERIOD *
(1781 - 1550 BC)

13th Dynasty (1781 - 1650)
There are approximately 70 known rulers, who had very short tenures.

14th Dynasty (1710 - 1650)
An indefinite number of minor rulers, all of whom contemporary to the 13th and 14th Dynasties.

15th Dynasty (1650 - 1550)
The main Hyksos rulers:
Salitis
Sheshi
Jaqobher
Khayan
Ipepi
Khamudi

16th Dynasty (1650 - 1550)
Minor Hyskos rulers governed at the same time as the 15th Dynasty.

17th Dynasty (1650 - 1550)
Fifteen Theban rulers, the most important of whom are:
Antef V
Sobekemsaf I
Sobekemsaf II
Antef VI
Antef VII
Seqenenra Tao I
Seqenenra Tao II
Kamose

* NEW KINGDOM *
(1550 - 1075 BC)

18th Dynasty (1550 - 1291)

Ahmes	1550 - 1525
Amenhotep I	1525 - 1504
Thutmose I	1504 - 1492
Thutmose II	1492 - 1479
Hatshepsut	1479 - 1458
Thutmose III	1479 - 1425
Amenhotep II	1424 - 1397
Thutmose IV	1397 - 1387
Amenhotep III	1387 - 1350
Amenhotep IV/ Akhenaten	1350 - 1333
Smenkhkare	1335 - 1333
Tutankhamun	1333 - 1323
Ay	1323 - 1319
Horemheb	1319 - 1291

19th Dynasty (1291 - 1185)

Ramesses I	1291 - 1289
Seti I	1289 - 1279
Ramesses II	1279 - 1212
Merenptah	1212 - 1202
Ammenemes	1202 - 1199
Seti II	1199 - 1193
Siptah	1193 - 1187
Tausret	1193 - 1185

20th Dynasty (1187 - 1075)

Sethnakht	1187 - 1184
Ramesses III	1184 - 1153
Ramesses IV	1153 - 1147
Ramesses V	1147 - 1143
Ramesses VI	1143 - 1135
Ramesses VII	1135 - 1127
Ramesses VIII	1127 - 1126
Ramesses IX	1126 - 1108
Ramesses X	1108 - 1104
Ramesses XI	1104 - 1075

* THIRD INTERMEDIATE PERIOD *
(1075 - 664 BC)

21st Dynasty (1075 - 945)

Smendes I	1075 - 1049
Neferkare	1049 - 1043
Psusennes I	1045 - 994
Amenemope	994 - 985
Osorkon the Elder	985 - 979
Siamun	979 - 960
Psusennes II	960 - 945

22nd Dynasty (945 - 718)

Sheshonq I	945 - 924
Osorkon I	924 - 899
Sheshonq II	890 circa
Takelot I	889 - 883
Osorkon II	883 - 850
Takelot II	853 - 827
Sheshonq III	827 - 775
Pamy	775 - 767
Sheshonq V	767 - 729
Osorkon IV	729 - 718

23rd Dynasty (820 - 718)

Petubastis	820 - 795
Sheshonq IV	795 - 788
Osorkon III	788 - 760
Takelot III	765 - 756
Rudamun	752 - 718

24th Dynasty (730 - 712)

Tefnakht	730 - 718
Bocchoris	718 - 712

25th Dynasty (775 - 653)

Alara	775 - 765
Kashta	765 - 745
Piye (Piankhy)	745 -713
Shabaka	713 - 698
Shabataka	698 - 690
Taharqa	690 - 664
Tanutamani	664 - 653

* LATE AGE *
(664 - 332 BC)

26th Dynasty (664 - 525)

Psammetik I	664 - 610
Neko	610 - 595
Psammetik II	595 - 589
Apries	589 - 570
Amasis	570 - 526
Psammetik III	526 - 525

27th Dynasty (525 - 404)

Cambyses	525 - 522
Darius I	521 - 486
Xerxes I	486 - 465
Artaxerxes I	465 - 424
Xerxes II	424
Darius II	423 - 405
Artaxerxes II	405 - 404

28th Dynasty (404 - 399)

Amyrtaios	404 - 399

29th Dynasty (399 - 380)

Neferites I	399 - 393
Hacoris	393 - 380

30th Dynasty (380 - 342)

Nectanebo I	380 - 362
Teos	362 - 360
Nectanebo II	360 - 342

31st Dynasty (342 - 332)

Artaxerxes III	342 - 338
Arses	338 - 336
Darius III	336 - 332

* GREEK PERIOD *
(332 - 30 BC)

The Macedonians (332 - 305)

Alexander the Great	332 - 323
Philip Arrhidaeus	323 - 317
Alexander IV	317 - 305

Ptolemaic Dynasty (305 - 30)

Ptolemy I Soter	305 - 282
Ptolemy II Philadelphus	285 - 246

Ptolemy III Euergeter	246 - 222
Ptolemy IV Philopator	222 - 205
Ptolemy V Epiphanes	205 - 180
Ptolemy VI P.	180 - 164, 163 - 145
Ptolemy VII Neos Philopator	145
Ptolemy VIII E.	170 - 163, 145 - 116
Ptolemy IX S.	116-110, 109-107, 88-80
Ptolemy X Alexander	110 - 109, 107 - 88
Ptolemy XI Alexander	80
Ptolemy XII N. D.	80 - 58, 55 - 51
Berenice IV	58 - 55
Cleopatra VII Philopator	51 - 30
Ptolemy XV Cesarion	36 - 30

* ROMAN PERIOD *
(30 BC - 313 AD)

The emperors whose names appear in hieroglyphics and demotic texts are cited.

Augustus	30 BC - 14 AD
Tiberius	14 - 37
Caligula	37 - 41
Claudius	41 - 54
Nero	54 - 68
Galba	68 - 69
Otho	69
Vespasian	69 - 79
Titus	79 - 81
Domitian	81 - 96
Nerva	96 - 98
Trajan	98 - 117
Hadrian	117 - 138
Antoninus Pius	138 - 161
Marcus Aurelius	161 - 180
Lucius Verus	161 - 169
Commodus	180 - 192
Septimius Severus	193 - 211
Caracalla	198 - 217
Geta	211 - 212
Macrinus	217 - 218
Diadumenianus	218
Severus Alexander	222 - 235
Gordian III	238 - 244
Philippus (Philip the Arab)	244 - 249
Decius	249 - 251
Gallus and Volusianus	251 - 252
Valerian	253 - 260
Gallienus	253 - 268
Macrianus and Quietus	260 - 261
Aurelian	270 - 275
Probus	276 - 282
Diocletian	284 - 305
Maximianus	285 - 305
Galerius	293 - 311
Maximinus Daia	305 - 313

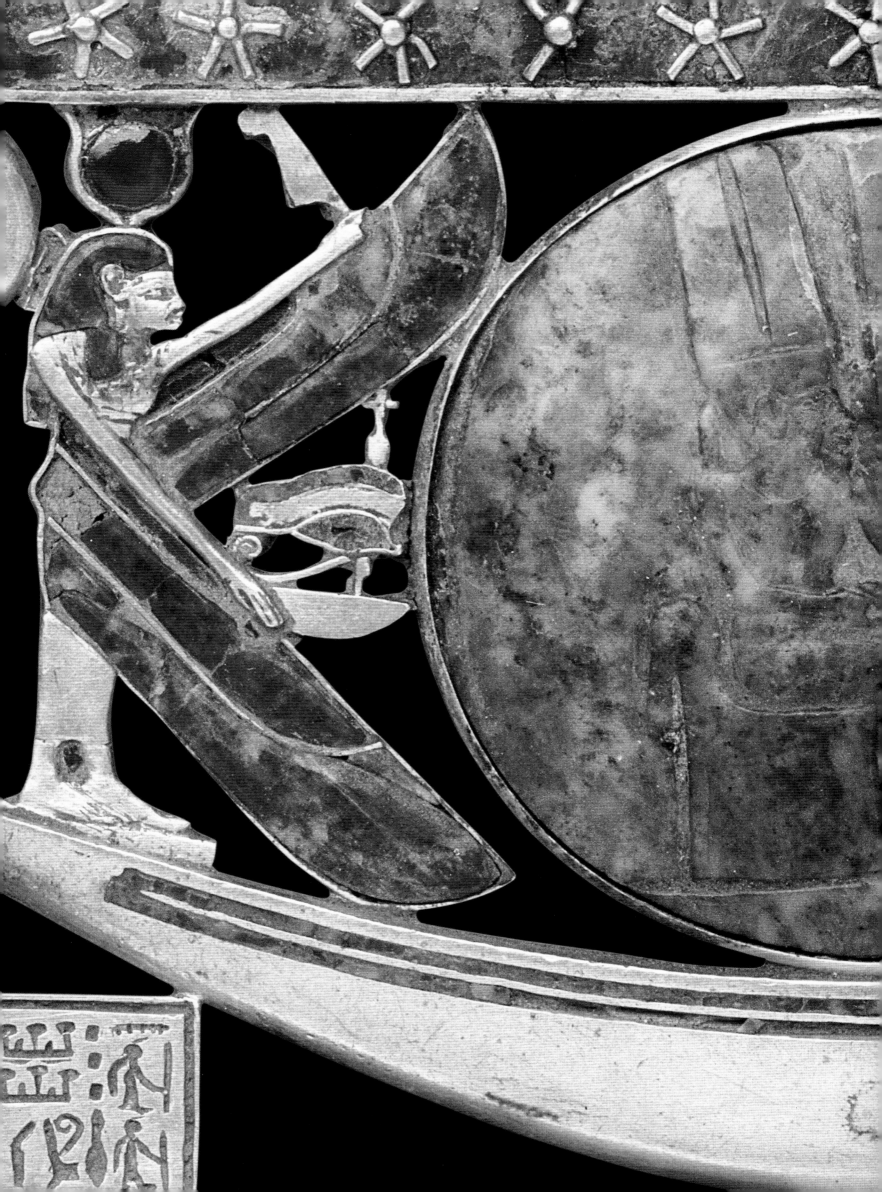

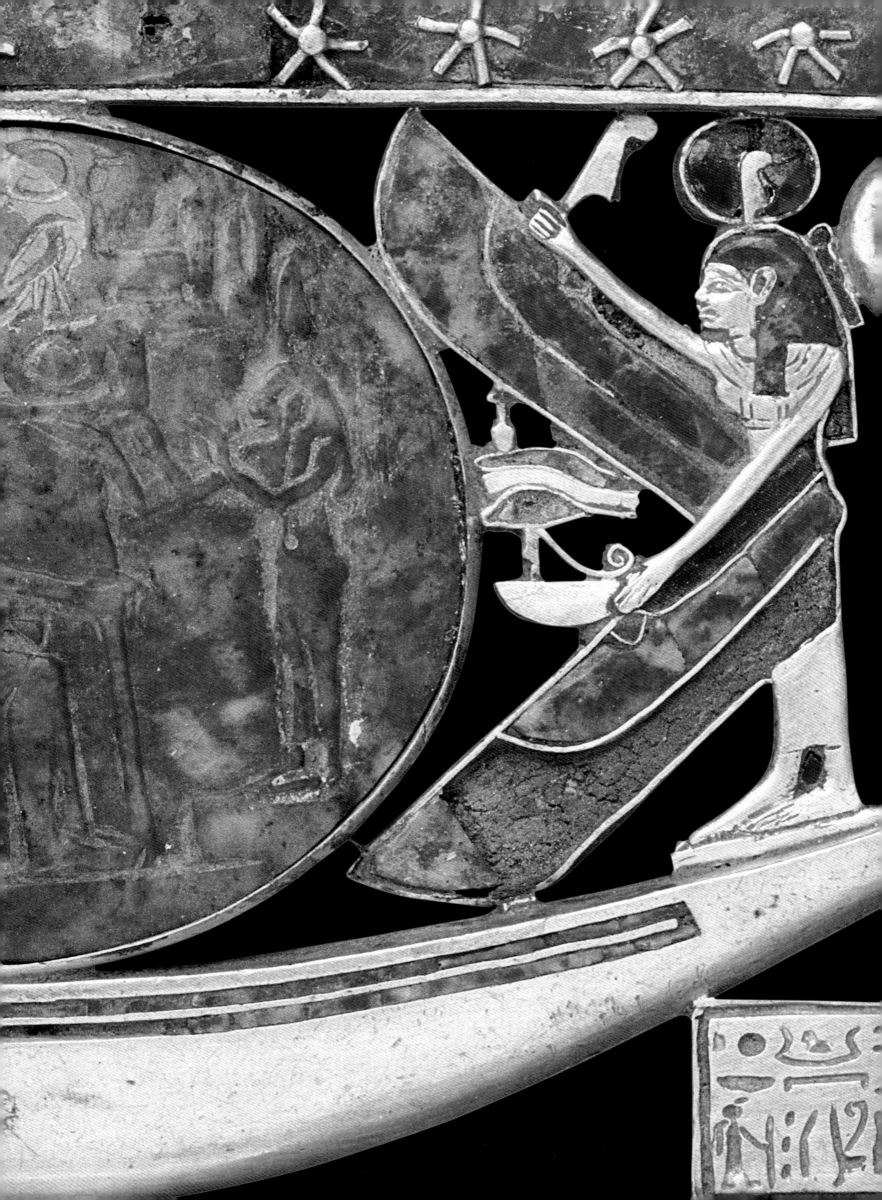

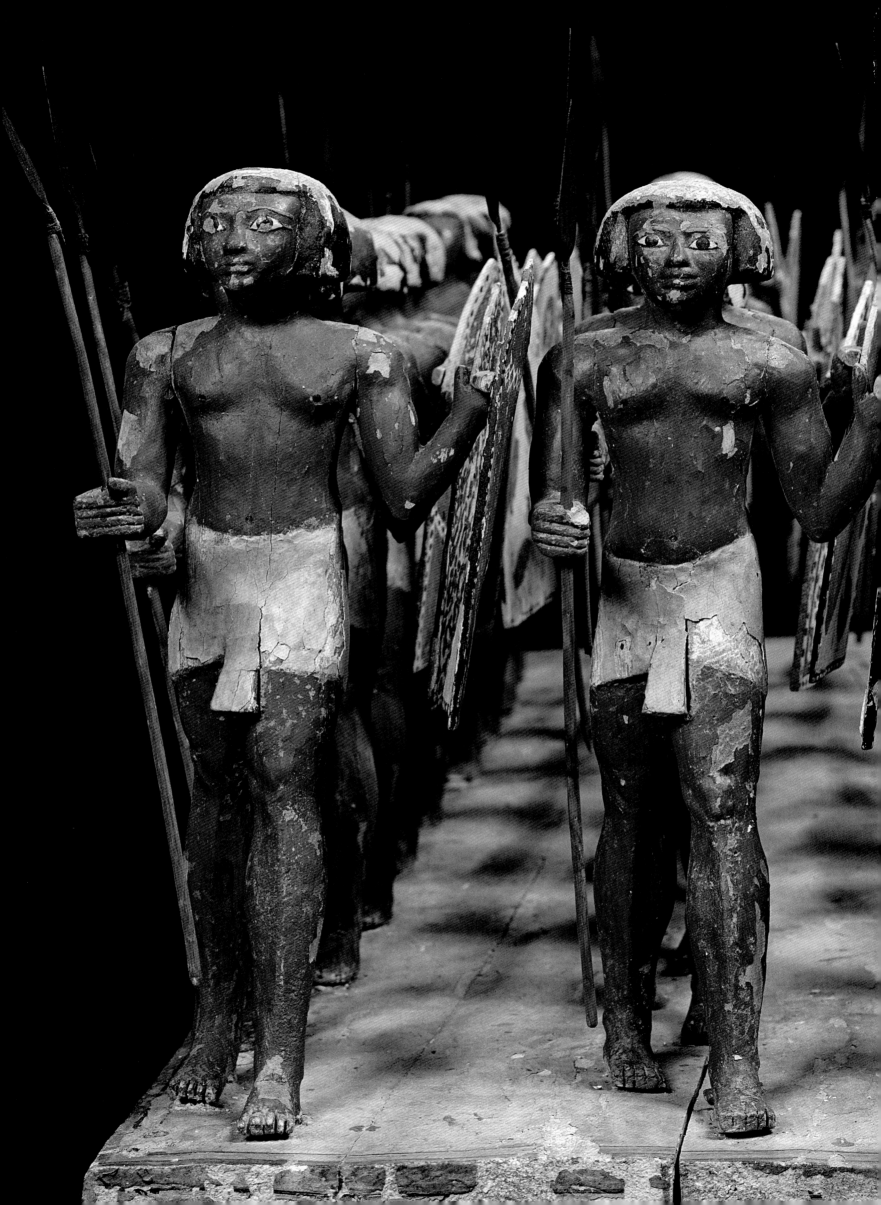

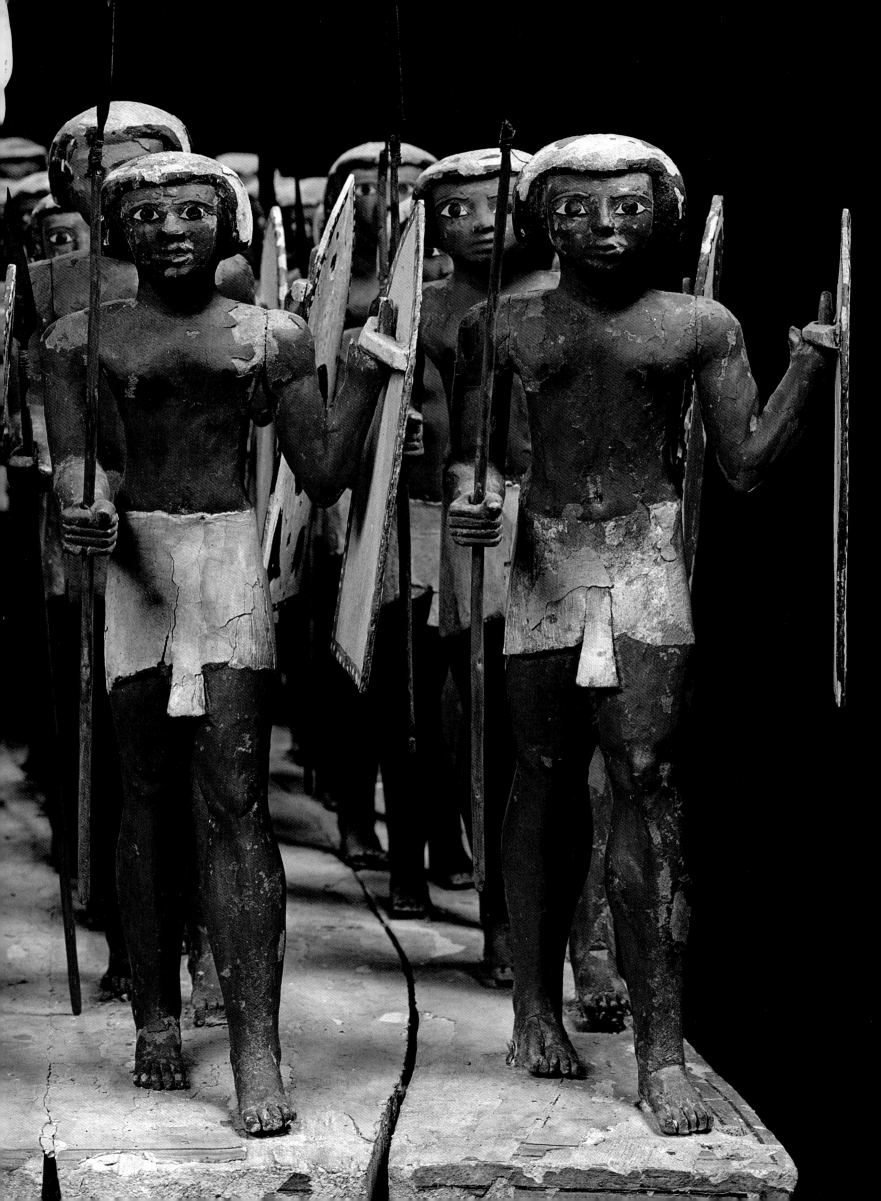

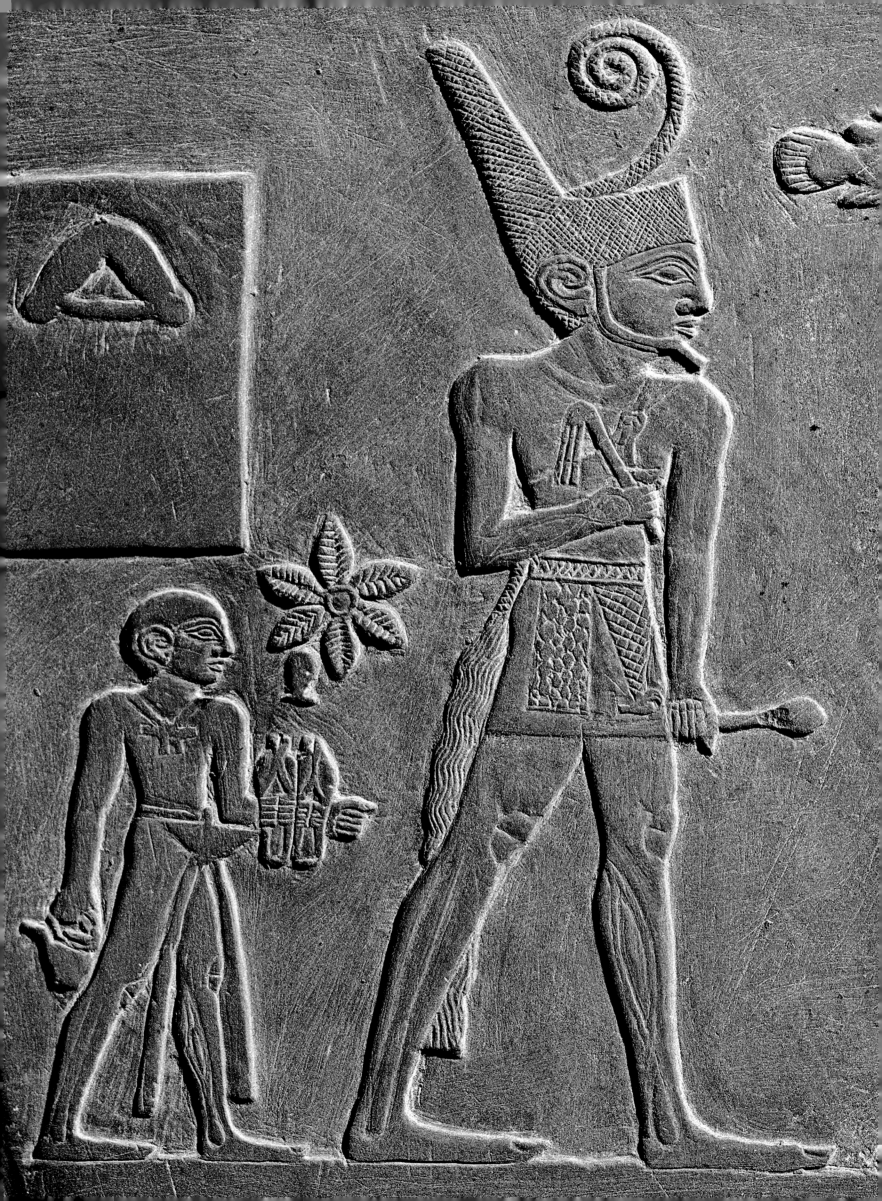

THE PREDYNASTIC
AND
PROTODYNASTIC PERIODS

THE ORIGINS OF

EGYPTIAN HISTORY WERE

CHARACTERIZED BY THE

SLOW AND GRADUAL

FORMATION OF A

POWERFUL AND UNIFIED

STATE UNDER A SINGLE

RULER.

The phase in which the Egyptian state was formed has conventionally been divided into two separate stages,

the Predynastic Period (from about 4000 BC to what is referred to as Dynasty '0', in about 3150 BC) and the Protodynastic Period (First–Second Dynasties, approximately 3150–2900 BC). The culminating event was the unification of the entire Nile Valley—Upper and Lower Egypt—under a single power that successfully merged different cultures and habitats. Regardless of how this came about, this unification would remain entrenched in the Egyptian tradition and was essentially considered the creation of the ordered world. It was a tradition that would be reiterated throughout the pharaonic state at every coronation, when the new king was proclaimed "Lord of the Two Lands."

Archaeological studies and excavations are seeking to shed more light on a historic period that has yielded very little information, most of which comes from the Nile Valley rather than the Delta, where settlements were always subject to alluvial deposits.

Recent studies tend to move back the start of social formations in Egyptian territory to approximately 5000 BC. Discoveries near Nabta Playa—a site now located deep in the Sahara Desert, about 60 miles west of Abu Simbel—have offered intriguing insight for theorizing the presence of a human society with funerary and religious beliefs that were already well developed even at such an early date, as evidenced by the remains of a ceremonial center and large-scale stone structures.

Dating back to about 4000 BC, the 'Naqada culture'—named after a site in Upper Egypt—is identified with an early cultural formation that has been documented only in the area around Thebes. This culture had highly distinctive traits revealing clear-cut social stratification and manifesting evident symbols of a central power. More specifically, the phase known as Naqada II—dated approximately 3500 BC, by which time the Naqada culture extended from Fayum to Nubia—marked the start of the Egyptian unification process. Clearly, this was merely a political unification at first, and only later did cultural unification arise, culminating in the second half of the Naqada III phase (or Dynasty '0').

Several scholars have theorized a sort of 'naqadization' of Egypt, from the Delta to Elephantine. Initially, this would have led to clashes between various local chieftains, but ultimately two united blocks were formed—Upper and Lower Egypt—and they were finally united. In this long process, the town of Naqada may be been absorbed by a coalition of the lords of Abydos and Hierakonopolis, who first unified Upper Egypt and then annexed Lower Egypt.

The site of Hierakonopolis, in particular, seems to have been one of the most important predynastic centers as early as 3600 BC. Archaeological excavations have identified the remains of dwellings, necropolises differentiated by social group, and even large vats for preserving beer, with a 'bottling factory' nearby. This discovery is important, because it points to the concept that during this period there was already some kind of economic organization that could stock and distribute raw materials.

The Predynastic and Protodynastic Periods

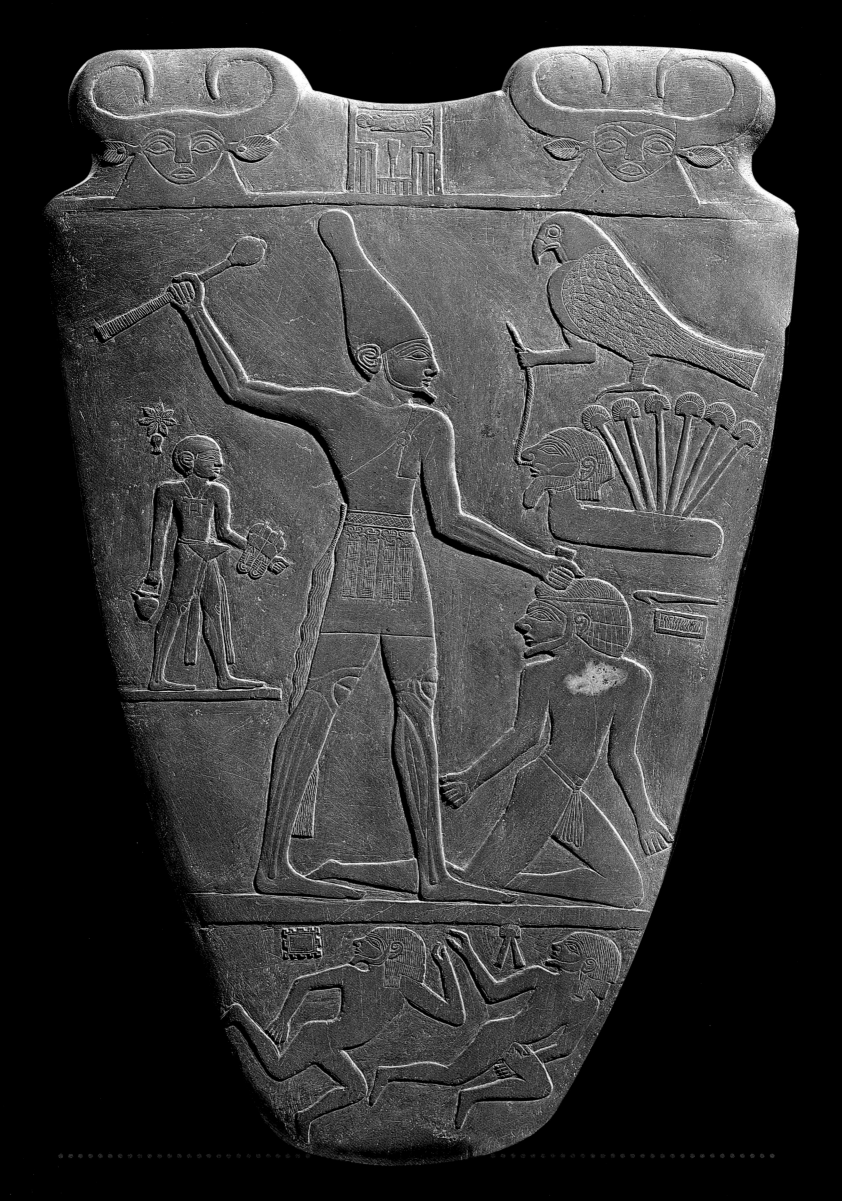

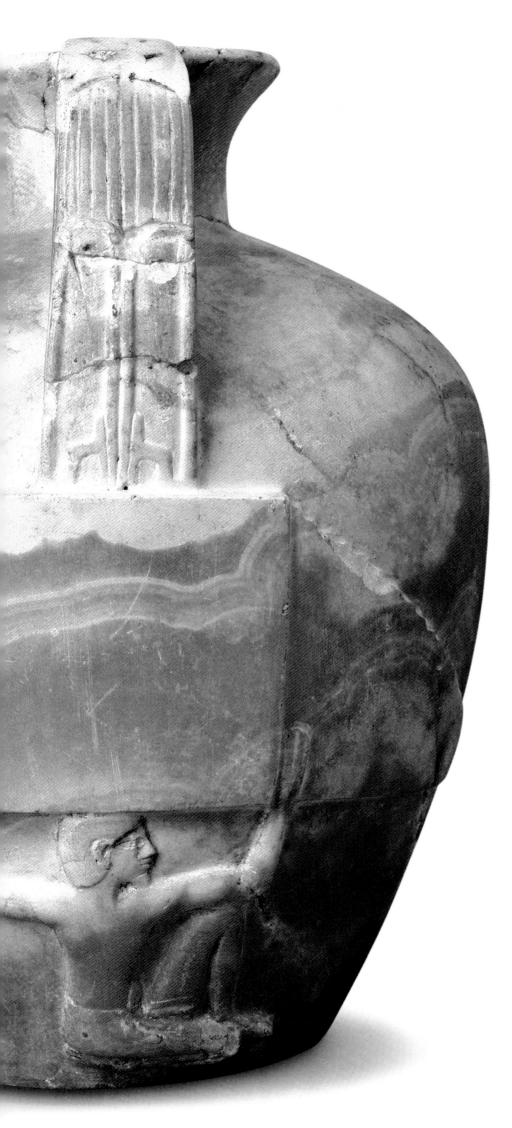

The development of a number of important cities in southern Egypt, such as Hierakonopolis, al-Kab, Naqada, This, Abydos, Armant, Gebelein, and Elephantine, was paralleled by the formation of sedentary cultures of farmers-herders around the Nile Delta. The contacts of the latter cultures with the Near East are apparent, most notably at the Buto and Maadi sites.

To understand the drive that must have led the Naqada culture to expand northward, one must consider the search for raw materials, essential by this time for the smooth operation of advanced organizational systems and for glorification of the elite.

Nonetheless, this process must have been a violent one, as testified by the numerous battle scenes portrayed on vases, plates, tablets, and the heads of clubs that have been found from the Predynastic Period. Thus, legitimation of the state must have been based on definitive liberation from clashes and struggles: in other words, the transition from a chaotic state to one of order, as the Egyptian tradition would continue to propagandize throughout its history.

The Narmer Palette, discovered in 1897 as a votive offering at the Temple of Horus in Hierakonopolis, has traditionally been considered the celebration of the final phase of the clashes during the Predynastic Period. It seems that during this era, a single ruler from the south—King Narmer, indicated as the first king of the First Dynasty—headed two coalitions. The obverse side of this palette portrays King Narmer, wearing the white crown of Upper Egypt, as he vanquishes an inhabitant of the swamps of the Nile Delta, alluding to the victory of the south over the north. However, recent studies tend to consider this palette a monument celebrating the country's unity rather than its unification, which may have occurred long before. Egyptian sources mention a dynasty of demigods that preceded the first pharaohs, legendary figures that may have represented the faraway rulers of a united country whose name was lost in the oral tradition.

Figures like Narmer, Scorpion, Menes, and Aha can all be considered the first rulers of a United Egypt, which established its capital at Memphis. The issue continues to be disputed among scholars, but King Aha, who can probably be identified with Menes, is generally considered the founder of the First 'Thinite' Dynasty, named after the city of This, near Abydos, where the dynasty probably originated.

The history of the first two dynasties is obscure and there are numerous gaps, despite the fact that their tombs of these sovereigns have been identified and have provided plenty of food for thought. The pharaohs of the First Dynasty continued to be buried in the southern part of the country, at the archaic necropolis of Abydos—Umm al-Qaab—in impressive burial mounds with a large funerary chamber, surrounded by storerooms and secondary chambers for minor burials. Annexed to these burials there were enormous sacred enclosures or 'funerary palaces' that were set about 100 yards from the actual tomb in the 'North Necropolis' still being studied today. The most extraordinary of these royal tombs, with over 200 annexed rooms, is the one of Pharaoh Djer (First Dynasty), and since the period the Middle Kingdom it has been considered the tomb of Osiris.

With the first kings of the Second Dynasty, the royal necropolis was transferred to Saqqara, in the northern part of the country. The last two kings of the Second Dynasty were instead buried in Abydos, due probably to domestic turmoil. Several impressive tombs with a rectangular structure in the form of a mastaba—which means 'bench' in Arabic, hence the name of this type of tomb—were also found at Saqqara, and they have likewise been attributed to the rulers of the First Dynasty. Scholars generally agree that the monuments at Saqqara can be considered cenotaphs, while the mounds at Abydos were actual burial sites.

Without going into detail on the various aspects, recently concluded studies as well as others now underway indicate that the burials and royal enclosures of Abydos, as well as the subsequent innovations of the tombs of the rulers of the Second Dynasty at Saqqara, were the inspiration and forerunners of Djoser's 'step pyramid' (Third Dynasty) and the pyramids of the Old Kingdom. For example, a sensational discovery has been made recently at the archaic necropolis of Abydos. Fourteen large trenches for boats have been found there, dating back to the First Dynasty, and they can be linked with the boat trenches from the same period, albeit smaller in size, discovered at Saqqara. The connection with the boat trenches of the pyramids of the Old Kingdom is inevitable.

The archaeological remains of the Protodynastic Period thus make it possible to reveal the basic groundwork that was laid for the development of an elaborate and well-organized state, founded on strong theocratic power that could keep the country's internal diversities under control.

Room 43 on the ground floor of the museum, across from the entrance, is devoted in part to the Predynastic and Protodynastic Periods. The first item displayed in this room is the Narmer Palette, an inscription on a piece of schist, which celebrates the unification of the Egyptian state under a single ruler, followed by the "Tablet of the Libyan tribute," also inscribed on schist. These are followed by the ivory tablets of Kings Aha and Djer (both from the First Dynasty), and the senet game made of wood and ivory, discovered in the tomb of King Djet (First Dynasty). There is also an ivory comb that belonged to this ruler. Other notable items include the alabaster jubilee vase, and the stone vases with gold lids from the tomb of Khasekhem (Second Dynasty). The schist statue wrapped in a sed tunic, found at the Temple of Hierakonopolis, also portrays this sovereign.

On the upper floor, in Room 4—devoted to jewelry—there is a set of bracelets made of gold, turquoise, amethyst, and lapis lazuli, found at the tomb of King Djer.

30
JE 64872

THE JUBILEE VASE

ALABASTER
HEIGHT CM 37
DIAMETER CM 28
2nd Dynasty
(2770-2649 BC)

Found by the Egyptian Antiquities Service (1932-1933) at Saqqara, in the subterranean galleries of the step pyramid together with thousands of other vases, this specimen is thought have celebrated the Sed festival, which renewed the ruler's earthly power. The god Heh supports the royal podium, flanked by two staircases, represented on the belly of the vase, thereby ensuring the king would rule for "millions" of years.

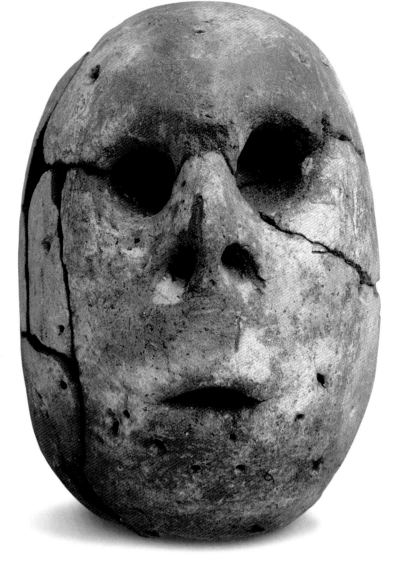

32 top
JE 97472

MAN'S HEAD

CLAY
HEIGHT CM 10.3
WIDTH CM 6.7
Neolithic (late 5th
millennium BC)

The excavations
conducted in Merimde
Benisalama by the
German Institute of
Archaeology (1982) led
to the discovery of this
clay head with a
piercing gaze.
Accentuated cavities
mark the main features
of the face, which is
framed by tiny holes
that may have held
feathers to imitate the
look of the figure's hair
and beard. The head
was probably set on a
post or wooden object.

32 bottom

VASE LABELS

CLAY
1st Dynasty (2920-2770 BC)

JE 99160 - 99162

These labels were found in the tomb
of King Qaa, at the royal acropolis of
Abydos, dating back to the Archaic
Period. Via a hole, they were affixed
to oil containers, indicating the name
of the responsible official, the name
of the year of delivery, the quantity
and the origin.

33
JE 64910

JAR WITH PAINTED DECORATION

PAINTED CLAY
HEIGHT CM 22
DIAMETER CM 17
Predynastic Period,
Naqada II (3500-3100 BC)

Though its provenance
is unknown, the jar has
been dated to the
Naqada II period, which
was characterized by
ocher pottery that was
painted dark red. The
decorative motifs refer
to the Nile landscape,
represented with
sequences of straight
and wavy lines in
symmetrical
arrangements. Top, a
two-cabin boat is sailing
along the Nile, and
there are several
ostriches on the
riverbank

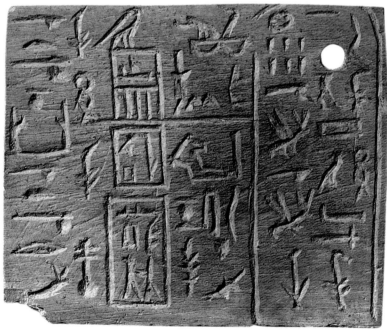

The Predynastic and Protodynastic Periods

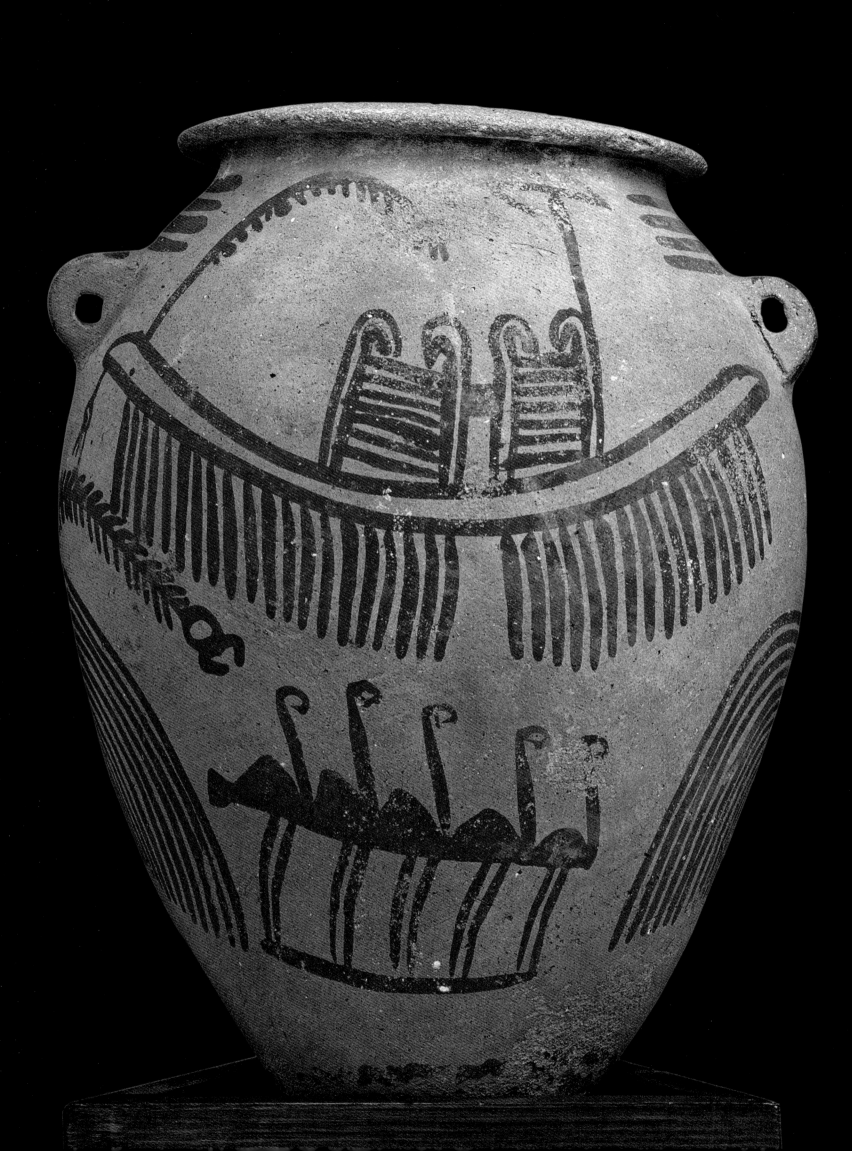

34 top
JE 43103

PALETTE WITH COW'S HEAD

SCHIST
HEIGHT CM 15
Predynastic Period,
Naqada II
(3500-3100 BC)

The decoration on this palette used for cosmetics seems to evoke the stylized head of the goddess Hathor, the "heavenly cow" whose horns, ears, and head are surmounted by stars. This artifact, which was found by W.M.F. Petrie (1911), comes from Tomb 59 at Gerzeh.

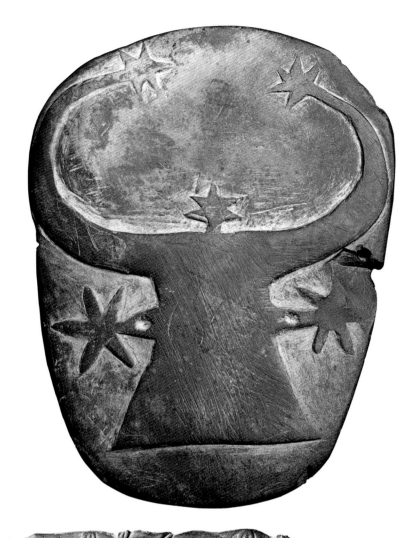

35
JE 32169 =
CG 14716

THE NARMER PALETTE

SCHIST
HEIGHT CM 64
WIDTH CM 42
Dynasty "0", Narmer's reign (circa 3000 BC)

In the upper register on the obverse, Narmer, wearing the crown of Lower Egypt, is escorted by officials as he inspects his vanquished enemies, who have been decapitated. The artifact was discovered in Hierakonopolis by J. Quibell (1894).

34 bottom
JE 27434 =
CG 14238

TABLET OF THE LIBYAN TRIBUTE

SCHIST
HEIGHT CM 19
WIDTH CM 22
End of the Predynastic Period (3000 BC)

Discovered in Abydos, the tablet may celebrate a victory in Libyan territory, as suggested by the hieroglyph in the lower register, next to an olive grove.

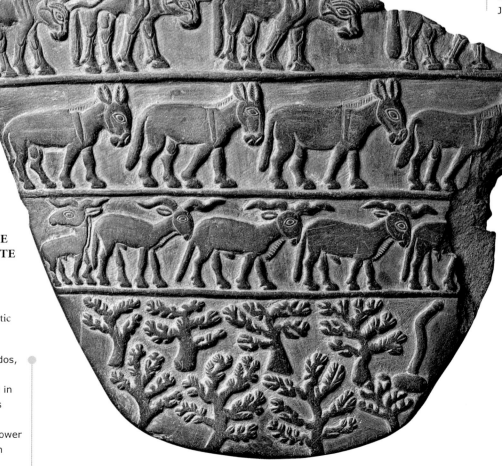

The Predynastic and Protodynastic Periods

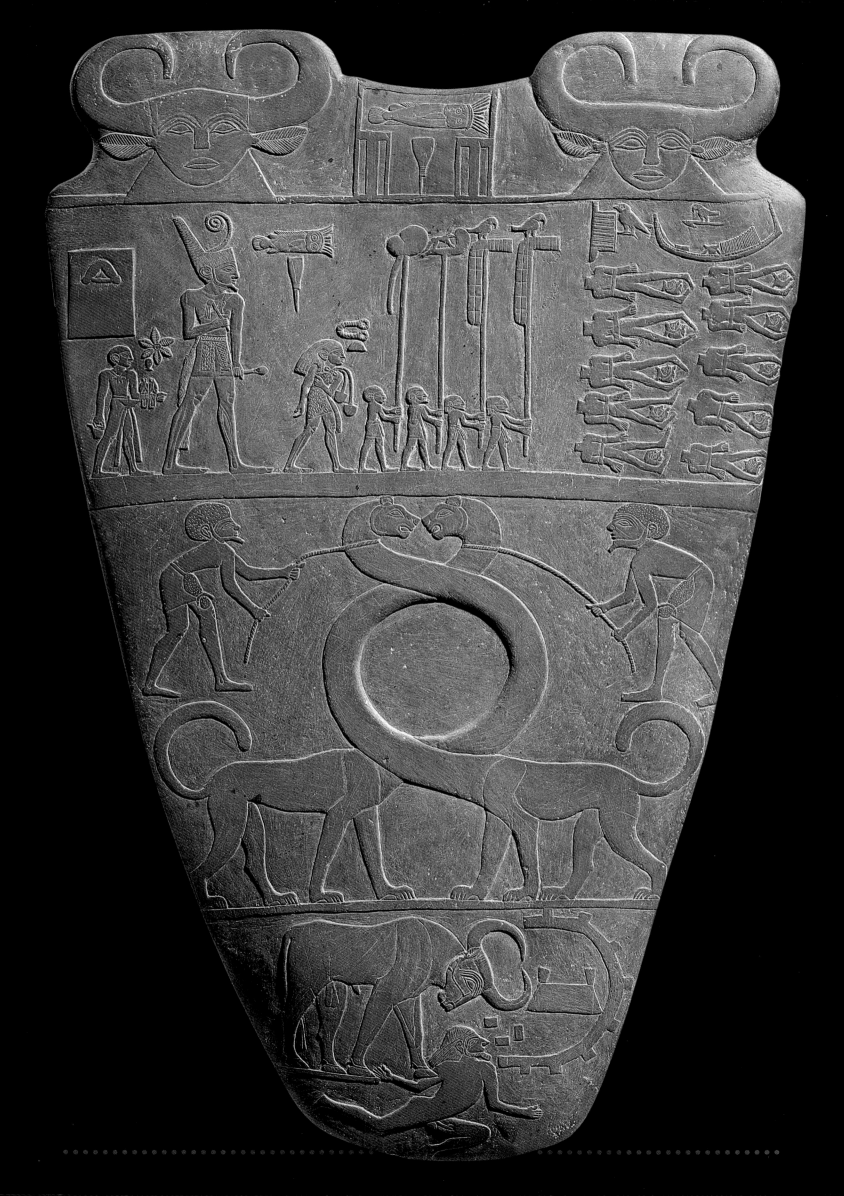

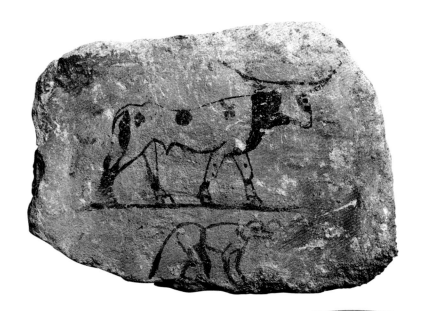

36 top | JE 70149

OSTRACON WITH BULL AND BABOON

PAINTED LIMESTONE
1st Dynasty
(2920-2770 BC),
Den's reign

This ostracon fragment, which is probably a sketch, comes from the tomb of the chancellor Hemaka at Abydos. It is depicts a bull and a monkey on two registers.

36 center
JE 70160

DISK WITH DOVES

INLAID LIMESTONE
DIAMETER CM 9.7
3rd Dynasty
(2630-2611 BC),
Djoser's reign

The disk with inlaid alabaster geometric motifs around the edge, discovered by W.B. Emery in Djoser's pyramid (1936), depicts two doves in relief.

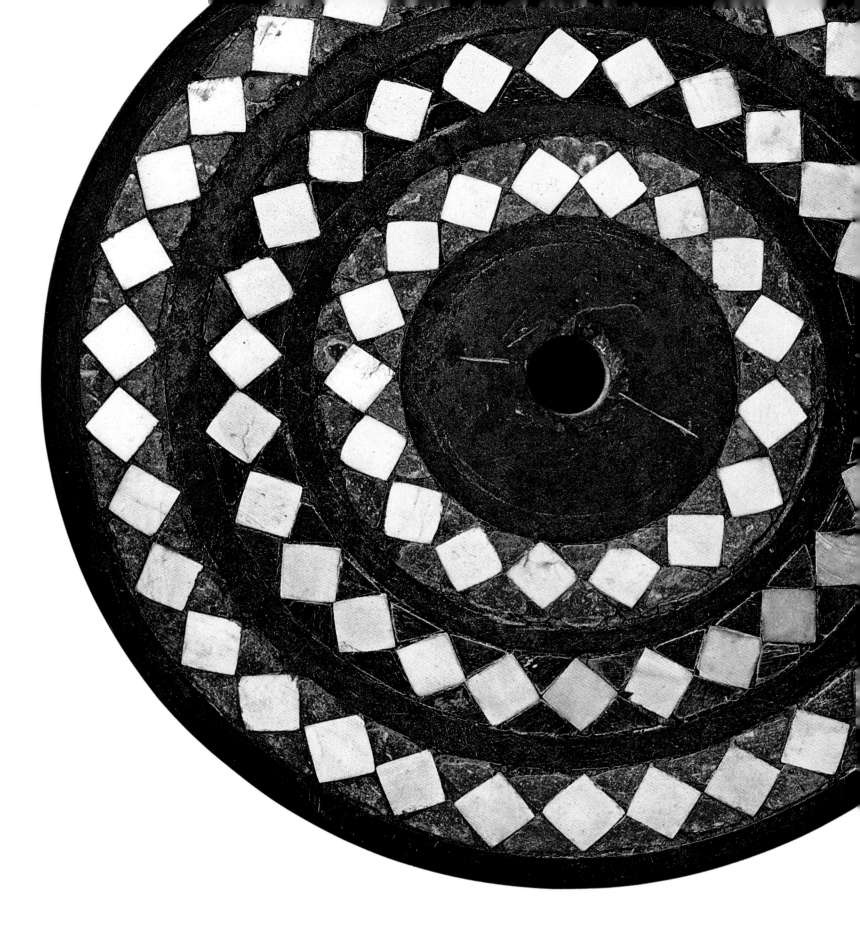

36 bottom	JE 70164
DISK WITH DOGS AND GAZELLES	Discovered by W.B. Emery amidst Hemaka's tomb furnishings at Saqqara (1936), this disk, whose function is unclear, shows sophisticated inlaid decoration depicting two running dogs hunting a pair of gazelles.
BLACK STEATITE INLAID WITH ALABASTER DIAMETER CM 8.7 1st Dynasty (2920-2770 BC), Den's reign	

37	JE 70162
DISK WITH GEOMETRIC MOTIFS	The disk, discovered by W.B. Emery amidst Hemaka's tomb furnishings (1936), is exquisitely decorated with inlaid alabaster geometric motifs forming concentric circles. A pivot was probably inserted in the central hole.
SCHIST INLAID WITH LIMESTONE DIAMETER CM 10 3rd Dynasty (2770-2649 BC), Djoser's reign	

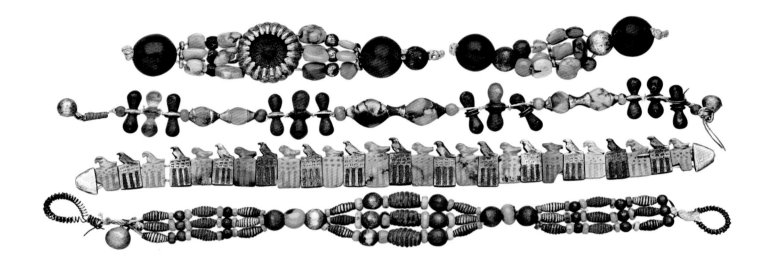

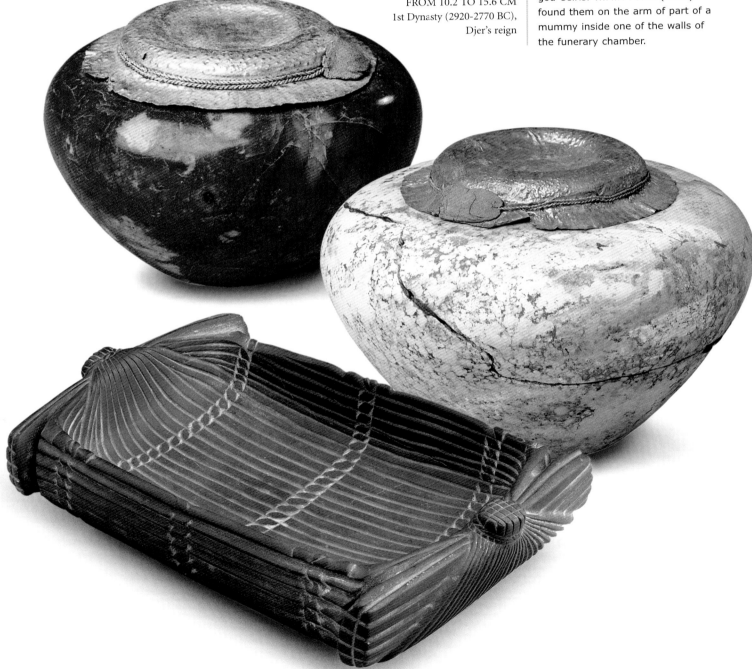

38 top

**BRACELETS FROM
DJER'S TOMB**

GOLD, LAPIS LAZULI,
TURQUOISE, AMETHYST
LENGTH: VARIABLE
FROM 10.2 TO 15.6 CM
1st Dynasty (2920-2770 BC),
Djer's reign

JE 35054

These bracelets are from Djer's tomb, the most impressive one at the royal necropolis of Abydos and, starting in the Middle Kingdom, considered the burial place of the god Osiris. W.M.F. Petrie (1901) found them on the arm of part of a mummy inside one of the walls of the funerary chamber.

The Predynastic and Protodynastic Periods

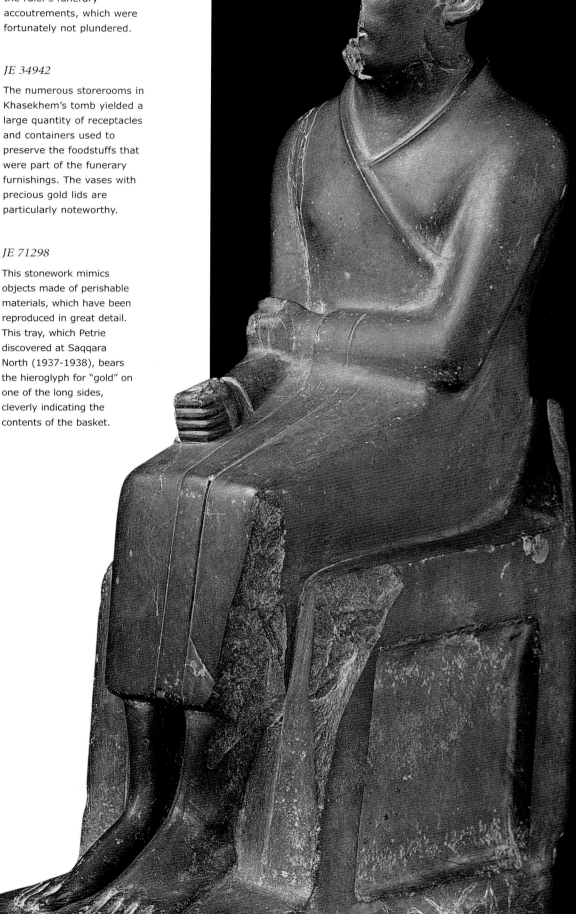

Between 1900 and 1901, Petrie discovered thousands of vases in the tomb of King Khasekhem at Abydos. This specimen with a gold lid testifies to the opulence of the ruler's funerary accoutrements, which were fortunately not plundered.

The numerous storerooms in Khasekhem's tomb yielded a large quantity of receptacles and containers used to preserve the foodstuffs that were part of the funerary furnishings. The vases with precious gold lids are particularly noteworthy.

This stonework mimics objects made of perishable materials, which have been reproduced in great detail. This tray, which Petrie discovered at Saqqara North (1937-1938), bears the hieroglyph for "gold" on one of the long sides, cleverly indicating the contents of the basket.

J. Quibell found this statue celebrating the king in his Jubilee garb at Hierakonopolis (1898). The renewal of the king's power through the Jubilee ritual proclaimed the king the victor over Chaos, embodied by 47,209 vanquished enemies depicted at the base of the throne.

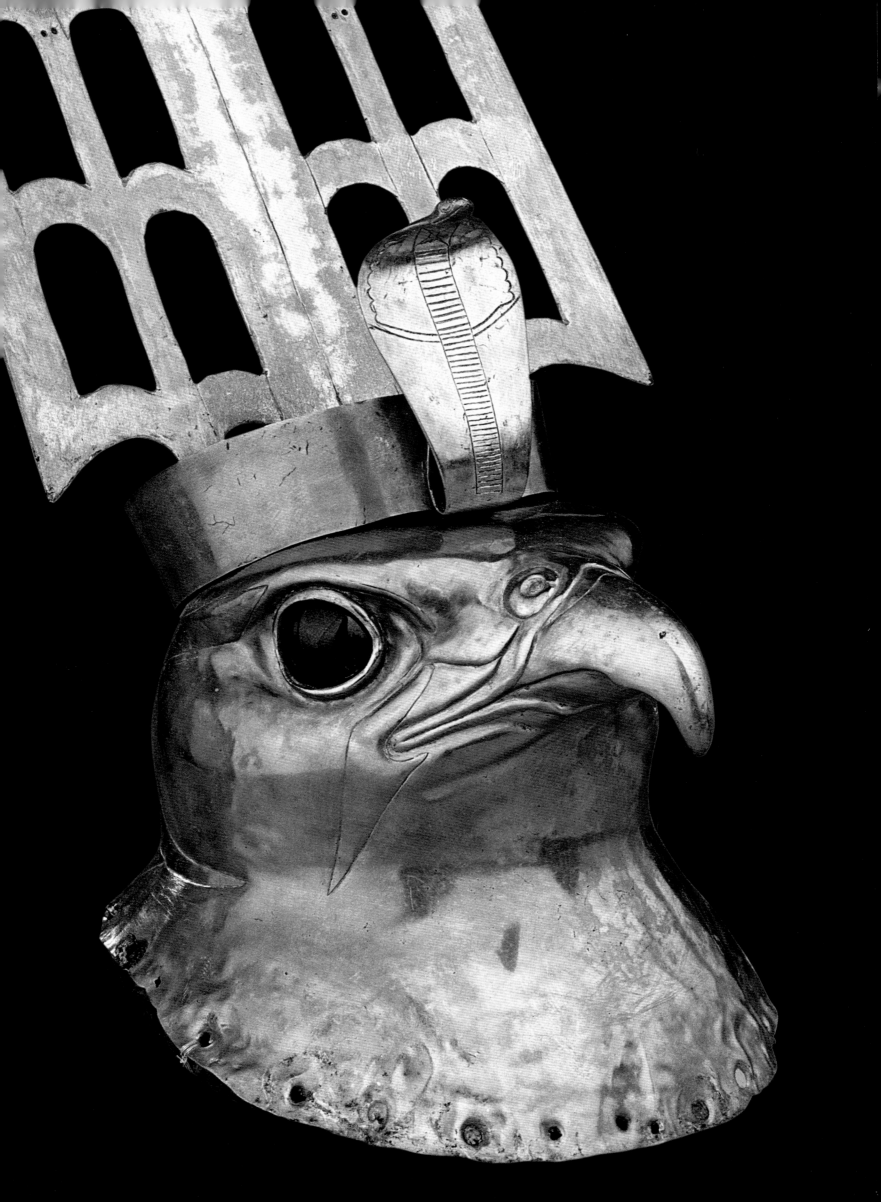

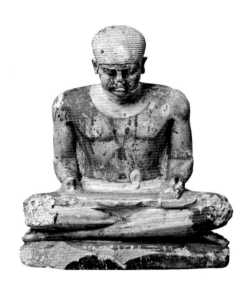

THE OLD KINGDOM

THE "AGE OF THE

PYRAMIDS" WAS A

PARTICULARLY PROSPEROUS

PERIOD FOR ANCIENT

EGYPT, WHICH WAS A

POWERFUL STATE UNITED

UNDER A SINGLE POWER.

WELL ORGANIZED

INTERNALLY, IT

SUCCESSFULLY EXPANDED

OUTSIDE ITS BORDERS.

The Old Kingdom is generally referred to as "the age of the pyramids" even though pyramids continued to be built throughout the Middle Kingdom.

Nevertheless, the majesty of these constructions at Giza is not the only reason for this name. Indeed, it stems chiefly from the fact that important symbolism is tied to the pyramids, and this symbolism is what identified Egyptian society in the second half of the third millennium BC. We can compare this era with the period in which Gothic cathedrals flourished in Europe. Both constructions were the outcome of a specific ecosystem, in which idealistic factors, faith, enthusiasm, and aggressiveness played an important role.

Starting with the Third Dynasty, the pharaohs were buried inside pyramidal structures. The brilliant work of the 'sage' and architect Imhotep, in the service of Pharaoh Djoser, has traditionally been cited as a watershed in Egyptian history, and this ruler came to be celebrated as the one who introduced the use of monumental stone. This was not only a technological feat, but a full-fledged revolution in both aesthetics and symbolism. Imhotep developed the mastaba tomb—a tomb with a parallelepiped superstructure resembling a bench, known in Arabic as mastaba—into the step pyramid. However, with the Fourth Dynasty rulers the pyramid achieved the architectural perfection and grandeur that remained unparalleled in later eras. Inside the pyramid's sacred enclosure, an intricate funerary rite was conducted and perpetuated in a series of architectural structures that generally escape the untrained eye because of their poor state of conservation. Zahi Hawass, director of the Giza Pyramids Excavation and now Secretary General of the Supreme Council of Antiquities, has identified fourteen elements that seem to have comprised the pyramid complex. The pyramid itself represents its chief architectural element: this is where the ruler's body was actually laid to rest.

Everything was created to celebrate the deification of the dead pharaoh, his transfiguration and ascent to heaven like an everlasting and immortal star, welcomed by the gods in celebration:

How beautiful indeed is the sight of you [the dead pharaoh], how reassuring your gaze," say they, say the gods, when this god [the dead pharaoh] ascends to heaven, when Unas [sovereign from the Fifth Dynasty] ascends to heaven, his renown over him, his terror on both sides of him, his magic preceding him! . . . The gods come to him . . . the gods who are in heaven, the gods who are on earth. They have raised the dead pharaoh on their arms and you, Unas, ascend to heaven, and you climb on it in this its name of "ladder." (from The Pyramid Texts, Utterance 306)

The Pyramid Texts, defined as a collection of utterances to be recited during the embalming and burial ritual, were engraved in long columns of hieroglyphics along the interior walls of the pyramids, starting with the Fifth Dynasty. Their purpose was to ensure the dead ruler's ascent to heaven and ensure his immortality.

In the 'shadow of the pyramids,' the Egyptian population celebrated its participation in its ruler's

40
JE 32158

FALCON'S HEAD

GOLD AND OBSIDIAN
HEIGHT CM 37.5
6th Dynasty
(2323-2152 BC)

This precious head was found in the temple of the falcon god Horus at Nekhen, ancient Hierakonopolis. The sanctuary, which was discovered during Quibell's excavation campaign (1897-1899), yielded a large quantity of material from all eras, demonstrating the mythological importance of this site.

immortality. In this period, the pharaoh was the only one thought to have an otherworldly destiny, and thus he was the only one who could ensure eternal life for his subjects. He generously granted them a sarcophagus and burial, ensured them the funerary ritual and a funerary priesthood that would regularly renew this ritual, allowed them to erect a statue, ensured that their ka would eat and drink in eternity, and guaranteed that they would have the necessary funerary accouterments. Above all, however, with them he shared his victory over the barrier of death: "He who loves the king shall be an imakh, but he who is hostile to His Majesty shall have no tomb, and his corpse shall be thrown into the water [like the body of criminal] . . ." (from The Loyalist Instructions). In effect, however, the enormous expenditure of resources and personnel required to build and decorate the tomb, together with the support of this funerary cult, would have been impossible without the material assistance of the central power.

Sprawling necropolises developed around the pyramids for members of the royal family or for officials buried in richly decorated mastaba tombs, who thus ensured that, by being so close to their king, they would join him in the afterlife. The Egyptian Museum in Cairo has various wall fragments from these splendid tombs.

This aspect of the Egyptian culture reflects strong centralized power that could exploit the country's human and material resources to maintain the perfect state of things as established during creation, which the ancient Egyptians personified as the goddess Maat. The ruler was the one who 'achieved Maat,' Order, thus driving away from the created world the forces of

41
CG 83

STATUE OF PTAHSHEPSES AS A SCRIBE

PAINTED LIMESTONE
HEIGHT CM 42
5th Dynasty (2465-2323 BC)

The statue of the official Ptahshepses portrayed as a scribe was found in Mastaba C10 at Saqqara.

43
JE 49158

STATUE OF DJOSER

PAINTED LIMESTONE
HEIGHT CM 142
WIDTH CM 45.3
DEPTH CM 95.5
3rd Dynasty, Djoser's reign (2630-2611 BC)

Discovered by the Antiquities Services in the serdab of Djoser's tomb complex (1924-1925), this statue of the pharaoh wrapped in the Jubilee tunic is the first life-size sculpture in the round portraying royalty.

Chaos that constantly threatened it. He incarnated son-god Horus on earth, becoming transfigured into the father-god Osiris, who died and was regenerated in the underworld, in the Afterlife. This belief is exquisitely celebrated in the diorite statue of Khafre, displayed at the Egyptian Museum in Cairo. In this portrayal, he is protected by the wings of the falcon-god Horus, yet is also identified with him. Starting with the Fourth Dynasty, the pharaoh appeared officially as the "son of the Sun [god] on earth," as also celebrated in his regal title. A famous tale from the Westcar Papyrus announces the birth of the first three rulers of the Fifth Dynasty as the direct offspring of the sun-god and the wife of a priest from Heliopolis, the city sacred to the cult of the sun-god Re. It was this role as 'son' of the Egyptian ruler—Horus, son of Osiris, and also son of the sun-god—that allowed the pharaoh to interact with the divine world and present himself as the sole intermediary between men and the gods.

Alongside the pharaoh, a team of efficient officials, led by the vizier, ensured that the government machine ran smoothly. Officials prided themselves on performing their duties perfectly, on their proper conduct, and on the fact that they had acted according to the pharaoh's wishes. The tombs of dignitaries ultimately contained an autobiographical text that was essentially standardized and idealized, celebrating their impeccable work, which contributed to preserving the world order and achieving Maat.

This strong and efficient government apparatus, held by a dominant central power, was also in a position to organize expeditions to faraway and hostile areas. There is proof that, during the Old Kingdom, Egypt expanded its trade along the coasts and to the inland areas of the Eastern Mediterranean, and it also penetrated Nubia. Starting in the earliest periods, the lack of raw materials—chiefly wood—and the search for precious materials compelled the Egyptians to go beyond the country's natural boundaries. The splendid Khufu boat, discovered in 1954 completely disassembled in a ditch on the southern side of this pharaoh's pyramid and reconstructed through careful restoration work, was made of Lebanese cedar, considered one of the most precious types of wood, and acacia. Today it can be viewed at the Solar Boat Museum. Harkhuf, a well-known official from the age of Merenre and Pepi II, proudly indicated in his tomb that, in the faraway lands of modern-day Sudan, he had captured a dwarf, considered a priceless gift for the pharaoh.

Art, like architecture, also served the purpose of exalting the pharaoh's power and idealizing his perfect administration. Thus, the pharaoh was glorified in all his magnificence, portrayed in the bloom of youthful vigor and adorned with symbolic attributes. There are also portraits of officials, holding a long rod—the wooden statue referred to as "the village mayor" of Kaaper is a striking example—as they supervised work in the fields or livestock, and of scribes, intently writing on papyrus rolls set on their laps. The position of the scribe, in particular, was prestigious during this period, because the activity of writing—and everything connected with it—was considered fundamental for creating an organized state. Dignitaries proudly had themselves portrayed as scribes, often including the scribe's tools among their funerary accouterments. An example of this can be seen with Hesira in the wooden panels from his tomb displayed at the Egyptian Museum. A series of sculptural masterpieces was created using the figure of the scribe, and one of the loveliest examples is the one of Mitri, done in stuccowork and painted wood.

Central power was entrusted to expert and capable dignitaries who were nonetheless well aware of their own power. The enormous favors—including financial ones—granted to them by the pharaoh transformed the country into what was effectively a feudal state, in which local power was handed down from father to son for generations. Toward the end of the Fifth Dynasty, this gradually led to the growing independence of provincial lords, which slowly weakened the centralized power. This was due also in part to a critical climatic situation that affected East Africa at the end of the third millennium. It was a period of Sahelian climate that brought famine to the Nile Valley, with insufficient flooding and difficulties in keeping the irrigation canals running properly.

The 'pessimistic literature' reflects the hardships of this historic phase, known as the First Intermediate Period. It was an era devoid of a strong and determined central power, and the threat of a return to a chaotic original state can clearly be perceived.

The land is completely ruined;
nothing is left . . .
This land is destroyed,
there is no one who takes care of her,
no one who speaks of her,
no one who sheds tears.
What will happen to this land?
. . .
All good things have disappeared,
the land is ruined,
laws have been promulgated against it.
All that has been done has been destroyed,
what was found has been lost.
It is as if what was done had never been achieved.
. . .
The land is impoverished, but it has numerous leaders;
is has been stripped, but its imposts are strong.
(from the Prophecy of Neferti)

46 and 47
JE 46499

MYCERINUS TRIAD

GRAY-GREEN SCHIST
HEIGHT CM 95.5
4th Dynasty, Mycerinus'
reign (2494-2472 BC)

G. Reisner unearthed
the Mycerinus triads in
the courtyard of the
king's valley temple at
Giza (1908). Mycerinus
is always depicted with
the goddess Hathor on
his right, whereas the
personification of a
nome or province –
Thebes in this case –
is shown on his left.

The Old Kingdom itinerary starts just past the museum entrance in Room 48, which houses the statue of Pharaoh Djoser (Third Dynasty), from the serdab of his funerary complex. Next to it, in Room 43, are the splendid wooden panels from the Tomb of Hesira. Then in Room 47 are the triads of Pharaoh Mycerinus (Fourth Dynasty), the extant part of the pink limestone statue of the ruler Neferefre (Fifth Dynasty) and the schist head of King Userkaf (Fifth Dynasty). Room 46 displays fragments of limestone reliefs from the mastaba of Ipi at Saqqara, as well as a series of painted limestone statues, notably the double statue of Nimaatsed. Room 41 holds the alabaster statue of Mycerinus; the walls of this room are lined with a series of wall fragments from various mastabas. Next is Room 42, with the splendid diorite statue of Khafre; there is also a sycamore statue of the mayor of the village of Kaaper, the painted limestone statue of a scribe, and the wooden false door of Ika

from Saqqara. Room 36 boasts a stunning granite head of an unidentified figure, and Room 37 next to it has the only extant statuette of Khufu and the refined funerary accouterments of his mother, Queen Hetepheres. Room 31 holds statues of Ranofer and a reserve head from Giza. The ground floor itinerary ends in Room 32, which displays a series of masterpieces: the splendid statue group of Rahotep and Nofret, the dwarf Seneb with his family, the scribe Mitri in stuccoed painted wood, and the two life-size copper statues of the rulers Pepi I and Merenre. Portrayed on the walls are the "Geese of Meidum," a painting from a mastaba at Saqqara, dating from the Fourth Dynasty.

Room 4 on the upper floor holds priceless objects from Hetepheres' funerary furnishings and a gold falcon's head from Hierakonopolis. In Room 32 are small wooden models, discovered among funerary accouterments, which portray everyday life.

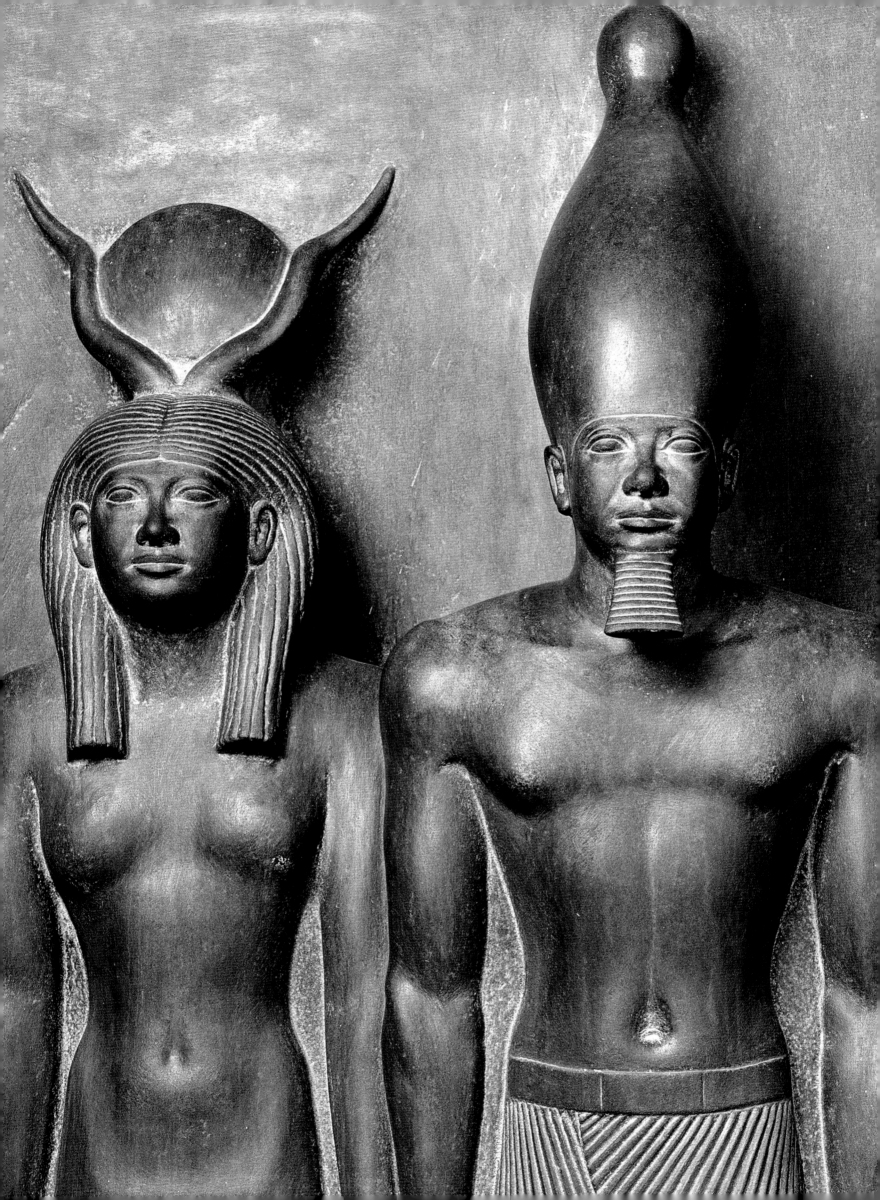

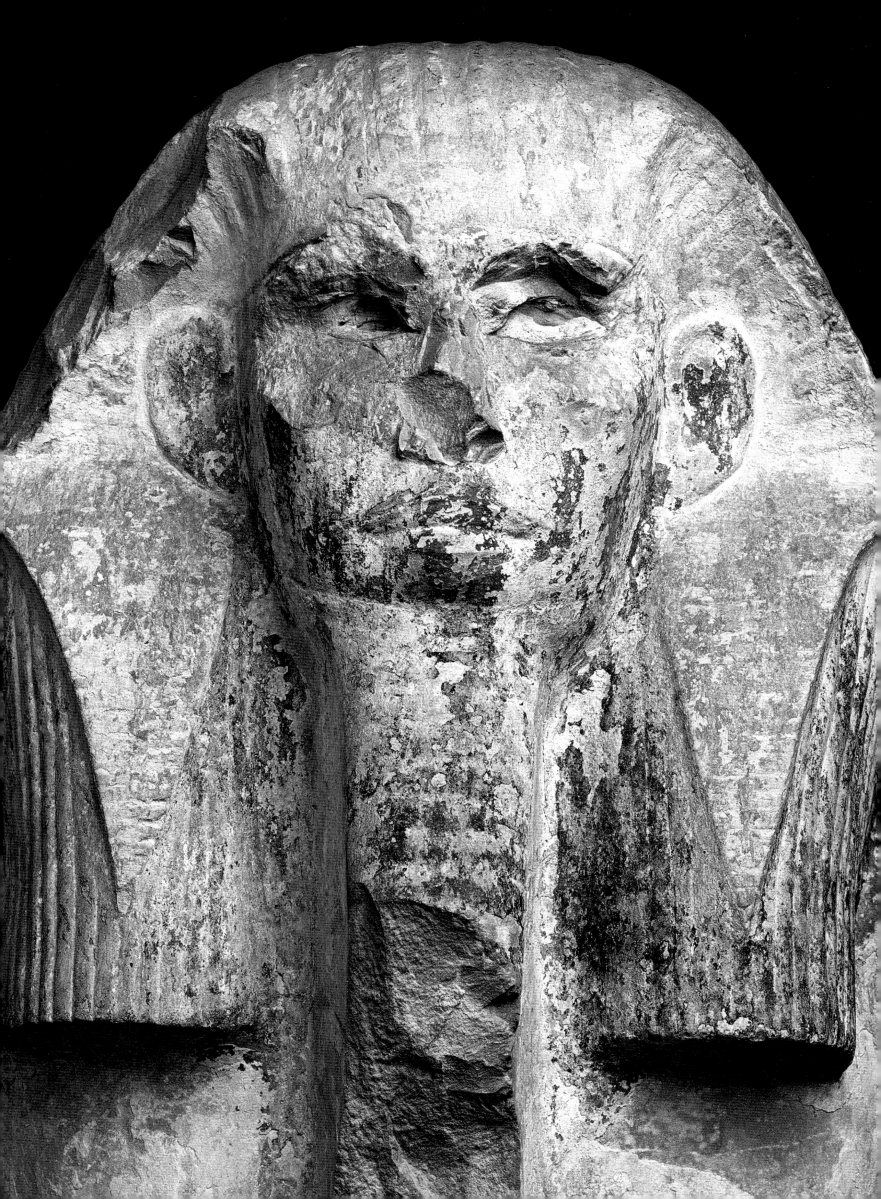

48	JE 49158
STATUE OF DJOSER	The gaze of the statue discovered by the Antiquities Services in Djoser's tomb complex (1924-1925) at Saqqara is striking, despite the fact that the gems used for the eyes have been lost.
PAINTED LIMESTONE HEIGHT CM 142 WIDTH CM 45.3 DEPTH CM 95.5 3rd Dynasty, Djoser's reign (2630-2611 BC)	

49 top	JE 68921
DECORATIVE PANEL	Discovered by the Antiquities Services in Djoser's tomb complex (1924-1925), this panel was part of the facing in the underground rooms of the step pyramid.
LIMESTONE AND FAÏENCE HEIGHT CM 181 WIDTH CM 203 3rd Dynasty, Djoser's reign (2630-2611 BC)	

49 bottom JE 97472
BASE OF A STATUE OF DJOSER
LIMESTONE HEIGHT CM 15 LENGTH CM 66 WIDTH CM 48 3rd Dynasty, Djoser's reign (2630-2611 BC)

The highly evocative pedestal holds the feet of Djoser, the victor for all eternity over Egypt's enemies, represented by nine bows, before the ruler's subjects, who are personified by three rekhyt birds. C.M. Firth discovered this artifact at Saqqara (1926).

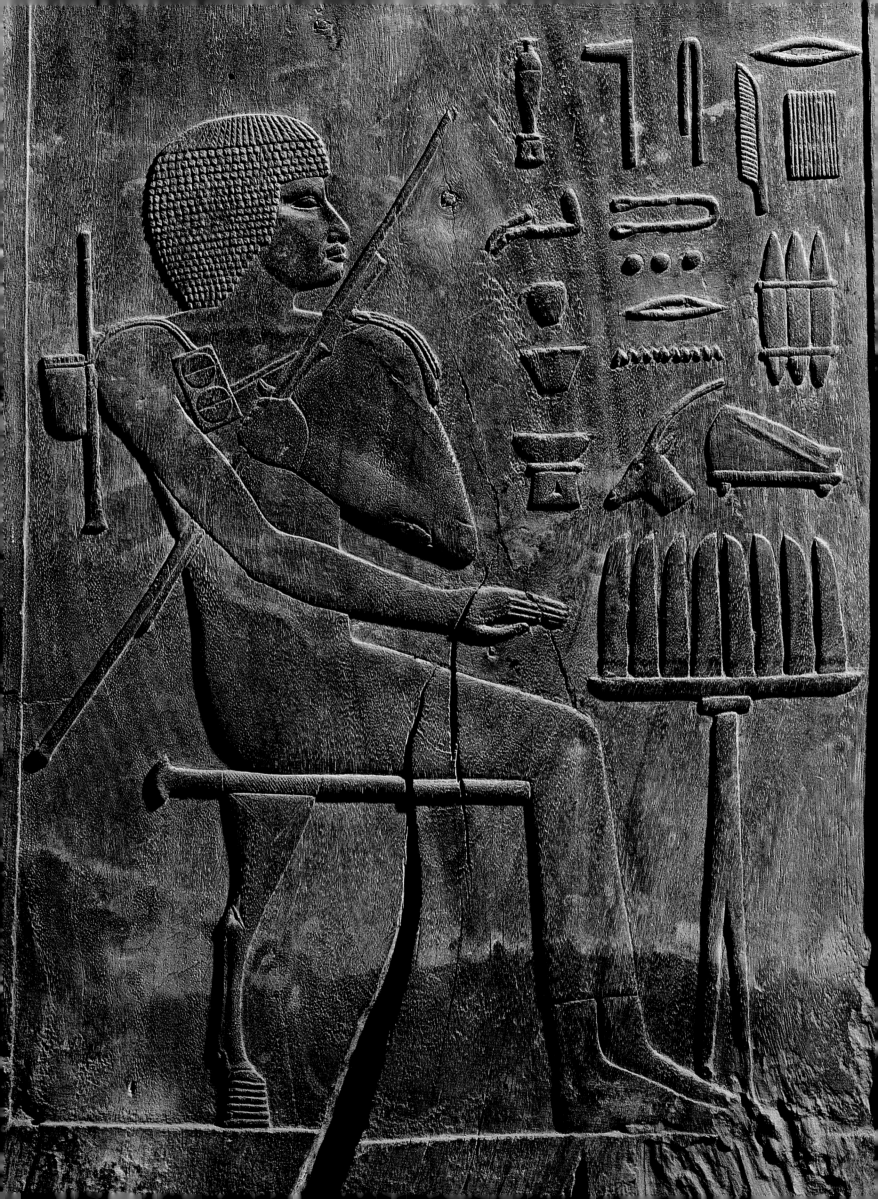

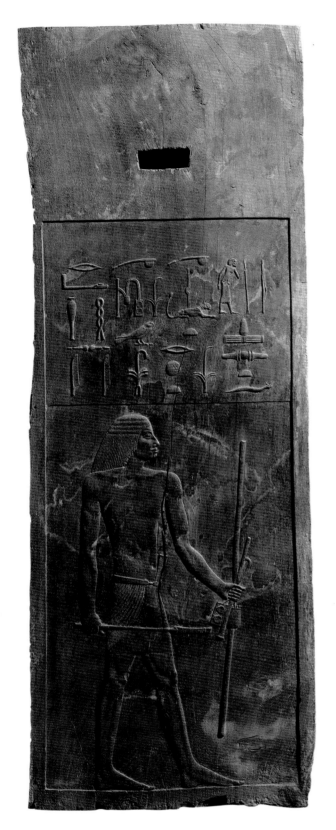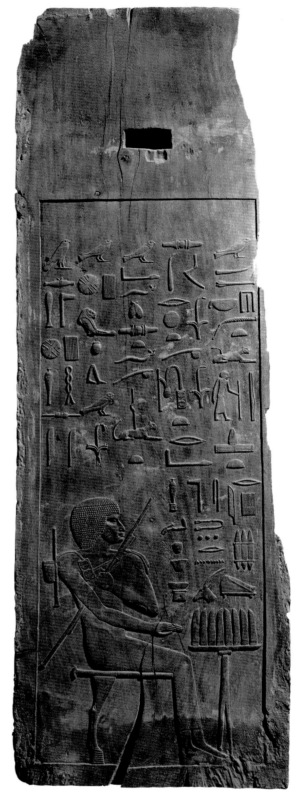

JE 28504 = CG 1426, 1427, 1428

PANELS OF HESIRA

WOOD
HEIGHT CM 114
WIDTH CM 40
3rd Dynasty (2649-2575 BC)

In these panels, which were discovered mounted in niches in Hesira's mastaba at Saqqara, particularly on the west wall of the corridor of the superstructure, the deceased is portrayed as a scribe, in an upright position and seated before the offering table. The official bears various titles, including that of royal scribe and the king's chief dentist. The decoration reveals careful attention to detail, as can be noted particularly in the various wigs. These artifacts were removed by A. Mariette.

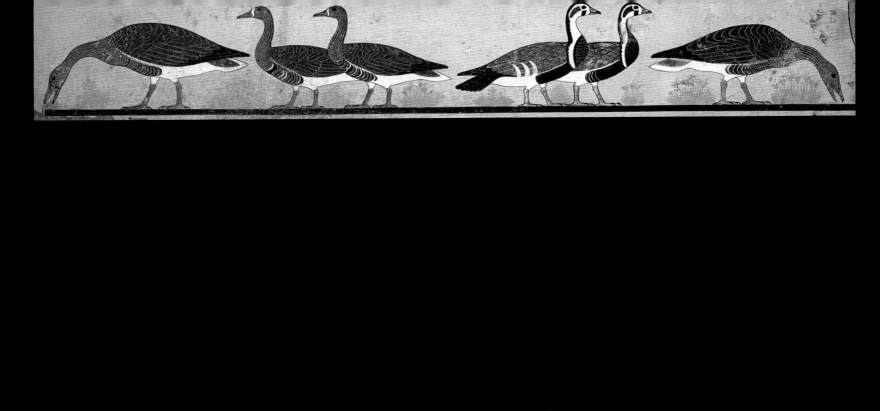

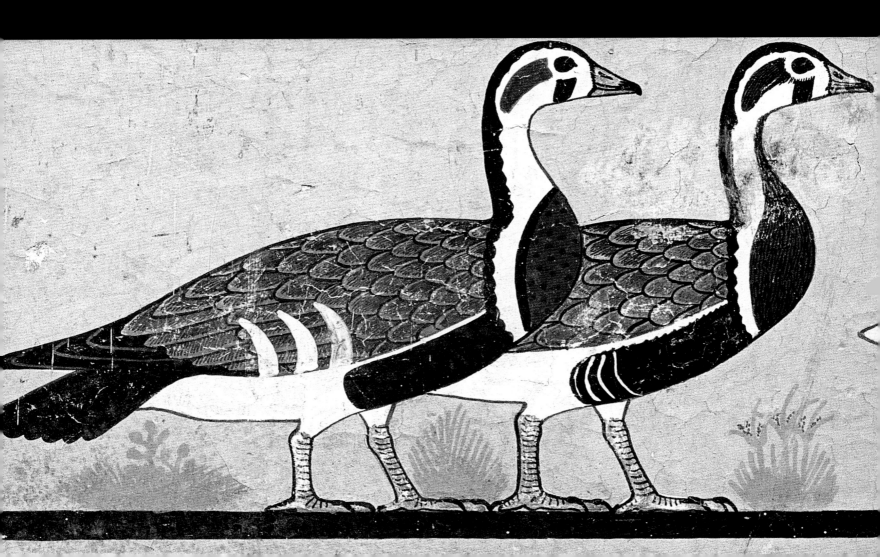

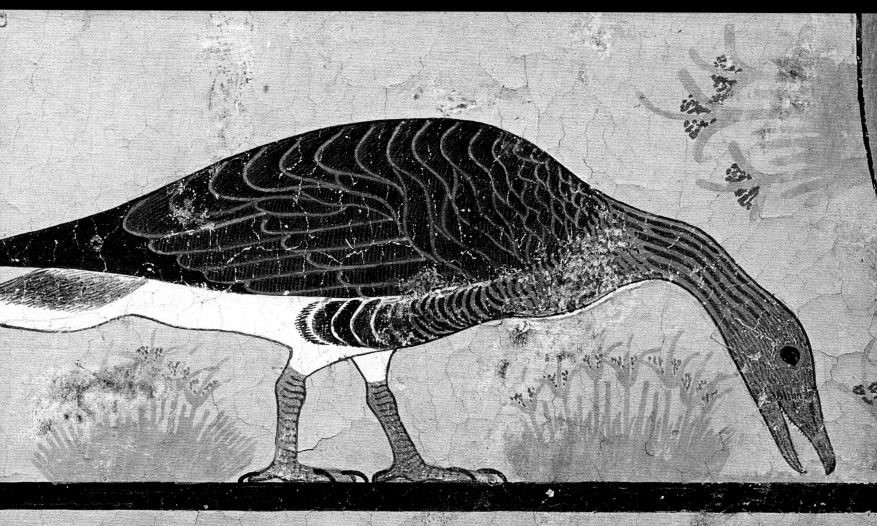

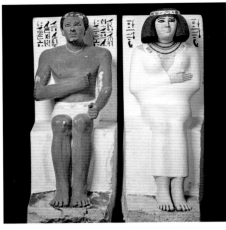

52 top and 52-53 | *JE 34571 = CG 1742*

"GEESE OF MEIDUM"

PAINTED PLASTER
HEIGHT CM 27
WIDTH CM 172
4th Dynasty, Snefru's reign
(2575-2551 BC)

The "geese" are one of the loveliest and best-preserved examples of wall painting. Mariette discovered them at Meidum, in the mastaba of Nefermaat and Atet (1871).

53 top left | *JE 89289*

STELE OF SNEFRU

LIMESTONE
HEIGHT CM 372
4th Dynasty, Snefru's reign
(2575-2551 BC)

The stele is from the second pyramid Snefru built at Dahshur South. The fragment holds the serekh, with the determinative glyph for king and a portrayal of Snefru wearing the Jubilee tunic and the double crown.

53 top right | *JE 98943*

**FRAGMENTARY STELE
OF SNEFRU**

LIMESTONE
HEIGHT CM 180
WIDTH CM 55
4th Dynasty, Snefru's reign
(2575-2551 BC)

This fragmentary statue of Snefru was discovered in the pharaoh's valley temple at Dahshur (1997).

54-55
CG 3 and 4

**STATUES OF RAHOTEP
AND NOFRET**

PAINTED LIMESTONE
HEIGHT CM 121 (RAHOTEP)
CM 122 (NOFRET)
4th Dynasty, Snefru's reign
(2575-2551 BC)

The statues of the spouses, founded by A. Mariette (1871) in the mastaba of Rahotep at Meidum, are masterpieces of the early Old Kingdom. The rigidity of these figures is enlivened by the quartz and crystal encrustations used for the eyes.

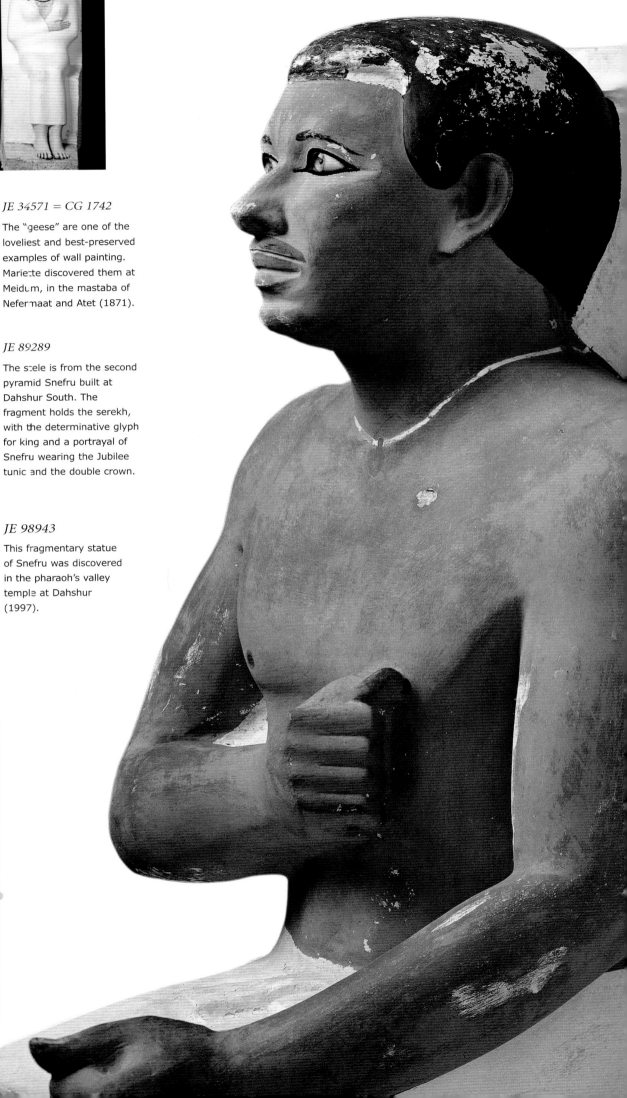

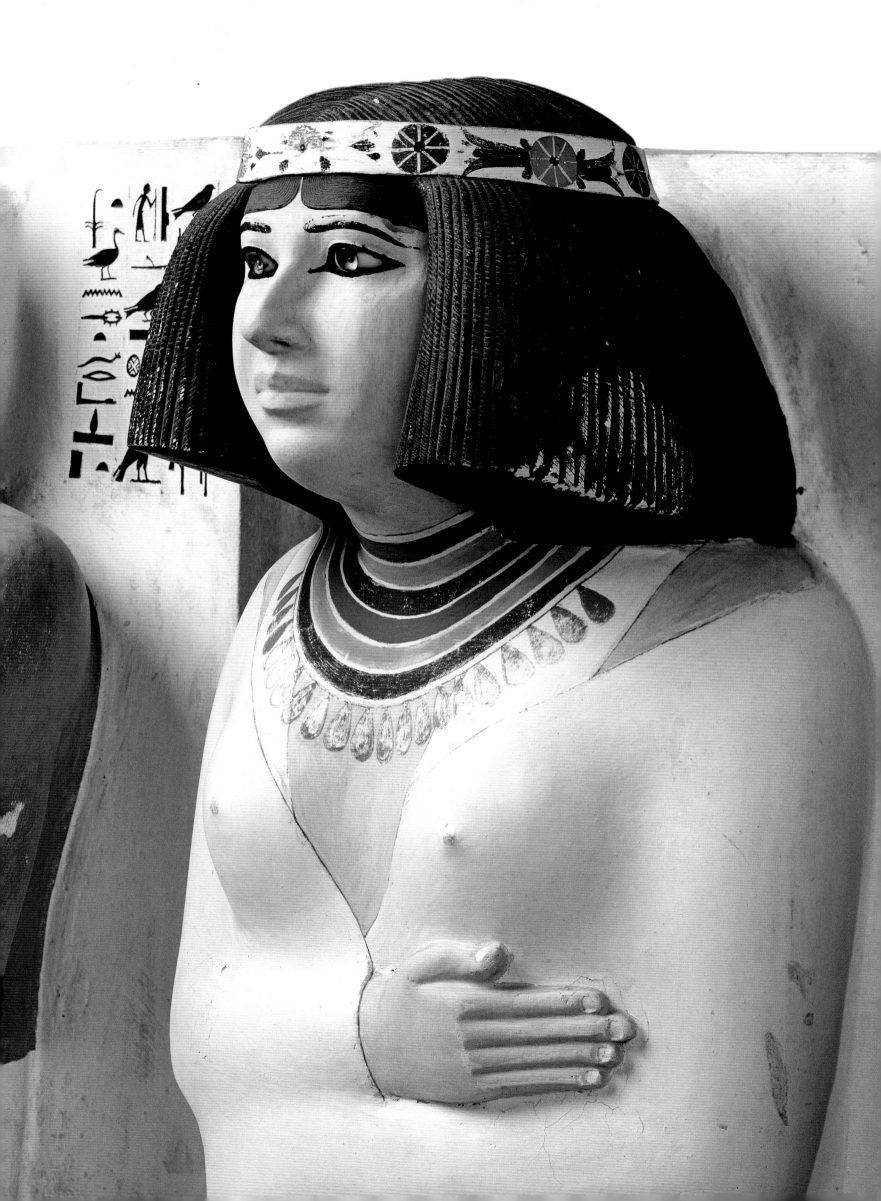

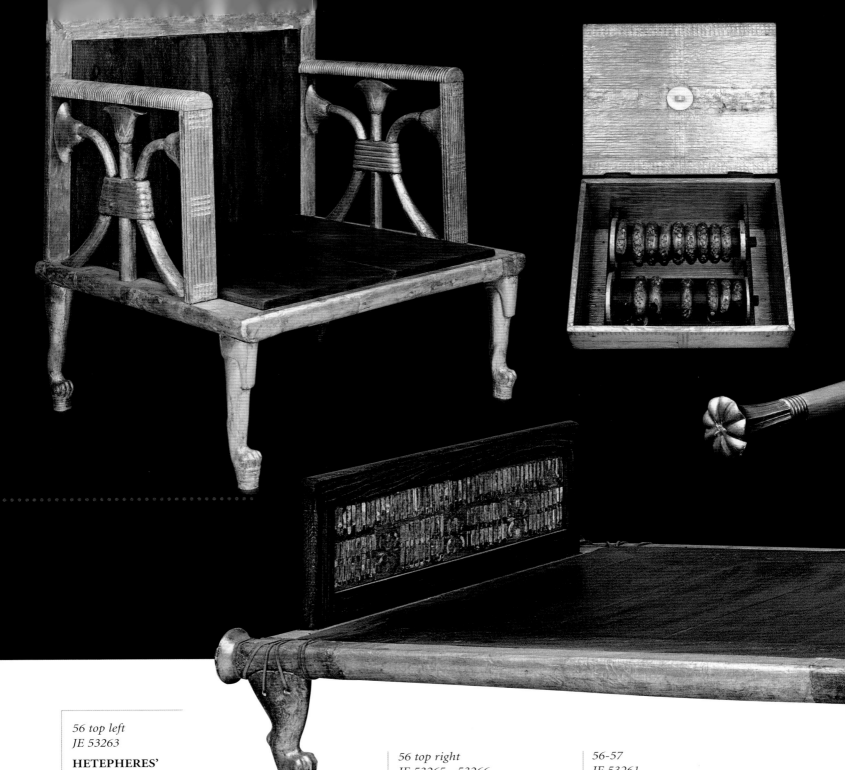

56 top left
JE 53263

**HETEPHERES'
CHAIR**

WOOD AND
GOLD LEAF
HEIGHT CM 79.5
WIDTH CM 71
4th Dynasty, Snefru's reign
(2575-2551 BC)

This chair was found in
Hetepheres' tomb, at
Giza, which was
fortuitously discovered
by the Reisner expedition
(1925). The elegant
workmanship of the
arms and legs reveals
the level of sophistication
achieved by the
craftsmen of the era.

56 top right
*JE 53265 - 53266 -
52281*

**BOX WITH
HETEPHERES'
BRACELETS**

BOX: GILT WOOD
LENGTH CM 41.9
BRACELETS: SILVER AND
SEMIPRECIOUS STONES
DIAMETER CM 9-11
4th Dynasty, Snefru's reign
(2575-2551 BC)

This box contained a set of
bracelets that probably
belonged to Queen
Hetepheres, the mother
of Khufu.

56-57
JE 53261

HETEPHERES' BED

WOOD AND GOLD LEAF
LENGTH CM 178
HEIGHT CM 21.5-35.5
WIDTH CM 97
4th Dynasty, Snefru's reign
(2575-2551 BC)

The queen's shaft tomb
has yielded magnificent
items, such as this
wooden bed covered in
gold leaf.

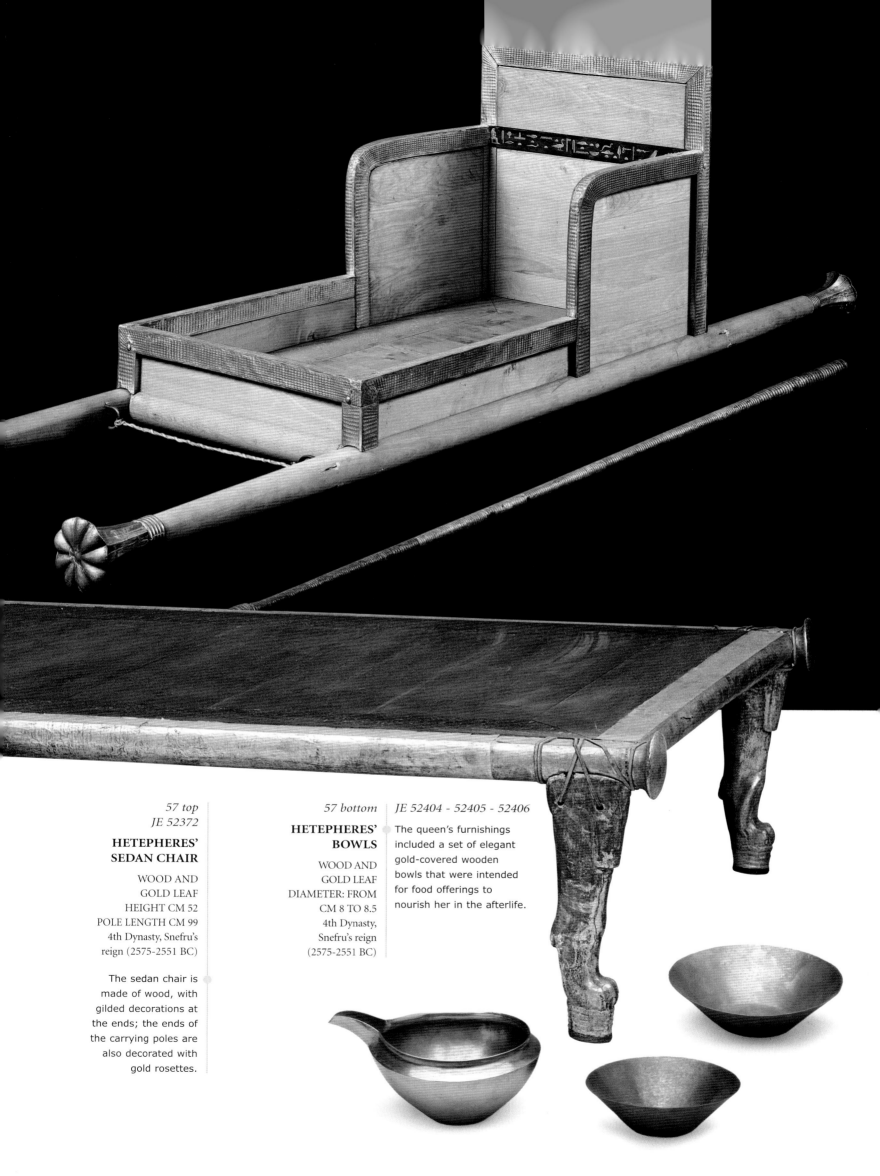

57 top
JE 52372

**HETEPHERES'
SEDAN CHAIR**

WOOD AND
GOLD LEAF
HEIGHT CM 52
POLE LENGTH CM 99
4th Dynasty, Snefru's
reign (2575-2551 BC)

The sedan chair is
made of wood, with
gilded decorations at
the ends; the ends of
the carrying poles are
also decorated with
gold rosettes.

57 bottom

**HETEPHERES'
BOWLS**

WOOD AND
GOLD LEAF
DIAMETER: FROM
CM 8 TO 8.5
4th Dynasty,
Snefru's reign
(2575-2551 BC)

JE 52404 - 52405 - 52406

The queen's furnishings
included a set of elegant
gold-covered wooden
bowls that were intended
for food offerings to
nourish her in the afterlife.

58 left | *JE 36143*

STATUETTE OF KHUFU

IVORY
HEIGHT CM 7.5
4th Dynasty, Khufu's reign
(2551-2528 BC)

All that remains of the constructor of the Great Pyramid is this statuette, which bears the Horus name of Khufu on the right side of the throne. It was found by W.M.F. Petrie in 1903 in the temple of Osiris at Abydos, and initially its head was mutilated.

58 right and 59 | *JE 46215 - JE 46217*

"RESERVE" HEADS

LIMESTONE
HEIGHT CM 25.5
4th Dynasty, Khafre's reign
(2520-2494 BC)

The profound meaning of the "reserve" heads is a mystery. They were found only in the funerary chambers or next to private sarcophaguses of the Fourth Dynasty. The ones illustrated here are from the west necropolis at Giza, where they were discovered by G. Reisner (1925).

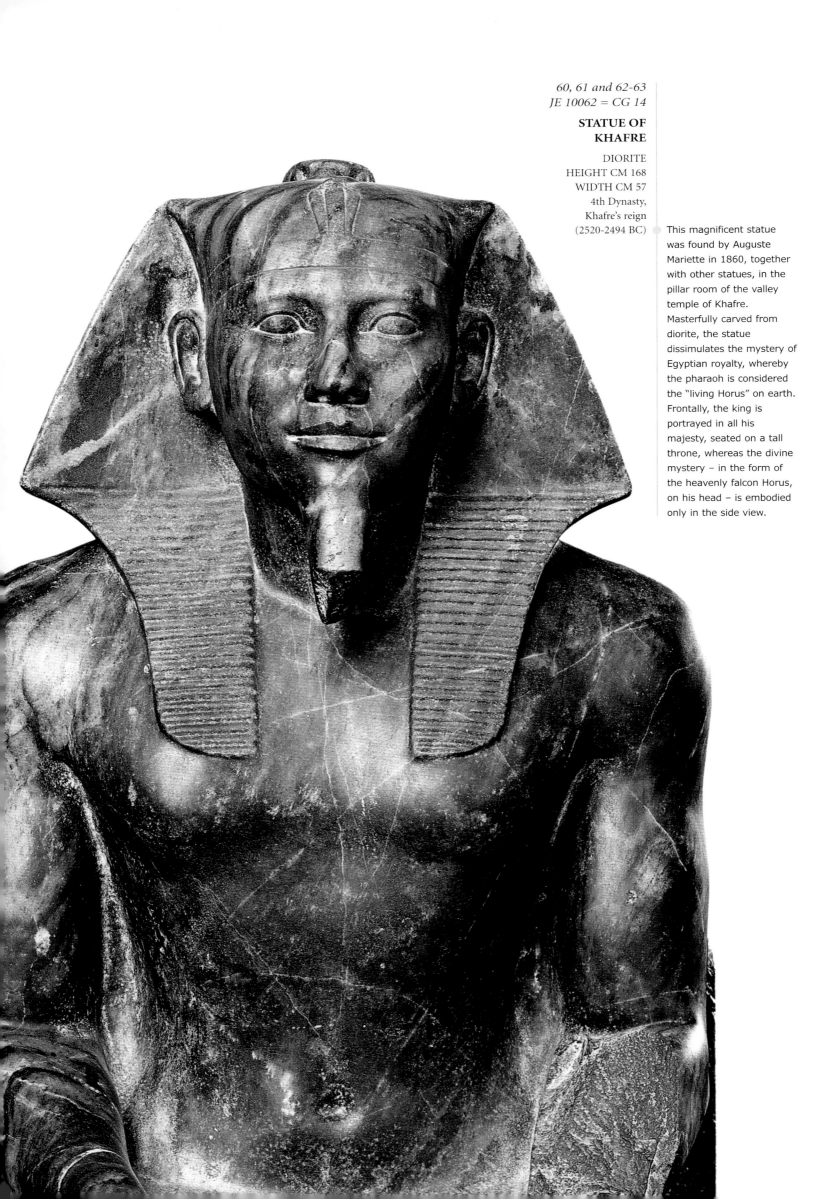

60, 61 and 62-63
JE 10062 = CG 14

STATUE OF KHAFRE

DIORITE
HEIGHT CM 168
WIDTH CM 57
4th Dynasty,
Khafre's reign
(2520-2494 BC)

This magnificent statue was found by Auguste Mariette in 1860, together with other statues, in the pillar room of the valley temple of Khafre. Masterfully carved from diorite, the statue dissimulates the mystery of Egyptian royalty, whereby the pharaoh is considered the "living Horus" on earth. Frontally, the king is portrayed in all his majesty, seated on a tall throne, whereas the divine mystery – in the form of the heavenly falcon Horus, on his head – is embodied only in the side view.

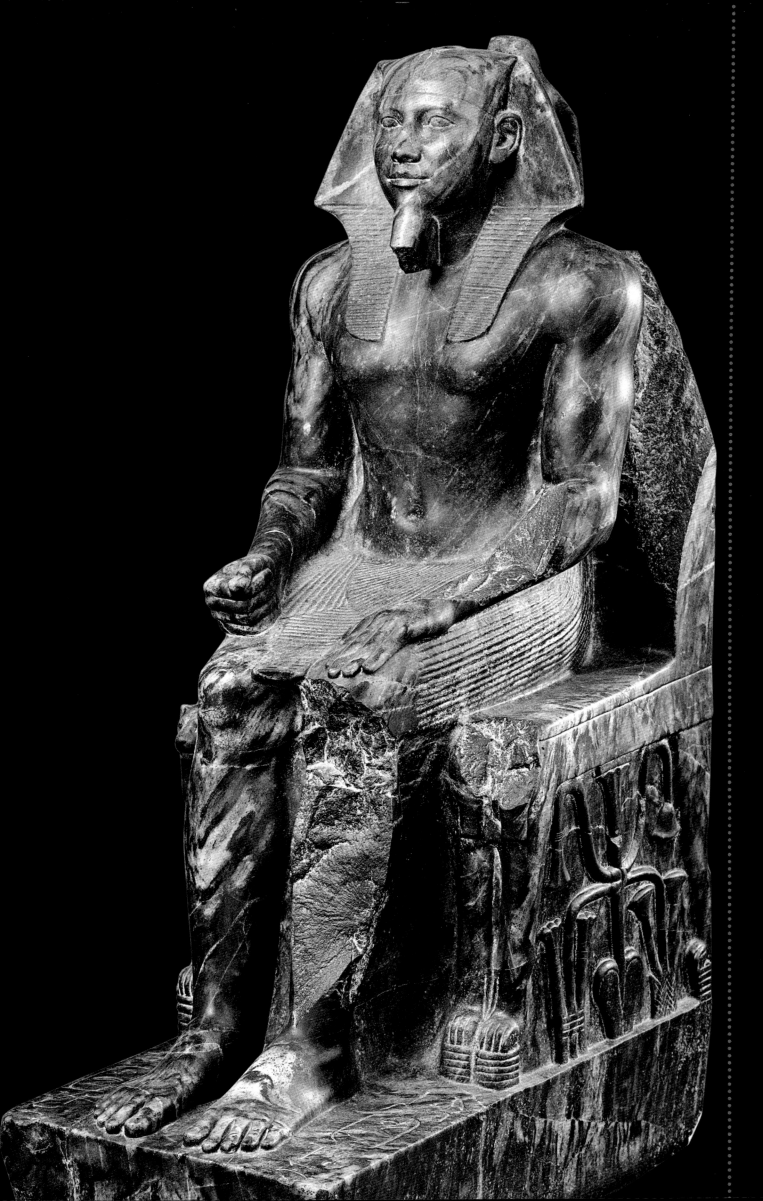

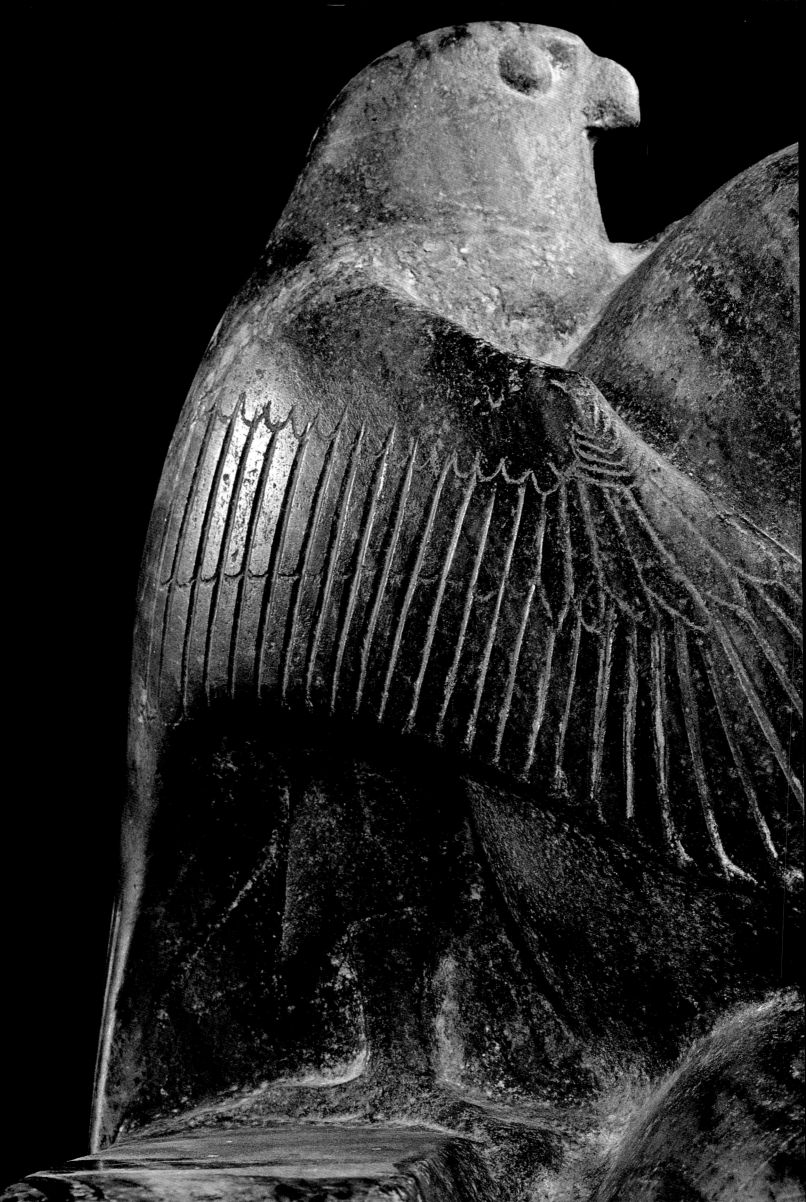

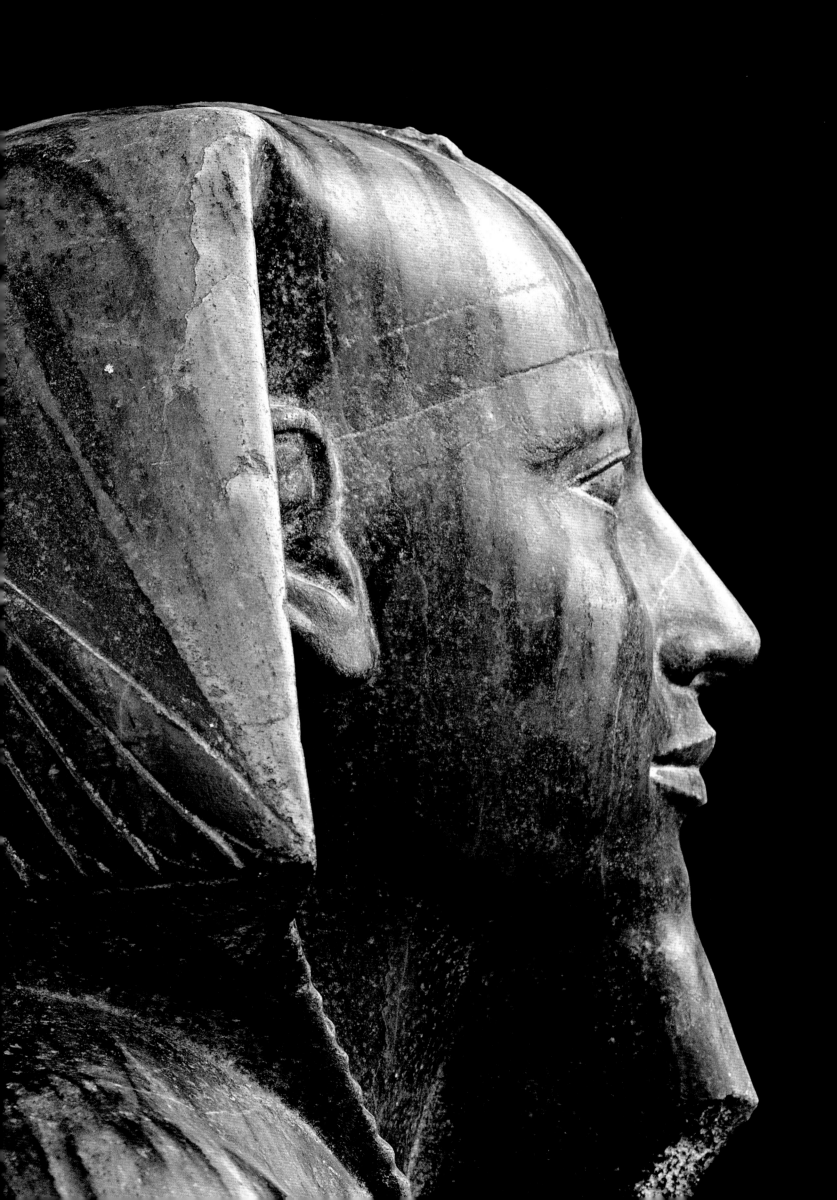

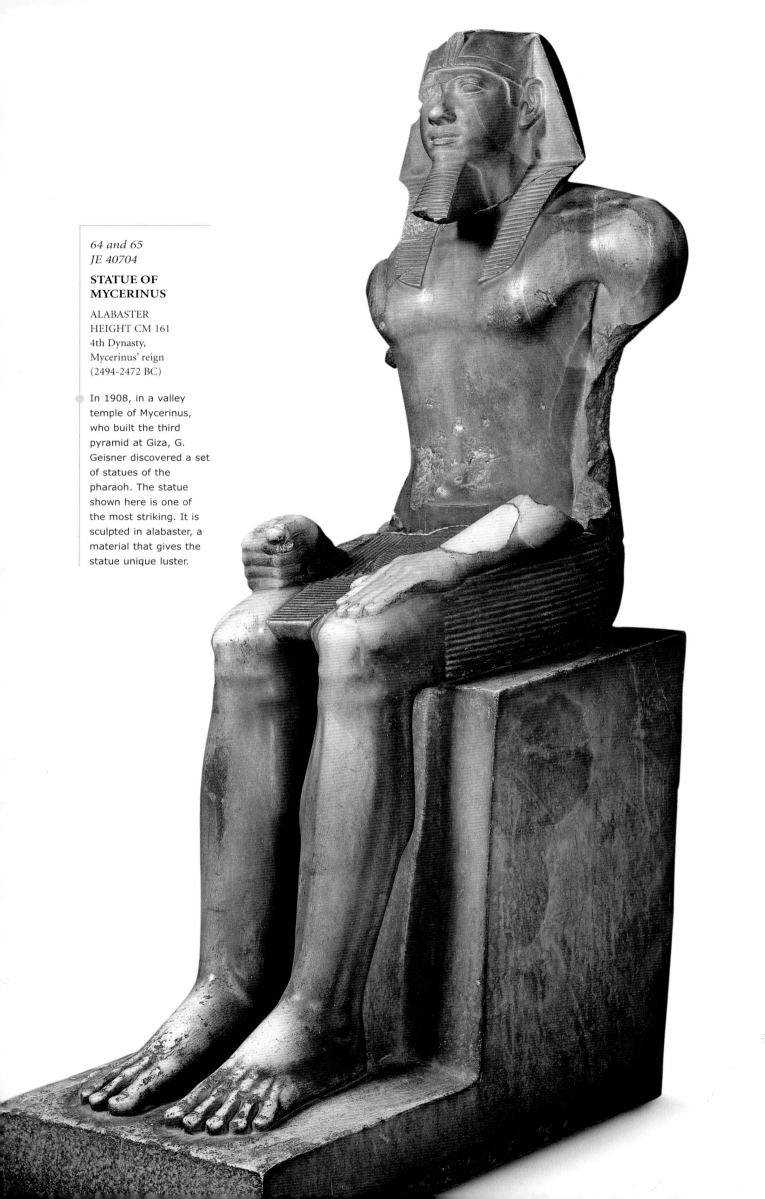

64 and 65
JE 40704

STATUE OF MYCERINUS

ALABASTER
HEIGHT CM 161
4th Dynasty,
Mycerinus' reign
(2494-2472 BC)

In 1908, in a valley
temple of Mycerinus,
who built the third
pyramid at Giza, G.
Geisner discovered a set
of statues of the
pharaoh. The statue
shown here is one of
the most striking. It is
sculpted in alabaster, a
material that gives the
statue unique luster.

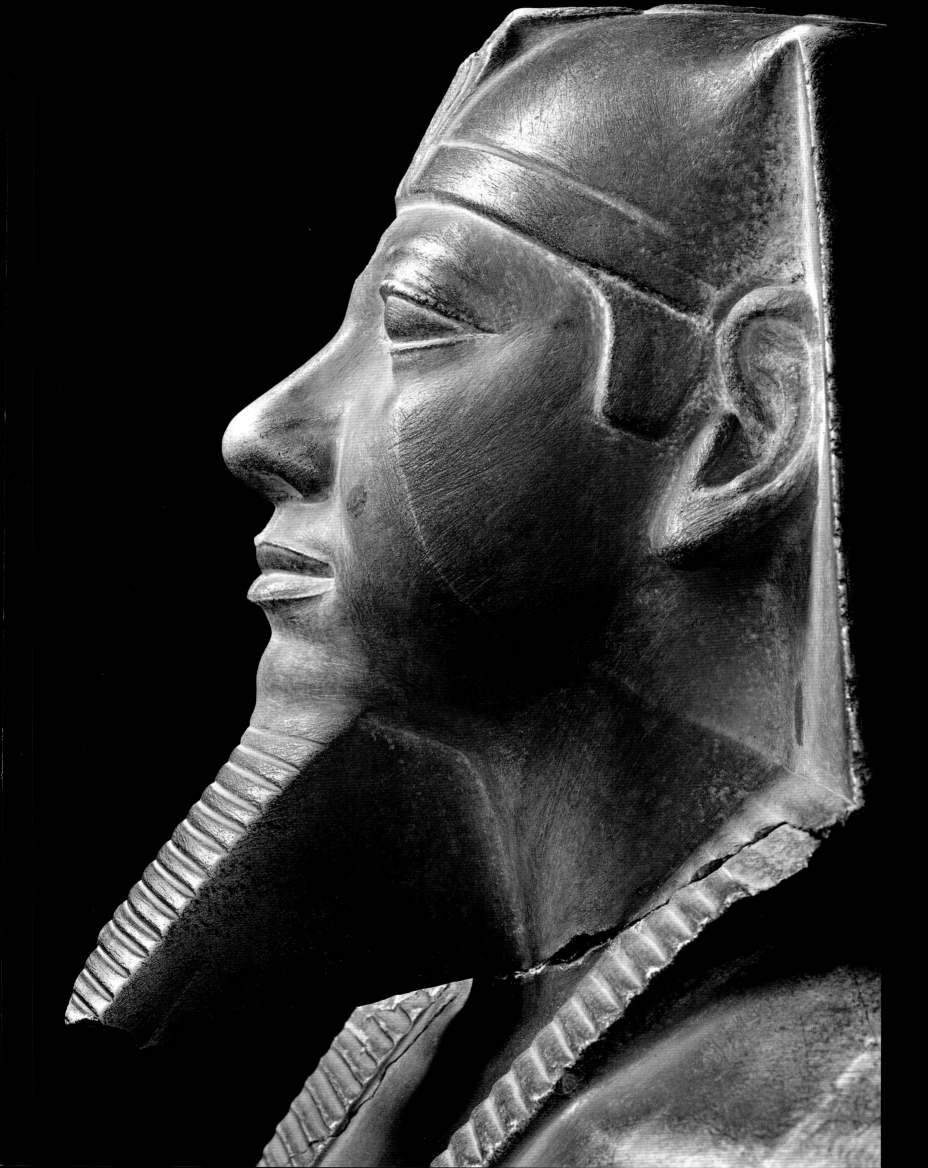

67 | JE 40679

MYCERINUS TRIAD

GRAY-GREEN SCHIST
HEIGHT CM 92.5
4th Dynasty,
Mycerinus' reign
(2494-2472 BC)

The pharaoh is embraced by Hathor (on his right) and by the goddess of the nome (province) of Cynopolis, receiving her protection. The meaning of these statuary groups is unknown. They may be the pharaoh's offerings to the goddess Hathor or incarnations of the nomes of Egypt, ensuring the ruler eternal power even after death.

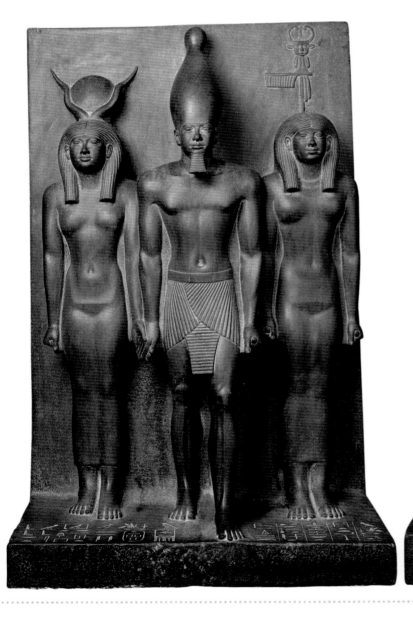

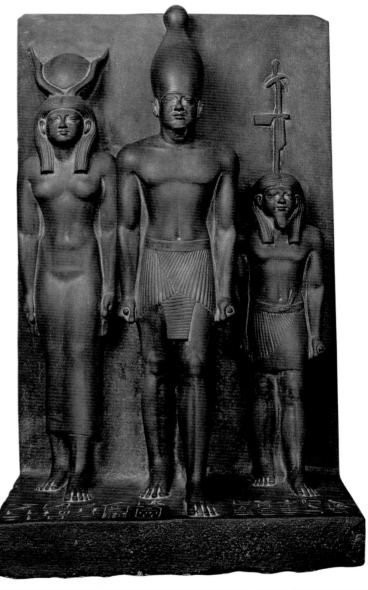

66 left | JE 40678

MYCERINUS TRIAD

GRAY-GREEN SCHIST
HEIGHT CM 93
4th Dynasty, Mycerinus' reign
(2494-2472 BC)

In this group, found by G. Reisner in the valley temple of Mycerinus (1908), the pharaoh is holding Hathor's hand as if she were his bride, and is accompanied by the goddess of the nome of Diospolis Parva.

66 right | JE 46499

MYCERINUS TRIAD

SGRAY-GREEN SCHIST
HEIGHT CM 95.5
4th Dynasty, Mycerinus' reign
(2494-2472 BC)

In this triad, found by G. Reisner in the valley temple of Mycerinus (1908), the god of the nomo of Thebes is on the pharaoh's left as Mycerinus advances solemnly next to Hathor without touching her.

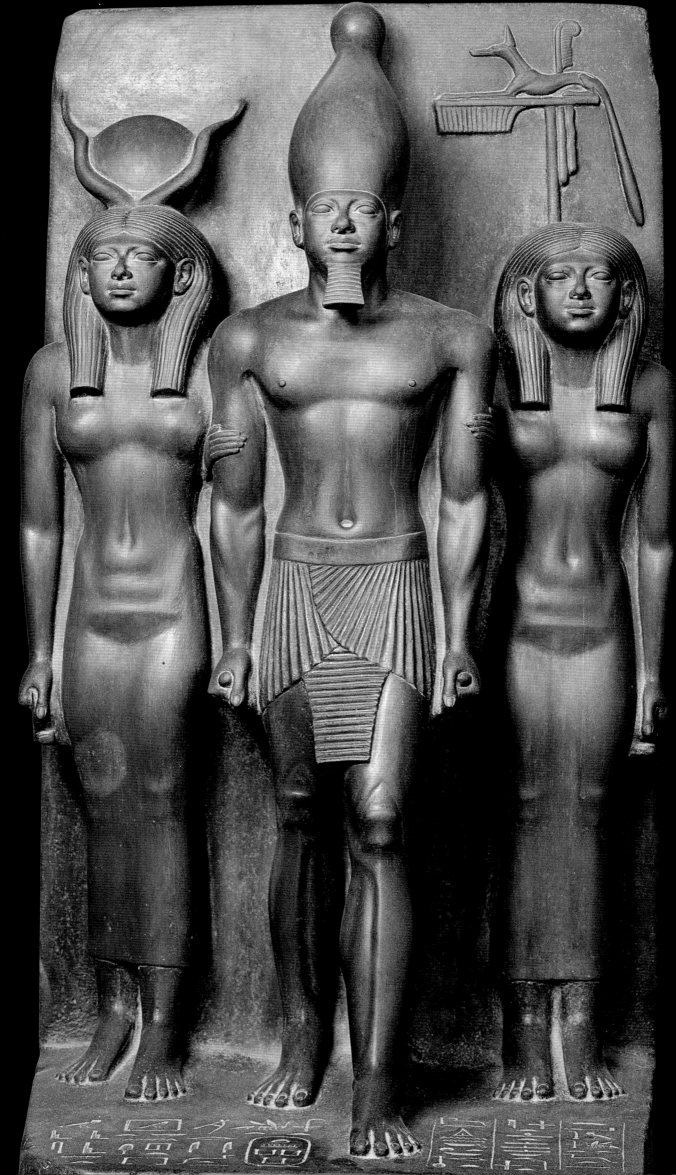

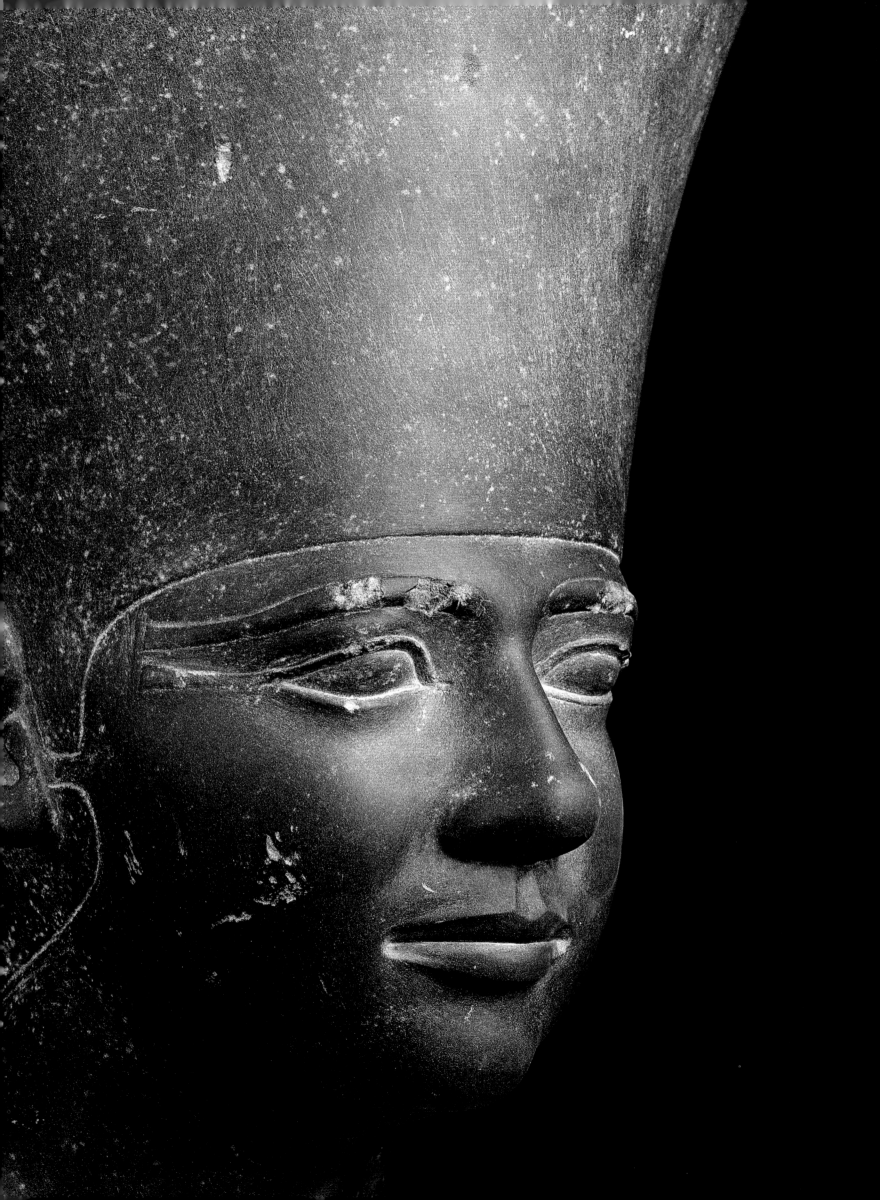

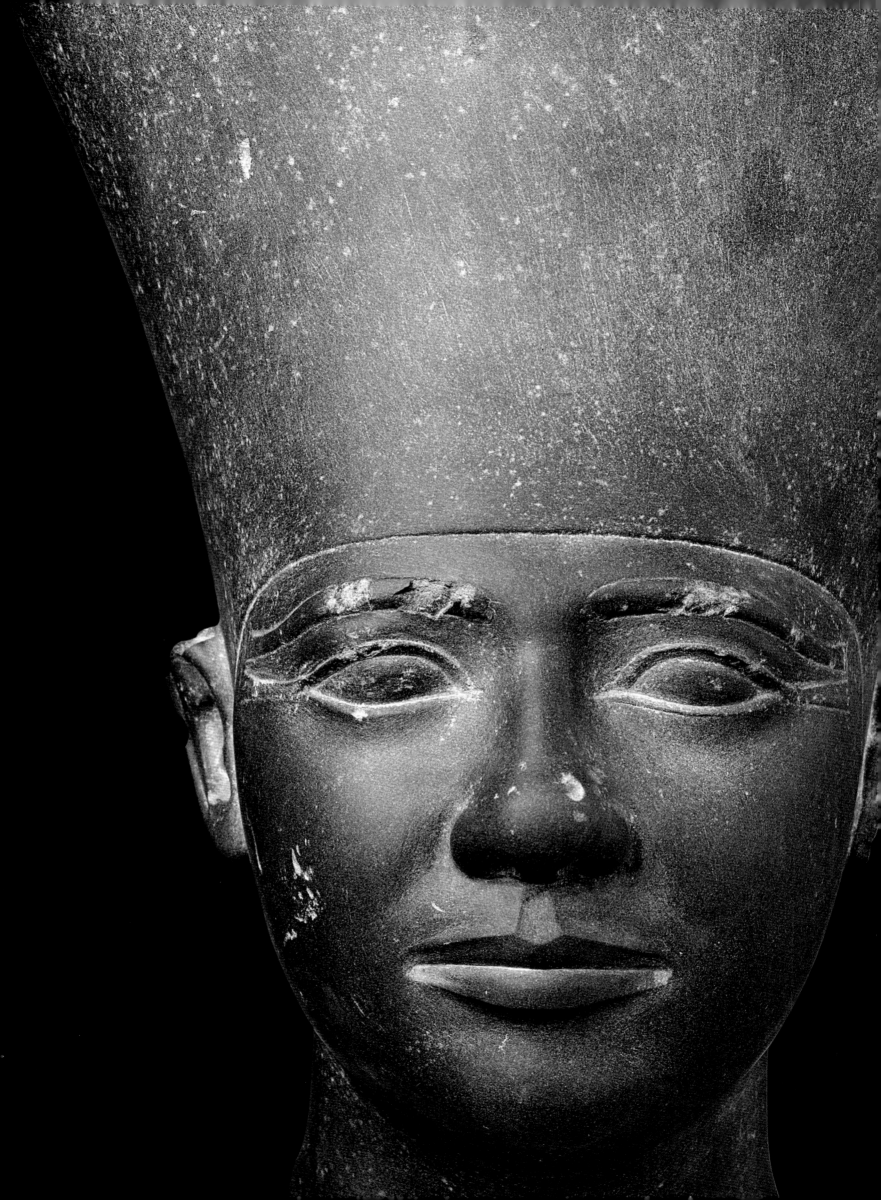

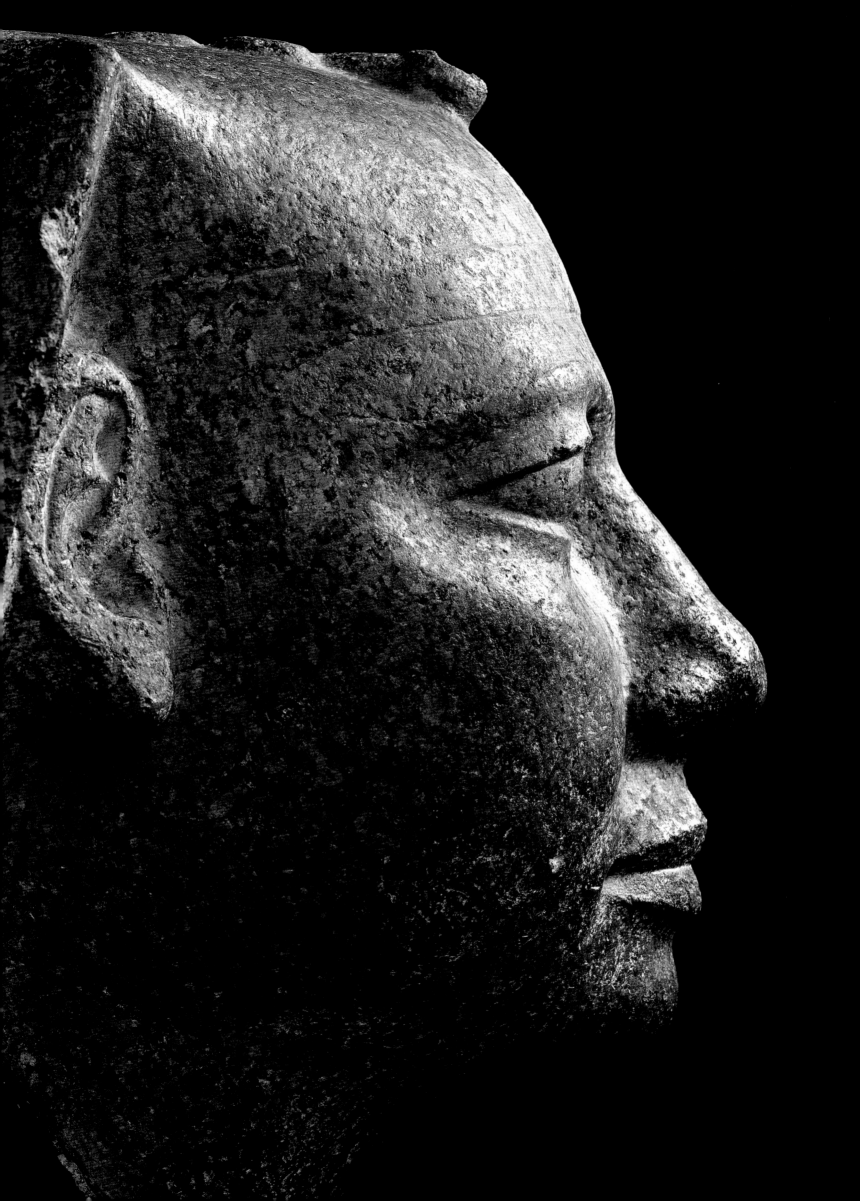

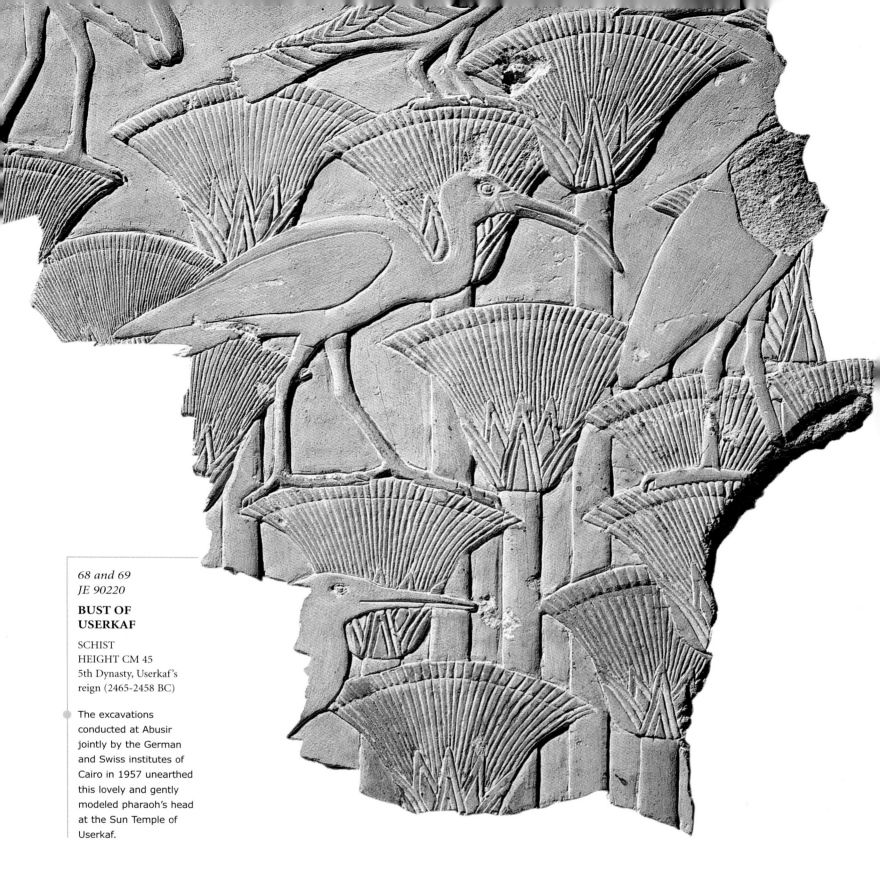

68 and 69
JE 90220

**BUST OF
USERKAF**

SCHIST
HEIGHT CM 45
5th Dynasty, Userkaf's
reign (2465-2458 BC)

The excavations
conducted at Abusir
jointly by the German
and Swiss institutes of
Cairo in 1957 unearthed
this lovely and gently
modeled pharaoh's head
at the Sun Temple of
Userkaf.

70

BUST OF USERKAF

RED GRANITE
HEIGHT CM 75
5th Dynasty,
Userkaf's reign
(2465-2458 BC)

JE 52501

The head pertains to a
colossus of Userkaf,
discovered by C.M. Firth on
the south side of the
courtyard of the king's
funerary temple at Saqqara
(1926). The red granite linked
the statues to the pillars in
the courtyards, which were
made of the same material.

71

**RELIEF WITH
BIRDS AND
PAPYRUS PLANTS**

LIMESTONE WITH
TRACES OF COLOR
HEIGHT CM 102
5th Dynasty,
Userkaf's reign
(2465-2458 BC)

JE 56007

In the courtyard of the
funerary temple of
Userkaf, studied by C.M.
Firth in 1928-1929,
exquisite reliefs in white
limestone, probably
polychrome, created a
contrast with the black
basalt flooring and the
pink granite pillars.

The Old Kingdom

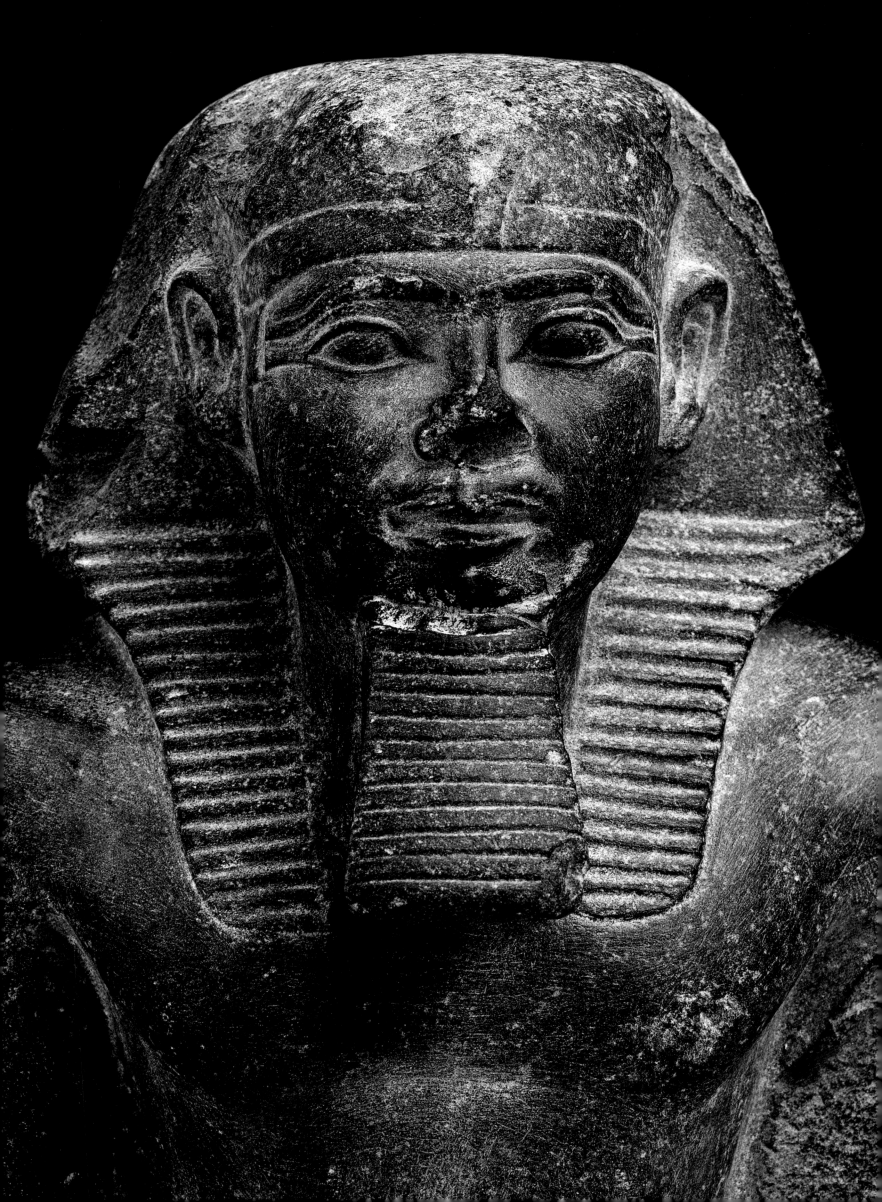

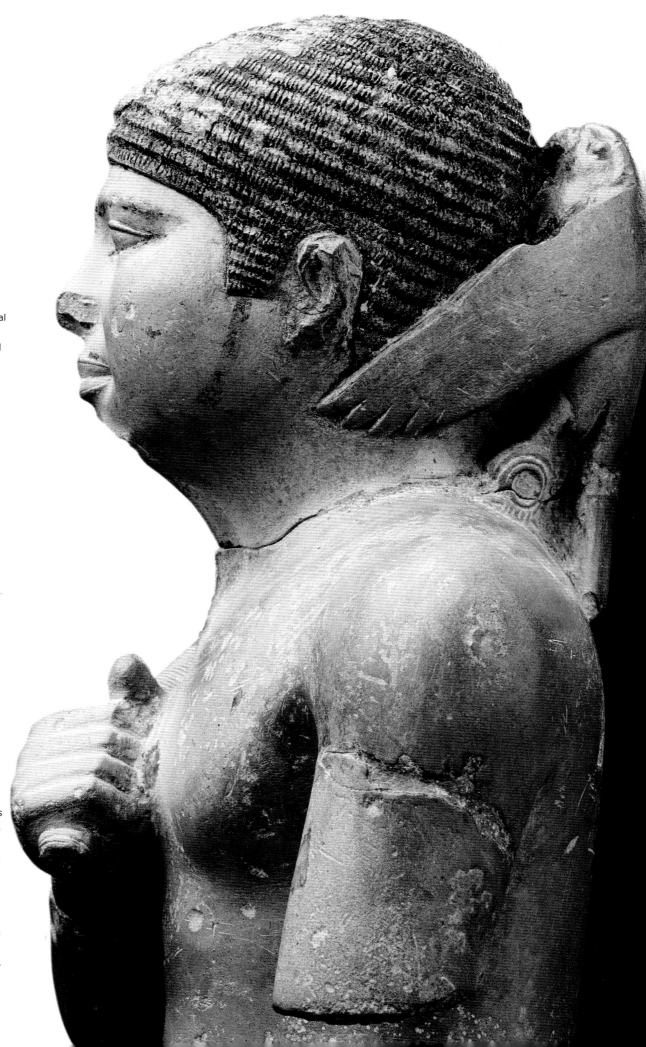

72
JE 98177

STATUE OF NEFEREFRE

BASALT
5th Dynasty,
Neferefre's reign
(2419-2416 BC)

The Czech archaeological expedition to Abusir (1984-1985) discovered this statue at the funerary complex of Neferefre. The site unexpectedly yielded a large quantity of material, including an important papyrus archive.

73
JE 98171

STATUETTE OF NEFEREFRE

PAINTED PINK LIMESTONE
HEIGHT CM 34
5th Dynasty, Nefererfre's reign (2419-2416 BC)

The pharaoh's youth is emphasized by the pinkness of the stone, which contrasts with his black wig; the uraeus has been lost. Horus, the falcon god, spreads its wings over him to guarantee legitimacy and protection. The artifact, discovered by the Czech expedition to Abusir (1984-1985), is from the ruler's temple.

74 top

**STATUE OF
MERESANKH WITH
TWO DAUGHTERS**

PAINTED LIMESTONE
HEIGHT CM 43.5
WIDTH CM 21
DEPTH CM 20.5
Late 5th Dynasty (second
half of the 24th century BC)

JE 66617

This statuary group,
discovered by S. Hassan
at Giza (1920-1930) in
the mastaba of
Meresankh, is composed
of the figure buried in
the tomb, embraced by
his two daughters.

74 bottom left

**STATUE OF MITRI
AS A SCRIBE**

GESSOED AND
PAINTED WOOD
HEIGHT CM 76
WIDTH CM 50
Late 5th Dynasty (24th-
23rd century BC)

JE 93165

This splendid work
depicting Mitri as a scribe
comes from his tomb. It
was found by the
Antiquities Service
(1925-1926) together
with many others
showing him alone or
with his bride.

74 right

STATUE OF TI

PAINTED LIMESTONE
HEIGHT CM 198
5th Dynasty,
Niuserre's reign
(2416-2392 BC)

JE 10065 = CG 20

This statue of the
dignitary, walking
solemnly, comes from
the tomb of Ti, one of
the most spectacular of
the Old Kingdom, at
Djoser's funerary
complex at Saqqara.

75
JE 30272 = CG 36

**STATUE OF
A SCRIBE**

PAINTED LIMESTONE
HEIGHT CM 51
First half of the
5th Dynasty
(mid-25th century BC)

Discovered at Saqqara,
this statue of an
unknown figure shows
the stereotyped pose of a
scribe, with a stylus –
which has been lost – in
his right hand and a
papyrus scroll in his left.

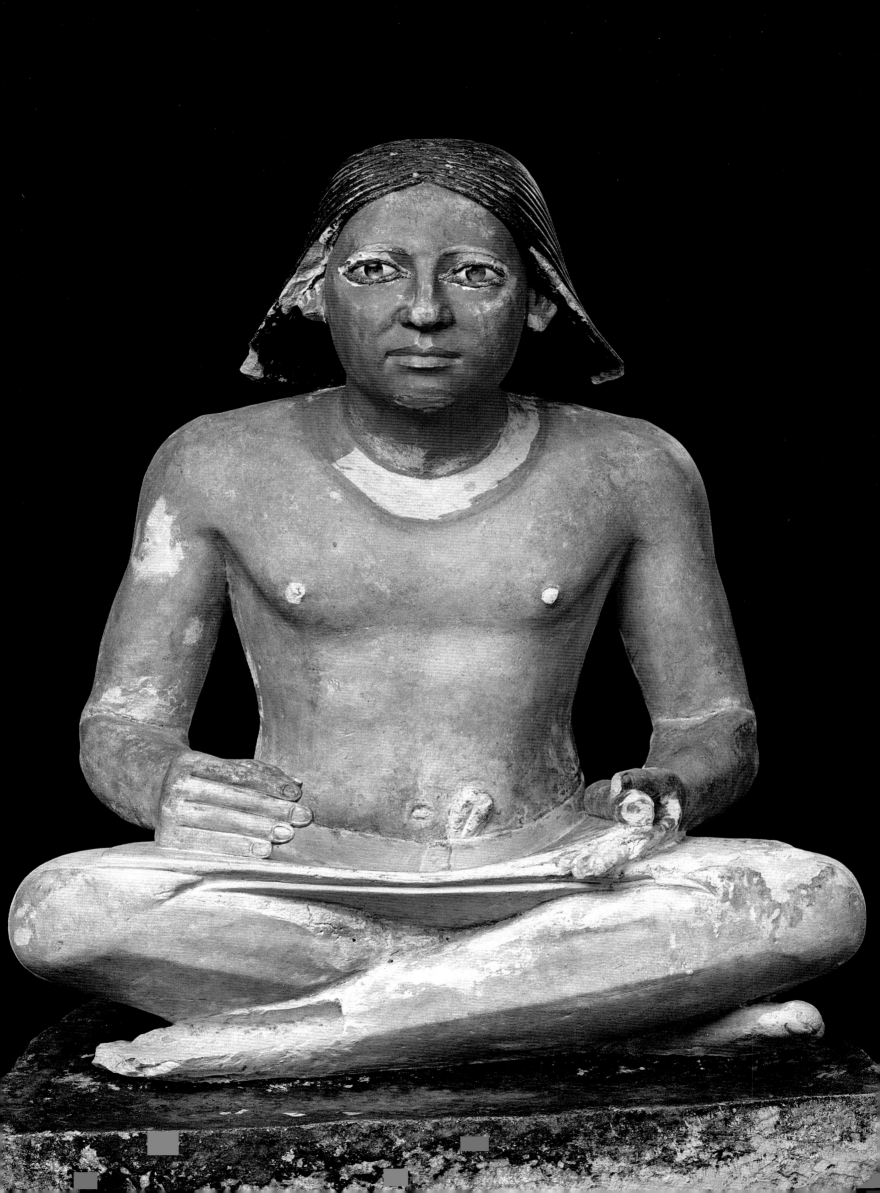

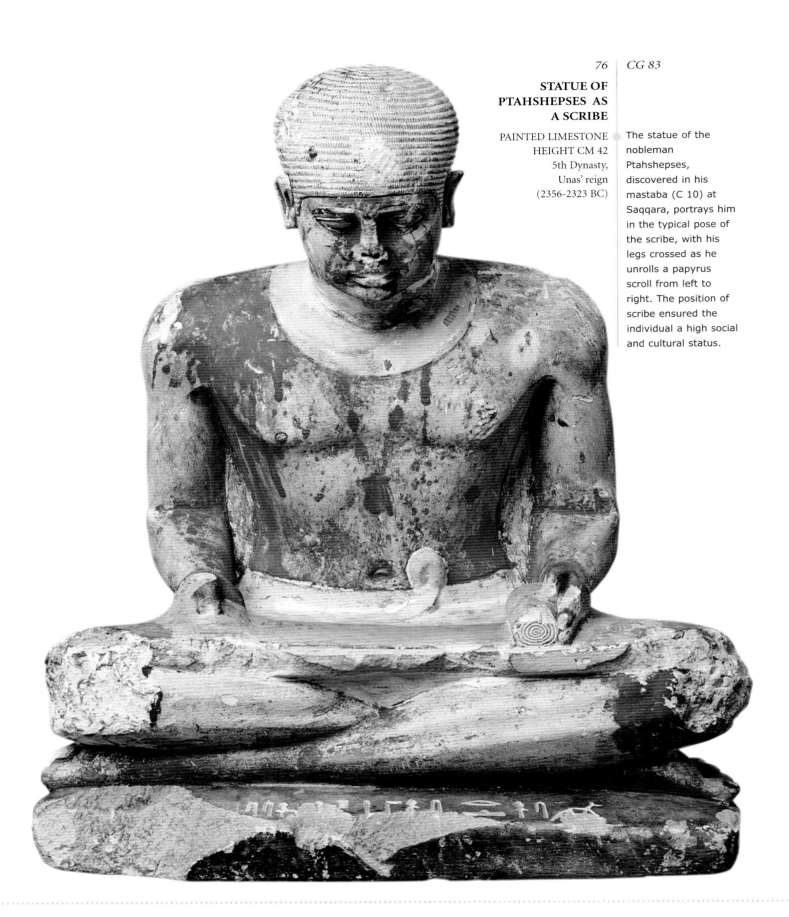

**STATUE OF
PTAHSHEPSES AS
A SCRIBE**

PAINTED LIMESTONE
HEIGHT CM 42
5th Dynasty,
Unas' reign
(2356-2323 BC)

The statue of the
nobleman
Ptahshepses,
discovered in his
mastaba (C 10) at
Saqqara, portrays him
in the typical pose of
the scribe, with his
legs crossed as he
unrolls a papyrus
scroll from left to
right. The position of
scribe ensured the
individual a high social
and cultural status.

77 left | *JE 10064 = CG 18*

STATUE OF RANOFER

PAINTED LIMESTONE
HEIGHT CM 186
First half of the 5th Dynasty
(mid-25th century BC)

The pair of statues A.
Mariette discovered in
Ranofer's tomb at Saqqara
(1860) is striking in its
attempt at naturalism,
despite the static pose and
the fact that the figure is
attached to the background
stone.

77 right | *JE 10063 = CG 19*

STATUE OF RANOFER

PAINTED LIMESTONE
HEIGHT CM 186
First half of the 5th Dynasty
(mid-25th century BC)

Ranofer shown in the
bloom of youth, with a
muscular chest and finely
chiseled face, as opposed
to the other specimen
depicting him at a more
advanced age, with a
pronounced belly and
puffy cheeks.

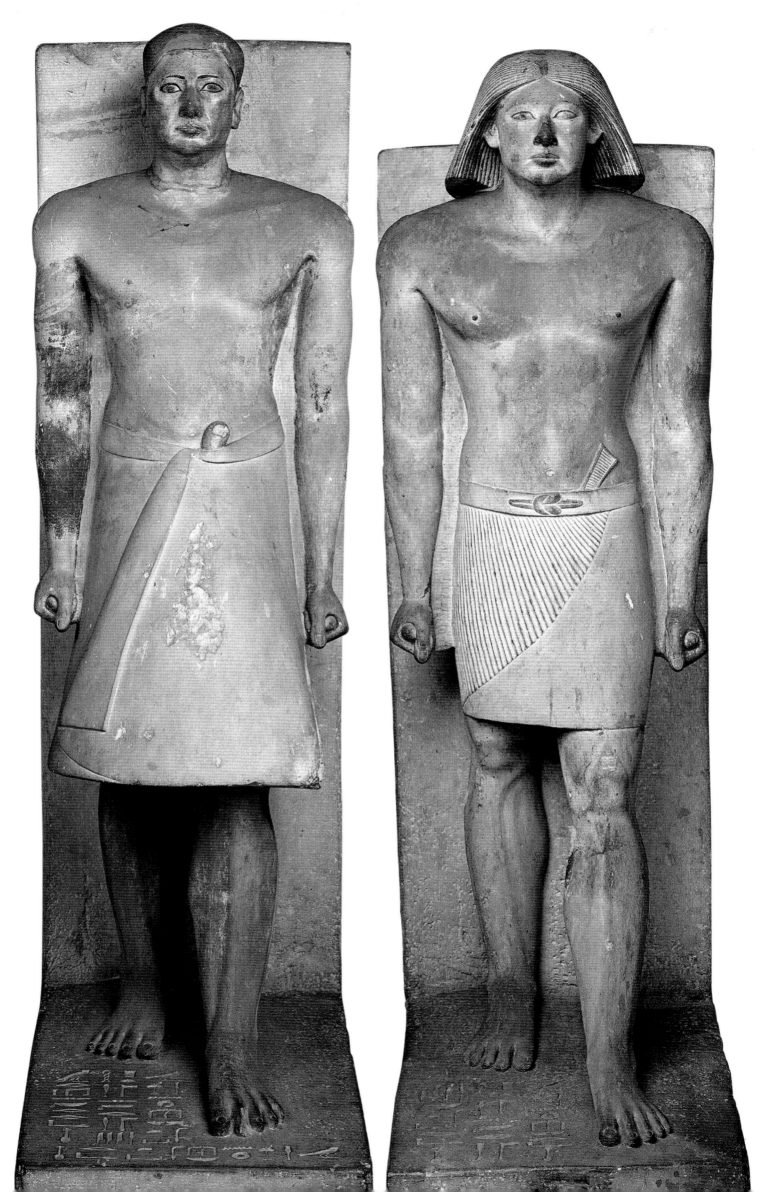

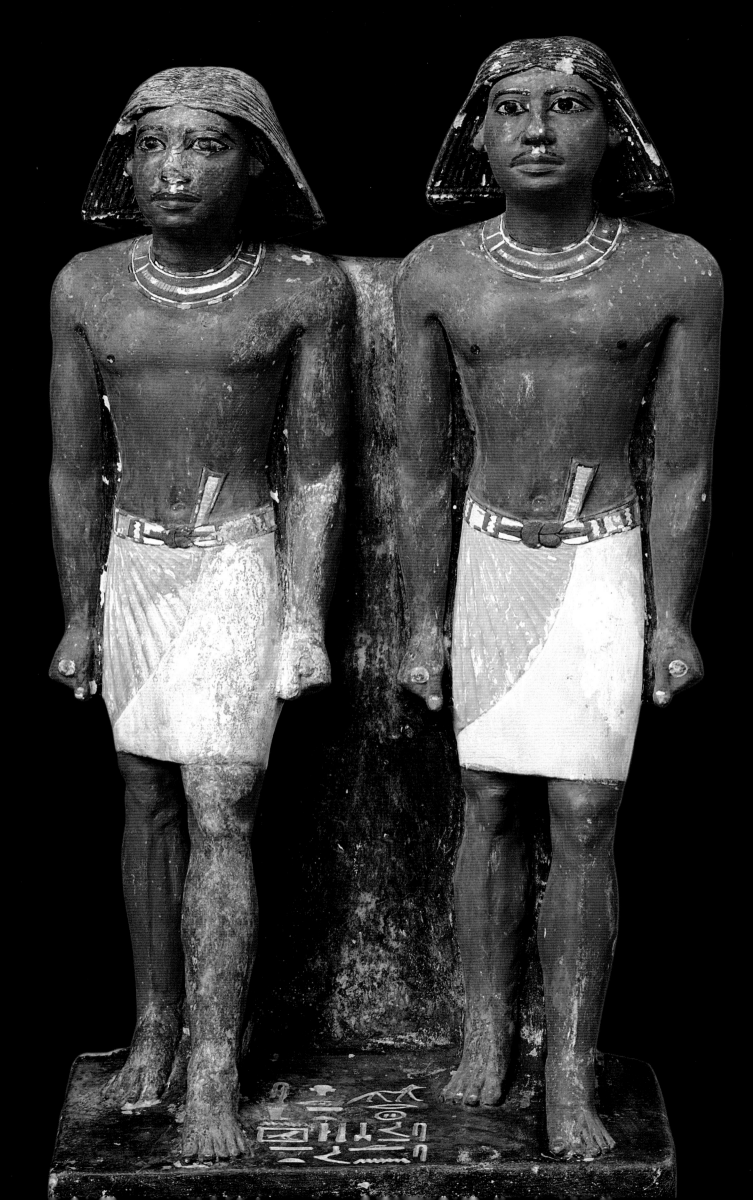

DOUBLE STATUE OF NIMAATSED

PAINTED LIMESTONE
HEIGHT CM 57
Second half of the
5th Dynasty
(early 24th century BC)

CG 133

This dual image of Nimaatsed, found at Saqqara by A. Mariette (1860), is indubitably a singular work. It may have been intended as a portrayal of the deceased with his ka, or guardian spirit, which is smaller in size.

THE FAMILY OF NEFERHERENPTAH

PAINTED LIMESTONE
Late 5th Dynasty – early 6th
Dynasty (24th-23rd century BC)

Daughter
JE 87807
HEIGHT CM 39

Mother
JE 87806
HEIGHT CM 53

Father
JE 87804
HEIGHT CM 65

Son
JE 87805
HEIGHT CM 37

The family group is a type of statuary typical of the Old Kingdom, and it was generally sculpted from a single block of stone. Instead, the figures found by S. Hassan at Giza (1936), in the mastaba of Neferherenptah, take on their own autonomy in space, which can also be noted in the different shaping of the bodies.

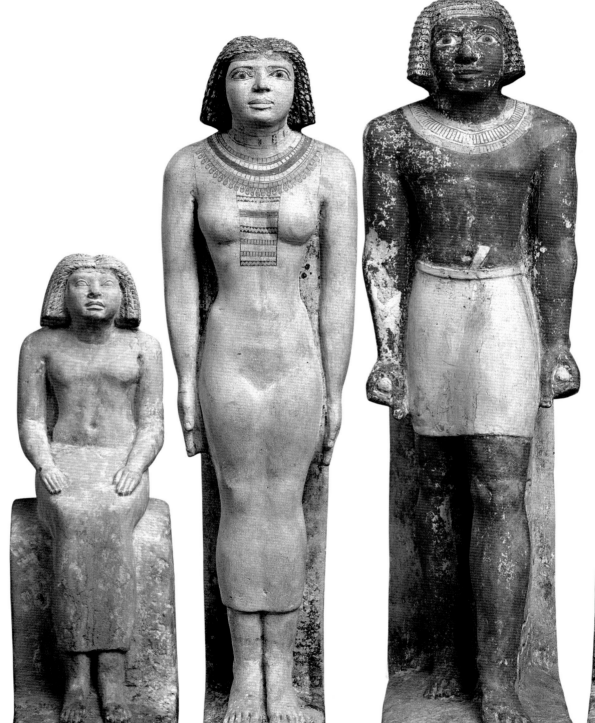

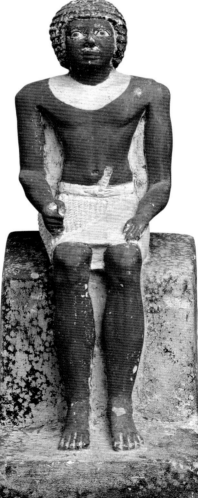

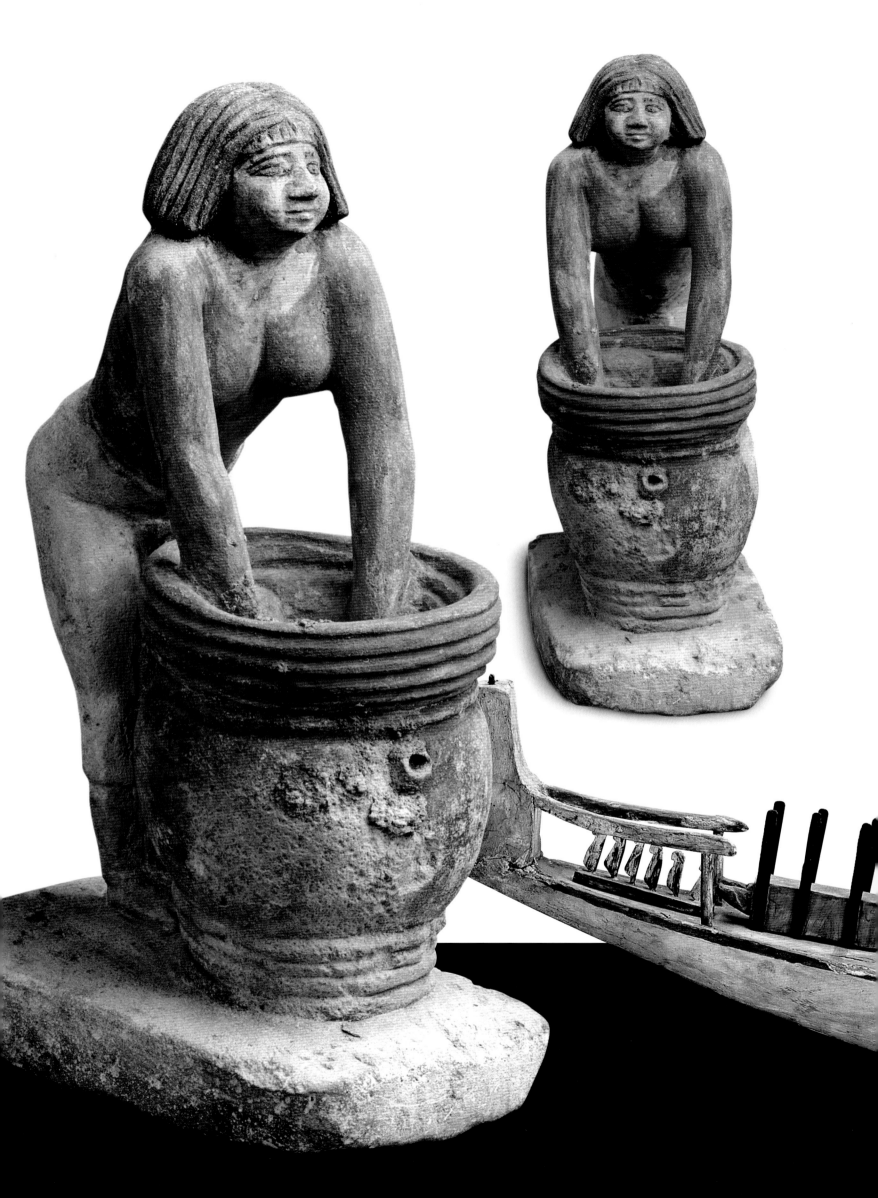

JE 66624

STATUETTE OF A WOMAN MAKING BEER

PAINTED LIMESTONE
HEIGHT CM 28
Late 5th Dynasty
(mid-24th century BC)

Starting in the Fourth Dynasty, three-dimensional figures appeared. Depicted in various daily activities, they were matched by two-dimensional descriptions in the wall reliefs. This artifact is from the mastaba of Meresankh, at Giza, and was discovered by S. Hassan (1929-1930).

80-81

SOLAR BOAT MODEL

WOOD
LENGTH CM 74.50
Late 5th Dynasty
(mid-24th century BC)

JE 32823 = CG 4953

This model, unearthed at Deir el-Bersheh, depicts a solar boat. The term refers to a particular type of boat that was placed near royal burials. To date, scholars do not agree on its purpose.

81 right
JE 72232

STATUETTE OF A MAN PLUCKING A GOOSE

PAINTED LIMESTONE
HEIGHT CM 42
5th Dynasty (2465-2323 BC)

This man, shown plucking a goose, was probably helping to prepare the funeral banquet, in which the offering of a goose played an important role. The statuette was discovered at Saqqara by S. Hassan (1935).

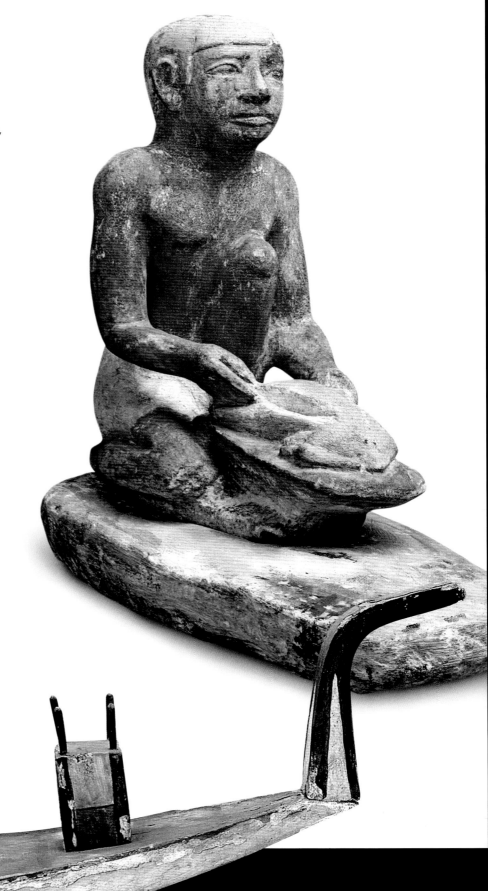

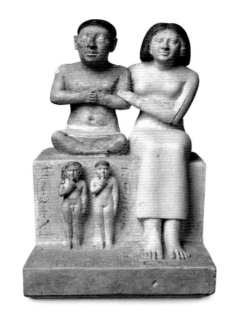

82 top
JE 51280

**THE DWARF SENEB
WITH HIS FAMILY**

PAINTED LIMESTONE
HEIGHT CM 34
WIDTH CM 22.5
DEPTH CM 25
Late 5th Dynasty –
early 6th Dynasty
(24th-23rd century BC)

The different positions of
the family members in this
group, discovered by
Junker in Seneb's mastaba
at Giza (1926-1927),
convey a sense of
dynamism. Seneb's
dwarfism is concealed by
the fact that he is seated.

82 bottom

**FALSE-DOOR STELE
OF IKA**

ACACIA
HEIGHT CM 200
WIDTH CM 150
5th Dynasty
(2465-2323 BC)

JE 72201

The false door was an
important symbol of
communication
between the worlds of
the living and the
dead. This specimen
was found at Saqqara
by the Antiquities
Service (1936).

83

**FALSE-DOOR STELE
OF ITETI**

PAINTED LIMESTONE
HEIGHT CM 360
WIDTH CM 210
Early 6th Dynasty
(2323-2152 BC)

JE 15157

On this false door
discovered by Mariette
in Iteti's mastaba at
Giza (1861), the
deceased is portrayed
on the uprights
together with his titles,
and in the door
opening, where he is
portrayed in half-relief.

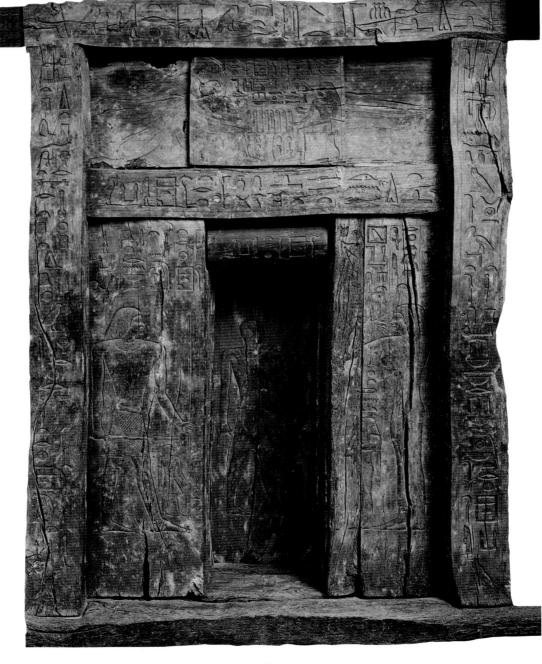

The Old Kingdom

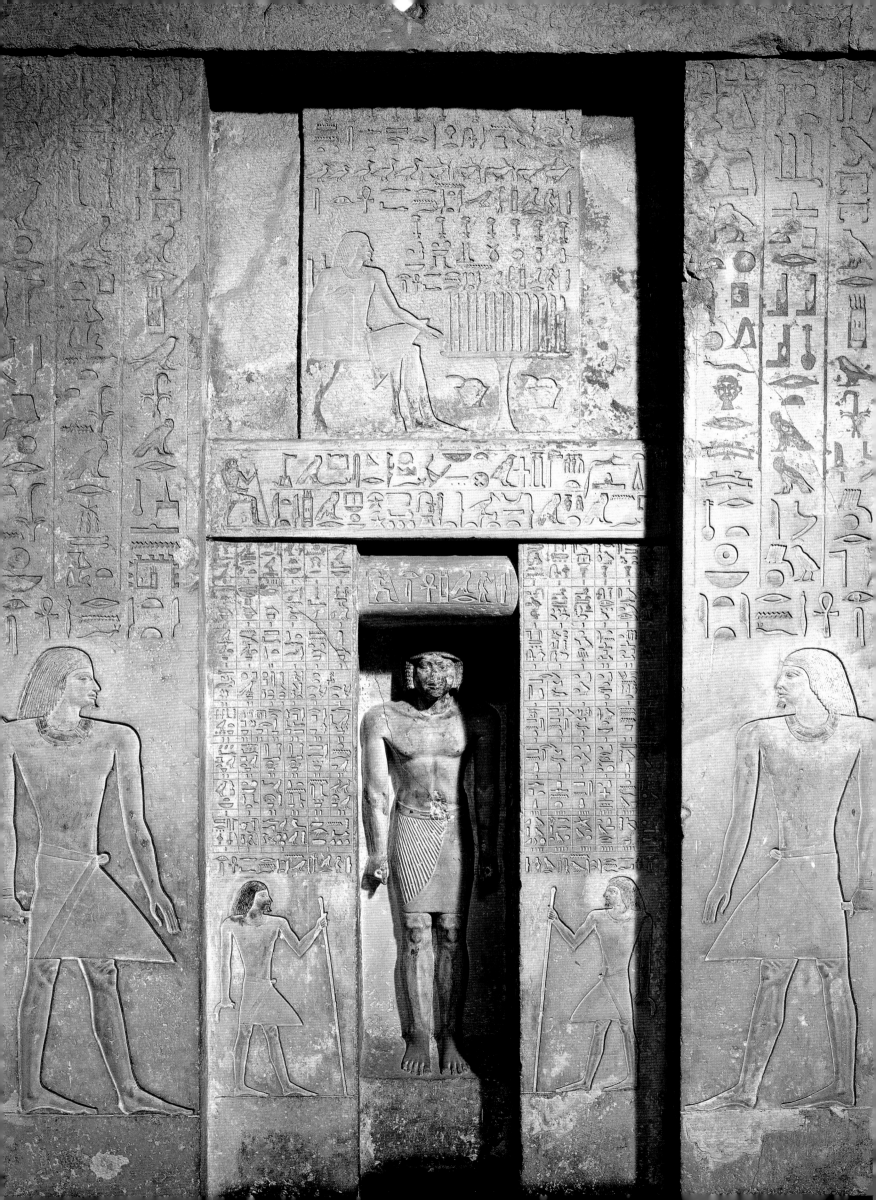

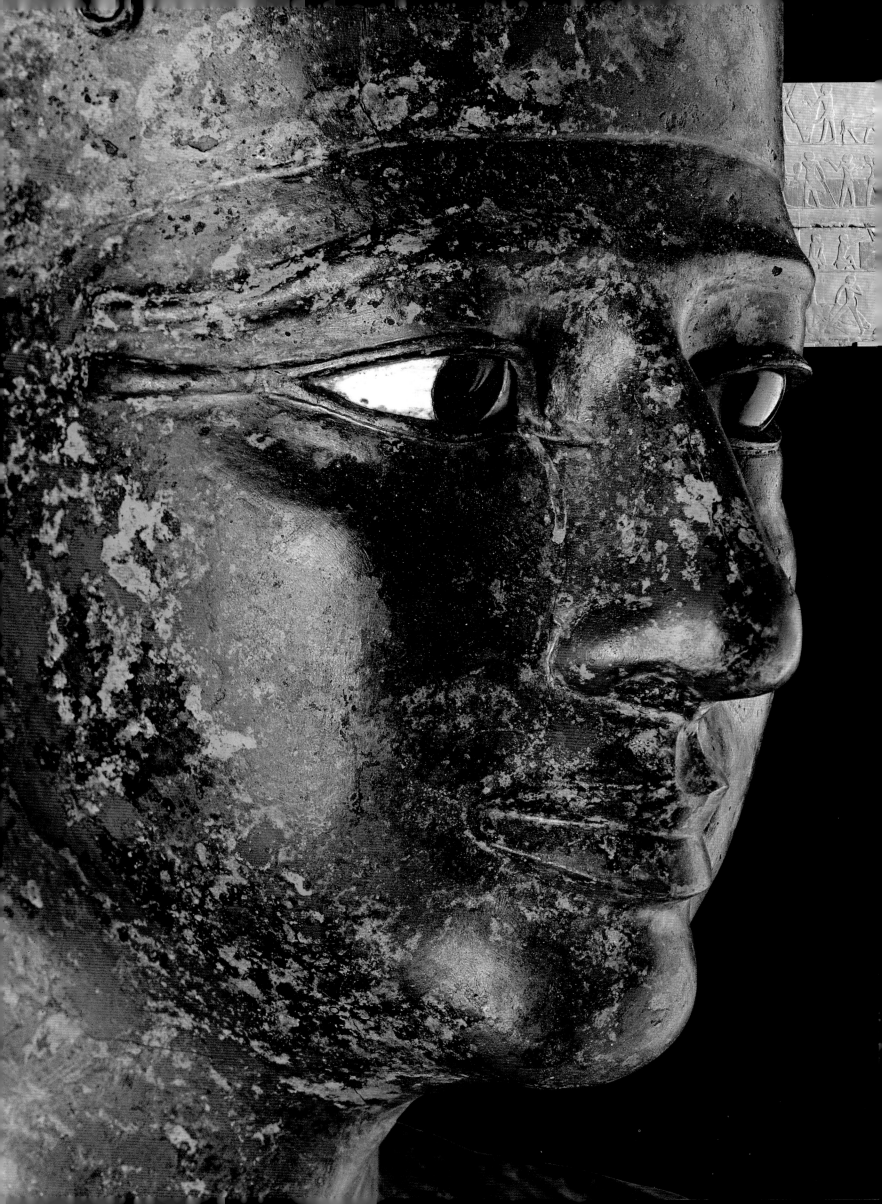

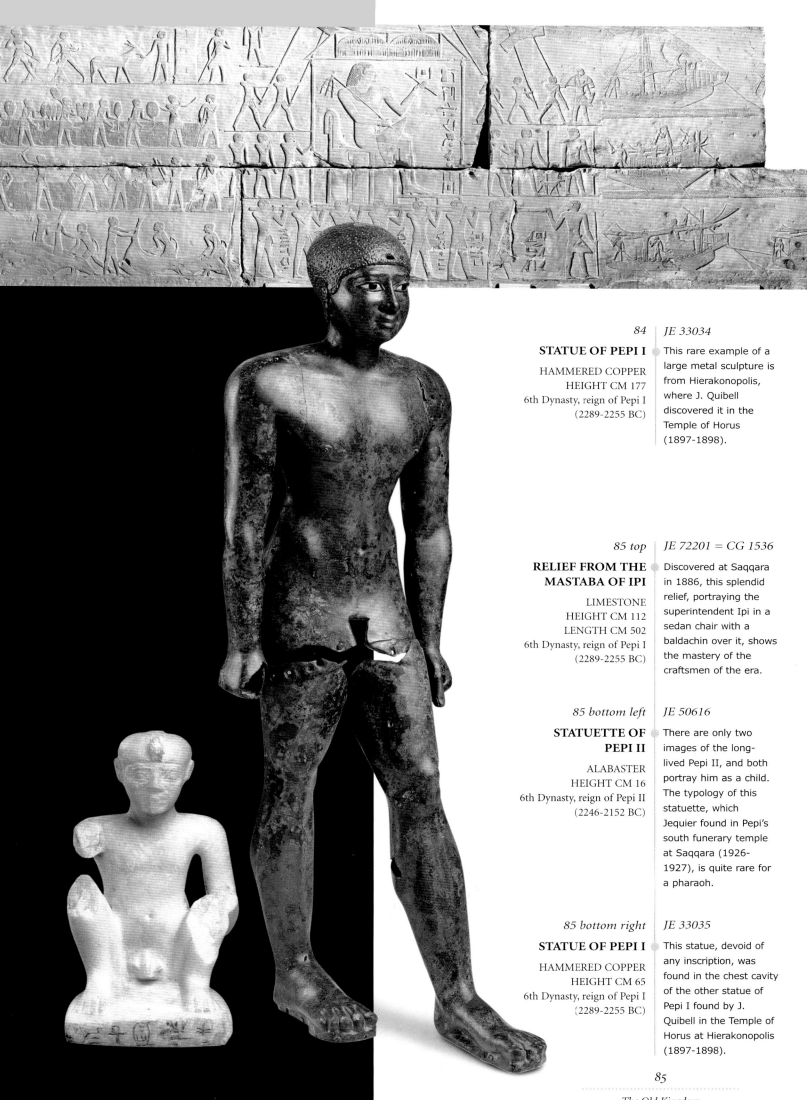

<div>

84

STATUE OF PEPI I

HAMMERED COPPER
HEIGHT CM 177
6th Dynasty, reign of Pepi I
(2289-2255 BC)

JE 33034

This rare example of a
large metal sculpture is
from Hierakonopolis,
where J. Quibell
discovered it in the
Temple of Horus
(1897-1898).

85 top

**RELIEF FROM THE
MASTABA OF IPI**

LIMESTONE
HEIGHT CM 112
LENGTH CM 502
6th Dynasty, reign of Pepi I
(2289-2255 BC)

JE 72201 = CG 1536

Discovered at Saqqara
in 1886, this splendid
relief, portraying the
superintendent Ipi in a
sedan chair with a
baldachin over it, shows
the mastery of the
craftsmen of the era.

85 bottom left

**STATUETTE OF
PEPI II**

ALABASTER
HEIGHT CM 16
6th Dynasty, reign of Pepi II
(2246-2152 BC)

JE 50616

There are only two
images of the long-
lived Pepi II, and both
portray him as a child.
The typology of this
statuette, which
Jequier found in Pepi's
south funerary temple
at Saqqara (1926-
1927), is quite rare for
a pharaoh.

85 bottom right

STATUE OF PEPI I

HAMMERED COPPER
HEIGHT CM 65
6th Dynasty, reign of Pepi I
(2289-2255 BC)

JE 33035

This statue, devoid of
any inscription, was
found in the chest cavity
of the other statue of
Pepi I found by J.
Quibell in the Temple of
Horus at Hierakonopolis
(1897-1898).

</div>

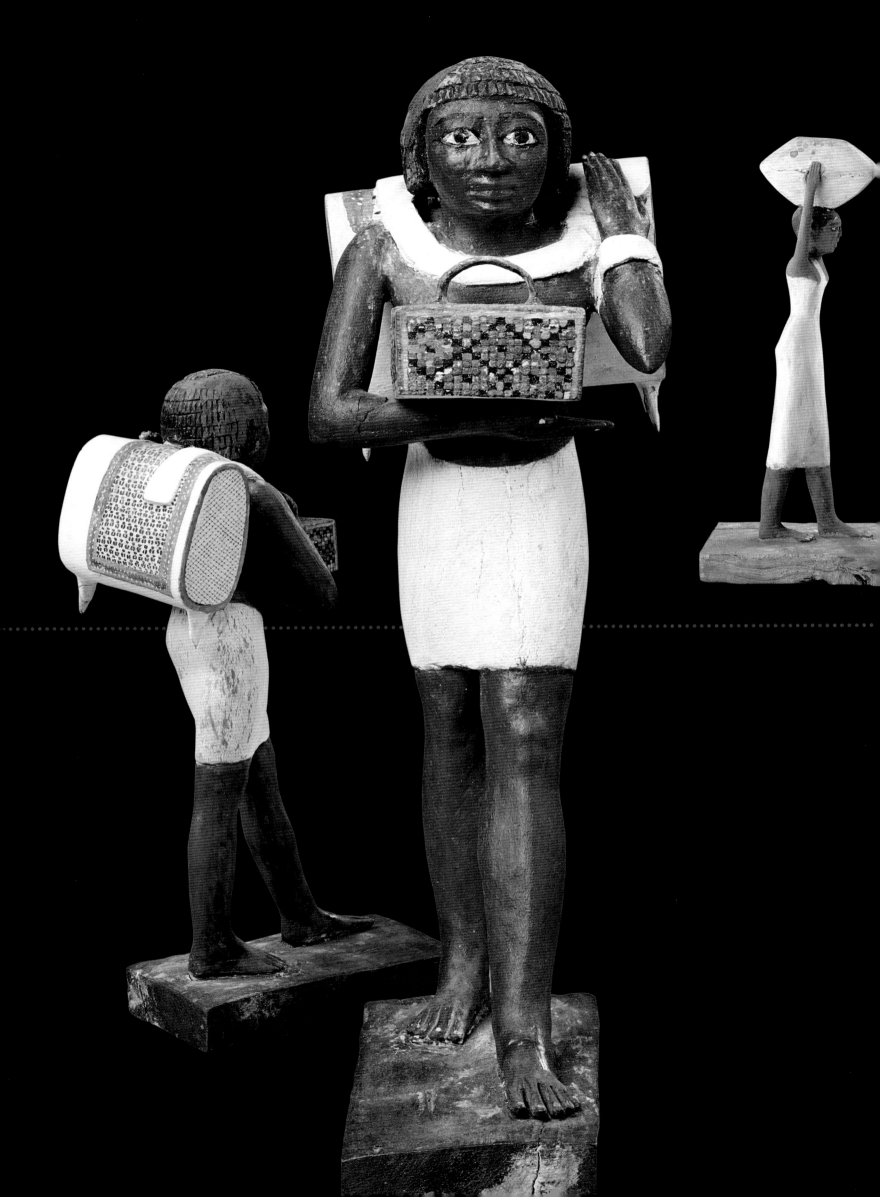

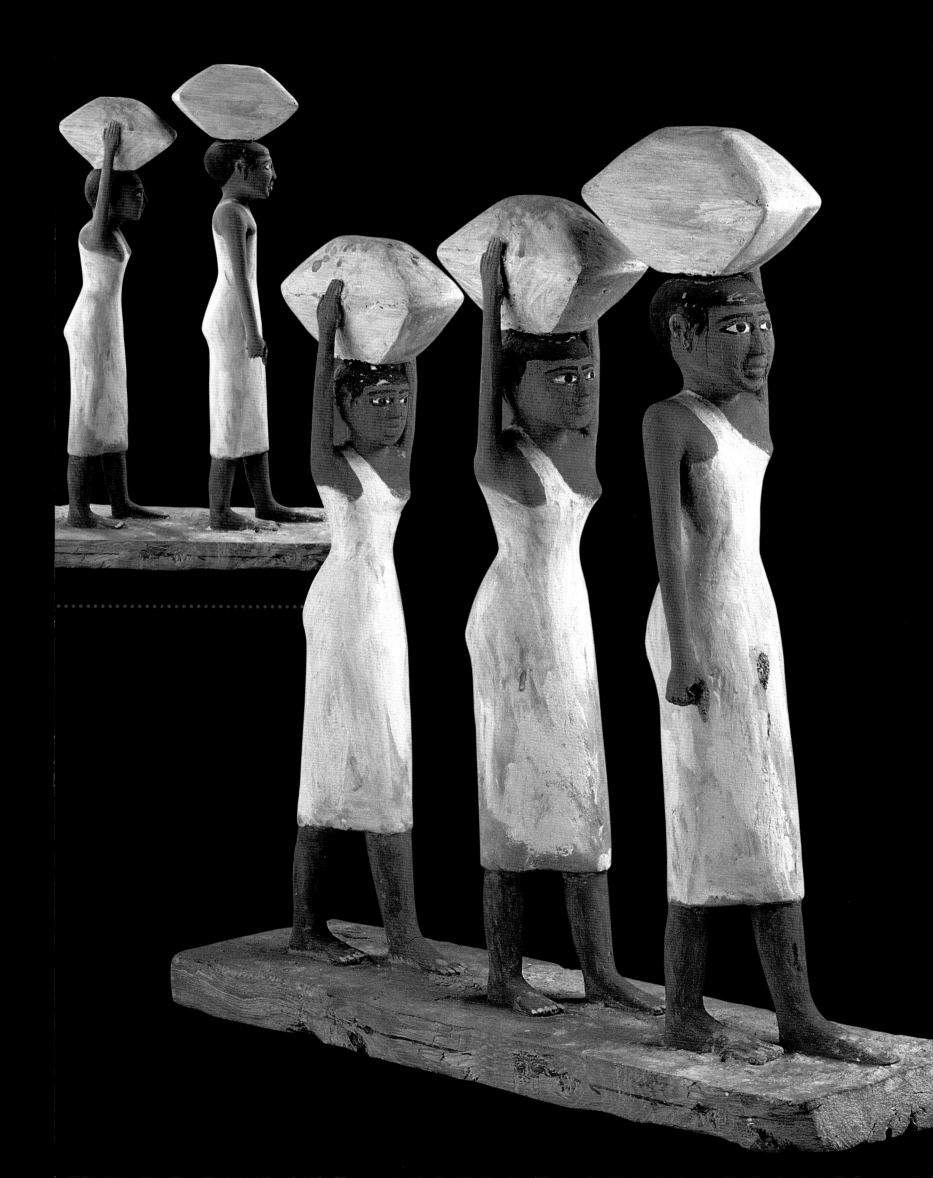

BEARER

PAINTED WOOD
HEIGHT CM 36.5
6th Dynasty, reign of Pepi I
(2289-2255 BC)

The statuettes shown from pages 86 to 89 were discovered by the Antiquities Services in the tomb of Niankhpepi the Black, at Meir (1894). They pertain to a type of effigy of servants that reveals the potential for representing the dynamism of an action, in contrast with traditional courtly art.

FEMALE BEARERS

PAINTED WOOD
HEIGHT CM 59
LENGTH CM 56
6th Dynasty, reign of Pepi I (2289-2255 BC)

The decreasing height of these bearers, who are identical, gives the group a sense of movement.

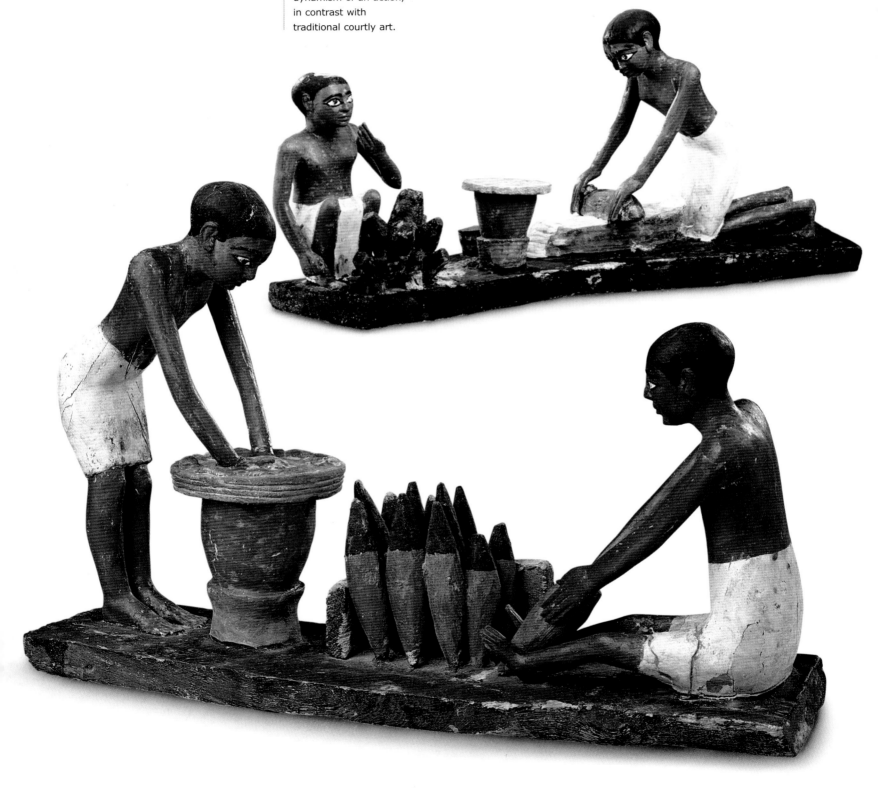

The Old Kingdom

MILLING

PAINTED WOOD
LENGTH CM 60

CG 244

**PREPARATION OF
BREAD AND BEER**

PAINTED WOOD
LENGTH CM 53
6th Dynasty, reign of Pepi I
(2289-2255 BC)

A woman is milling flour
as her companion stirs
the fire (top); two men
make bread and beer,
which were staples in the
Egyptian diet.

89 top | CG 249

MAN HOEING

PAINTED WOOD
HEIGHT CM 29

This stylized statuette
shows a farmer tilling
the soil with sharp
blows.

89 bottom left | JE 30820

**MAN POKING THE
FIRE**

PAINTED WOOD
LENGTH CM 30.5

This figure is
particularly lively. The
servant, keeping his
distance, blows into
the oven to keep the
fire going.

89 bottom right | CG 245

**MAN ROASTING
A DUCK**

PAINTED WOOD
HEIGHT CM 24
6th Dynasty, reign of
Pepi I (2289-2255 BC)

The man is fanning
the fire with one
hand, as he roasts a
piece of duck
skewered on a long
stick held in his other
hand.

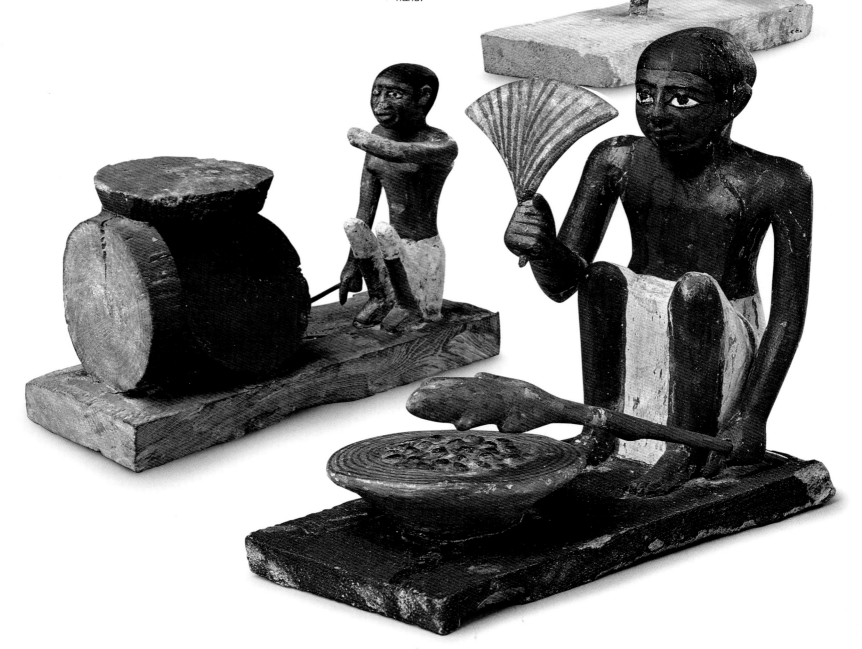

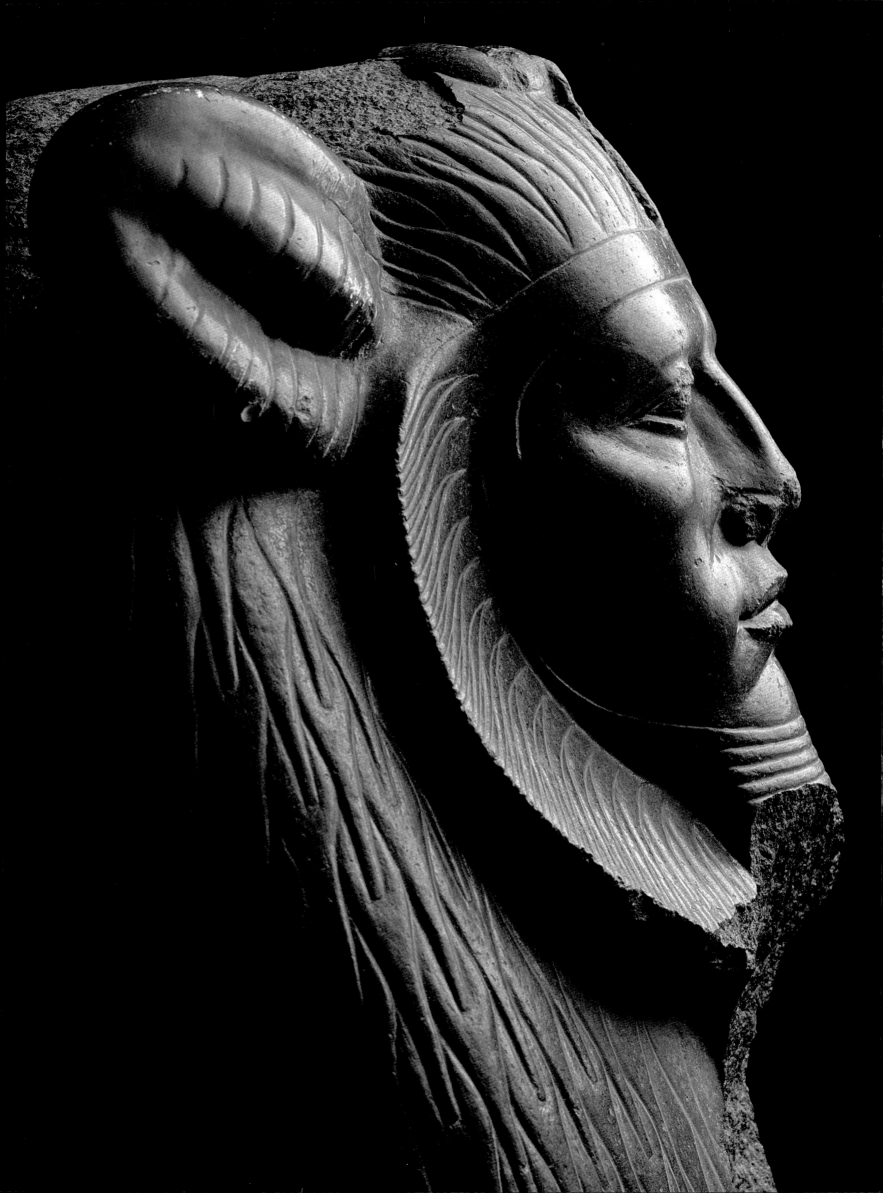

THE MIDDLE KINGDOM

THE CULTURE OF THE MIDDLE
KINGDOM REACHED A LEVEL
WORTHY OF BEING CONSIDERED
A "CLASSIC AGE," A POINT OF
REFERENCE AND COMPARISON
STARTING AS EARLY AS THE
FOLLOWING ERA. POWERFUL
RULERS CAPABLE OF
MAINTAINING THE COUNTRY'S
BOUNDARIES CONTRIBUTED TO
THIS PEACEFUL AND
PROSPEROUS DEVELOPMENT.

The desire to gain more decisive
control over the northern part of the country while also defending its borders from attacks from the outside is reflected by the fact that the first sovereign of the Twelfth Dynasty,

Amenemhat I, or 'new man,' founded the new capital of Iti-tawi in the north, at the entrance to Fayum. The very name of this city, which means "Amenemhat takes the Two Lands," and the title of this sovereign, which propagandizes a 'rebirth' (uhem-mesut) of the country, bear witness to the resolute decision to reestablish a strong central power.

At the end of the Eleventh Dynasty, the Theban princes had already commenced the slow process of reuniting the country. It was with King Mentuhotep II in particular that Northern and Southern Egypt were again united under a single ruler. This is also indicated by the name of this sovereign when he rose to the throne, "He who gives heart to the Two Lands" and was later celebrated in his new name of Horus in Year 29 of his reign: "Uniter of the Two Lands."

With the successive rulers of the Twelfth Dynasty, Egypt enjoyed a phase of such widespread stability and prosperity, reflected in all aspects of the Egyptian culture, that the period came to be referred to as the 'classic' age even during the Ramesside Period. This was also a period of great literary vitality, with compositions that were handed down through the centuries. They were works of political 'propaganda' intended primarily to glorify a powerful royalty capable of safeguarding the reality of the First Time, or the perfect state of things that only the figure of the pharaoh, legitimated by the divine world, can (and must) preserve for eternity. Literary figures and works such as the hero Sinuhe, the "Tale of the Shipwrecked Sailor," the "Eloquent Peasant," Neferti, and the "Lament of Ipuwer"—to name a few—served the purposes of the central power, whose goal was to 'achieve Maat' on earth and drive away Isefet ('the negation of Maat'). The hope for perfect operation of the state machine is reflected in the literary genre of the Teachings, in which a sage/father speaks to a young man/son to teach him the rules of Maat, with the hope that civil society will preserve them through him forever.

In order to avert any unrest in his country upon his death, in Year 20 of his reign Amenemhat I brought his son Sesostris I to the throne, inaugurating a policy of 'co-regency' intended to bring great stability to the country. The policy of the sovereigns of the Twelfth Dynasty also strived to reinforce the borders of Egypt and limit any incursions by outlying populations. The Nubian area, in particular, was monitored and secured by constructing a string of well-equipped and well-connected military fortresses. There is also evidence of the Egyptians in the area of the Near East. They established important economic relations, and this is also reflected by the presence of Asian workers in Egypt. The most significant demonstration comes from the discovery of 'foreign' ceramics and documents attesting to Asiatic names in the city of Kahun, at the eastern end of Fayum. The city was founded to house the workers and officials who were building the pyramid of Pharaoh Sesostris II. Abandoned toward the end of the Thirteenth Dynasty for unknown reasons, the city was reoccupied during the New Kingdom.

Englishman Sir William Flinders Petrie studied the city of Kahun during the campaigns of

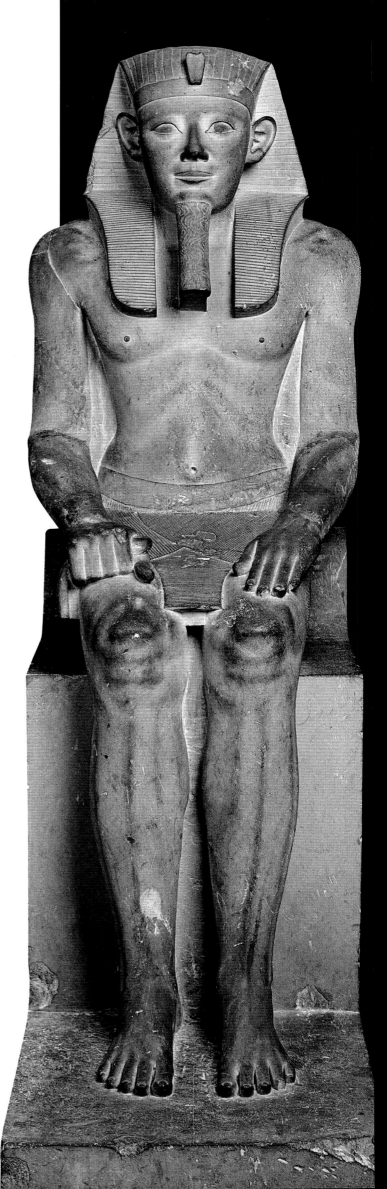

91
JE 30862

NECKLACE CLASP OF SAT-HATHOR

GOLD, CARNELIAN, LAPIS LAZULI, TURQUOISE
HEIGHT CM 2.7
12th Dynasty, reign of Sesostris III (1881-1842 BC)

This clasp was unearthed by J. De Morgan in the tomb of Sat-Hathor at Dahshur, inside the funerary complex of Sesostris III (1894). The artifact displays the skill and imagination of the goldsmiths of the period. A Hathoric column has been turned into a pendant between two entwined lotus blossoms.

1888–1889 and 1889–1890, and it immediately became clear that this was a unique archaeological case. This was the first time the complete layout of an ancient Egyptian city had been uncovered, together with an enormous amount of information—including textual materials—that made it possible to reconstruct the daily life of the period. These findings parallel the fortunate discovery of the city of laborers who worked on the royal necropolises of the Valleys of the Kings and the Queens at Deir al-Medina west of Thebes, a discovery that, in turn, provided invaluable information about the New Kingdom. In fact, it was possible to reconstruct the entire plan of the city of Kahun, identifying its layout and reconstructing its individual houses, which yielded all types of objects: stone and metal implements, papyrus documents, pottery, jewelry, toys, clothing, amulets, various figurines, and more.

In 1914, Petrie discovered four shaft tombs in the area near Kahun, inside the funerary enclosure of the pyramid of Sesostris II. Inside Tomb no. 8 he found an ebony box containing the splendid jewelry of the pharaoh's daughter, Princess Sithathoryunet, sister of Sesostris III and the wife of Amenemhat II. In addition to this discovery, there is the one from the excavation campaign conducted by De Morgan in 1894 and 1895 at Dashur, in the funerary enclosures of the pyramids of Amenemhat II and Sesostris III. Here Morgan discovered the tombs—and jewelry—of six royal princesses. The tombs and treasures of Sat-Hathor and Mereret were found near the tomb of Sesostris III in 1894, and in 1895 the intact tombs and the treasures of the princesses Ita, Khnumet, Itaweret, and Sithathormerit

93
JE 31139 =
CG 414

SEATED STATUE OF SESOSTRIS I

LIMESTONE
HEIGHT CM 200
12th Dynasty, reign of Sesostris I (1974-1929 BC)

This monument is connected with the sensational discovery of ten statues of Sesostris I, buried during the pharaonic age, at the ruler's funerary temple at al-Lisht. The perfect modeling of the statue accentuates the pharaoh's majesty. The statue was unearthed by the French Institute of Archaeology (1894).

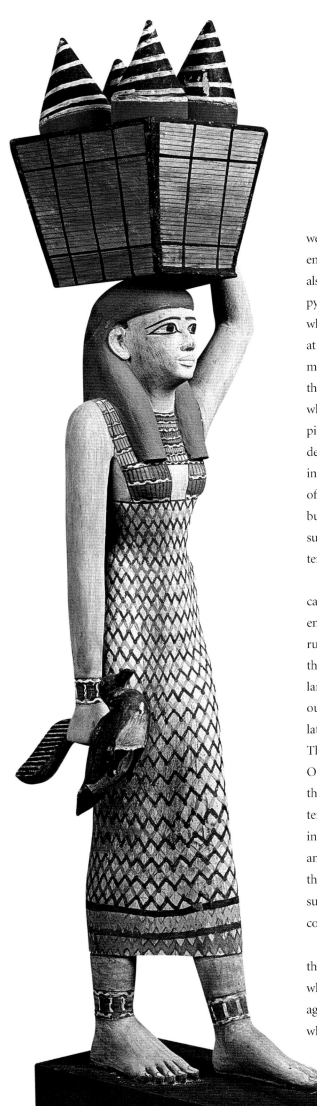

were uncovered near the tomb of Amenemhat II. Lastly, in 1920 a gold uraeus was also found in the burial chamber of the pyramid of Sesostris II. These treasures, which are preserved almost in their entirety at the Egyptian Museum in Cairo, have made it possible to reconstruct the skill of the goldsmiths and craftsmen of the period, who were capable of creating true masterpieces. This discovery has also permitted indepth study of the Egyptians' jewelry-making techniques, which showed a high level of specialization even in this remote age, but it also points to a trade network that supplied the country with valuable raw materials quarried in faraway lands.

The Middle Kingdom's great prosperity can also be attributed to the fact that Egypt enjoyed a relatively peaceful period. The rulers of the Twelfth Dynasty concentrated their efforts on the Nile Valley in particular, defending its borders and keeping the outlying populations in check through relations that revolved chiefly around trade. The great attention lavished on the Fayum Oasis bears witness to this. Starting with the reign of Sesostris II, in particular, extensive reclamation work was undertaken in the area, constructing important canals and dams to exploit the water resources of the Bahr Yussuf branch of the Nile, which supplied this area and what would later become the oasis' large lake.

Order in the country was also ensured through careful domestic policy, through which the Twelfth Dynasty pharaohs managed to control the powerful local lords who, at the end of the Old Kingdom, had managed to gain enormous power that was handed down from father to son. The splendid burials of these nomarchs, discovered in provincial necropolises, testifies to their great influence. As a way of averting the danger of this provincial power, Sesostris III was forced to get rid of the office of nomarch and transfer control of the country to the vizier. The country was thus divided into three major provinces that were directly under royal authority. With Sesostris III in particular, and with his successor Amenemhat III, Egypt enjoyed a period of great splendor, ruled by a strong sovereign who successfully dominated hostile internal and external forces. This is celebrated in the Hymn to Sesostris III, written on a papyrus discovered during Petrie's excavations. "[Sesostris III] conquered Upper Egypt and placed the Double Crown on his head. . . . He united the Two Lands, and joined the Reed and Bee. . . . He protected the Two Lands, and brought peace to the Two Regions. . . . He brought Egypt to life and eliminated its needs. . . . He gave life to men and breath to the dead. . . . He fought for its frontier and repelled devastators" (from the Hymn to Sesostris III).

A strong and stable power was also ensured through the Twelfth Dynasty's self-glorification, taking up elements of the magnificent past in both art and architecture; this is most evident with the first pharaohs of the dynasty. In terms of funerary architecture as well, there are strong ties with the layout of the pyramidal complexes of the end of the Sixth Dynasty. The royal necropolis was moved from Thebes

(Eleventh Dynasty) to the north—al-Lisht, Dashur, al-Lahun, Hawara—and the capital was also moved, following the country's political events. Since ancient times, the 'Egyptian Labyrinth' intrigued numerous Greek and Roman writers—Herodotus, Diodorus Siculus, Strabo, Pliny the Elder, and Pomponius Mela—as did other Greek papyruses from Fayum, most of which date back from the second century BC. The Labyrinth has generally been identified as the funerary temple of Amenemhat III at Hawara. "I saw it myself and it is indeed a wonder beyond words; for if one were to gather together all of the buildings of the Greeks and their most striking works of architecture, they would all clearly prove to have cost less labor and money than this labyrinth. . . . The pyramids, too, were greater than words can tell, and each of them is the equivalent of many of the great works of the Greeks; but the labyrinth even surpasses the pyramids" (Herodotus, History, II, 148, 1–3). Some scholars think that this enormous construction may have been intended for the Sed festival, the jubilee celebrating the renewal of royal power. Thus, this suggests intriguing points of contact with Djoser's great complex at Saqqara (Third Dynasty).

The Middle Kingdom died out slowly, over the lifetimes of more than fifty kings from the Thirteenth Dynasty. There was a gradual loss of centralized power—exactly as had occurred at the end of the Old Kingdom—as the country was also threatened by the presence of 'foreigners' in the northern part of the country who arrived and presented themselves as sovereigns. The Second Intermediate Period, which lasted about two centuries, is characterized by the dynasties of the Hyskos (Fifteenth and Sixteenth). This Asian population filtered down from Avaris, their capital in the Delta, and reached the southern city of Thebes, ending Egypt's political and cultural isolation forever.

A series of rooms dedicated to the Middle Kingdom (Eleventh–Twelfth Dynasties) is located on the ground floor of the museum. In the atrium visitors can admire the basalt pyramidion from the pyramid of Amenemhat III at Dashur, and the colossus of Sesostris III, made of pink granite and discovered in the Cachette at Karnak. The itinerary starts with Room 32, which has an elegant limestone pillar of Sesostris I, decorated on all sides. Next is Room 26, with the gray granite statue of Queen Nofret and the black-faced statue of Mentuhotep II. Located in Room 21 is the striking yellow limestone statue of Amenemhat III, and the adjacent Room 22 houses a series of important sculptures of Sesostris I. In Room 16 there is a series of statues of Amenemhat III, notably a double statue of the ruler as well as his sphinx in gray granite, both of which were discovered at Tanis. The itinerary on the ground floor ends at Room 11 with the splendid wooden statue of the Ka of Awibre-Hor at Dashur.

The upper floor is laid out by theme. Room 34 displays everyday items, such as a large ivory pin from Thebes. Room 4 holds the treasures of the princesses of the Twelfth Dynasty and the uraeus of Sesostris II, which was discovered in his pyramid at al-Lahun. Coffins can be seen in Room 21, including Neferi's coffin, while those of Khuy and Senbi are in Room 37. Lastly, Room 48 has the limestone sarcophagi of Ashayt and Kauit from Deir al-Bahari. Rooms 27 and 37, dedicated to funerary furnishings, boast magnificent wooden models of daily life and of army troops. The itinerary ends with the lunette of Room 48, with a group of dancing ivory figurines and a woman's head in gilded wood, both of which discovered by the excavations conducted at al-Lisht by the Metropolitan Museum of Art, New York.

94
JE 46725
OFFERING BEARER
PAINTED WOOD
HEIGHT CM 123
11th Dynasty
(2135-1994 BC)

This statue was found during excavations at Deir al-Bahari conducted by Metropolitan Museum of Art of New York (1919-1920). The object was discovered with many other models in an annex of the tomb of Meketre, a high-ranking official. The notable size of the bearer is surprising, and the figure almost looks like a three-dimensional transposition of material sustenance for the afterlife.

JE 45626

**FUNERARY STELE
OF AMENEMHAT**

PAINTED LIMESTONE
HEIGHT CM 30
WIDTH CM 50
11th Dynasty
(2135-1994 BC)

The scene demonstrates the deceased seated at the offering table, accompanied by family members. The stele is from the necropolis of el-Asasif, where it was discovered during the excavations conducted by the New York Metropolitan Museum of Art (1915-1916).

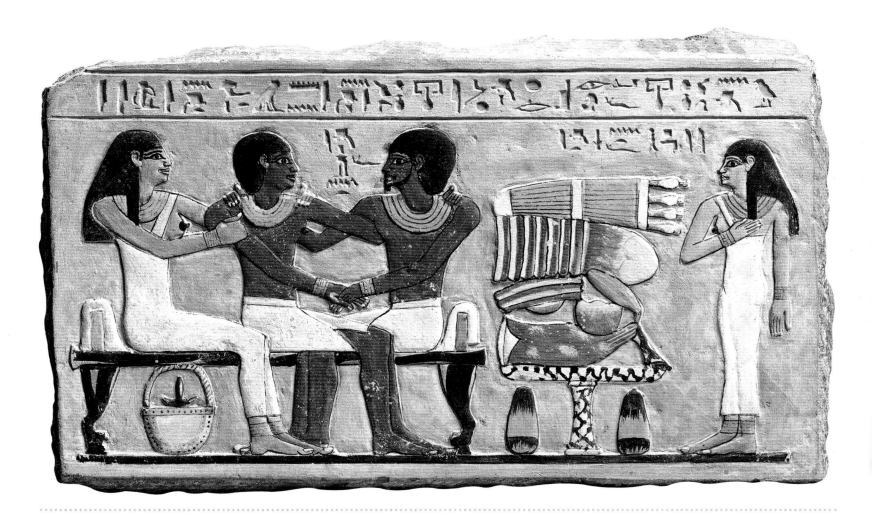

97 JE 362195

**STATUE OF
MENTUHOTEP II**

PAINTED SANDSTONE
HEIGHT CM 138
WIDTH CM 47
11th Dynasty,
reign of Mentuhotep II
(2035-2014 BC)

The pharaoh is wearing the white Jubilee tunic and the red crown, creating a powerful color contrast with his dark skin, an evident reference to Osiris, the god of regeneration. Howard Carter discovered this impressive statue at Deir al-Bahari, in the pharaoh's funerary temple (1900).

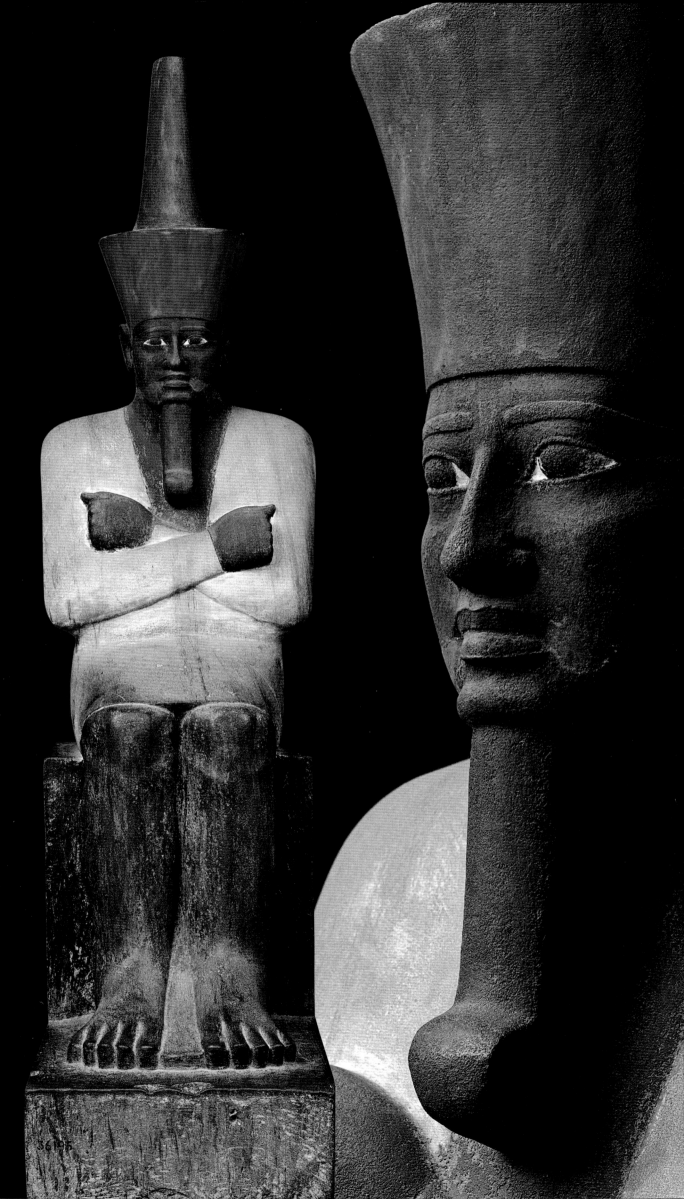

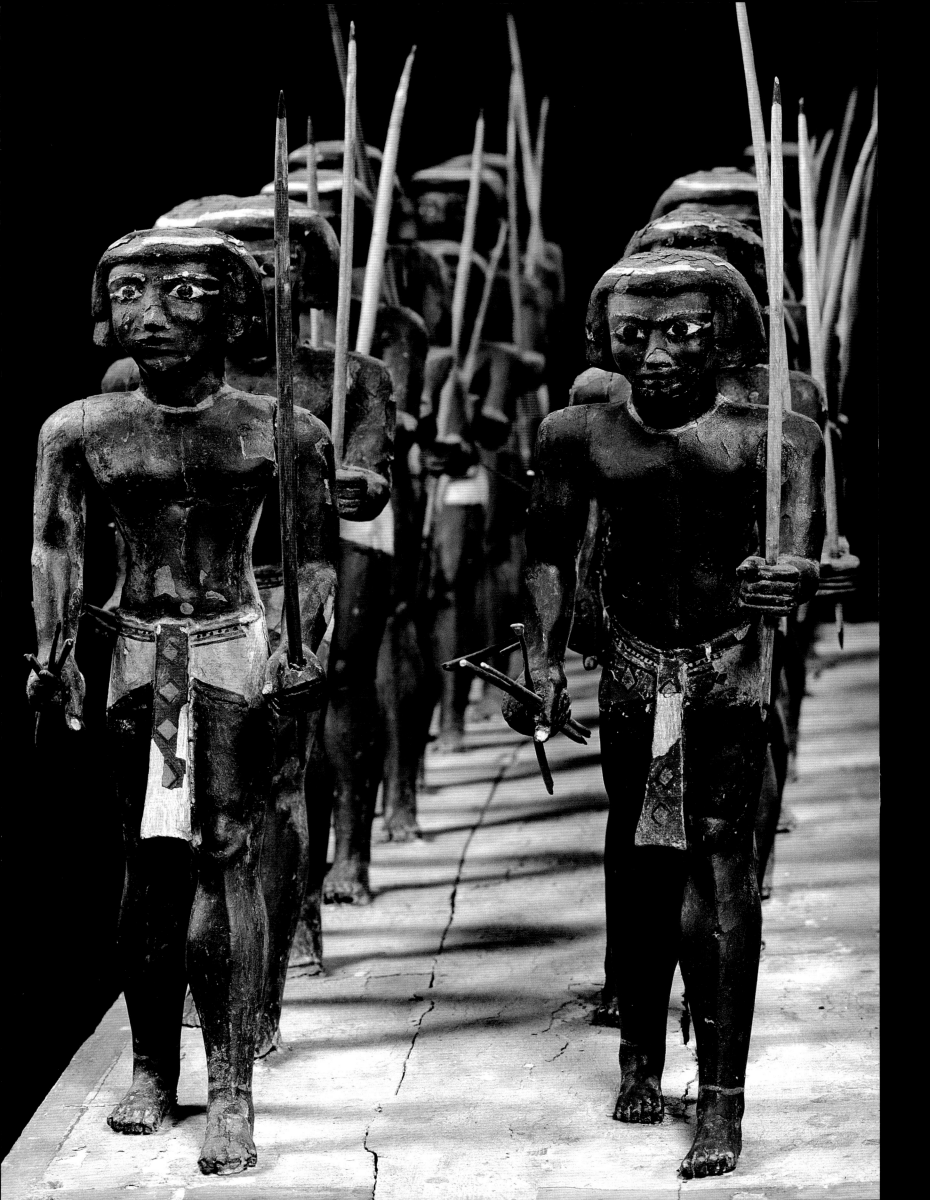



JE 30986 = CG 258

TROOP OF EGYPTIAN SOLDIERS

PAINTED WOOD
HEIGHT CM 59
WIDTH CM 62
LENGTH CM 169.5
11th Dynasty (2135-1994 BC)

Egyptian soldiers, carrying shields and lances, march in four aligned rows. The presence of the army among the various other models indubitably reflects a changed sociopolitical situation. The artifact is from the tomb of Prince Mesehti at Assiut.
This type of sculpture, popular until the end of the Twelfth Dynasty, created perfect three-dimensional reproductions of worldly activities conducted by the deceased or related to his position. They were placed in his tomb to accompany him on his journey to the afterlife.

98 and 99 top
JE 30969 = CG 257

TROOP OF NUBIAN ARCHERS

PAINTED WOOD
HEIGHT CM 55
WIDTH CM 72.3
LENGTH CM 190.2
11th Dynasty
(2135-1994 BC)

This model, found at Assiut, in the tomb of Prince Mesehti, reproduces a group of Nubian archers, wearing colorful thongs, who are perfectly aligned as they march.

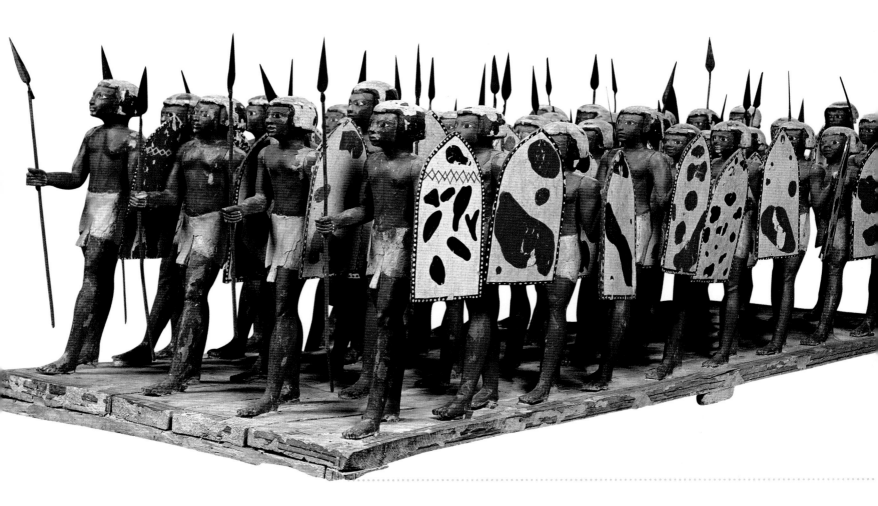

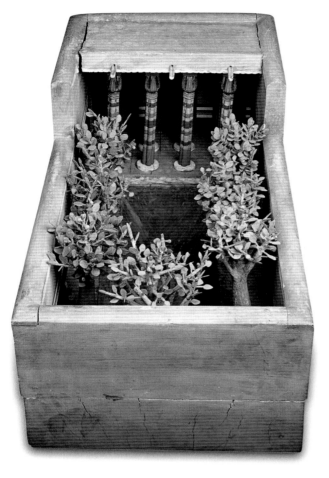

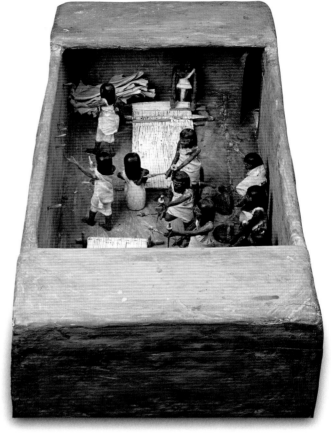

100 top left | JE 46721

MODEL OF HOUSE WITH GARDEN

PAINTED WOOD
HEIGHT CM 43
WIDTH CM 40
LENGTH CM 87
11th Dynasty (2135-1994 BC)

As shown by this model found in the tomb of Meketre during the excavation campaign conducted at Deir al-Bahari by the Metropolitan Museum of Art of New York (1919-1920), the most important part of an Egyptian house was the garden or vegetable patch, sometimes with a small pond, around which the household members would gather.

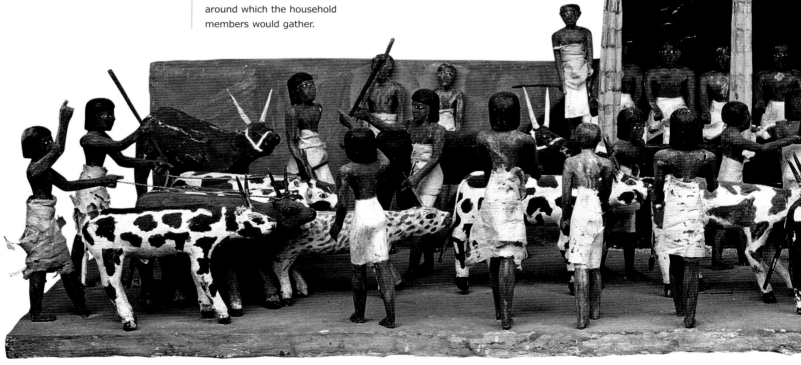

The Middle Kingdom

MODEL OF A WEAVING WORKSHOP

PAINTED WOOD
HEIGHT CM 25
WIDTH CM 42
LENGTH CM 93
11th Dynasty (2135-1994 BC)

Weaving involved several workmanship phases, as shown by the model discovered in Meketre's tomb. A workshop was generally annexed to the houses of the most well-to-do officials, such as the owner of this tomb.

MODEL OF A CARPENTRY WORKSHOP

PAINTED WOOD
HEIGHT CM 26
WIDTH CM 52
LENGTH CM 93
11th Dynasty (2135-1994 BC)

This wooden model, part of the furnishings in Meketre's tomb, documents another important activity, replicating a busy carpentry workshop. The tools of the trade, lined up neatly on a large table, can be recognized.

MODEL OF THE CATTLE COUNT

PAINTED WOOD
HEIGHT CM 55
WIDTH CM 72
LENGTH CM 173
11th Dynasty (2135-1994 BC)

This model is particularly lively. Meketra, the only person seated on a chair, is portrayed under a portico as he reviews his cattle. The scribes who were present had record the event on a papyrus scroll.

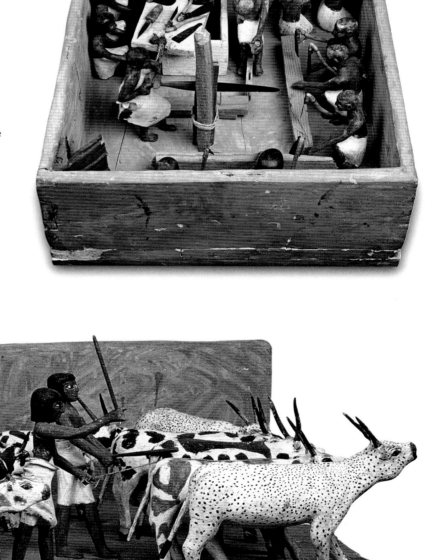

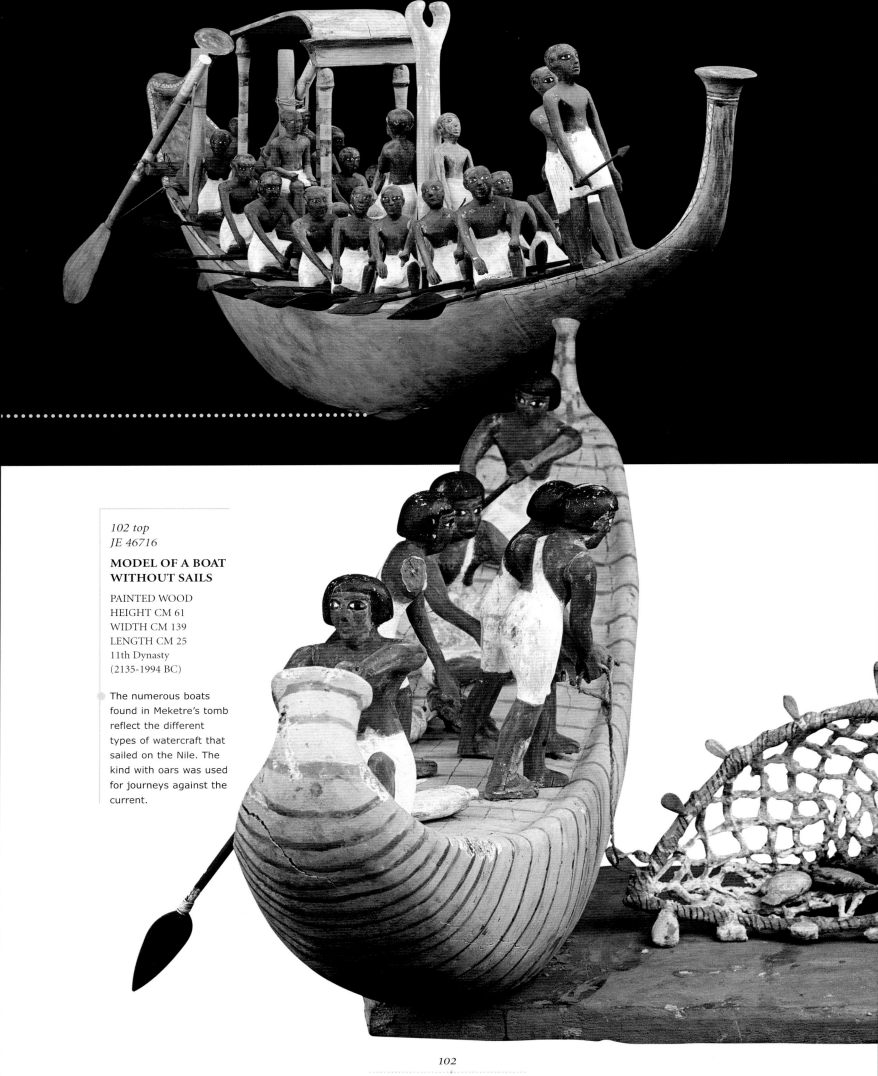

102 top
JE 46716

**MODEL OF A BOAT
WITHOUT SAILS**

PAINTED WOOD
HEIGHT CM 61
WIDTH CM 139
LENGTH CM 25
11th Dynasty
(2135-1994 BC)

The numerous boats
found in Meketre's tomb
reflect the different
types of watercraft that
sailed on the Nile. The
kind with oars was used
for journeys against the
current.

The Middle Kingdom

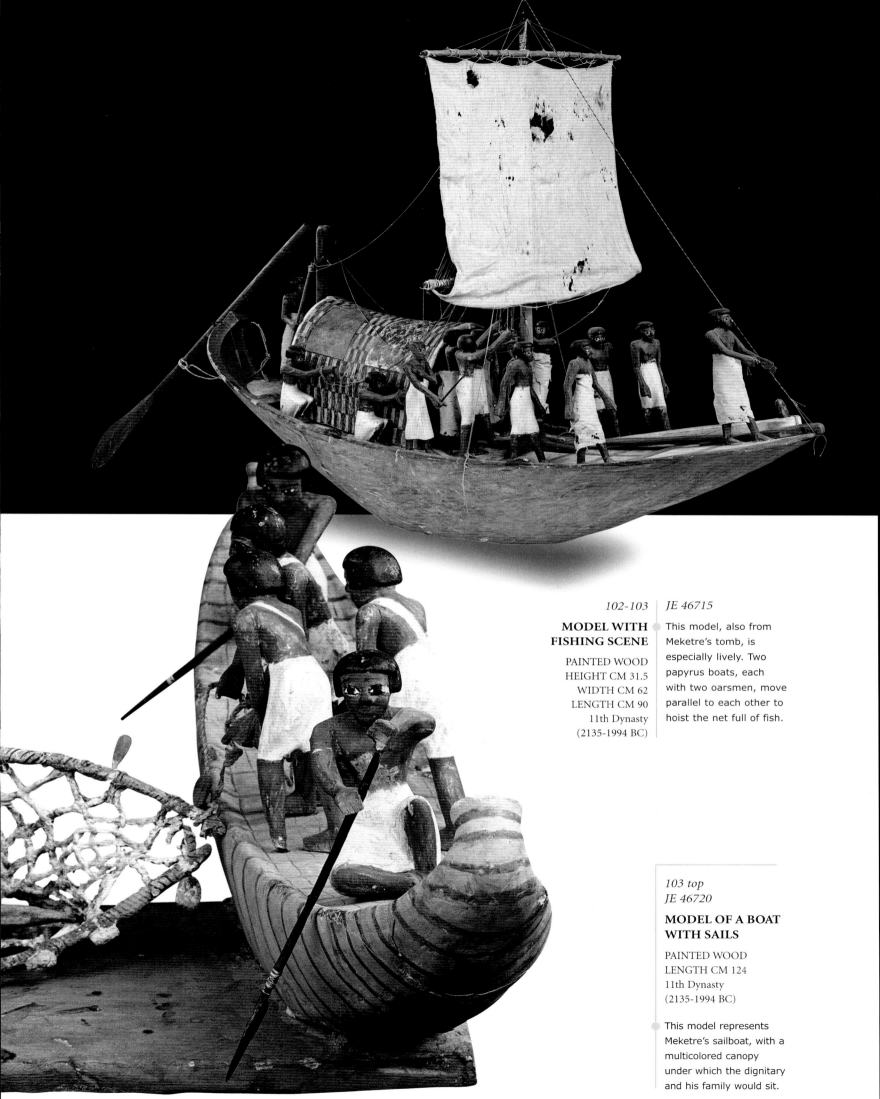

102-103 | JE 46715

MODEL WITH FISHING SCENE

PAINTED WOOD
HEIGHT CM 31.5
WIDTH CM 62
LENGTH CM 90
11th Dynasty
(2135-1994 BC)

This model, also from Meketre's tomb, is especially lively. Two papyrus boats, each with two oarsmen, move parallel to each other to hoist the net full of fish.

103 top
JE 46720

MODEL OF A BOAT WITH SAILS

PAINTED WOOD
LENGTH CM 124
11th Dynasty
(2135-1994 BC)

This model represents Meketre's sailboat, with a multicolored canopy under which the dignitary and his family would sit.

The Middle Kingdom

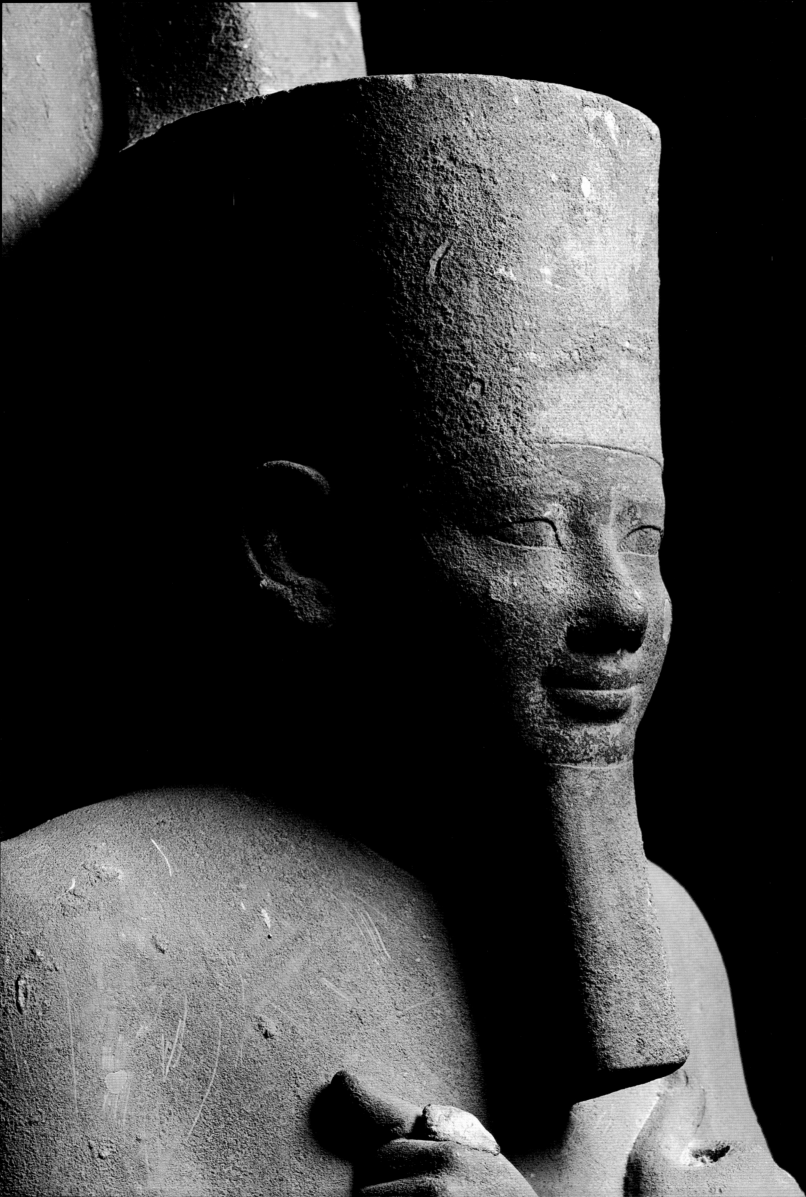

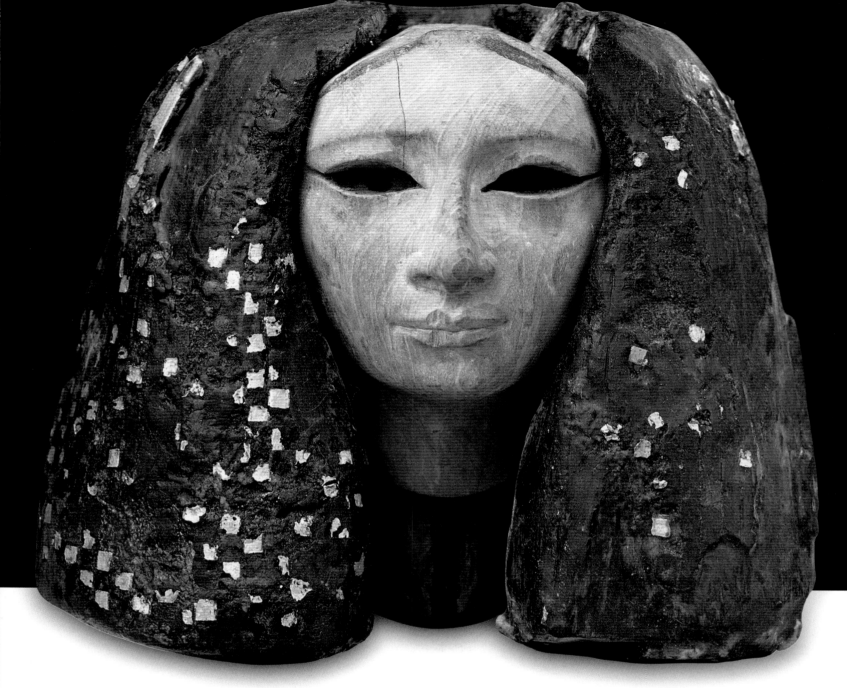

104	JE 36195 = CG 398	105	JE 39390
OSIRIS PILLAR OF SESOSTRIS I	The funerary complex of Sesostris I, at el-Lisht has yielded regal statues with different types of workmanship. This Osiris pillar, in particular, comes from the processional ramp of the pyramid, from which it was removed by J. Gautier (1894-1896).	**WOMAN'S HEAD**	This wooden head, decorated with gold plates, probably came from a statue of a princess. The artifact was found near the Pyramid of Amenemhat I, at el-Lisht, during the excavations conducted by the Metropolitan Museum of Art (1907).
PAINTED LIMESTONE HEIGHT CM 239 12th Dynasty, reign of Sesostris I (1964-1929 BC)		PAINTED WOOD WITH GILDING HEIGHT CM 10.5 12th Dynasty, reign of Amenemhat I (1994-1964 BC)	

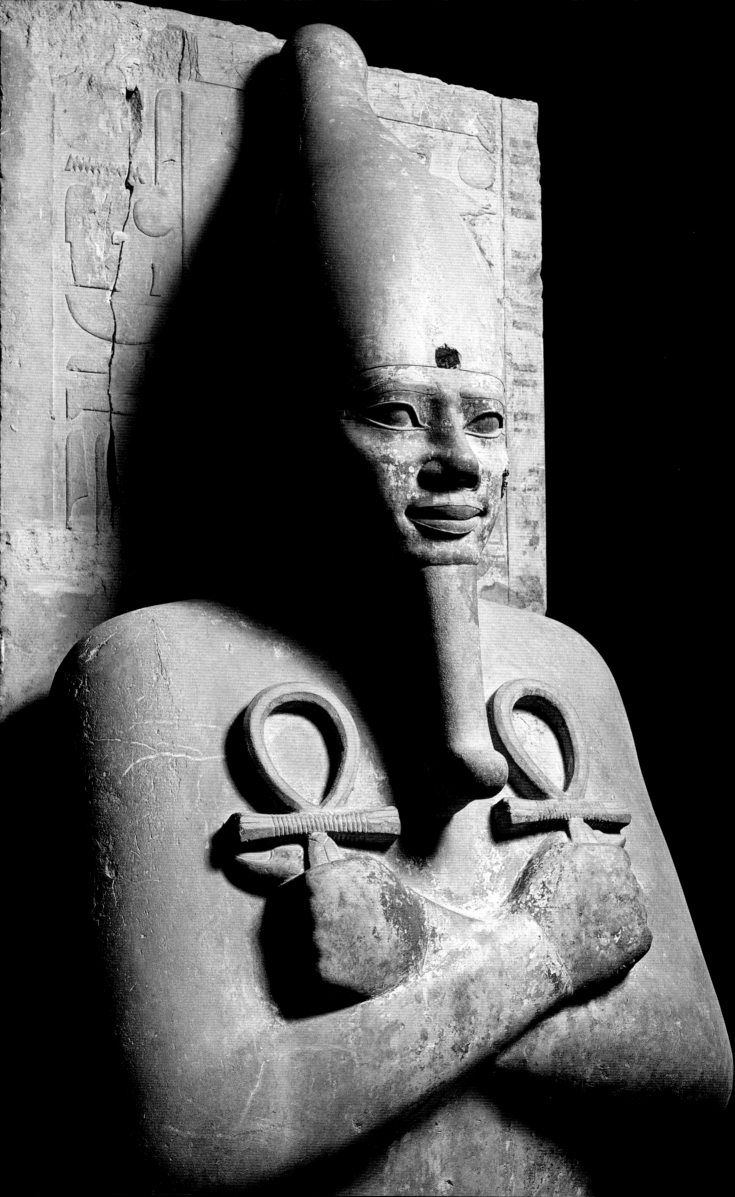

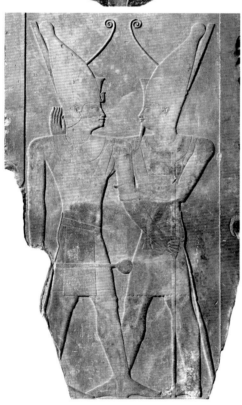

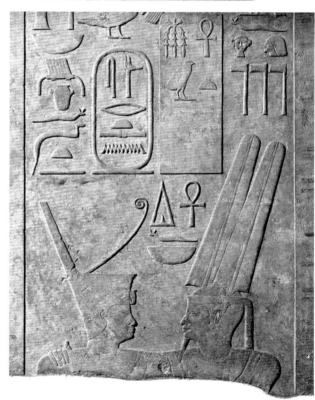

106 | JE 48851

**OSIRIS PILLAR OF
SESOSTRIS I**

PAINTED LIMESTONE
HEIGHT CM 470
12TH DYNASTY, REIGN OF
SESOSTRIS I
(1964-1929 BC)

The highly expressive
face on this Osiris pillar,
from the temple at
Karnak, emphasizes the
pharaoh's majesty. The
two large ankh symbols,
held in his hand, extend
from the tight-fitting
garment and lend force
to the figure.

107 | JE 36809

**OSIRIS PILLAR OF
SESOSTRIS I**

PAINTED LIMESTONE
HEIGHT CM 434
WIDTH CM 95
12TH DYNASTY, REIGN OF
SESOSTRIS I
(1964-1929 BC)

The god-like pharaoh is
portrayed next to four
deities. As revealed by
this pillar, discovered by
G. Legrain in the
courtyard of the cache of
the Temple of Amun-Ra at
Karnak (1903-1904), the
elegance of relief work
reached an extremely high
level under Sesostris I.

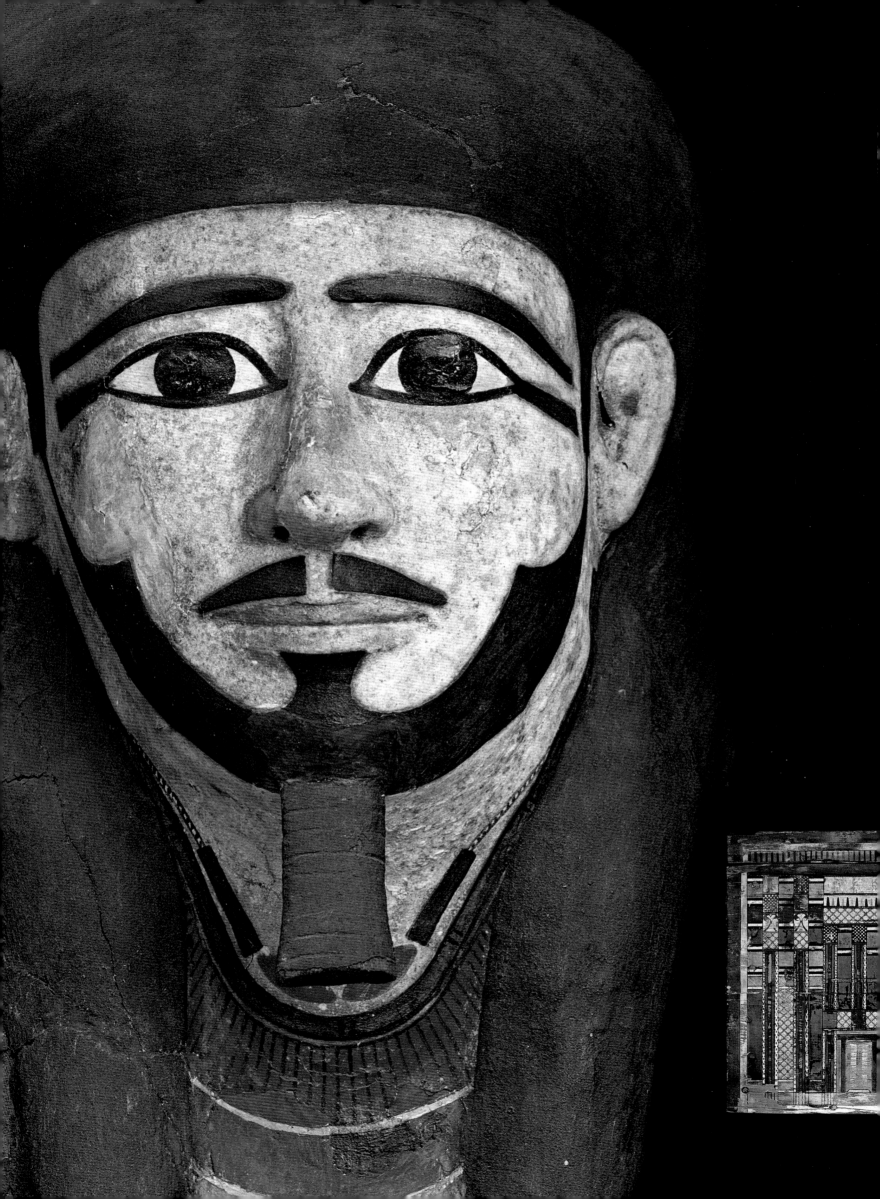

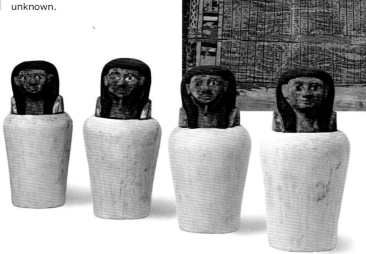

108
TR 7.9.33.1

BURIAL MASK

GESSOED AND
PAINTED LINEN
HEIGHT CM 50
Middle Kingdom
(1994-1650 BC)

The purpose of the
burial mask, which was
placed on the embalmed
body, was to protect the
face of the deceased,
replicating its features to
preserve them forever.
The provenance of the
artifact shown here is
unknown.

109 top
JE 32868 = CG 28083

SARCOPHAGUS
OF SEPI

PAINTED WOOD
HEIGHT CM 70
WIDTH CM 65
LENGTH CM 233
12th Dynasty
(1994-1781 BC)

The sarcophagus of
General Sepi is from his
tomb at Deir el-Bersha,
and it was discovered
during the excavation
work conducted by the
Antiquities Service (1897).
The lower portion of the
interior reproduces the
Book of the Two Ways, an
important funerary text
that describes the
afterlife, thus helping the
deceased overcome its
threats and dangers.

109 center
CANOPIC JARS OF
INEPUHOTEP

LIMESTONE AND
PAINTED WOOD
HEIGHT CM 34
Diameter CM 11
Early 12th Dynasty
(20th century BC)

JE 46774

The limestone creates a
lovely contrast with the
painted lids on these
canopic jars, discovered
during the excavation work
conducted by the Antiquities
Service at the North
Necropolis of the Pyramid of
Teti at Saqqara (1914).

109 bottom
SARCOPHAGUS OF SENBI

PAINTED WOOD
LENGTH CM 212
12th Dynasty
(1994-1781 BC)

JE 42948

The polychrome work on
this sarcophagus,
discovered by A. Kamal in
the tomb of the nomarch
Senbi at Meir (1910),
evokes the vivacity of the
mats that were used to
decorate the walls of
buildings.

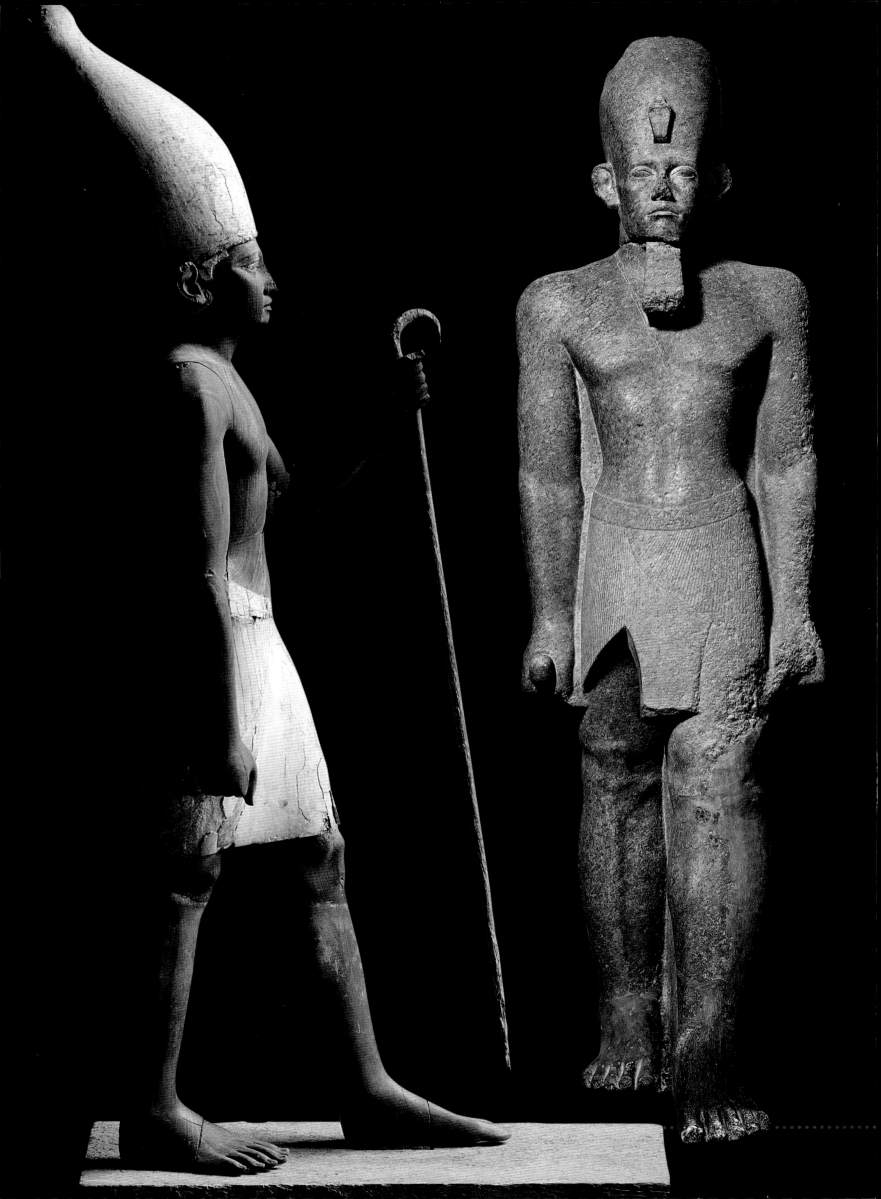

|

STATUETTE OF SESOSTRIS I

GESSOED AND PAINTED CEDAR
HEIGHT CM 56
WIDTH CM 11
12th Dynasty, reign of Sesostris I or of
Amenemhat II (1964-1898 BC)

This elegant royal figure has a somewhat static air. His eyes look downward, following his feet. The sculpture was found near the Pyramid of Sesostris I, at el-Lisht, during the excavations conducted by the New York Metropolitan Museum of Art (1915).

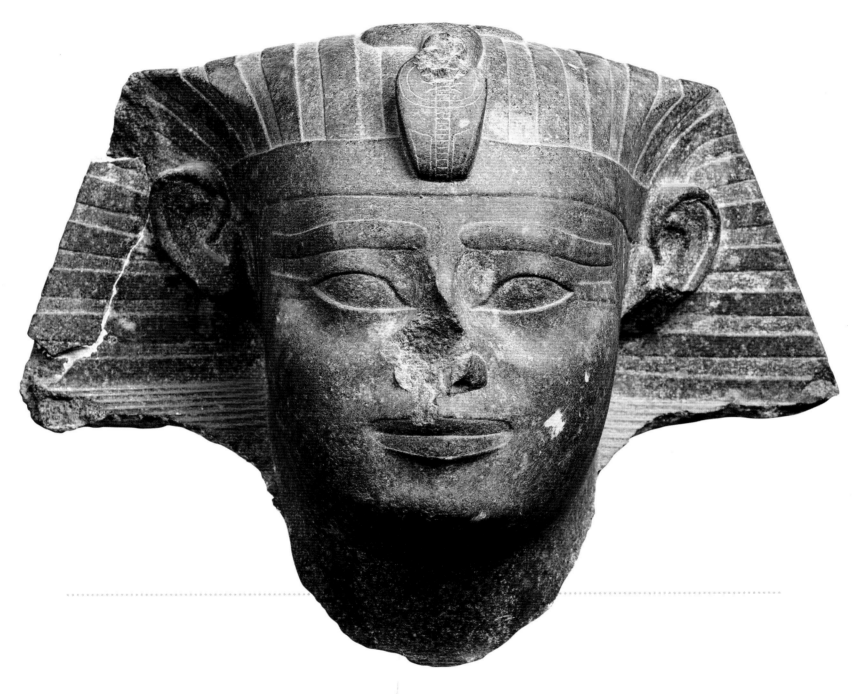

110 right | CG 42011

STATUE OF SESOSTRIS III

PINK GRANITE
HEIGHT CM 315
WIDTH CM 6.7
12th Dynasty,
reign of Sesostris III
(1881-1842 BC)

The composure and majesty of this colossus, discovered by G. Legrain in the courtyard of the cache at Karnak (1900 and 1903), perfectly conveys the qualities of a capable ruler like Sesostris III.

111 | JE 45489 = CG 42007

SPHINX HEAD OF SESOSTRIS I

GRAY GRANITE
HEIGHT CM 38
12th Dynasty,
reign of Sesostris I
(1964-1929 BC)

The slant of the eyes and the hint of a smile bring to life this splendid portrait of Sesostris I, expertly carved in hard granite. The sphinx body is missing. G. Legrain discovered the head in the cache at Karnak (1904).

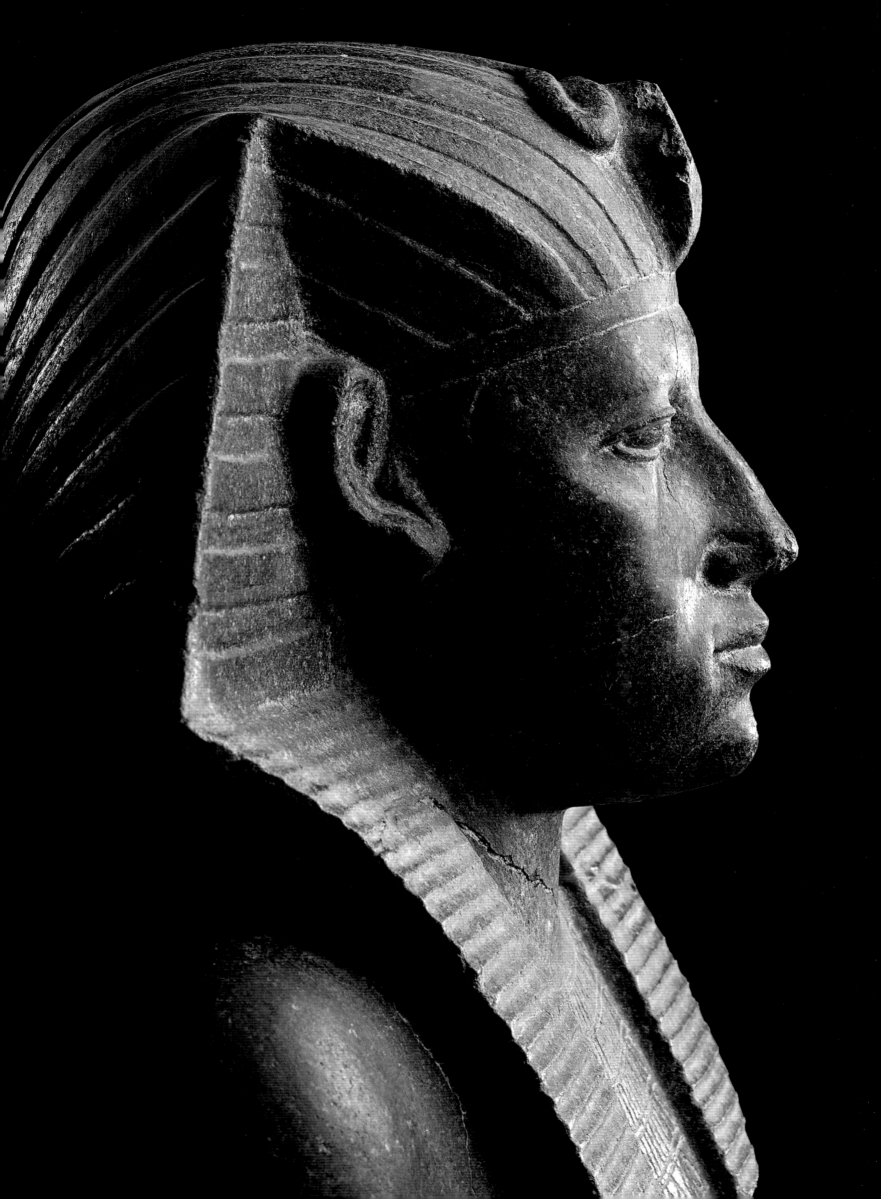

112 | *SR 3-9575 = CG 42015*

STATUE OF AMENEMHAT III

BLACK GRANITE
HEIGHT CM 73
12th Dynasty, reign of Amenemhat III
(1842-1794 BC)

The aquiline nose and the strong-willed curl of the lips powerfully characterize the face of this statue of Amenemhat III, one of the many treasures Legrain discovered in the courtyard of the cache at Karnak (1904).

113 top | *JE 37487 = CG 381*

**STATUE OF
QUEEN NOFRET**

BLACK GRANITE
HEIGHT CM 165
WIDTH CM 51
12th Dynasty, reign of Sesostris II
(1900-1881 BC)

This statue, found at Tanis by A. Mariette (1860-1861), was put together from two fragments discovered at different times. The queen is seated sedately on the throne, and is wearing a large wig with a uraeus.

113 bottom | *JE 35122*

**PYRAMIDION FROM THE
PYRAMID OF
AMENEMHAT III**

BASALT
HEIGHT CM 140
WIDTH AT THE BASE CM 185
12th Dynasty, reign of Amenemhat III
(1842-1794 BC)

The basalt of the cusp created a contrast with the white limestone cladding the pharaoh's pyramid at Dahshur. The pyramidion was decorated with elegant hieroglyphs carved on all sides, topped by two large eyes on the east side.

114-115
JE 30948 = CG 259

**STATUE OF
THE KA OF
AWIBRA HOR**

WOOD, GOLD LEAF,
AND GEMSTONES
HEIGHTS: STATUE CM
170; NAOS CM 207
13th Dynasty, reign of
Awibra Hor (18th – first
half of the
17th century BC)

Hor Awibra, with two arms symbolizing the ka on his head, rises from the naos. Dahshur, excavation campaign of J. De Morgan (1894).

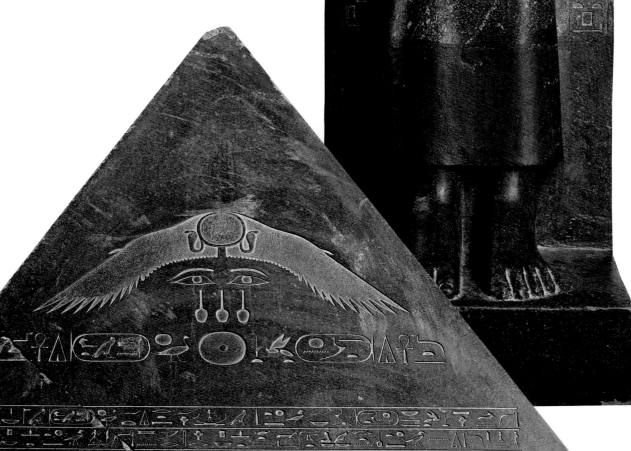

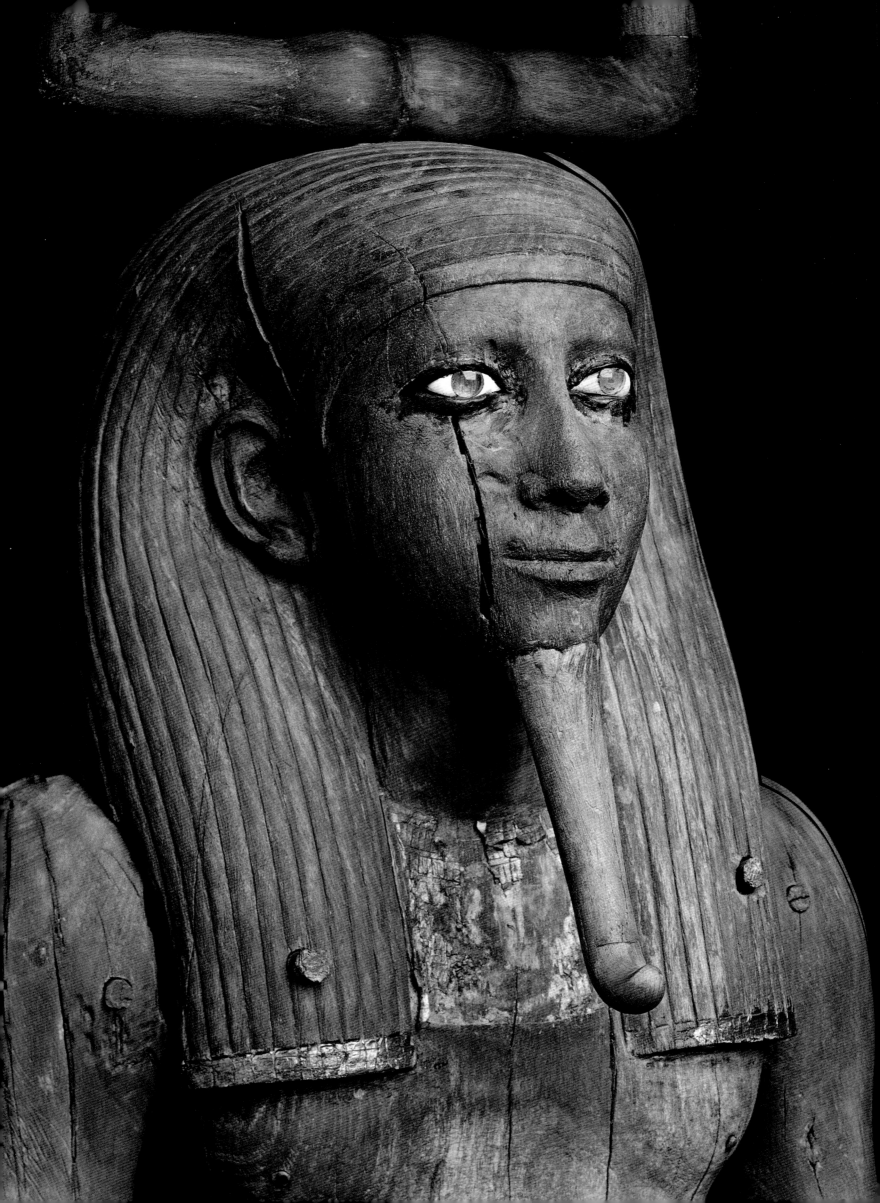

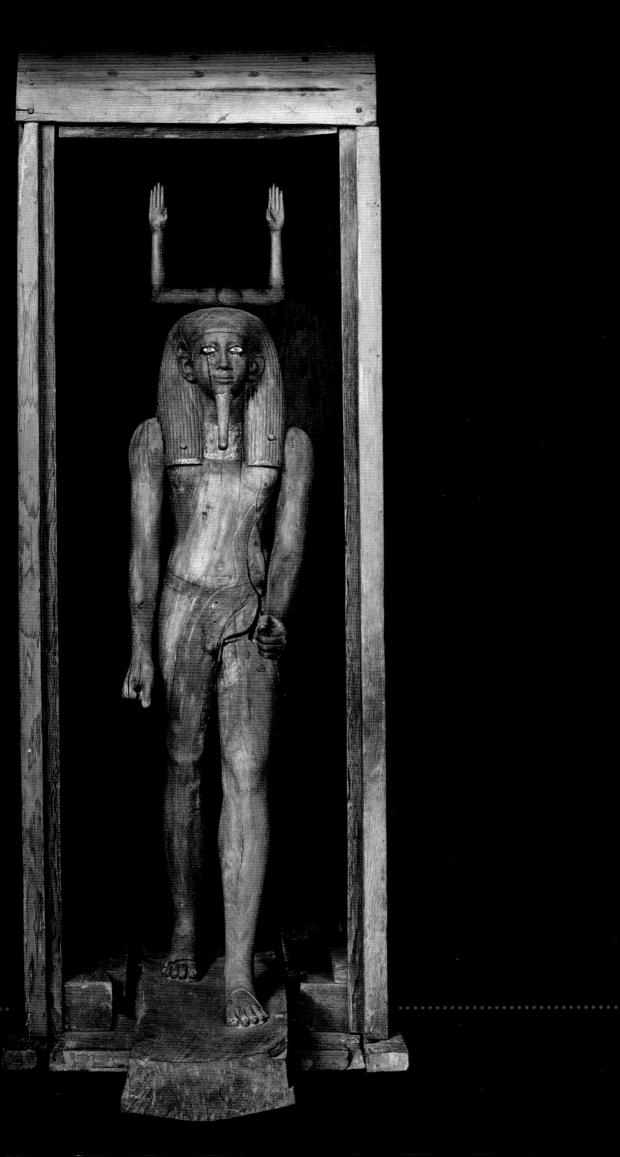

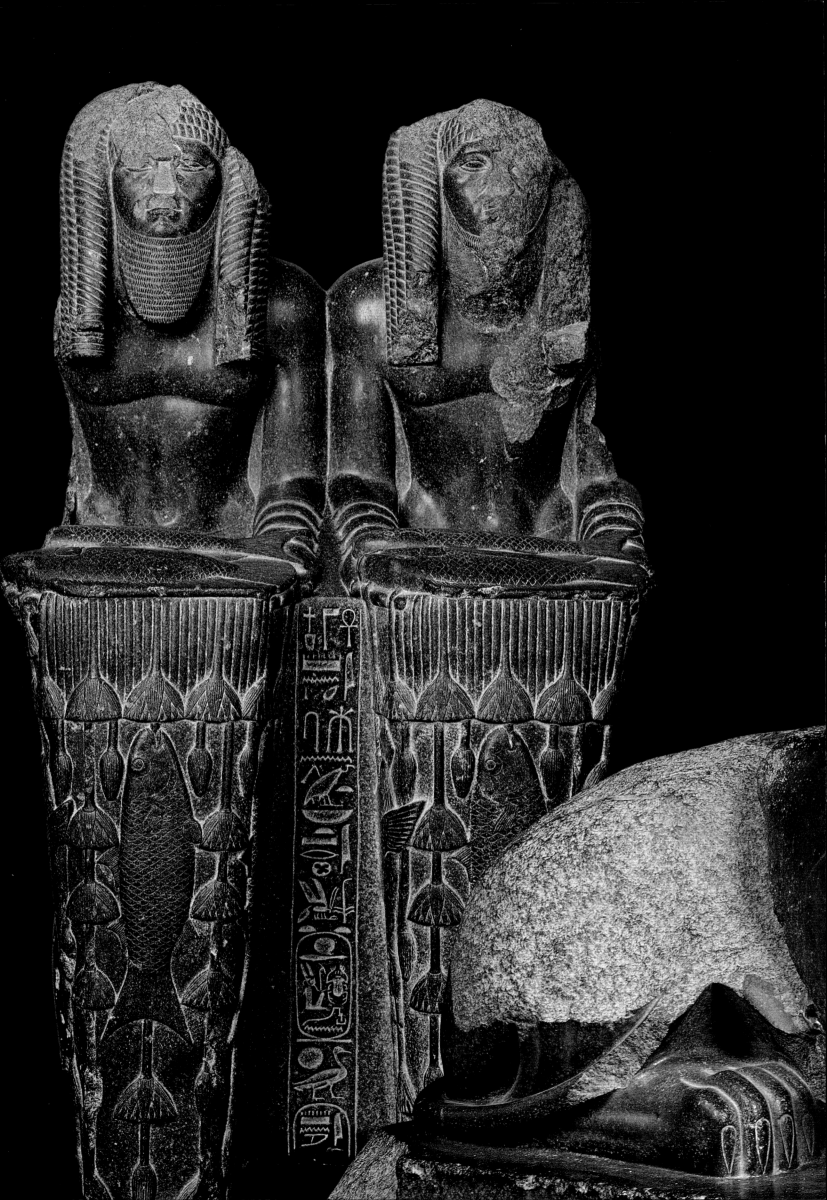

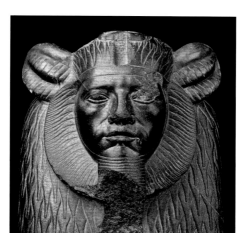

117 | JE 15210 = CG 394

**SPHINX OF
AMENEMHAT III**

BLACK GRANITE
HEIGHT CM 150
LENGTH CM 236
12th Dynasty, reign of
Amenemhat III
(1842-1794 BC)

This statue is part of a
series of maned
sphinxes of
Amenemhat III, which
were stolen during the
Hyksos period, the
19th and 21st
Dynasties, and
transported to Tanis to
be reused. It was
unearthed by Auguste
Mariette (1863).

116
JE 18221 = CG 392

**DOUBLE STATUE OF
AMENEMHAT III**

GRAY GRANITE
HEIGHT CM 160
WIDTH CM 100
DEPTH CM 80
12th Dynasty, reign of
Amenemhat III
(1842-1794 BC)

Found by P. Montet at
Tanis (1861), this double
statue portrays Amenemhat
III as a Nile deity,
offering trays of fish
and aquatic plants.

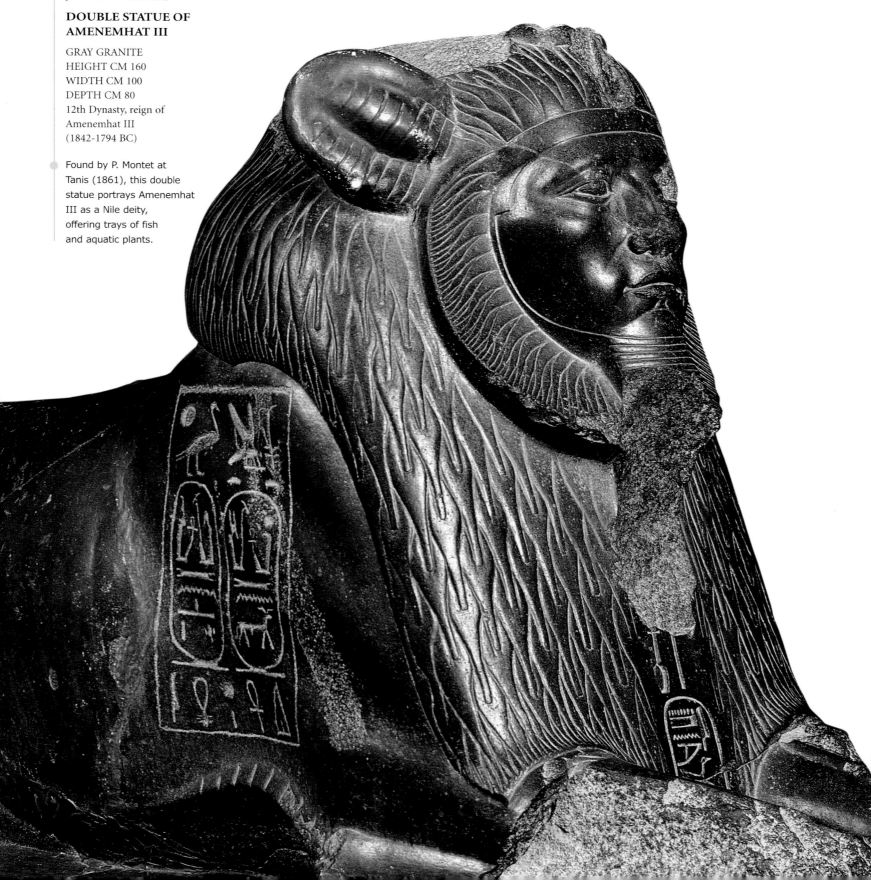

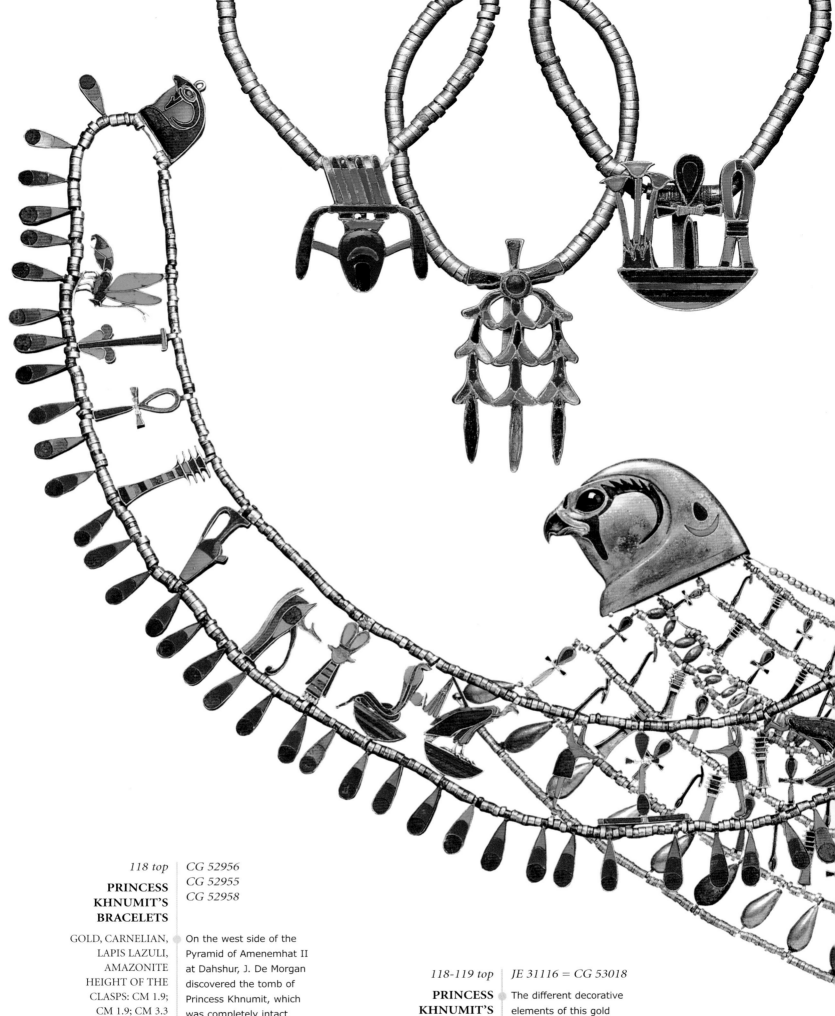

118 top | CG 52956
PRINCESS KHNUMIT'S BRACELETS | CG 52955
CG 52958

GOLD, CARNELIAN, LAPIS LAZULI, AMAZONITE HEIGHT OF THE CLASPS: CM 1.9; CM 1.9; CM 3.3 Dahshur, 12th Dynasty, reign of Amenemhat III (1929-1898 BC) | On the west side of the Pyramid of Amenemhat II at Dahshur, J. De Morgan discovered the tomb of Princess Khnumit, which was completely intact (1894). Many magnificent jewels were found, including these three exquisitely decorated gold bracelets with different charms.

118-119 top | JE 31116 = CG 53018
PRINCESS KHNUMIT'S NECKLACE | The different decorative elements of this gold necklace, found in pieces on Khnumit's mummy, represents a sequence of several important good-luck symbols.

GOLD, CARNELIAN, TURQUOISE, LAPIS LAZULI LENGTH CM 35

The Middle Kingdom

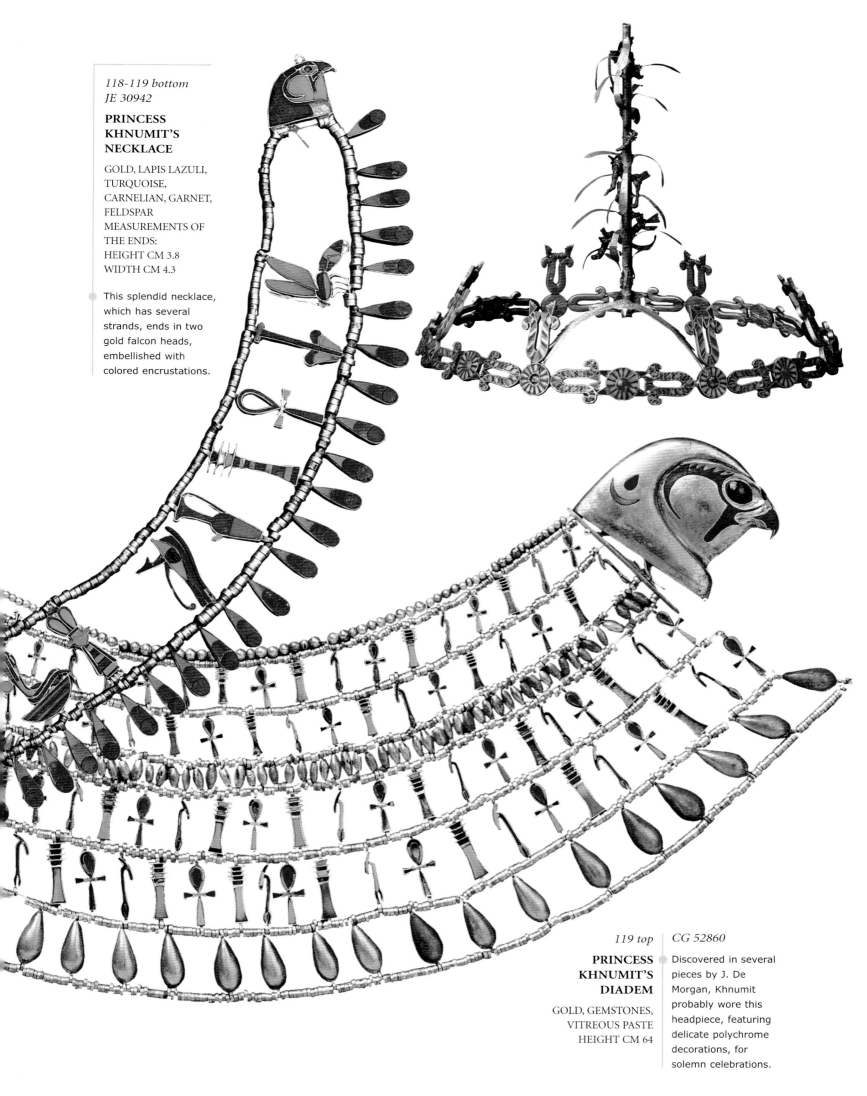

118-119 bottom
JE 30942

**PRINCESS
KHNUMIT'S
NECKLACE**

GOLD, LAPIS LAZULI,
TURQUOISE,
CARNELIAN, GARNET,
FELDSPAR
MEASUREMENTS OF
THE ENDS:
HEIGHT CM 3.8
WIDTH CM 4.3

This splendid necklace,
which has several
strands, ends in two
gold falcon heads,
embellished with
colored encrustations.

119 top

CG 52860

**PRINCESS
KHNUMIT'S
DIADEM**

GOLD, GEMSTONES,
VITREOUS PASTE
HEIGHT CM 64

Discovered in several
pieces by J. De
Morgan, Khnumit
probably wore this
headpiece, featuring
delicate polychrome
decorations, for
solemn celebrations.

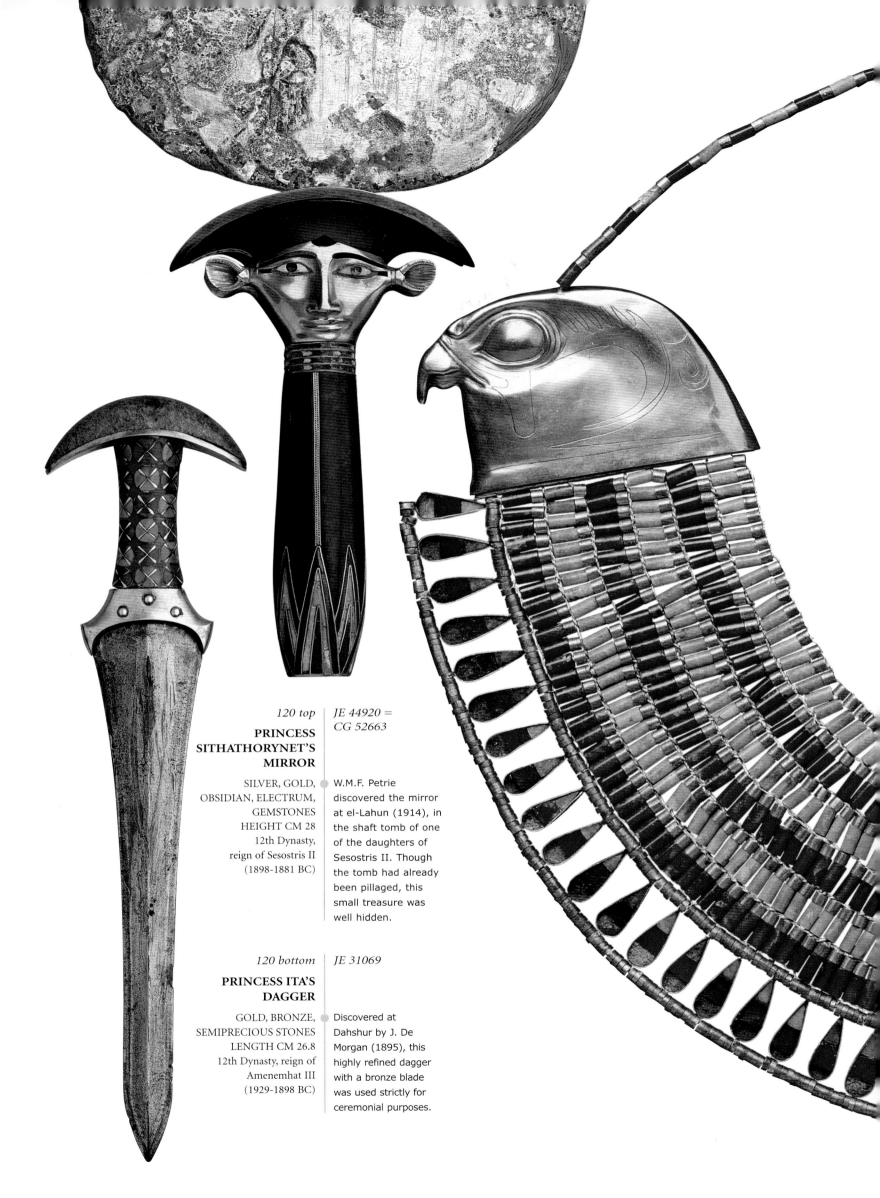

120 top | JE 44920 =
CG 52663

**PRINCESS
SITHATHORYNET'S
MIRROR**

SILVER, GOLD,
OBSIDIAN, ELECTRUM,
GEMSTONES
HEIGHT CM 28
12th Dynasty,
reign of Sesostris II
(1898-1881 BC)

W.M.F. Petrie
discovered the mirror
at el-Lahun (1914), in
the shaft tomb of one
of the daughters of
Sesostris II. Though
the tomb had already
been pillaged, this
small treasure was
well hidden.

120 bottom | JE 31069

**PRINCESS ITA'S
DAGGER**

GOLD, BRONZE,
SEMIPRECIOUS STONES
LENGTH CM 26.8
12th Dynasty, reign of
Amenemhat III
(1929-1898 BC)

Discovered at
Dahshur by J. De
Morgan (1895), this
highly refined dagger
with a bronze blade
was used strictly for
ceremonial purposes.

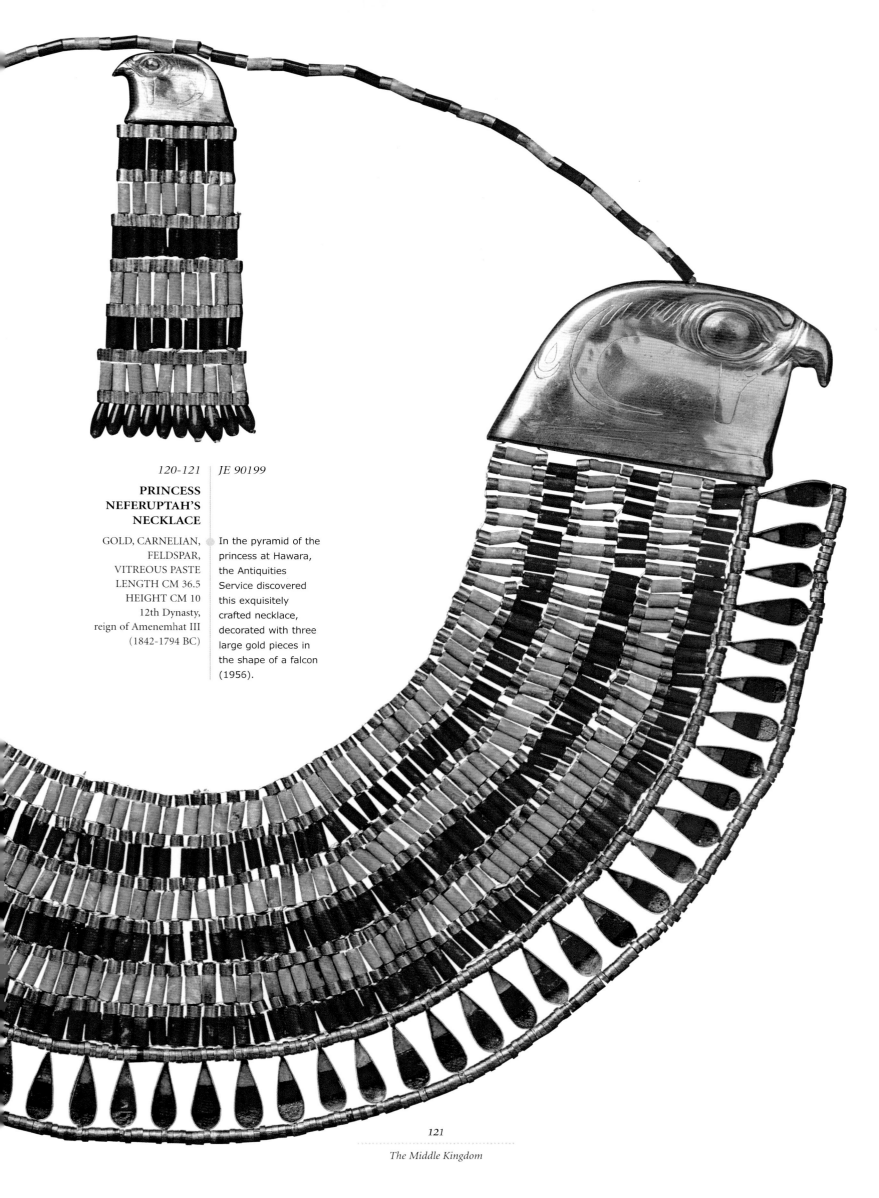

120-121 | JE 90199

**PRINCESS
NEFERUPTAH'S
NECKLACE**

GOLD, CARNELIAN,
FELDSPAR,
VITREOUS PASTE
LENGTH CM 36.5
HEIGHT CM 10
12th Dynasty,
reign of Amenemhat III
(1842-1794 BC)

In the pyramid of the
princess at Hawara,
the Antiquities
Service discovered
this exquisitely
crafted necklace,
decorated with three
large gold pieces in
the shape of a falcon
(1956).

121

The Middle Kingdom

122 top
JE 53070

MERERET'S PENDANT

GOLD AND SEMIPRECIOUS STONES
HEIGHT CM 4.6
12th Dynasty,
reign of Sesostris III
and of Amenemhat III
(1881-1794 BC)

Pillaged in ancient times, the tomb of Princess Mereret at Dahshur nevertheless yielded this pendant and other jewels concealed under the floor of the funerary chamber and discovered by J. De Morgan (1894).

122 center | *JE 46694 = CG 52702*

URAEUS OF SESOSTRIS II

GOLD AND SEMIPRECIOUS STONES
HEIGHT CM 6.7
12th Dynasty, reign of Sesostris II (1898-1881 BC)

W.M.F. Petrie discovered this splendid cobra at el-Lahun (1920), amidst the rubble in a room of the Pyramid of Sesostris II.

122 bottom | *JE 98785A, B (BRACELET);*
JE 98784A, B (ANKLE BRACELET)

BRACELET AND ANKLE BRACELET OF WERET II

GOLD AND SEMIPRECIOUS STONES
LENGTH AND HEIGHT OF THE BRACELET: CM 15.5; CM 4
ANKLE BRACELET: CM 21.5; CM 3.8
12th Dynasty, reign of Amenemhat II
and of Sesostris III
(late 20th–early 19th century BC)

The jewelry belonging to the wife of Sesostris III was found walled up in a pillaged tomb at Dahshur during the excavations conducted by the Metropolitan Museum of Art (1994-1995).

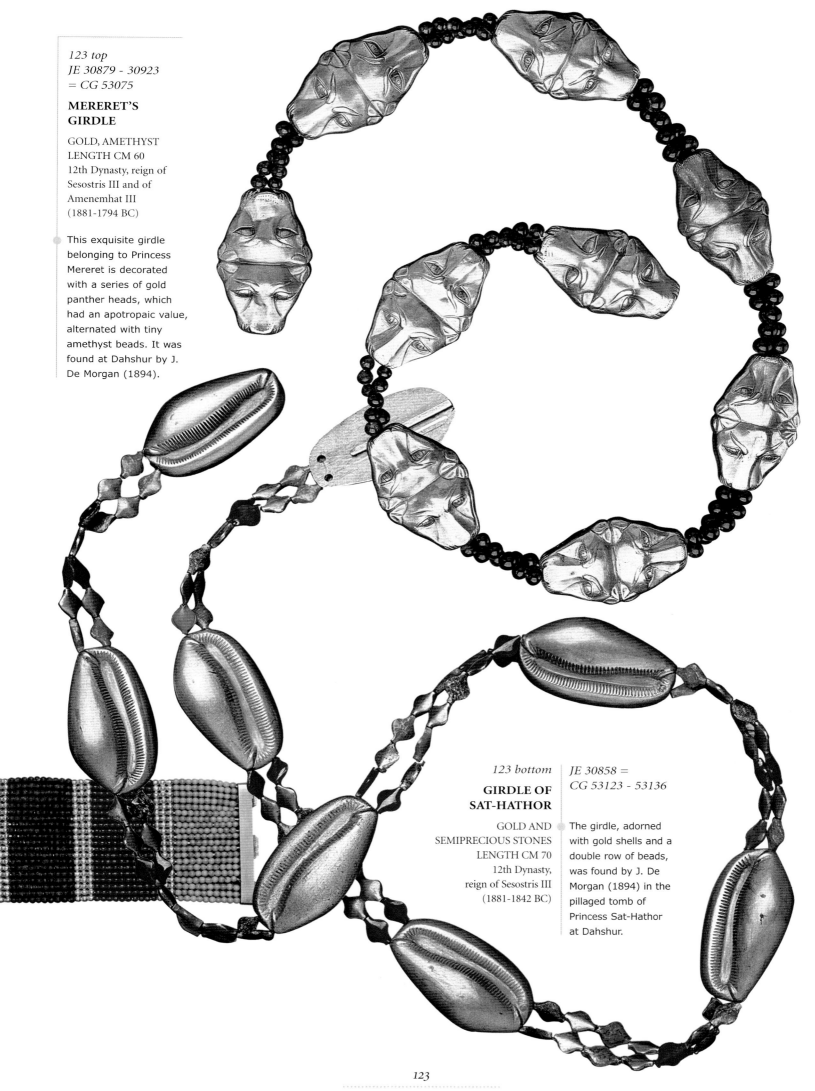

123 top
JE 30879 - 30923
= CG 53075

MERERET'S GIRDLE

GOLD, AMETHYST
LENGTH CM 60
12th Dynasty, reign of
Sesostris III and of
Amenemhat III
(1881-1794 BC)

This exquisite girdle
belonging to Princess
Mereret is decorated
with a series of gold
panther heads, which
had an apotropaic value,
alternated with tiny
amethyst beads. It was
found at Dahshur by J.
De Morgan (1894).

123 bottom

**GIRDLE OF
SAT-HATHOR**

GOLD AND
SEMIPRECIOUS STONES
LENGTH CM 70
12th Dynasty,
reign of Sesostris III
(1881-1842 BC)

JE 30858 =
CG 53123 - 53136

The girdle, adorned
with gold shells and a
double row of beads,
was found by J. De
Morgan (1894) in the
pillaged tomb of
Princess Sat-Hathor
at Dahshur.

124 top and 125	*JE 30875 = CG 52003*
PECTORAL WITH DEDICATION TO AMENEMHAT III	J. De Morgan's excavation of Mereret's tomb at Dahshur (1894) unearthed this elaborate pectoral with the typical scene of the vanquished enemy kneeling before the pharaoh, "Lord of the Two Lands and of all Foreign Lands," as he brandishes a club.
HEIGHT CM 7.9 WIDTH CM 10.5 12th Dynasty, reign of Amenemhat III (1842-1794 BC)	

124 bottom	*JE 31091*
KHNUMIT'S BRACELET CLASPS	The artifacts, which reproduce the protective sa symbols and panther heads, were discovered in Khnumit's tomb at Dahshur when it was excavated by J. De Morgan (1894).
HEIGHT CM 3.9 12th Dynasty, reign of Amenemhat III (1929-1898 BC)	

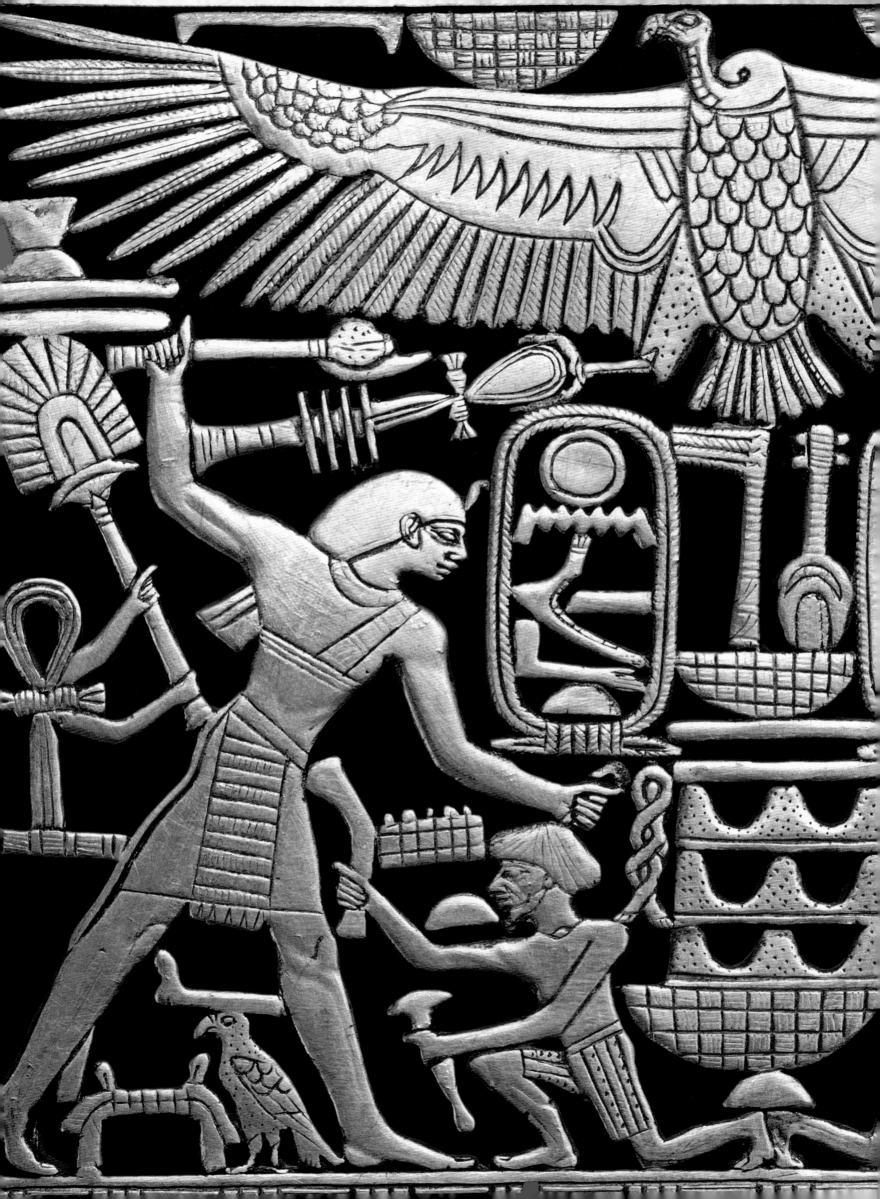

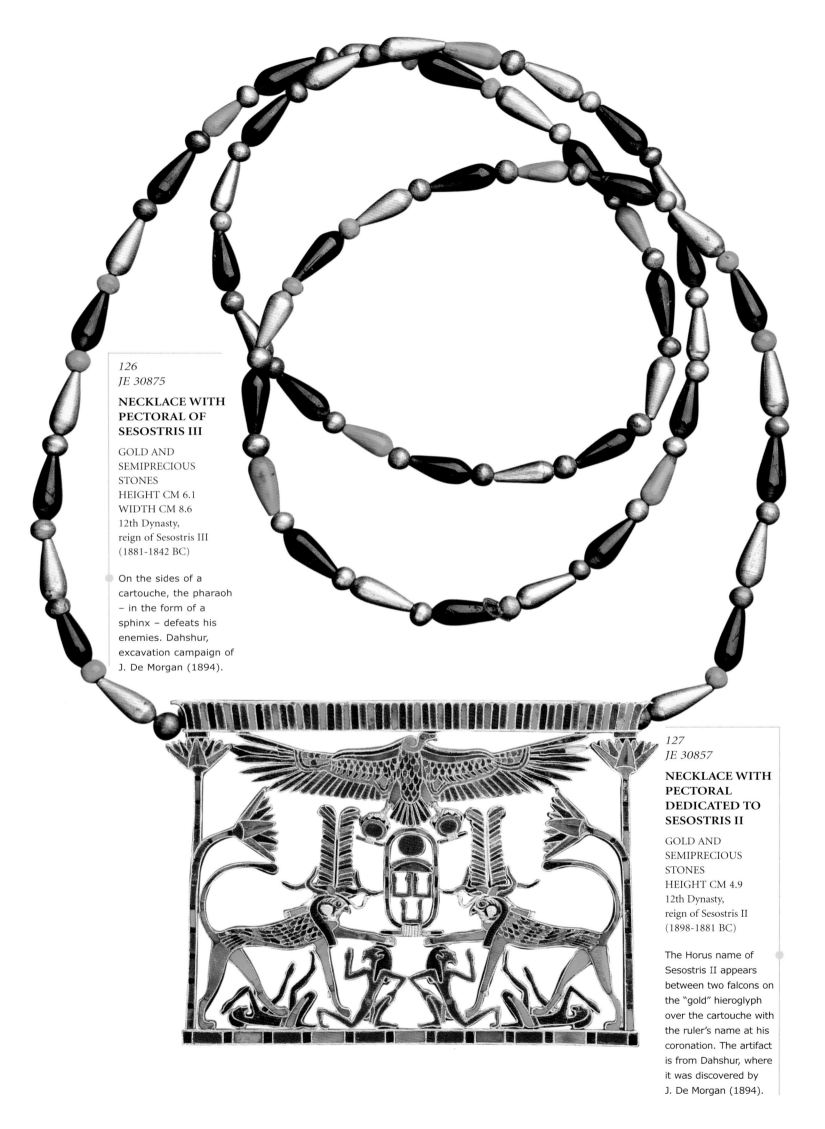

126
JE 30875

**NECKLACE WITH
PECTORAL OF
SESOSTRIS III**

GOLD AND
SEMIPRECIOUS
STONES
HEIGHT CM 6.1
WIDTH CM 8.6
12th Dynasty,
reign of Sesostris III
(1881-1842 BC)

On the sides of a
cartouche, the pharaoh
– in the form of a
sphinx – defeats his
enemies. Dahshur,
excavation campaign of
J. De Morgan (1894).

127
JE 30857

**NECKLACE WITH
PECTORAL
DEDICATED TO
SESOSTRIS II**

GOLD AND
SEMIPRECIOUS
STONES
HEIGHT CM 4.9
12th Dynasty,
reign of Sesostris II
(1898-1881 BC)

The Horus name of
Sesostris II appears
between two falcons on
the "gold" hieroglyph
over the cartouche with
the ruler's name at his
coronation. The artifact
is from Dahshur, where
it was discovered by
J. De Morgan (1894).

The Middle Kingdom

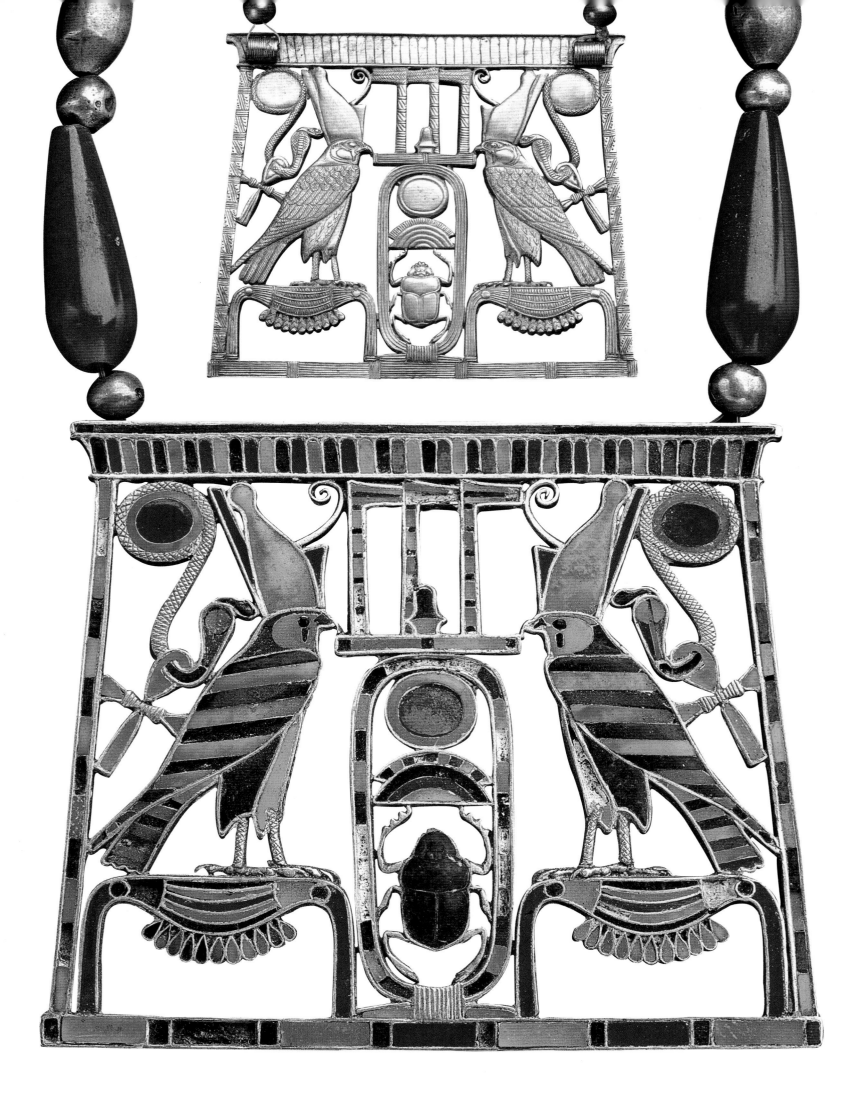

The Middle Kingdom

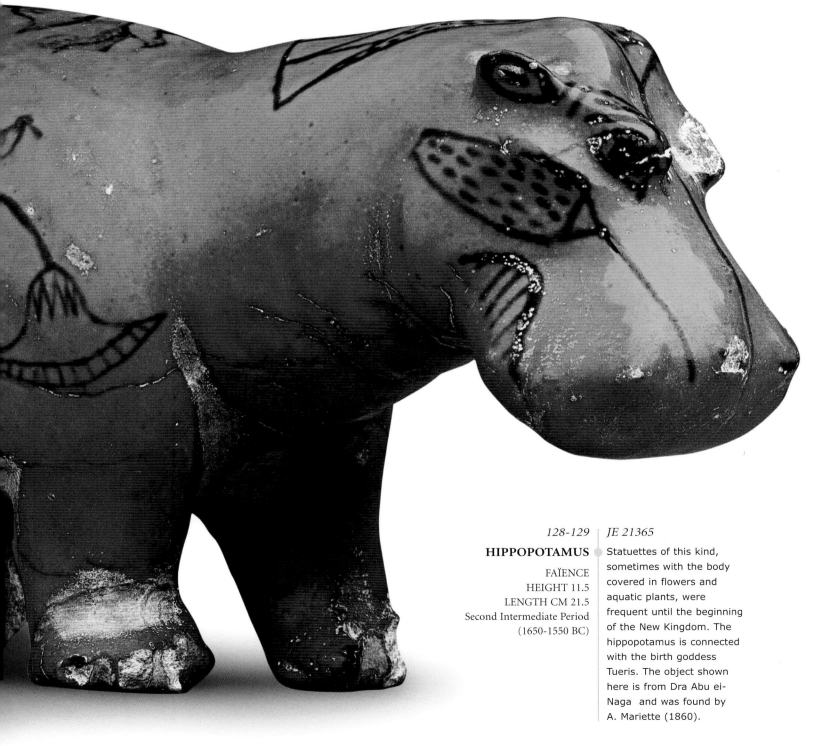

**"CONCUBINE"
OF THE DECEASED**

FAÏENCE
HEIGHT CM 13
11th Dynasty,
reign of Mentuhotep II
(2065-2014 BC)

This type of female statuette is often linked with funerary settings. The artifact shown here was found near the Theban necropolis during the excavations conducted by the Metropolitan Museum of Art (1922-1923). The lack of end portion with the legs suggests that the amulet was thought to have magical properties.

HEDGEHOG

FAÏENCE
HEIGHT CM 5.3
LENGTH CM 7
Middle Kingdom
(1994-1650 BC)

In tomb settings, the hedgehog had magical properties that have not been identified clearly. Faïence, the material used to make this artifact from the necropolis of Thebes, also symbolizes regeneration.

128-129 JE 21365

HIPPOPOTAMUS

FAÏENCE
HEIGHT 11.5
LENGTH CM 21.5
Second Intermediate Period
(1650-1550 BC)

Statuettes of this kind, sometimes with the body covered in flowers and aquatic plants, were frequent until the beginning of the New Kingdom. The hippopotamus is connected with the birth goddess Tueris. The object shown here is from Dra Abu ei-Naga and was found by A. Mariette (1860).

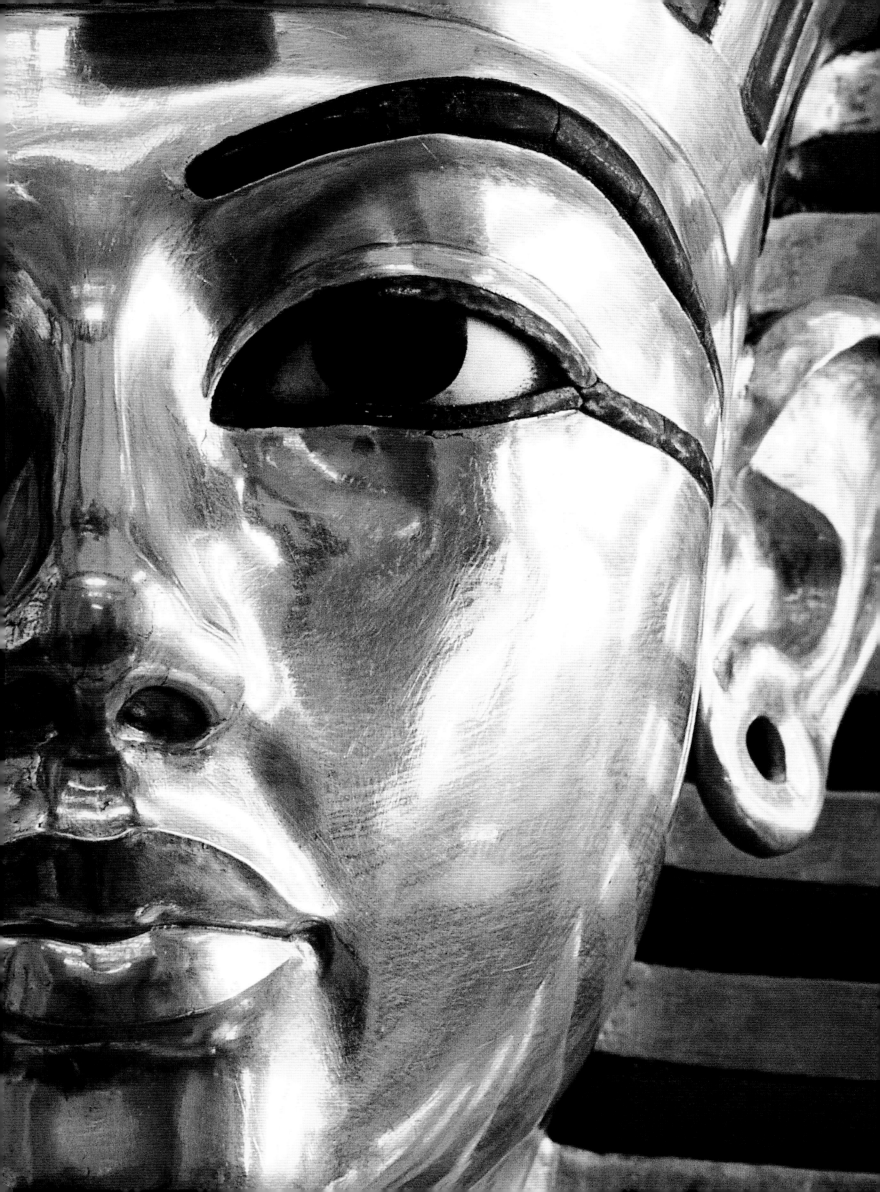

THE NEW KINGDOM

WARRIOR KINGS SUCCEEDED
EACH OTHER ON THE THRONE
AND THE ARMY ROSE AS A
NEW POWER IN SOCIETY.
WEALTH BROUGHT IN FROM
THE OUTSIDE CONTRIBUTED
TO THE DEVELOPMENT OF
SOCIETY AND THE
ADVANCEMENT OF THE ARTS.

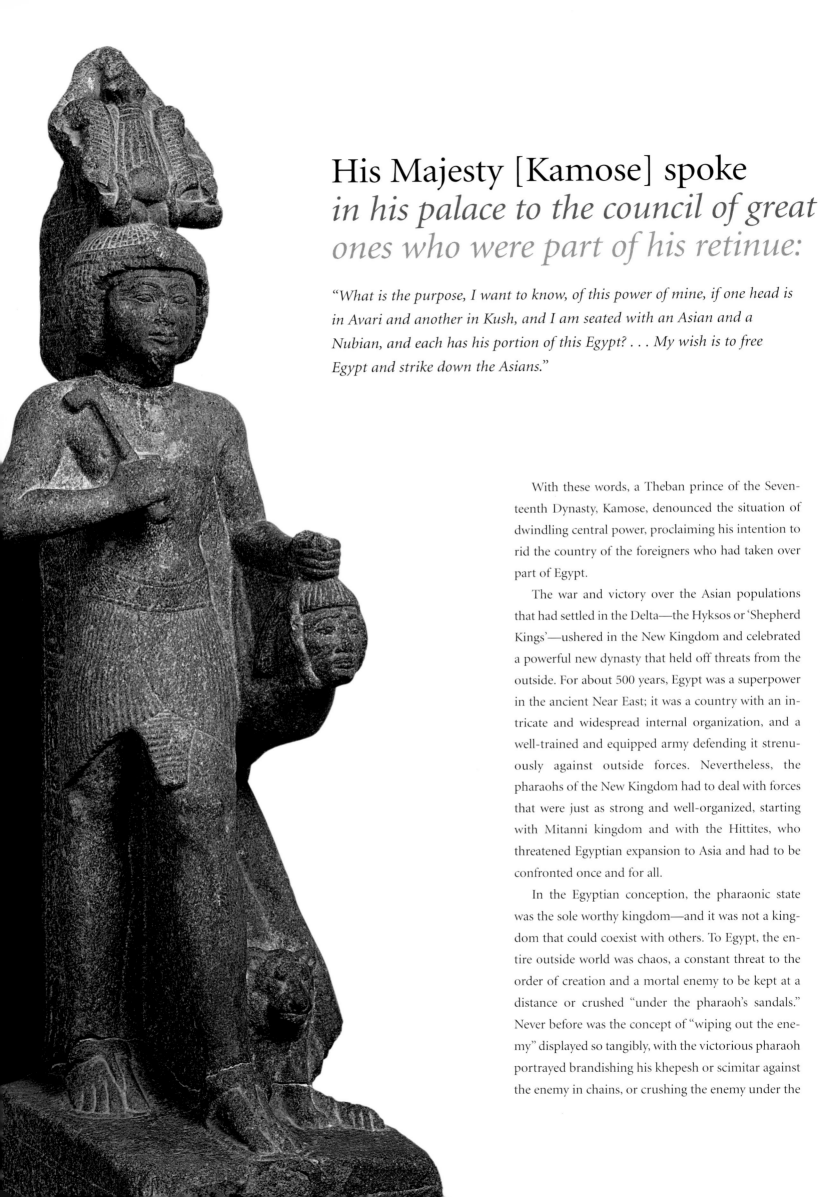

His Majesty [Kamose] spoke
in his palace to the council of great ones who were part of his retinue:

"What is the purpose, I want to know, of this power of mine, if one head is in Avari and another in Kush, and I am seated with an Asian and a Nubian, and each has his portion of this Egypt? . . . My wish is to free Egypt and strike down the Asians."

With these words, a Theban prince of the Seventeenth Dynasty, Kamose, denounced the situation of dwindling central power, proclaiming his intention to rid the country of the foreigners who had taken over part of Egypt.

The war and victory over the Asian populations that had settled in the Delta—the Hyksos or 'Shepherd Kings'—ushered in the New Kingdom and celebrated a powerful new dynasty that held off threats from the outside. For about 500 years, Egypt was a superpower in the ancient Near East; it was a country with an intricate and widespread internal organization, and a well-trained and equipped army defending it strenuously against outside forces. Nevertheless, the pharaohs of the New Kingdom had to deal with forces that were just as strong and well-organized, starting with Mitanni kingdom and with the Hittites, who threatened Egyptian expansion to Asia and had to be confronted once and for all.

In the Egyptian conception, the pharaonic state was the sole worthy kingdom—and it was not a kingdom that could coexist with others. To Egypt, the entire outside world was chaos, a constant threat to the order of creation and a mortal enemy to be kept at a distance or crushed "under the pharaoh's sandals." Never before was the concept of "wiping out the enemy" displayed so tangibly, with the victorious pharaoh portrayed brandishing his khepesh or scimitar against the enemy in chains, or crushing the enemy under the

**TUTANKHAMUN'S
BURIAL MASK**

GOLD, SEMIPRECIOUS STONES,
VITREOUS PASTE
HEIGHT CM 54
WEIGHT KG 11
18th Dynasty,
Tutankhamun's reign
(1333-1323 BC)

The burial mask that covered the face of Tutankhamun's mummy is the most spectacular item in the treasure discovered by Howard Carter and Lord Carnarvon (1922) in the tomb of the young pharaoh in the Valley of the Kings. The head, with a nemes headdress, false beard and wide necklace, is sculpted entirely in solid gold.

wheels of the royal chariot dashing at a gallop. The granodiorite statue of Ramesses VI, preserved at the Egyptian Museum in Cairo and portraying the pharaoh as he clutches a defeated prisoner by the hair, perfectly exemplifies this type of scene. Another example can be seen in the fragmentary relief depicting the faces of the vanquished Nubians, likewise in the hands of the victorious pharaoh.

In some cases, real war episodes replaced this ideal image of the king vanquishing the enemy, ritually driving chaos from the ordered world. The most striking of these portrays the Battle of Qadesh—a Syrian state on the Orontes River—fought by Ramesses II against the Hittite army and depicted almost obsessively at the most important temples of his lengthy reign: Karnak, Luxor, the Ramesseum, and Abu Simbel. Though in the Egyptian heads and reliefs Ramesses is extolled as a victor and skilled warrior who single-handedly defeated hundreds of thousands of attacking enemies, the battle actually ended without any definitive consequences for either side, and a peace treaty was ultimately stipulated.

The widespread praise of victory over foreigners and the start of a new and powerful reign under a Theban dynasty must have contributed to the veneration—and subsequent deification—of the first sovereigns of the Eighteenth Dynasty. Ahmose, the first ruler in the dynasty, his grandmother Tetisheri, his mother Ahhotep I, and his wife Ahmes-Nefertari became subjects of veneration. A fullfledged cult developed around the second sovereign of the dynasty, Amenhotep I, and his mother Ahmes-Nefertari at Deir al-Medina, the village housing the workmen who were building the tombs and royal mortuary temples of the New Kingdom in West Thebes. The Egyptian Museum has magnificent jewelry from the funerary accouterments of Queen Ahhotep I, as well as specimens of weapons that were probably dedicated to her by her children out of gratitude for her important contribution in driving the Hyksos from Egypt.

Throughout the period of the New Kingdom, the city of Thebes remained the most archetypal holy city, though the political capital was eventually moved to Memphis, farther north, and then to Pi-Ramesse in the Delta, in order to bring the court closer to the political hotbed of the Near East. The most important sanctuary in the country was located in Thebes. This was the Temple of Amun-Ra at Karnak, and every pharaoh wanted to show his presence there by undertaking expansion and restoration work in order to obtain the blessing of the dynastic god and of the powerful priests of Amun, who were backed by the god's wealth and properties.

132
JE 37173 =
CG 42152

**STATUE OF
RAMESSES VI
WITH PRISONER**

GRANODIORITE
HEIGHT CM 74
20th Dynasty,
reign of Ramesses VI
(1143-1135 BC)

G. Legrain discovered the statue, which portrays the theme of vanquishing the enemy, in the cache at Karnak (1903-1905). The pharaoh, with an axe in his right hand, holds a Libyan by the hair; the captive is portrayed with a long curl over his face and earrings.

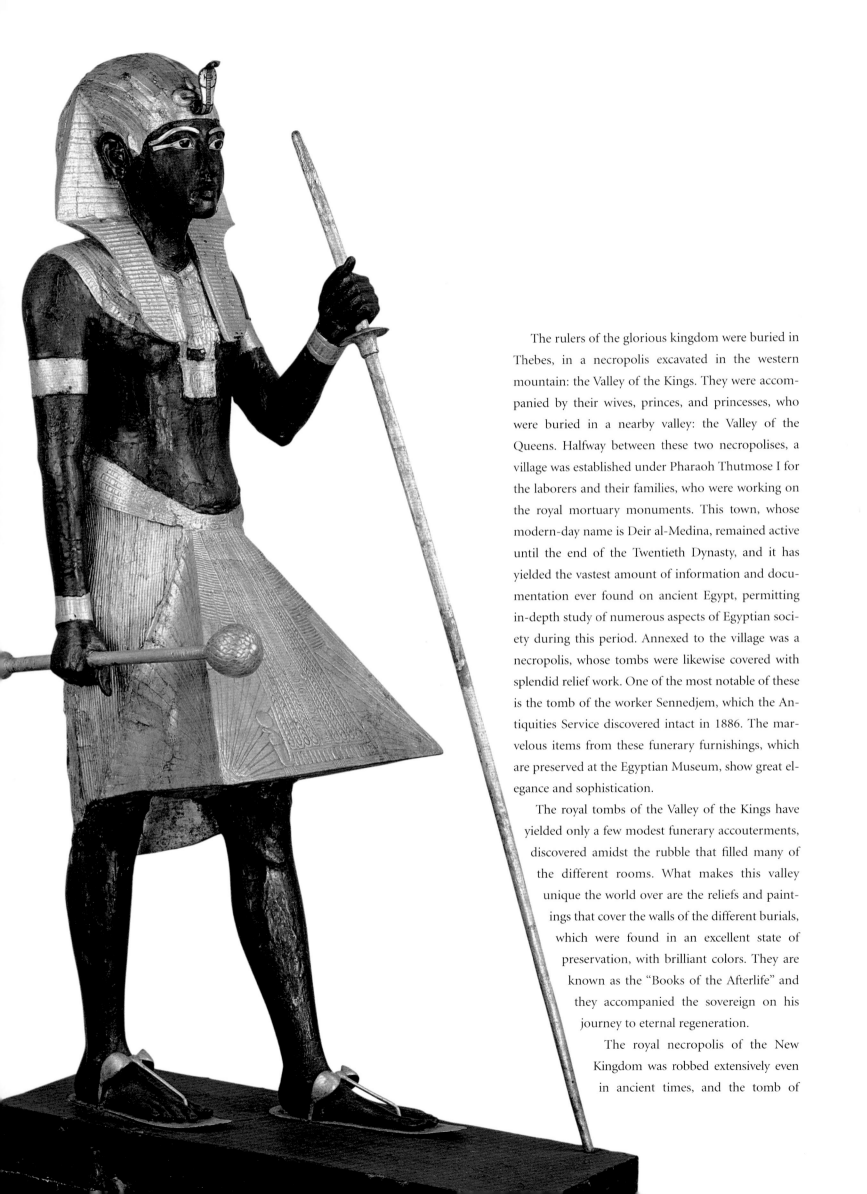

The rulers of the glorious kingdom were buried in Thebes, in a necropolis excavated in the western mountain: the Valley of the Kings. They were accompanied by their wives, princes, and princesses, who were buried in a nearby valley: the Valley of the Queens. Halfway between these two necropolises, a village was established under Pharaoh Thutmose I for the laborers and their families, who were working on the royal mortuary monuments. This town, whose modern-day name is Deir al-Medina, remained active until the end of the Twentieth Dynasty, and it has yielded the vastest amount of information and documentation ever found on ancient Egypt, permitting in-depth study of numerous aspects of Egyptian society during this period. Annexed to the village was a necropolis, whose tombs were likewise covered with splendid relief work. One of the most notable of these is the tomb of the worker Sennedjem, which the Antiquities Service discovered intact in 1886. The marvelous items from these funerary furnishings, which are preserved at the Egyptian Museum, show great elegance and sophistication.

The royal tombs of the Valley of the Kings have yielded only a few modest funerary accouterments, discovered amidst the rubble that filled many of the different rooms. What makes this valley unique the world over are the reliefs and paintings that cover the walls of the different burials, which were found in an excellent state of preservation, with brilliant colors. They are known as the "Books of the Afterlife" and they accompanied the sovereign on his journey to eternal regeneration.

The royal necropolis of the New Kingdom was robbed extensively even in ancient times, and the tomb of

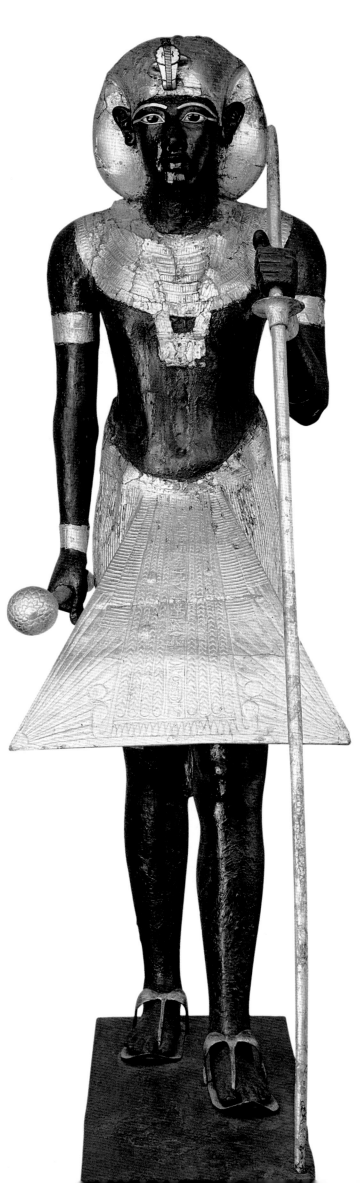

134 and 135

STATUES OF THE *KA* OF TUTANKHAMUN

WOOD FINISHED WITH POLISHED
BLACK RESIN AND GILDING
HEIGHT 192
WIDTH CM 53.3
LENGTH CM 98
18th Dynasty,
Tutankhamun's reign
(1333-1323 BC)

JE 60707 - 60708

To their discoverers, Howard Carter and Lord Carnarvon (1922), these two life-size statues seemed to guard over the entrance to the pharaoh's funerary chamber. Their size and the contrast between their skin colors and the various gilded attributes make them especially intriguing.

Pharaoh Tutankhamun, with all its furnishings, represents the only royal tomb discovered intact. Most of the upper floor of the Egyptian Museum is devoted to this marvelous treasure, which conveys some of the opulence of the court during that period. The richness of these funerary accouterments and the beauty of each object left its discoverer, archaeologist Howard Carter, speechless when the tomb was officially opened on November 27, 1922. "In all the history of the excavations, there has never been a sight as astonishing as the one revealed before our eyes by the light of the [electric] torch. . . . But one must imagine how those objects appeared before our eyes through the tiny hole we made in the closed and sealed wall, illuminated by the torchlight, the first light to penetrate the darkness of that room for 3000 years. . . . The discovery was extraordinary, above and beyond all experience, and at the time it seemed that the things to be done exceeded all human possibility."

This extraordinary and unexpected discovery is particularly striking because Tutankhamun, who died very young, was actually a minor sovereign in the panorama of the New Kingdom, and he was brought into the limelight due exclusively to the discovery of his treasure.

The reign of this boy-king marked a transitional period between the heresy of Akhenaten, his predecessor, and the subsequent 'restoration' phase. For about twenty years, Egyptian society was overwhelmed by the so-called 'religion of Aten' proclaimed by Amenhotep IV/Akhenaten. The pharaoh declared that the sun disk, Aten, was the only god, condemning worship of other deities, removing their names from monuments, abolishing the priesthood, closing temples, and confiscating their property. During the sixth year of his reign, the 'heretic' pharaoh also established a new capital, Amarna, founded on virgin land chosen by the god Aten. The pharaoh moved the court and his entire family there, also transferring the royal necropolis. The religious revolution of Amarna was powerfully reflected in the artistic field as well. Not only were there 'new' scenes, in which the sovereign was portrayed in intimate family scenes with his wife Nefertiti and his daughters, but the very representation of the human figure was so distorted that several scholars are convinced Akhenaten may have been afflicted with some disease.

Tutankhamun and his Restoration Stele, displayed in the Temple of Amun at Karnak, marked the return to normality following the Amarna heresy; temples were reopened and the priesthoods of the various deities were restored. The lineage of Ahmose, the first sovereign of the Eighteenth Dynasty, died out with the short reign of Tutankhamun, and power ended up in the hands of the chief commander of the army, Horemheb, the last glorious pharaoh of the Eighteenth Dynasty.

Another military leader, Horemheb's companion at arms Ramesses (I), a native of the Delta, ushered in the Nineteenth Dynasty and what would come to be known as the Ramesside Period. Eleven rulers named Ramesses would succeed each other in this dynasty. With the Ramessides, the army became a fundamental tool of the central power, focused more than ever on the issues of the Near East, which influenced Egyptian society on all levels, from fashion to religion. The Egyptian state reached its zenith of splendor with the great Ramesses II, who was as capable in foreign policy as he was in promoting an impressive architectural policy within the country: Ramesses was the most active builder in Egyptian history.

Following his long reign, Egypt and all the other countries in the Near East went through a period of great economic, political, and social crisis that inexorably redrew the political map of the entire area at the end of the Bronze Age.

The close of the Nineteenth and Twentieth Dynasties marked the beginning of a general phase of decline for the Egyptian state, though it experienced other moments of great splendor, particularly under Ramesses III. On the walls of his mortuary temple at Medinet Habu, in particular, this sovereign celebrated the victory of his glorious army against the Libyans at the edge of the Western Delta and against the so-called 'Sea Peoples,' the Mediterranean populations that had threatened the Egyptian coast in a coalition with the Libyans during the reign of Merenptah, as commemorated by the Israeli Stele now preserved in Cairo. Nevertheless, the victory acclaimed by Ramesses III did not manage to avoid the loss of Egyptian possessions in Syria-Palestine. In turn, this led to the loss of tax revenues, which inevitably triggered a serious economic crisis.

The rulers after Ramesses III succeeded each other with scandals and usurpations, and the powerful priests of Amun at Karnak took advantage of this. Under the reign of Ahmose, the benevolence of the god Amun toward the ruling dynasty was institutionalized with the figure of the "High Priest of Amun," chosen by the god's oracle at Karnak and appointed by the pharaoh. This figure, who played both a religious and administrative role, was aware of his position and, backed by his material wealth, which was constantly augmented by the various sovereigns, he gradually gained more and more power and independence.

Moreover, at the beginning of the Eighteenth Dynasty, Amun's influence was also extended to the female branch of the royal family when Ahmose named his wife Ahmes-Nefertari the "Wife of the god [Amun]." She was given all the resources required to create a college of priestesses as part of her retinue, and gained enormous control. The title, which is often found together with the title of "hand of god" or "Divine Votaress," was intended to celebrate the queen's mystical union with the demiurge god, thereby guaranteeing the harmony of the universe for eternity. In the New Kingdom, this role could be held exclusively by royal wives or princesses. Nevertheless, it was gradually transformed into what was effectively a powerful caste that, under the Twenty-fifth and Twenty-sixth Dynasties, wielded enormous influence within the country, creating a Lady of Thebes and overshadowing the power of the High Priest.

The New Kingdom thus drew to a close with critical debilitation of the central power, due to both internal and external causes. Once again, this would again lead to a rift in the country between the north, in the hands of the pharaoh, and the south, held by what was effectively a 'pontificate' of Amun.

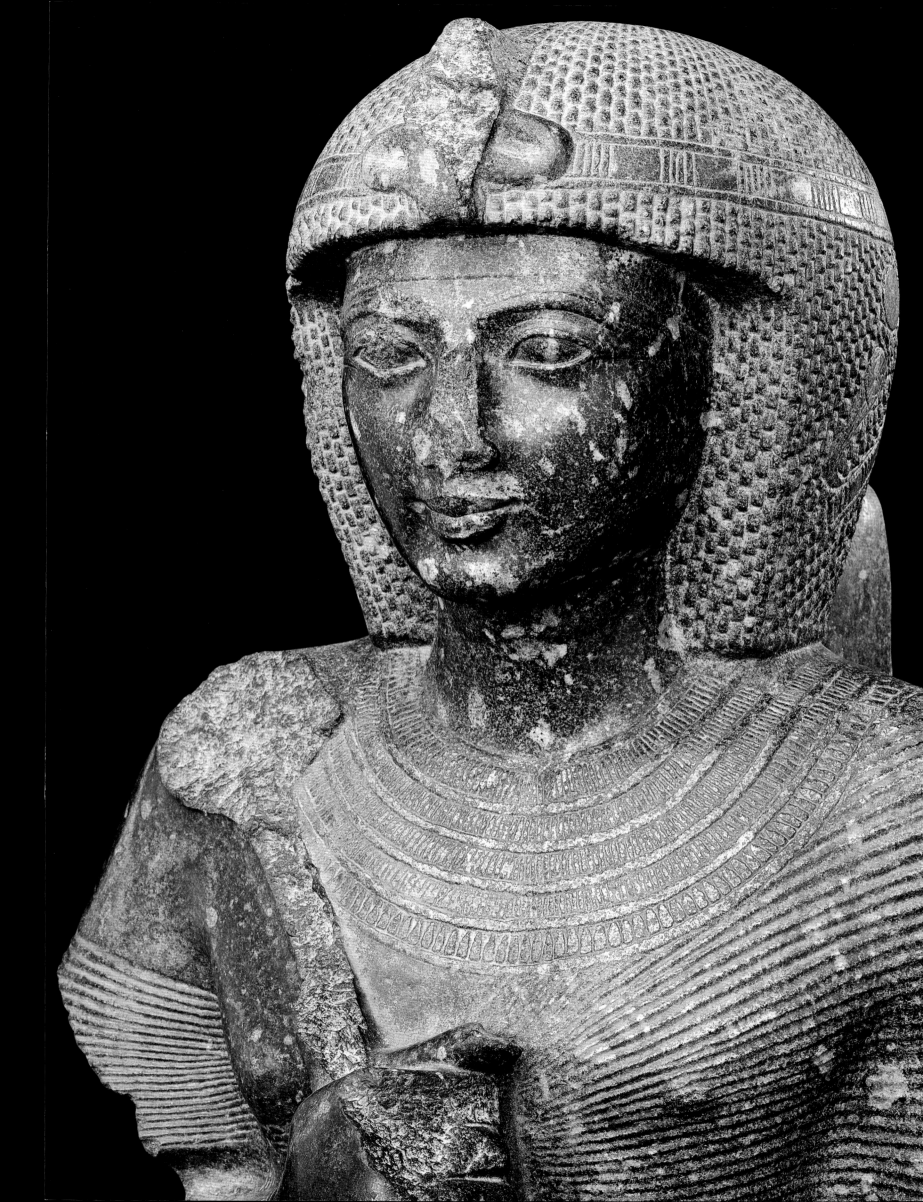

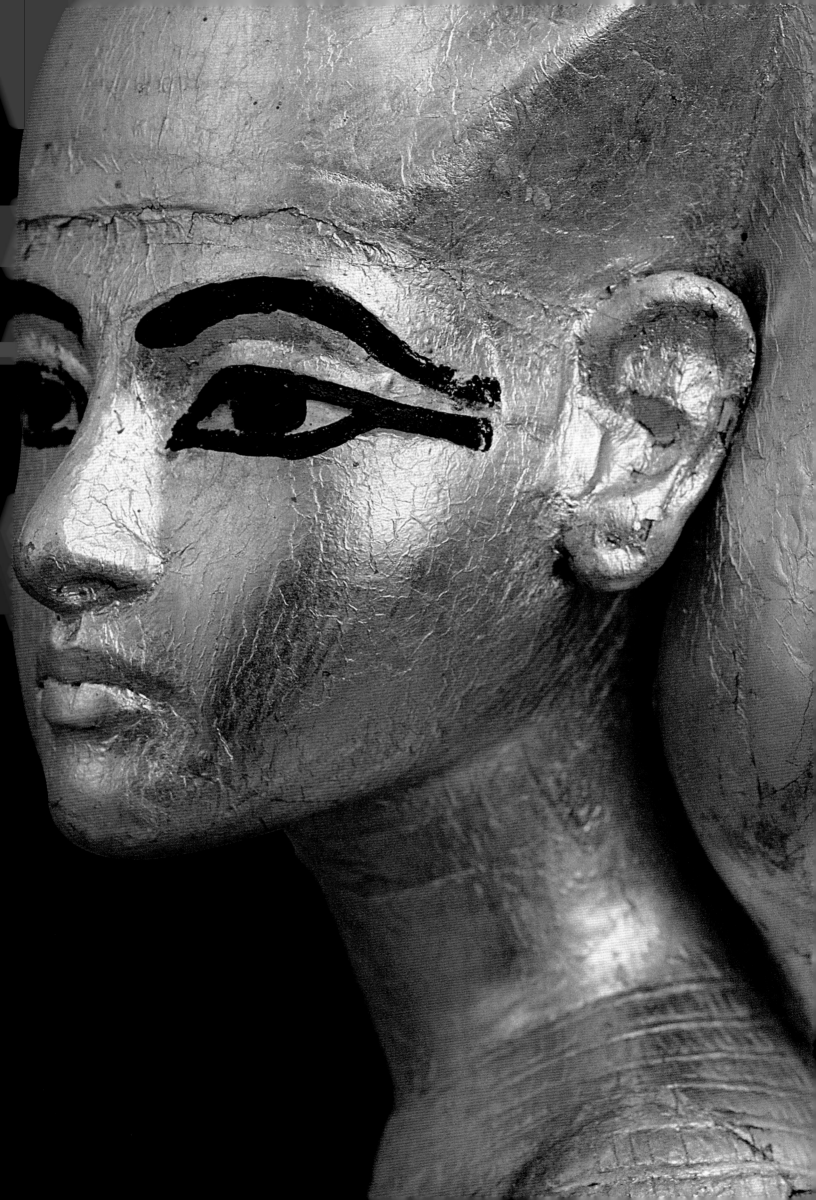

The material from the New Kingdom represents the most extensive documentation of the Egyptian Museum in Cairo. Most of the rooms on the ground floor are devoted to this glorious period in pharaonic history. Set against the back wall of the atrium is the colossal limestone group of Amenhotep III with his wife Teye, whereas two coffins—one belonging to Queen Hatshepsut and one to Merenptah, which was reused at Tanis by Psusennes I—are set along the back wall. The itinerary for the New Kingdoms starts in Room 11 with the painted limestone sphinx of Hatshepsut and the head from a fragmentary colossus of this queen. Room 12 houses a series of splendid pieces, including the Hathoric chapel of Thutmose III from Deir al-Bahari, in front of which is the painted limestone statue of the cow Hathor with Amenhotep II. The same type of work can be seen in the granite group of the serpent-goddess Meretseger with Amenhotep II. Also in this room is a head of Amenhotep III with a light-blue crown, the statue group of King Thutmose IV with his mother Tiya, the statue of Queen Hatshepsut's steward Senemut with Princess Neferura, a unique statuette of a sovereign in silicated wood, the statue of the god Khonsu-Tutankhamun, and the famous reliefs of the Punt expedition from the mortuary temple of Queen Hatshepsut.

Splendid pieces dating from the Amarna period are displayed in Rooms 8, 3, and 13. One of the most notable pieces in the latter room is Merenptah's Israeli Stele. The itinerary continues to Room 10, with a colossal painted quartzite statue of Tutankhamun, and the granite and limestone group of Ramesses II as a child with the god Horun, intended as a three-dimensional 'pun' on the name of Pharaoh Ramesses. Room 15 houses the painted limestone bust of Queen Meritamun and the splendid limestone statues of Nakhtmin and his wife; the extraordinary alabaster statue of King Seti I is also displayed here. The rooms that follow have

other items from the Ramesside period. In particular, Room 14 houses a statue of the scribe of Ramessesnakht with the baboon-god on his head, the statue of Ramesses VI, victorious over enemies, and a fragmentary relief with vanquished enemies. The standard-bearing statue of Seti I can be seen in Room 25.

Much of the upper floor also displays material from the New Kingdom. The treasure found in Tutankhamun's tomb is displayed in many rooms (45, 40, 35, 30, 25, 20, 15, 10, 9, 8, 3, 13, 7). Another important set of tomb furnishings, found in Tomb no. 46 at the Valley of the Kings, belonged to Yuya and Tuya, the parents of Teye, who was the Great Royal Wife of Amenhotep III; these furnishings are in Room . Room 4, devoted to jewelry, holds gold masterpieces from the Theban burial of Queen Ahhotep I, mother of Pharaoh Ahmose, together with valuable pottery from the Ramesside period found in a votive deposit at Bubastis. The rooms devoted to funerary accouterments (12, 17, 22, 27, 32, 37) preserve numerous objects from burials in the Valley of the Kings, and several splendid items from the tomb of the workman Sennedjem, found intact at Deir al-Medina (Room 17). Exquisite coffins can be seen in some of the rooms, including the coffin of Queen Ahhotep in stuccoed wood and gold leaf, the coffin of Queen Ahmes-Nefertari, and the lid of the wooden coffin of Ramesses II. Elegantly crafted everyday items are displayed in Room 34. Rooms 24 and 29 nearby hold fascinating papyruses and ostraca. In particular, the material from Deir al-Medina made it possible to learn more about many aspects of society during this period. Room 48 also has a series of interesting items, including the lovely fragmentary head of Teye, made of steatite, the ivory and gold statue of Thutmose III, and a series of finely crafted ushabty. The itinerary ends in Room 2 with the mummies of the glorious pharaohs of the Egyptian empire, including the one of Ramesses II with golden-blond hair.

138
JE 60686

CANOPIC SHRINE OF TUTANKHAMUN

STUCCOED AND GILDED WOOD
18th Dynasty,
Tutankhamun's reign
(1333-1323 BC)

The face shown here, one of the four female deities protecting all the sides of the canopic shrine, is a true masterpiece. Set on a sledge, the artifact was discovered by Howard Carter in the tomb of Tutankamun (1922).

AHHOTEP'S BRACELET

GOLD, LAPIS LAZULI
HEIGHT CM 3.4
DIAMETER CM 5.5
18th Dynasty,
Ahmes' reign
(1550-1525 BC)

The Antiquities Service discovered the burial of Queen Ahhotep, mother of Kamose and Ahmes, the first rulers of the New Kingdom, at the necropolis of Dra Abu el-Naga in West Thebes (1859).
The tomb yielded important funerary furnishings, including the objects shown on these two pages.

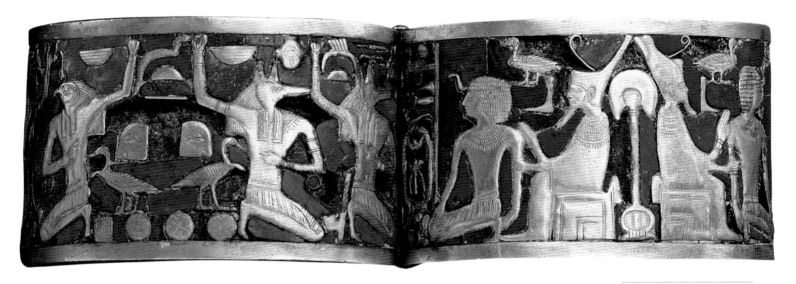

140 center | JE 4673

AHMES' CEREMONIAL AXE

WOOD, COPPER, GOLD,
GEMSTONES
HANDLE LENGTH CM 47.5
BLADE: LENGTH CM 26.3;
WIDTH CM 6.7
18th Dynasty,
Ahmes' reign
(1550-1525 BC)

This gilded cedar axe has a finely decorated blade and bears the cartouche of Ahmes, the ruler who definitively drove the Hyskos from Egypt.

140 bottom | JE 4665

AHMES' DAGGER WITH SHEATH

GOLD, ELECTRUM,
NIELLO,
SEMIPRECIOUS
STONES, WOOD
LENGTH CM 74
18th Dynasty,
Ahmes' reign
(1550-1525 BC)

This dagger, with a gold blade and a handle made of gilded inlaid cedar, belonged to the pharaoh Ahmes. Its sheath, devoid of any decoration, is made of two sheets of gold.

141
JE 4663 = CG 28501

SARCOPHAGUS OF AHHOTEP

WOOD, GOLD LEAF,
ALABASTER, OBSIDIAN
HEIGHT CM 212
18TH DYNASTY, AHMES'
REIGN (1550-1525 BC)

The tomb yielded a sarcophagus decorated with a rishi or feathered pattern and covered in gold leaf. The casket and the mummy were lost during recovery work.

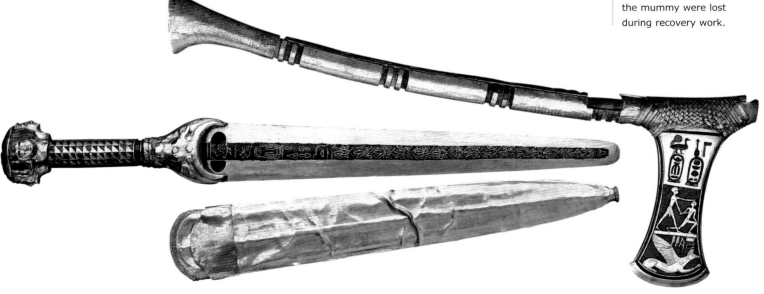

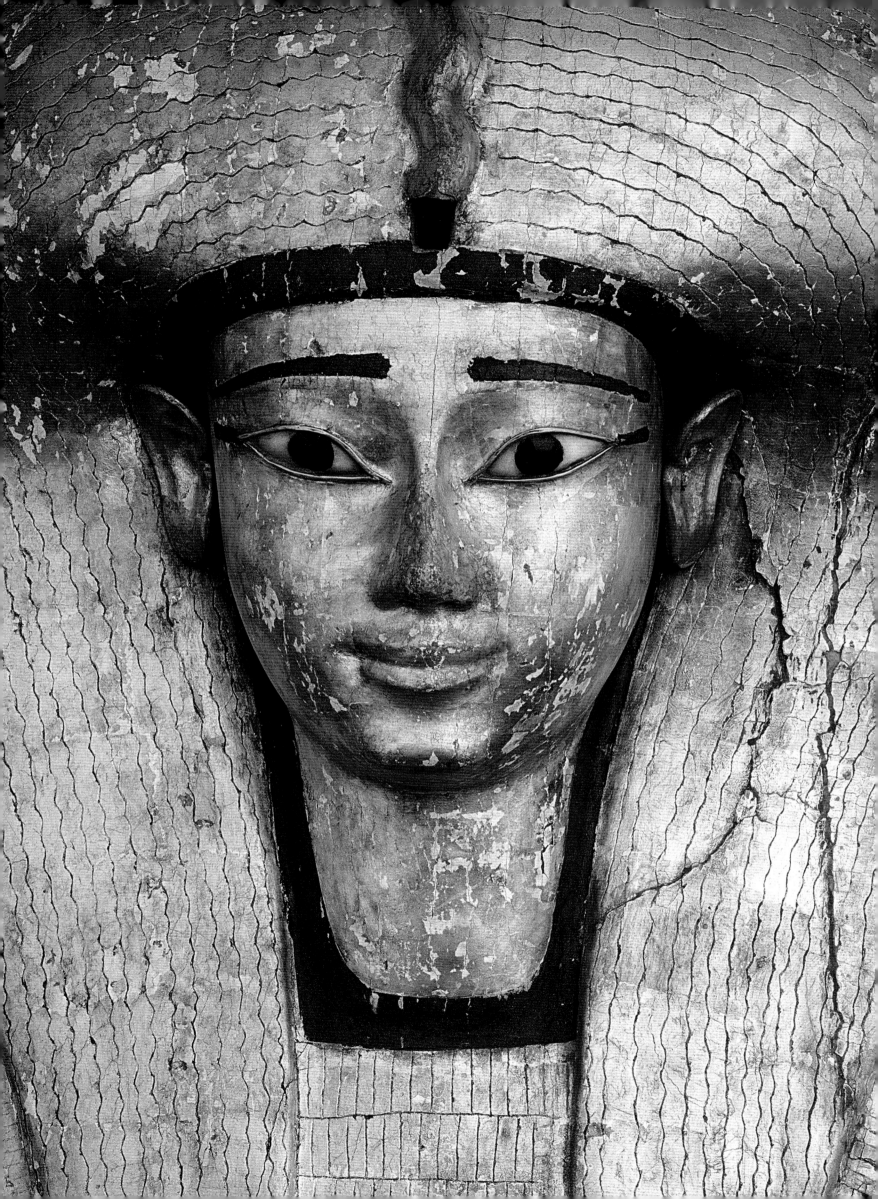

142 top
JE 14276 = CG 89661

FRAGMENTARY RELIEF OF THE EXPEDITION TO PUNT

PAINTED LIMESTONE
HEIGHT CM 49.3
WIDTH CM 45
18th Dynasty, Hatshepsut's reign
(1479-1458 BC)

The mortuary temple of Queen Hatshepsut at Deir al-Bahari yielded numerous reliefs whose colors are still astonishingly intense. The reliefs of Punt are from the south portico, and they illustrate the expedition sent by the queen to the faraway region of East Africa.

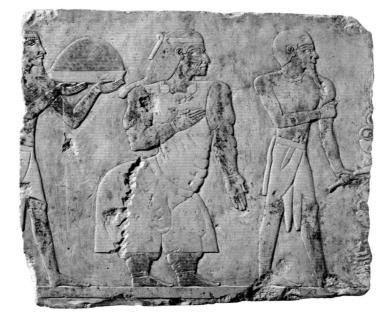

143 | *JE 56259 A - 56262*

HEAD FROM AN OSIRIS COLOSSUS OF HATSHEPSUT

PAINTED LIMESTONE
HEIGHT CM 61
18th Dynasty, Hatshepsut's reign
(1479-1458 BC)

A series of Osiris pillars along the front and a row of corresponding columns on the back decorate the portico of the upper terrace of the temple at Deir al-Bahari, leading to the courtyard created for outdoor celebrations. The Osiris pillars present male attributes, as the queen always preferred to be portrayed with red skin and a false beard. The site was excavated by the Metropolitan Museum of Art (1926).

142 bottom
JE 53113

SPHINX OF HATSHEPSUT

PAINTED LIMESTONE
HEIGHT CM 59.5
LENGTH CM 105
18th Dynasty, Hatshepsut's reign
(1479-1458 BC)

This sphinx of Queen Hatshepsut, from her temple at Deir al-Bahari, unmistakably evokes the maned sphinxes of the Twelfth Dynasty. The colors, which have been preserved in part on the face and the mane, give us a sense of the impact the statue must have had on visitors.

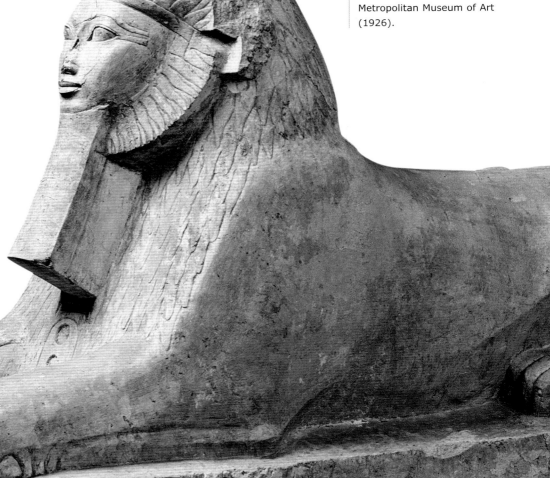

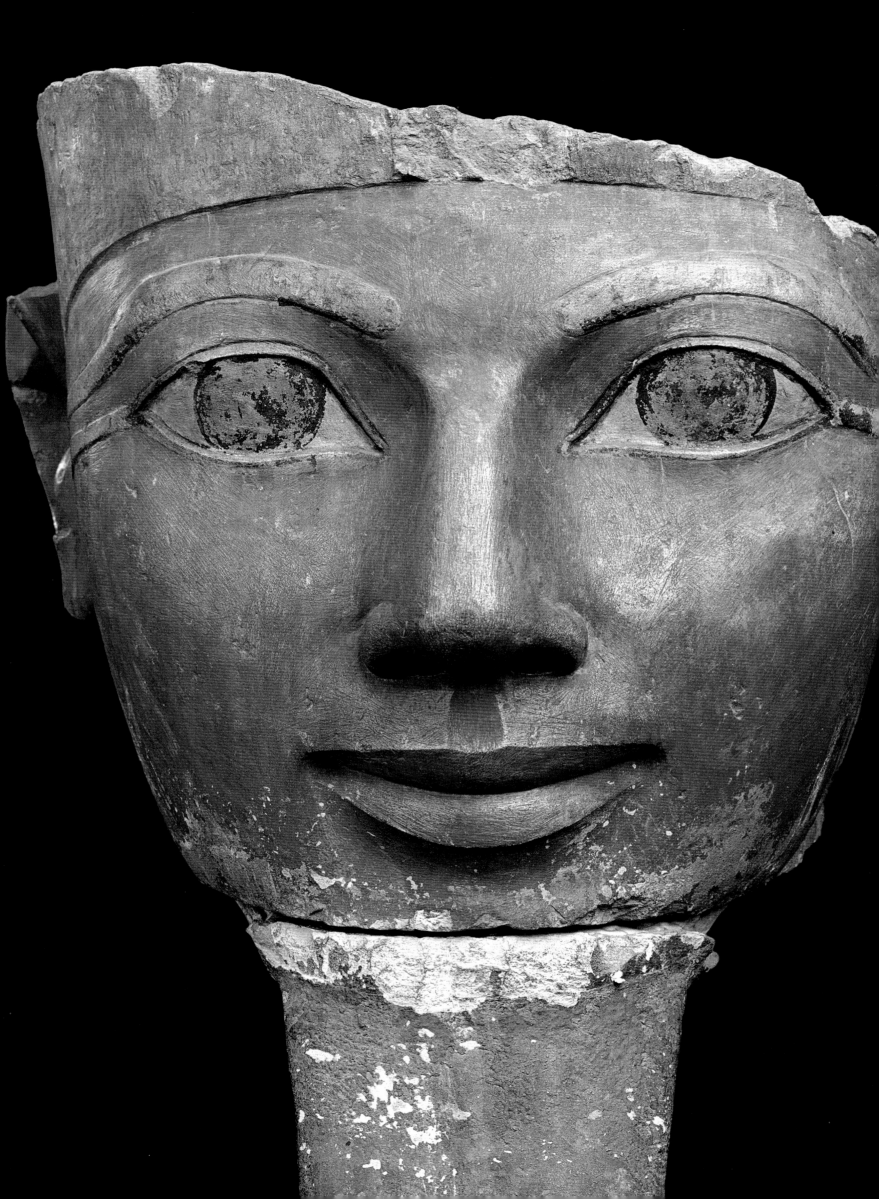

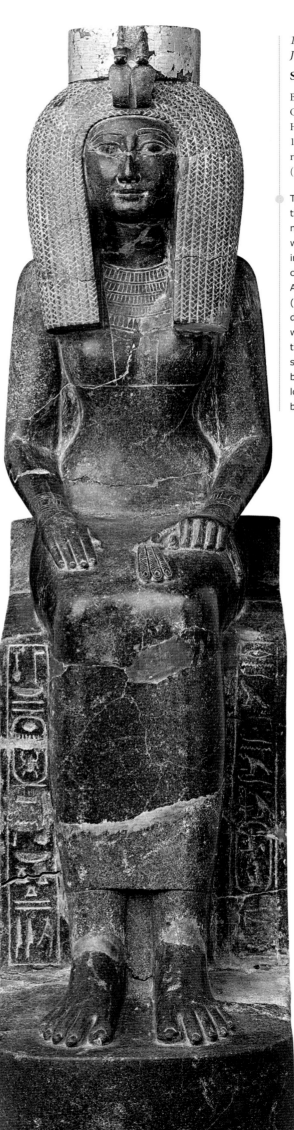

144 left
JE 53113

STATUE OF ASET

BLACK GRANITE,
GOLD PLATE
HEIGHT CM 98.5
18th Dynasty,
reign of Thutmose III
(1479-1458 BC)

Thutmose III dedicated
this sculpture to his
mother Aset. The statue
was found by G. Legrain
in the courtyard of the
cache of the Temple of
Amun-Ra at Karnak
(1904). The statue is
decorated with a splendid
wig with a uraeus. On
the head of the statue,
set on a cylindrical gold
base, there were two
long feathers that have
been lost.

144 right

**STATUE OF
SENENMUT WITH
NEFERURA**

BLACK GRANITE
HEIGHT CM 60
18th Dynasty,
Hatshepsut's reign
(1479-1458 BC)

JE 36923
CG 42116

Senenmut, the tutor
of Princess Neferura,
Hatshepsut's
daughter, holds his
protégé on his lap.
This sculpture,
known as a "tutor"
statue, was found by
G. Legrain at Karnak
(1904).

145

**STATUE OF
THUTMOSE III**

SCHIST
HEIGHT CM 200
18th Dynasty,
reign of Thutmose III
(1479-1425 BC)

JE 38234 BIS
CG 42053

A sweet smile,
slightly hooked nose
and large almond-
shaped eyes
characterize the face
of Thutmose III. The
statue is from the
courtyard of the
cache of the Temple
of Amun-Ra at
Karnak, where it was
discovered by G.
Legrain (1904).

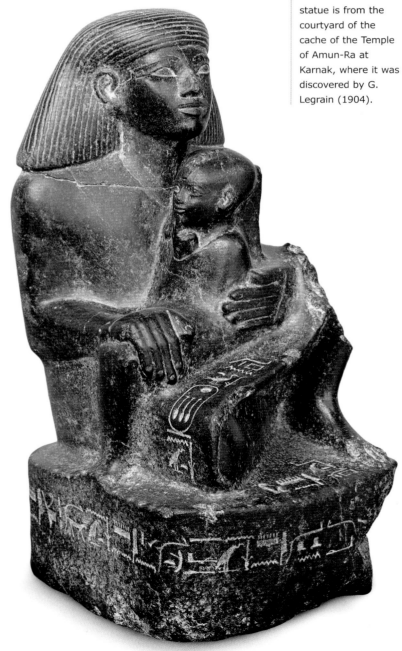

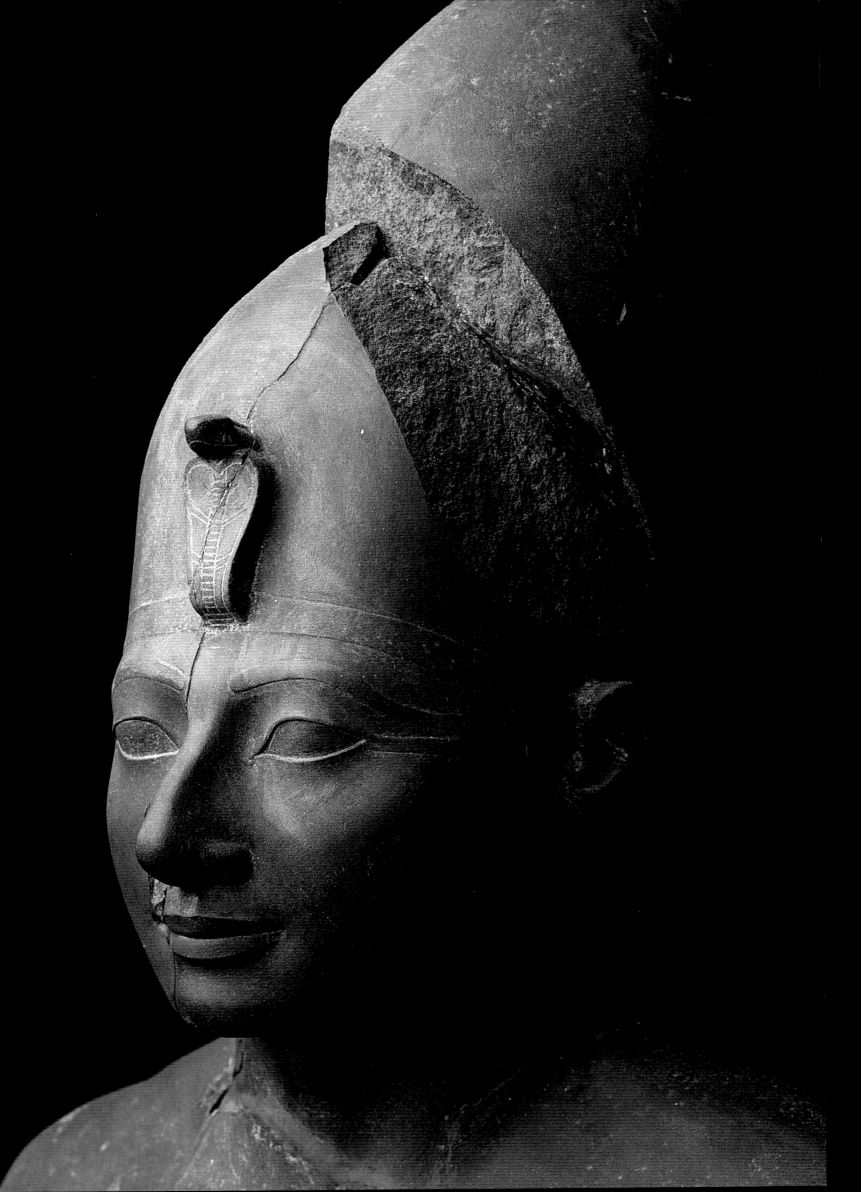

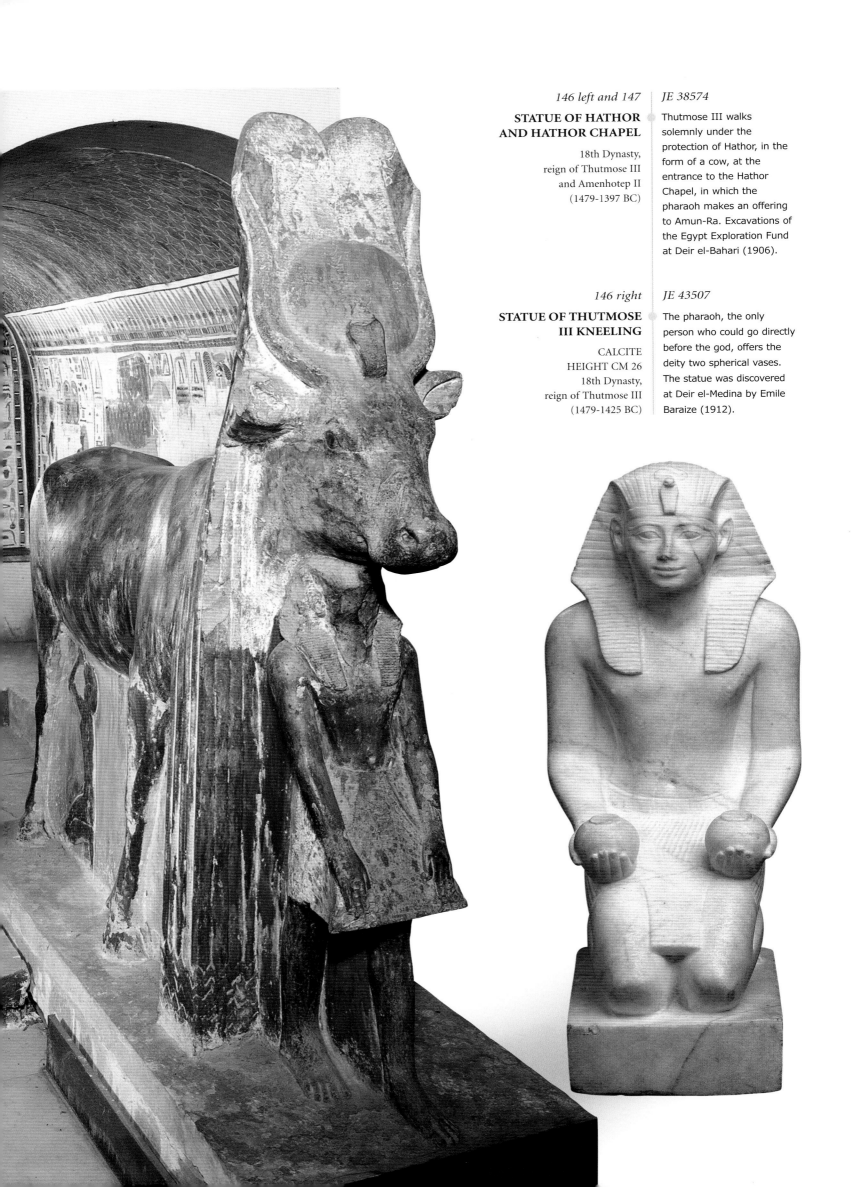

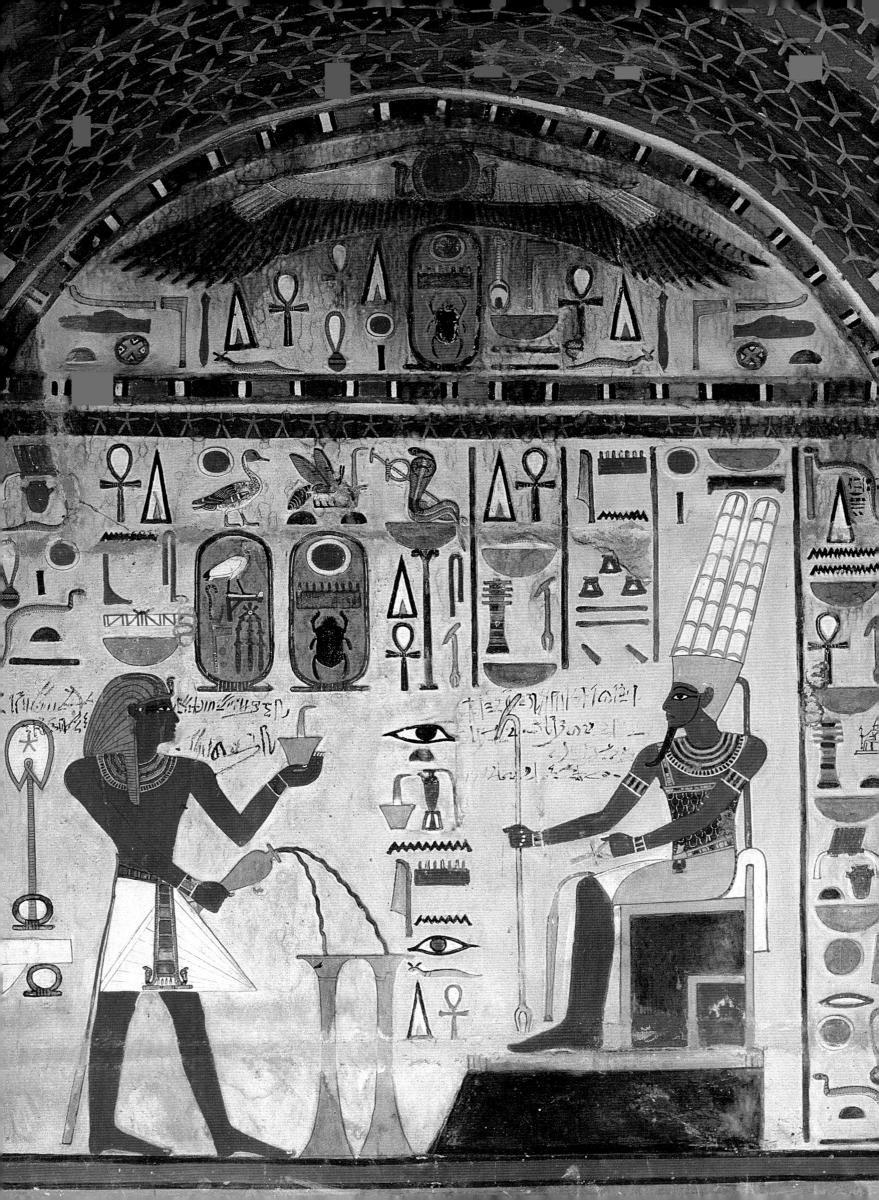

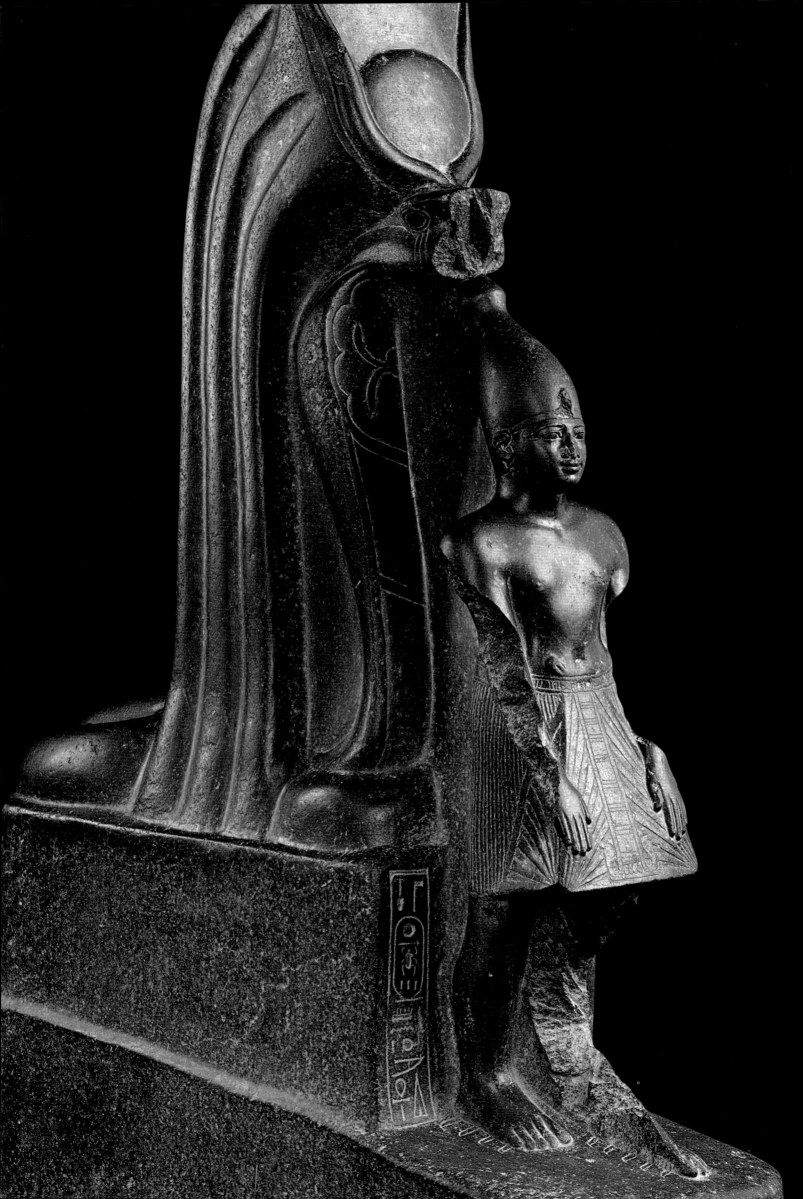

**STATUE OF
AMENHOTEP II
WITH MERETSEGER**

GRANITE
HEIGHT CM 125
18th Dynasty,
reign of Amenhotep III
(1424-1397 BC)

The pharaoh, depicted as
he crushes the Nine
Bows, is protected by
Meretseger, the goddess
of the west bank of
Thebes. The statue is
from the courtyard of the
cache at Karnak, where
it was discovered by G.
Legrain (1904).

**STATUARY GROUP
OF THUTMOSE IV
WITH TIYA**

GRAY GRANITE
HEIGHT 111.5
WIDTH OF BACK CM 69
18th Dynasty,
reign of Thutmose IV
(1397-1387 BC)

The headdress with a
vulture skin defines
Tiya's role as queen
mother; she is shown
seated next to her
son, Thutmose IV. The
two gaze serenely as
they embrace each
other. The group is
from the Temple of
Amun-Ra at Karnak.

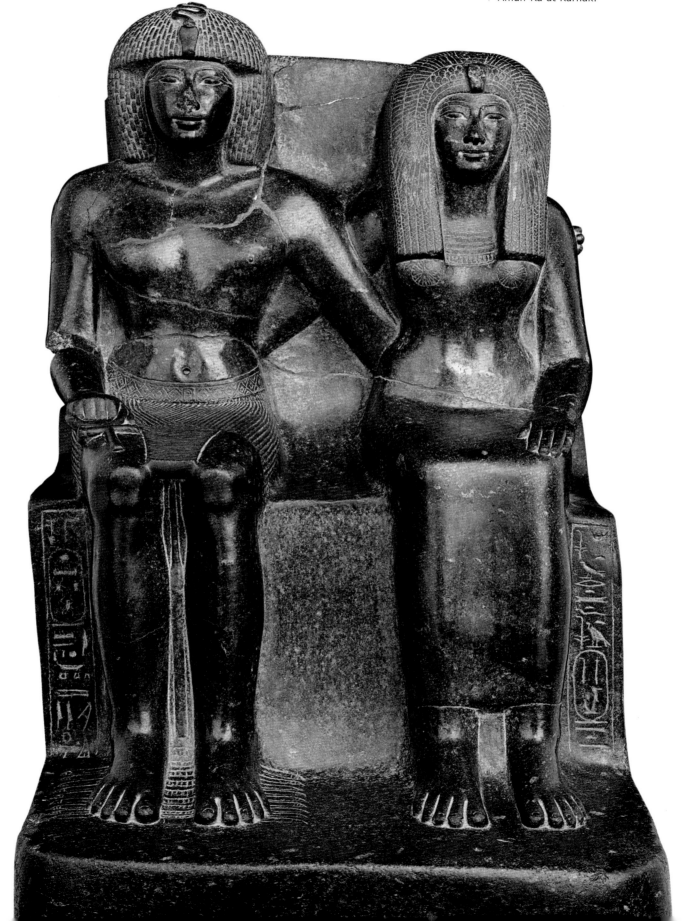

150 top | *JE 51102*

VASES IN THE NAME OF YUYA

PAINTED LIMESTONE
HEIGHT CM 25
18th Dynasty,
reign of Amenhotep III
(1387-1350 BC)

Most of the tomb furnishings of Yuya and Tuya, the parents of Teye, who was the Great Royal Wife, were found in their tomb in the Valley of the Kings during the excavations conducted by the Antiquities Service on behalf of Theodore Davis (1905). The four cosmetics jars show intriguing workmanship.

151 left | *JE 95232*

SARCOPHAGUS OF YUYA

WOOD, GOLD LEAF,
VITREOUS PASTE,
ALABASTER, CARNELIAN
HEIGHT CM 59
18th Dynasty,
reign of Amenhotep III
(1387-1350 BC)

In 1905, Quibell discovered the mummy of Yuya inside four caskets in Tomb KV 46 at the Valley of the Kings. Decorations in colored vitreous paste embellish both the lid and the bed of the sarcophagus.

150 bottom
JE 95342

PRINCESS SATAMUN'S CHAIR

GESSOED WOOD, GOLD
LEAF, PLANT FIBERS
HEIGHT CM 77
18th Dynasty,
reign of Amenhotep III
(1387-1350 BC)

This elegant wooden chair decorated in gold leaf belonged to Satamun, the daughter of Amenhotep III and Teye, depicted on the back of the chair bearing offerings. The chair was found in the tomb of Yuya and Tuya, in the Valley of the Kings, during the excavation work conducted by the Antiquities Service (1905).

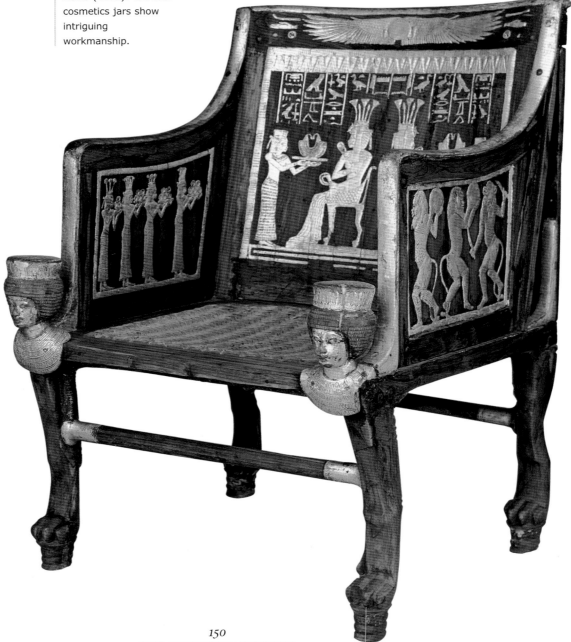

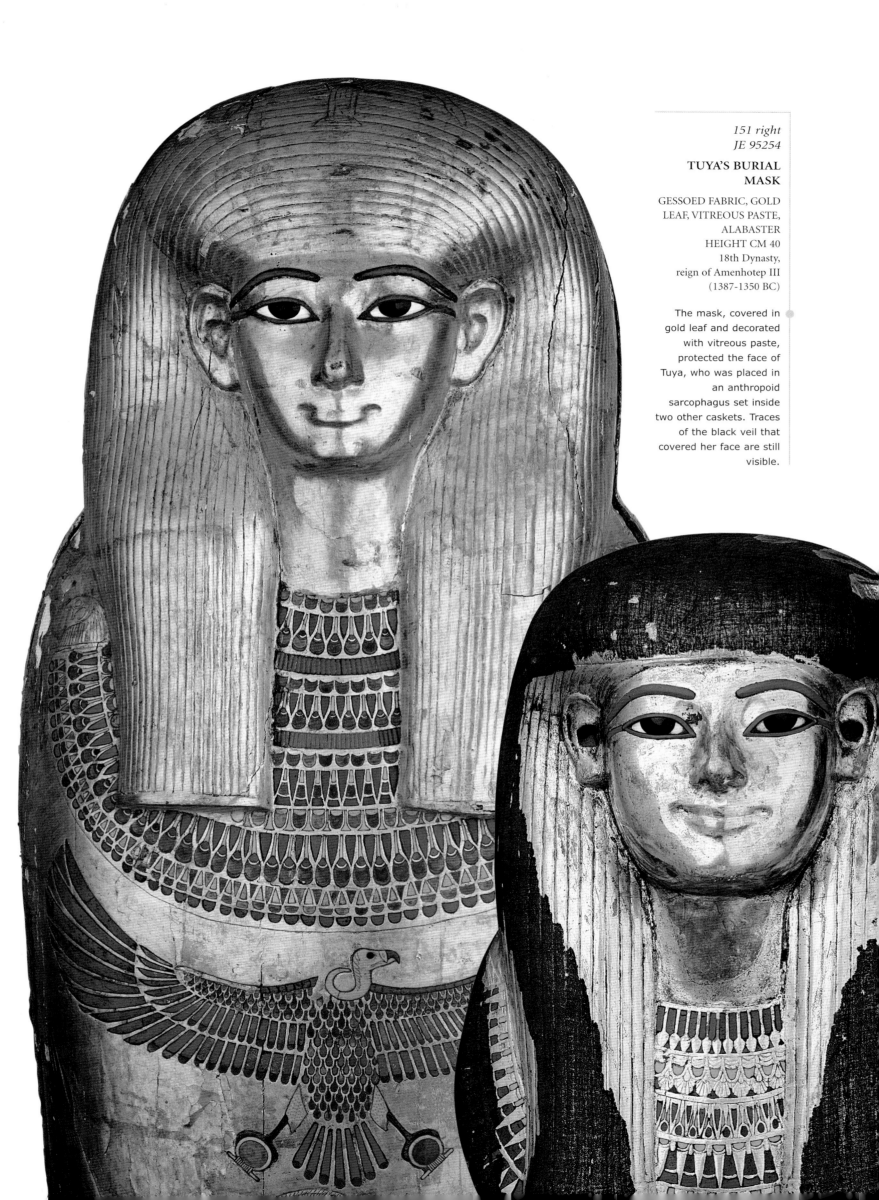

151 right
JE 95254

TUYA'S BURIAL MASK

GESSOED FABRIC, GOLD
LEAF, VITREOUS PASTE,
ALABASTER
HEIGHT CM 40
18th Dynasty,
reign of Amenhotep III
(1387-1350 BC)

The mask, covered in
gold leaf and decorated
with vitreous paste,
protected the face of
Tuya, who was placed in
an anthropoid
sarcophagus set inside
two other caskets. Traces
of the black veil that
covered her face are still
visible.

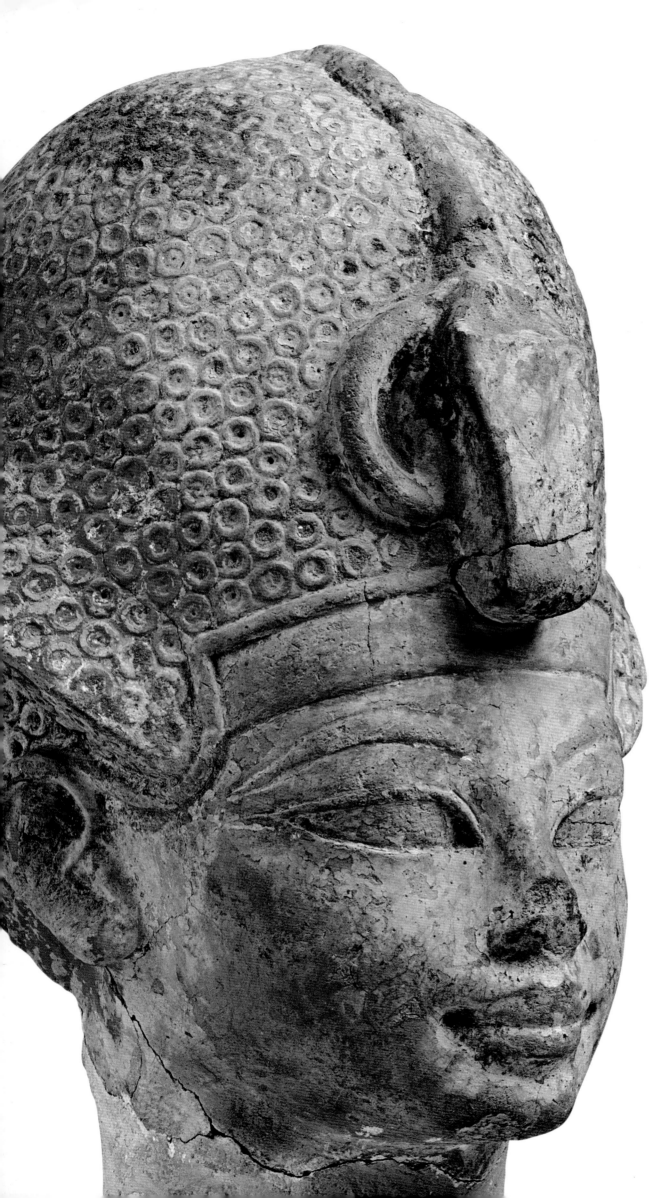

152
JE 38597

**BUST OF
AMENHOTEP III**

GESSOED AND
PAINTED CLAY
HEIGHT CM 38
18th Dynasty,
reign of Amenhotep III
(1387-1350 BC)

The large number of
extant statues of
Amenhotep III has made
it possible to date this
piece to the end of his
reign. Elongated almond-
shaped eyes and thick,
sharply outlined lips
characterize his face.
This fragmentary artifact
was found by G. Legrain
in the cache of the
Temple of Amun-Ra at
Karnak (1903-1905).

153
JE 38257

BUST OF TEYE

GREEN STEATITE
HEIGHT CM 7.2
18th Dynasty,
reign of Amenhotep III
(1387-1350 BC)

The queen's intense gaze,
unmistakable facial
features, elaborate wig
with a double uraeus and
crown with tall plumes,
which have been lost,
make this statuette a true
masterpiece. This
extraordinary artifact is
from the Temple of Hathor
at Serabit al-Khadem in
Sinai, and was discovered
by W.M.F. Petrie (1905).

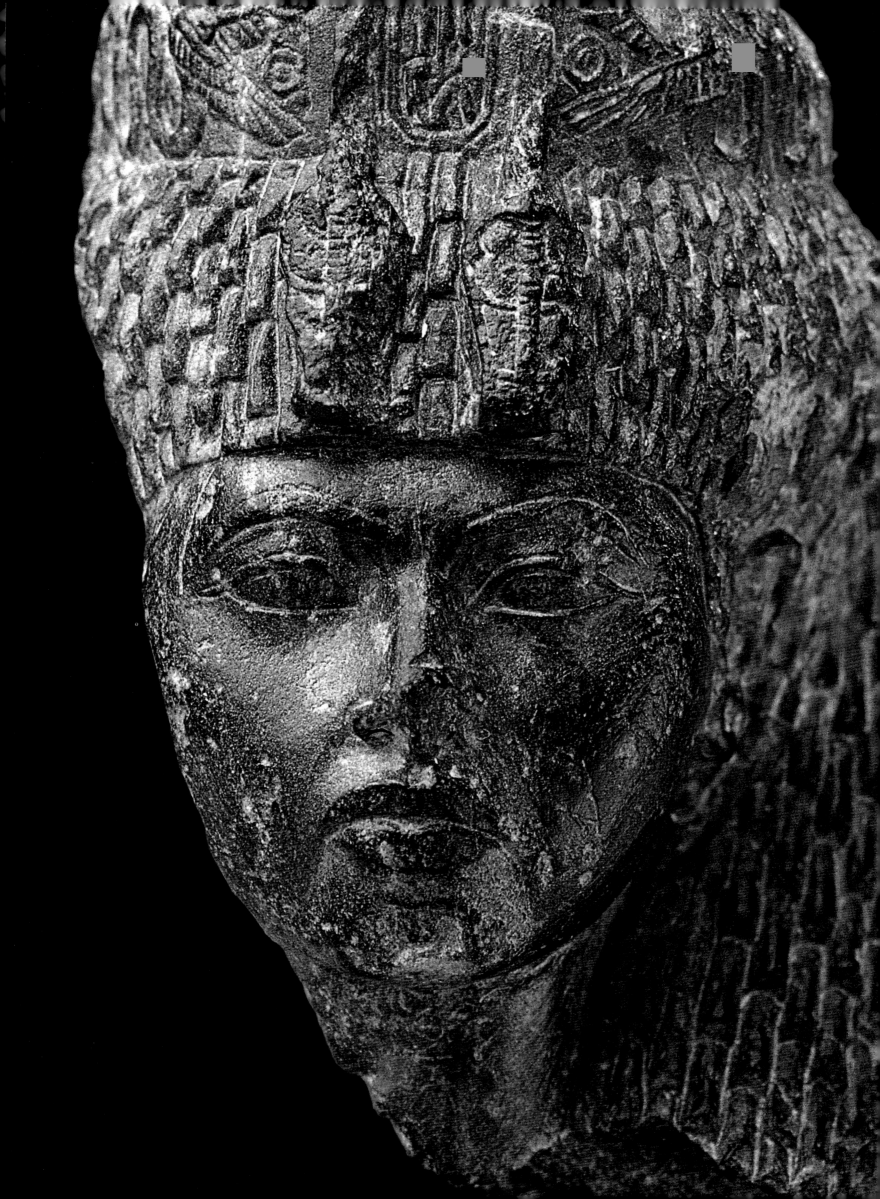

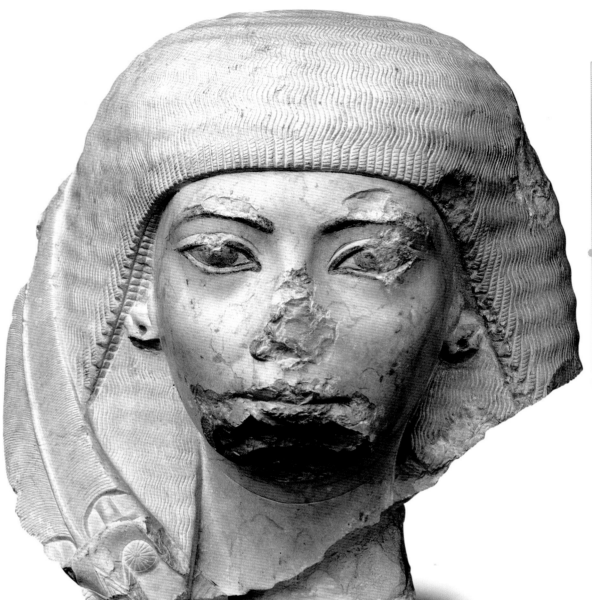

**FRAGMENTARY
STATUE OF
NAKHTMIN'S WIFE**

LIMESTONE
HEIGHT CM 85
End of the 18th Dynasty
(second half of the
14th century BC)

The detailing on the
face of this statue
reveals rare beauty. The
figure is wearing a
refined wig with a
diadem decorated with
floral motifs. The body
is swathed in a long
pleated tunic that
elegantly highlights its
shapeliness. This
fragmentary statue,
together with the head
of Nakhtmin, was
purchased in 1897.

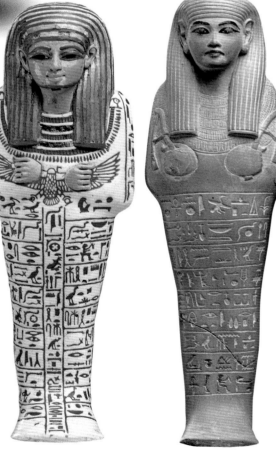

154 top
31630 = CG 779A

**STATUE OF
NAKHTIM**

LIMESTONE
HEIGHT CM 34
End of the 18th Dynasty
(second half of the
14th century BC)

The figure of
Nakhtmin, together
with that of his wife,
originally formed a
striking statuary
group. The exquisite
workmanship of the
relief denotes their
high rank. The artifact,
whose provenance is
unknown, was
purchased in 1897.

154 center
CG 48406

**USHABTY OF
PTAHMES**

POLYCHROME
FAÏENCE
HEIGHT CM 20
18th Dynasty, reign
of Amenhotep III
(1387-1350 BC)

This beautifully crafted
ushabty pertained to
Pthames, the Mayor of
Thebes and High Priest
of Amun. The elegant
contrast of colors
makes this statuette,
found at Abydos by A.
Mariette (1881), one of
a kind.

154 right
JE 39590

**USHABTY
OF HAT**

PAINTED LIMESTONE
HEIGHT CM 20.5
18TH DYNASTY,
AKHENATEN'S REIGN
(1346-1333 BC)

Traces of color make
this statuette
particularly lively and
intense. The statuette,
whose provenance is
unknown, was
purchased in 1908.
The hieroglyphic
inscription bears the
words used for a
funerary offering to
the sun disk Aten.

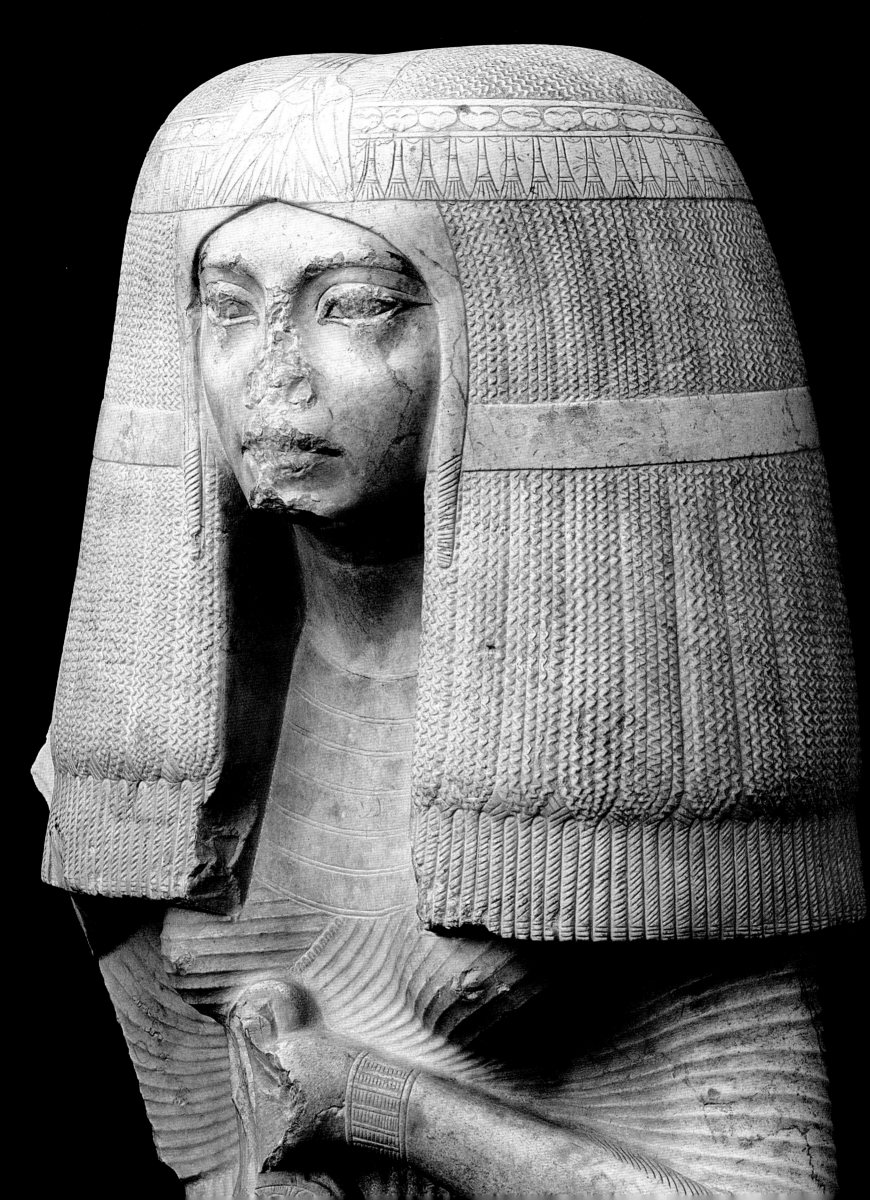

DOMESTIC ALTAR WITH FAMILY SCENE

PAINTED LIMESTONE
HEIGHT CM 44
18th Dynasty,
Akhenaten's reign
(1350-1333 BC)

The art of Amarna inaugurated a new and more naturalistic style, characterized by rich movement in the scene and the individualization of the members of the royal family. The altar shown here was discovered by L. Borchardt at Tell al-Amarna (1912).

COLOSSUS OF AKHENATEN

SANDSTONE
HEIGHT CM 185
18th Dynasty,
Akhenaten's reign
(1350-1333 BC)

The colossus, discovered by H. Chevrier in the Temple of Aten at Karnak (1926), reveals the traits distinctive of the Amarna period: an elongated face and skull, almond-shaped eyes, fleshy lips, a prominent chin, hollow cheeks, a long slender neck, wide hips and a pronounced belly.

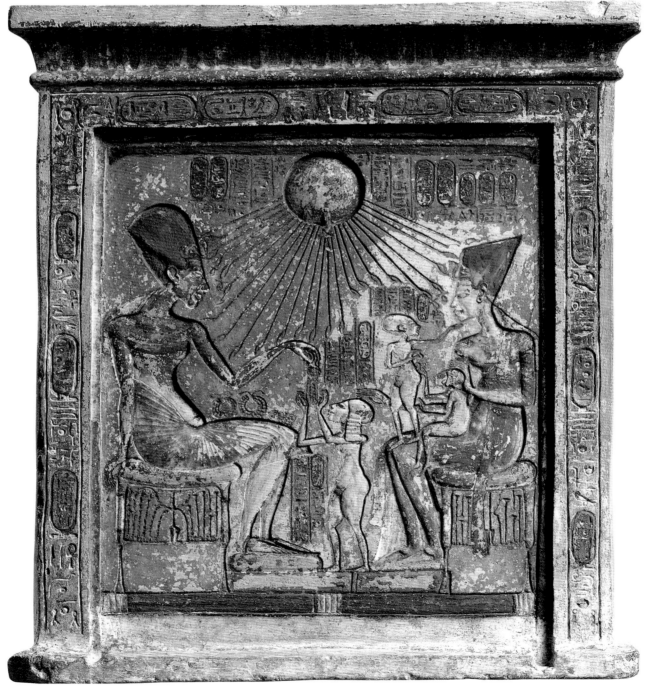

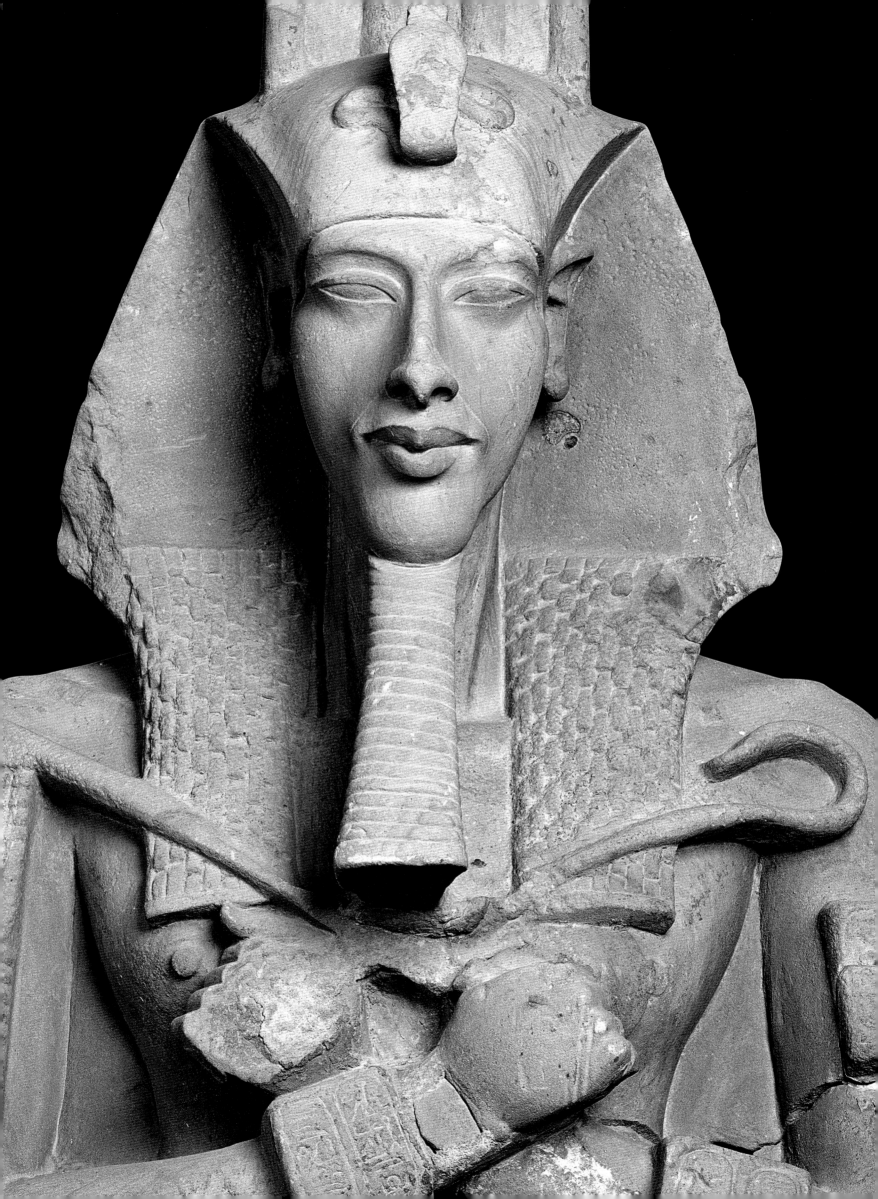

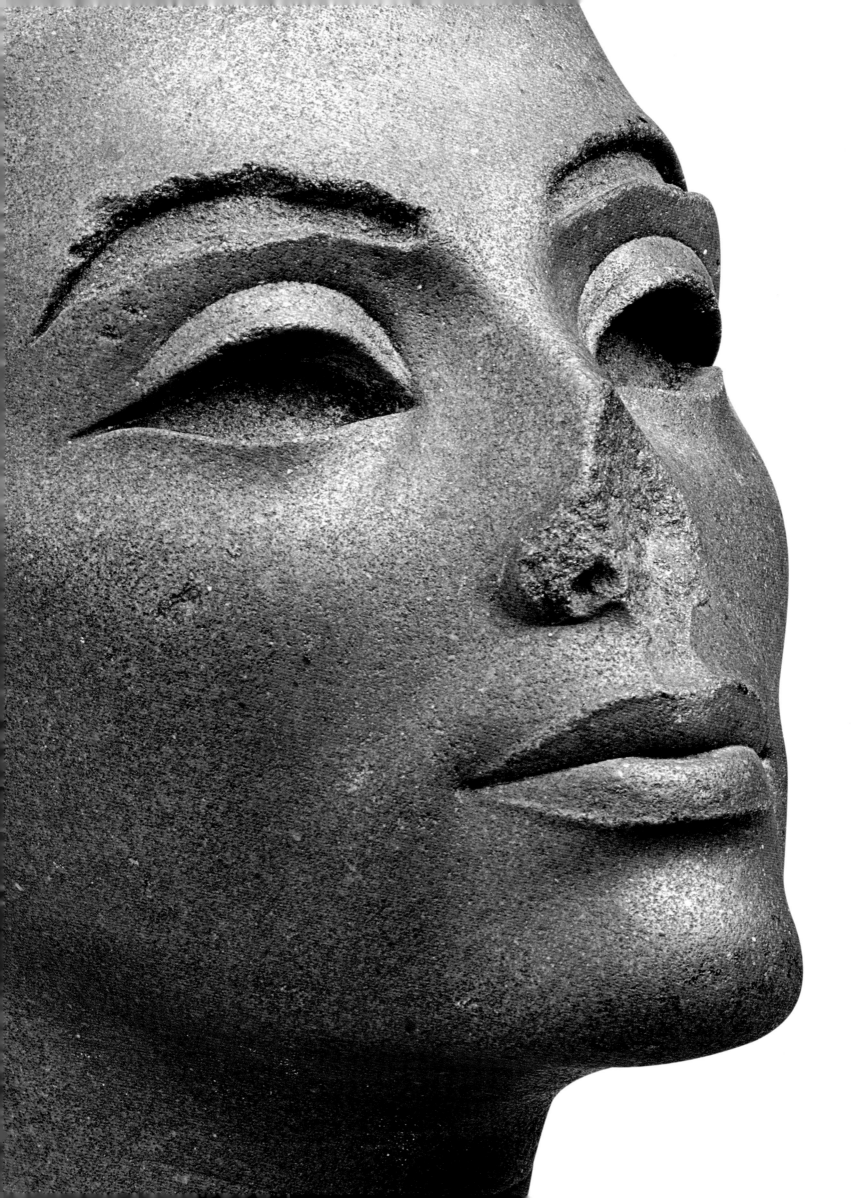

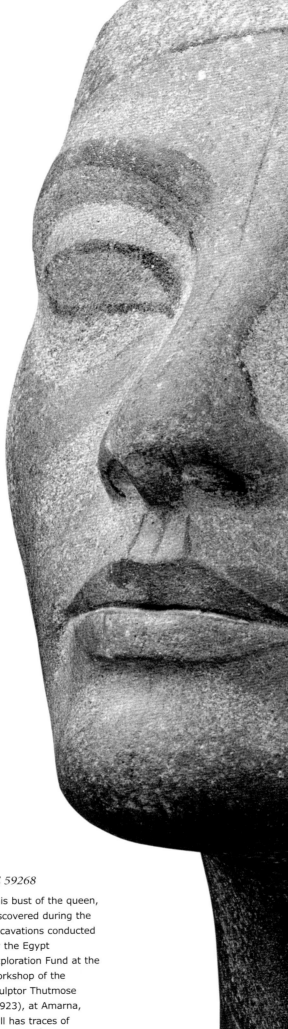

158
JE 45547

**BUST OF
AMARNAN QUEEN**

YELLOW-BROWN
QUARTZITE
HEIGHT CM 18
18th Dynasty,
Akhenaten's reign
(1350-1333 BC)

Discovered at
Merenptah's palace in
Memphis by the
expedition of the
University of
Pennsylvania (1915),
this head probably
pertained to the lovely
Queen Nefertiti,
Akhenaten's wife.
The color of the stone
gives the facial
features very soft
appearance. Only the
eyes are missing; they
were probably made
of vitreous paste.

159

**UNFINISHED
HEAD OF
NEFERTITI**

BROWN QUARTZITE
HEIGHT CM 35.5
Tell el-Amarna
18th Dynasty,
Akhenaten's reign
(1350-1333 BC)

JE 59268

This bust of the queen,
discovered during the
excavations conducted
by the Egypt
Exploration Fund at the
workshop of the
sculptor Thutmose
(1923), at Amarna,
still has traces of
black paint, used by
the artist as an aid
in carving the statue.

The New Kingdom

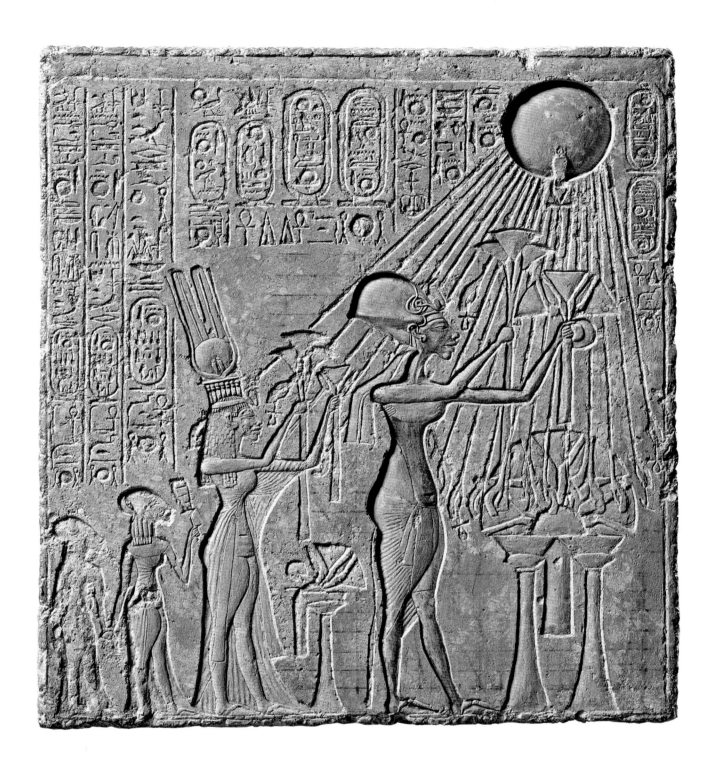

160 | *TR 10.11.26.4*

AMARNAN RELIEF

PAINTED LIMESTONE
HEIGHT CM 53
WIDTH CM 48
THICKNESS CM 8
18th Dynasty,
Akhenaten's reign
(1350-1333 BC)

The pharaoh, Aten's only priest, performs a ritual, accompanied by his family members in the sunlight, outside the temple. This relief, from the royal tomb of Amarna, was found by the Antiquities Service (1891).

161 | *JE 59396*

PORTRAIT OF NEFERTITI

LIMESTONE
HEIGHT CM 27
WIDTH CM 16.5
THICKNESS CM 4
18th Dynasty,
Akhenaten's reign
(1350-1333 BC)

Nefertiti profile is unmistakable in this exquisitely carved model for a relief, found in the Temple of Aten at Karnak (1951). The queen is wearing a tall and rigid crown with uraei that hang down and adorn her cheekbones.

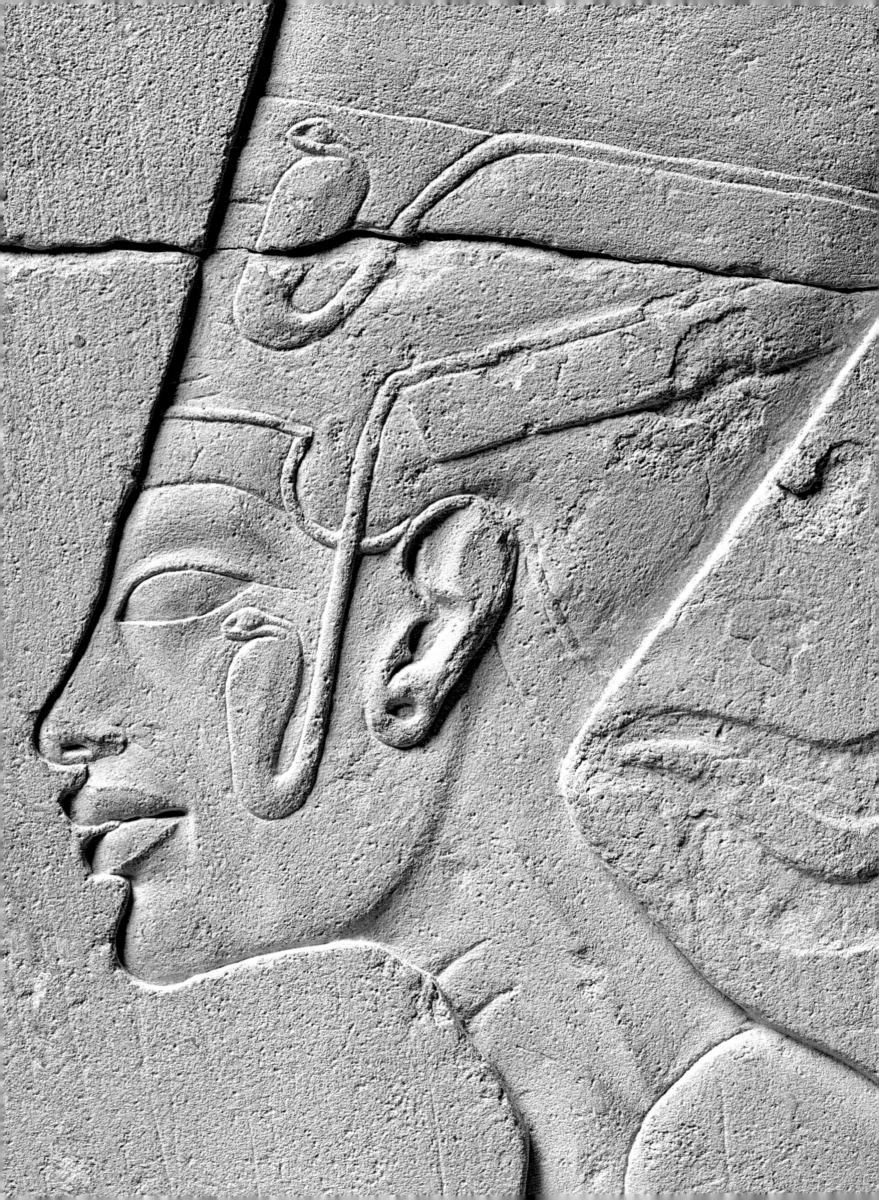

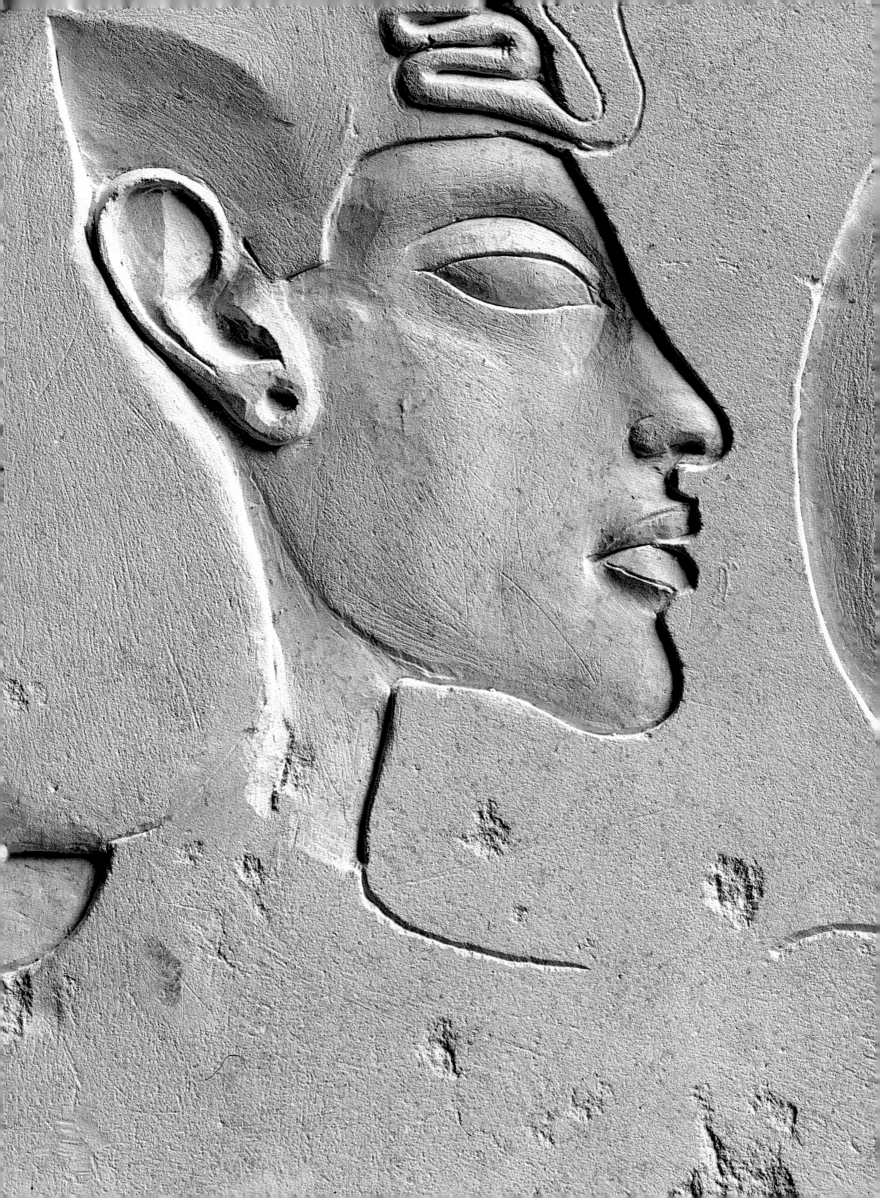

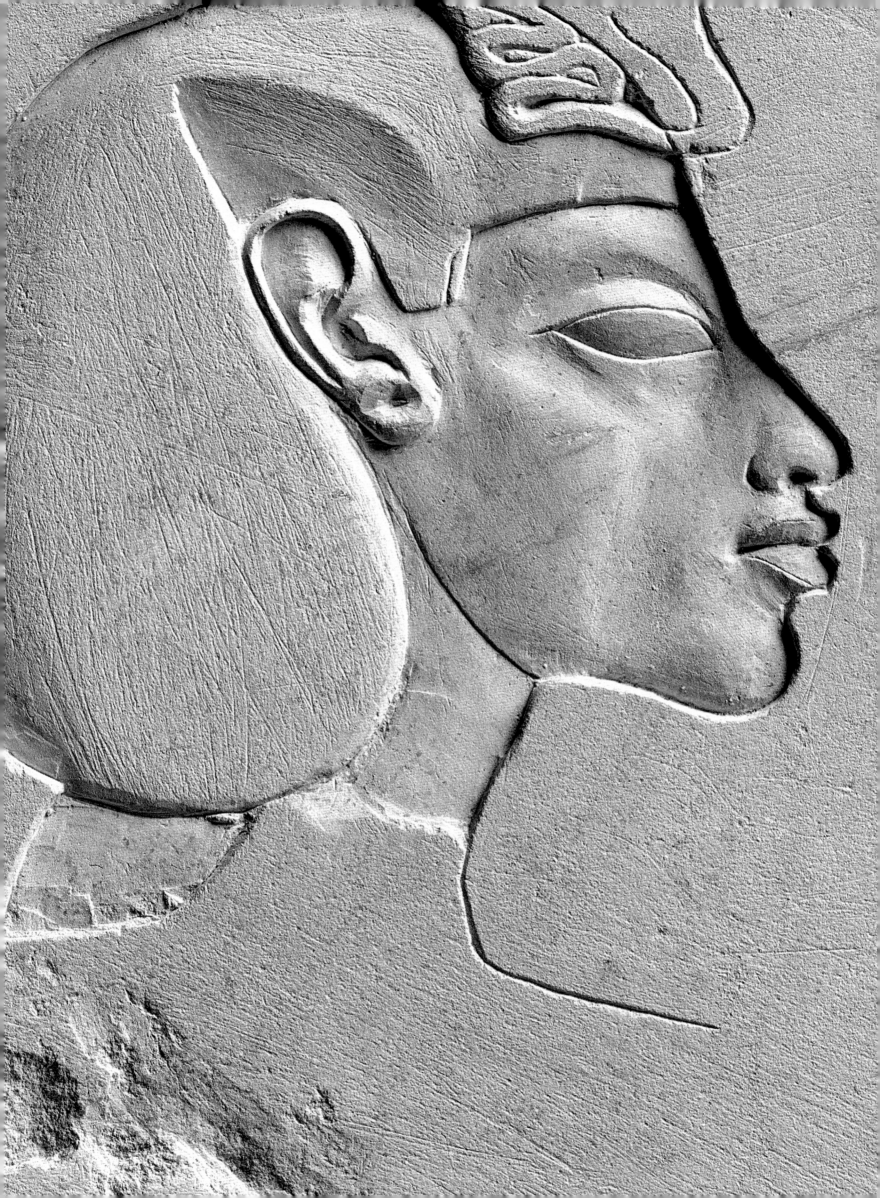

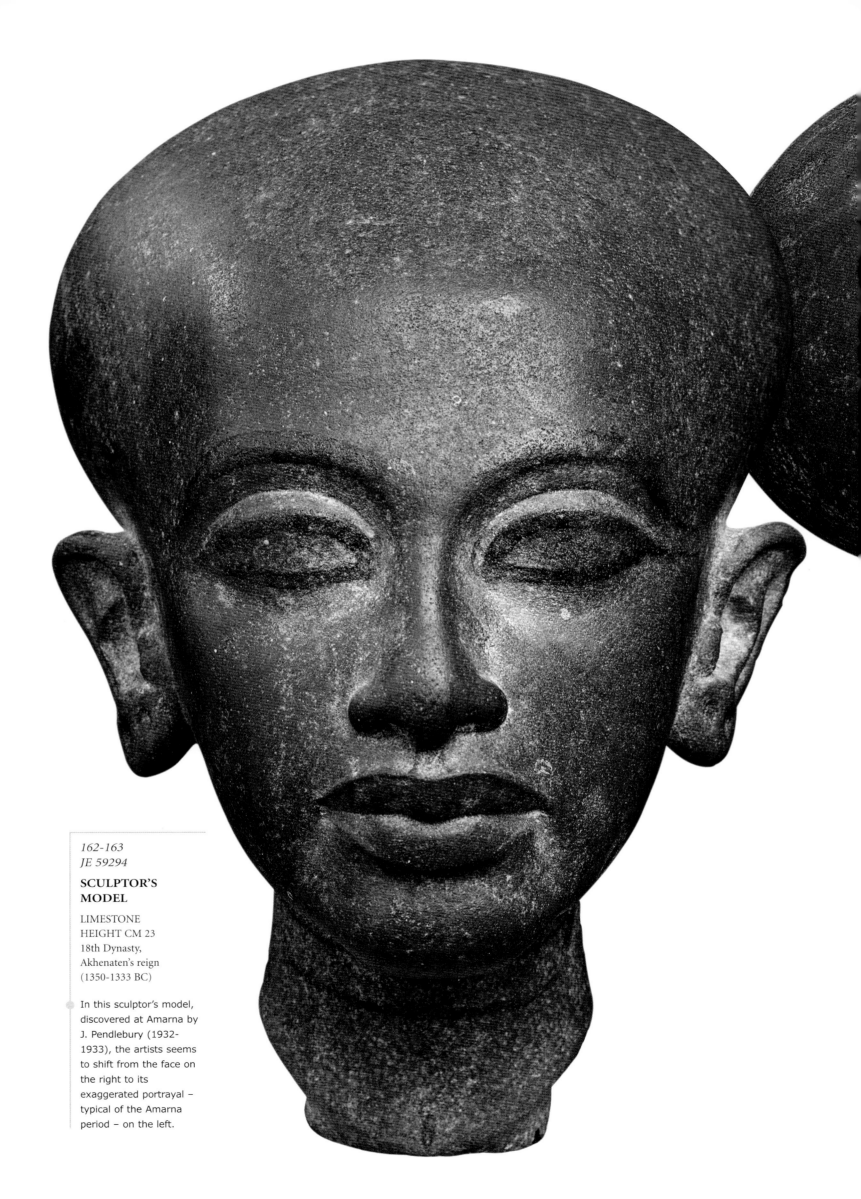

162-163
JE 59294

SCULPTOR'S MODEL

LIMESTONE
HEIGHT CM 23
18th Dynasty,
Akhenaten's reign
(1350-1333 BC)

In this sculptor's model,
discovered at Amarna by
J. Pendlebury (1932-
1933), the artists seems
to shift from the face on
the right to its
exaggerated portrayal –
typical of the Amarna
period – on the left.

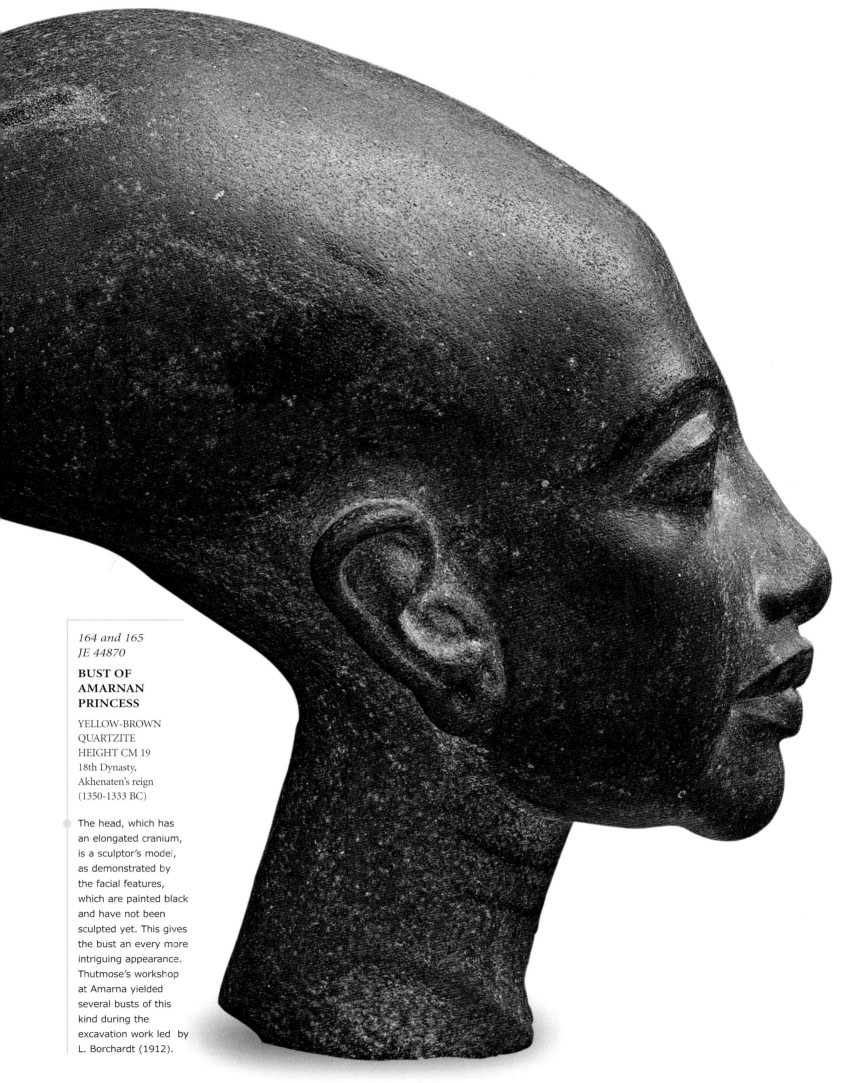

164 and 165
JE 44870

**BUST OF
AMARNAN
PRINCESS**

YELLOW-BROWN
QUARTZITE
HEIGHT CM 19
18th Dynasty,
Akhenaten's reign
(1350-1333 BC)

The head, which has
an elongated cranium,
is a sculptor's model,
as demonstrated by
the facial features,
which are painted black
and have not been
sculpted yet. This gives
the bust an every more
intriguing appearance.
Thutmose's workshop
at Amarna yielded
several busts of this
kind during the
excavation work led by
L. Borchardt (1912).

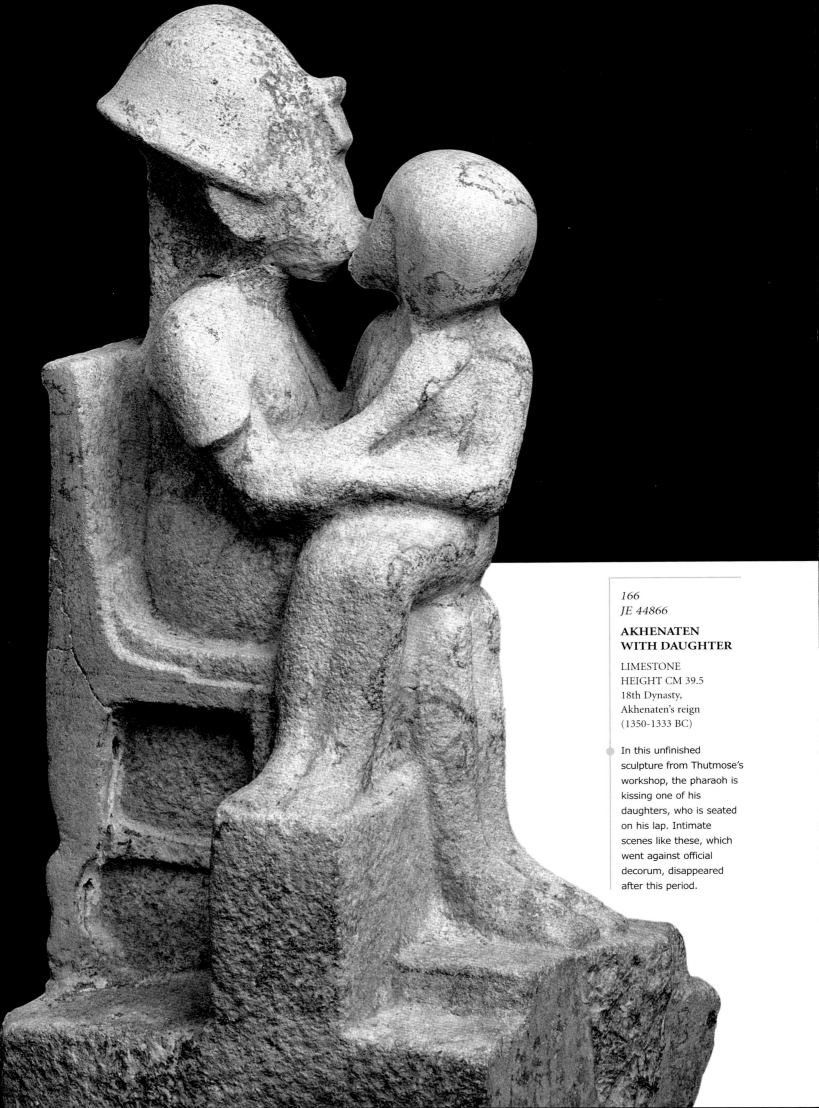

166
JE 44866

AKHENATEN WITH DAUGHTER

LIMESTONE
HEIGHT CM 39.5
18th Dynasty,
Akhenaten's reign
(1350-1333 BC)

In this unfinished sculpture from Thutmose's workshop, the pharaoh is kissing one of his daughters, who is seated on his lap. Intimate scenes like these, which went against official decorum, disappeared after this period.

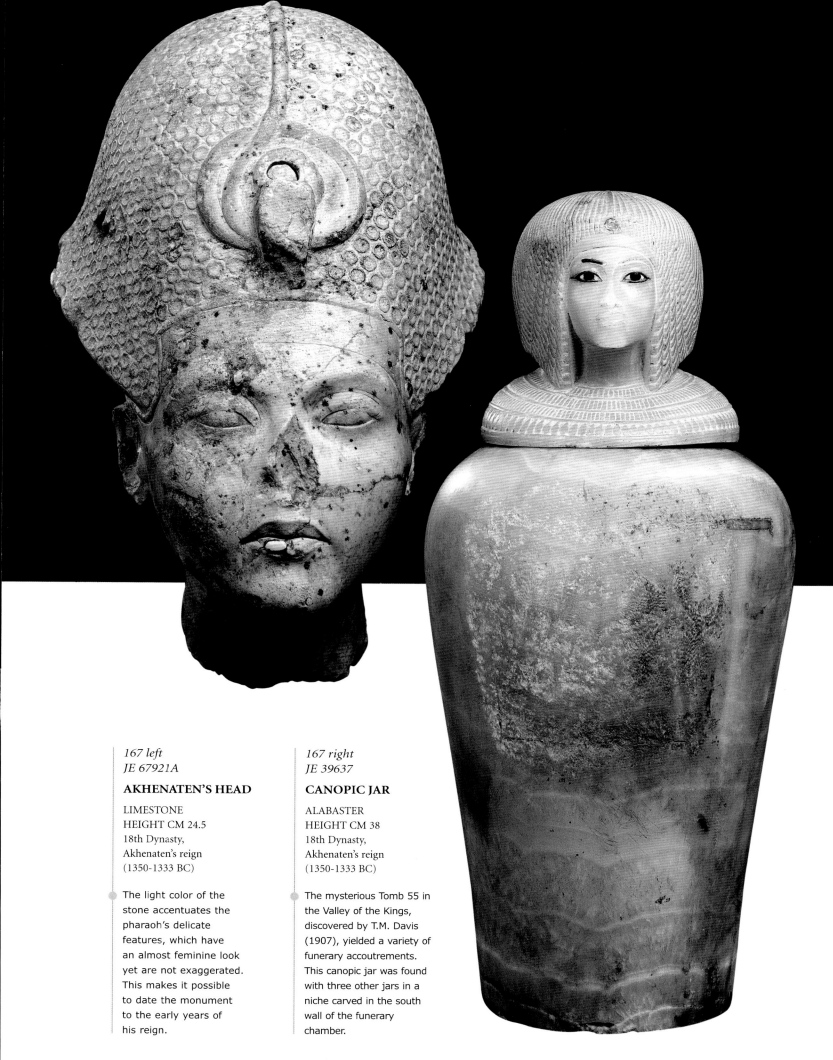

167 left
JE 67921A

AKHENATEN'S HEAD

LIMESTONE
HEIGHT CM 24.5
18th Dynasty,
Akhenaten's reign
(1350-1333 BC)

The light color of the
stone accentuates the
pharaoh's delicate
features, which have
an almost feminine look
yet are not exaggerated.
This makes it possible
to date the monument
to the early years of
his reign.

167 right
JE 39637

CANOPIC JAR

ALABASTER
HEIGHT CM 38
18th Dynasty,
Akhenaten's reign
(1350-1333 BC)

The mysterious Tomb 55 in
the Valley of the Kings,
discovered by T.M. Davis
(1907), yielded a variety of
funerary accoutrements.
This canopic jar was found
with three other jars in a
niche carved in the south
wall of the funerary
chamber.

168 top
JE 33030 - 33031

FLOOR FRAGMENT

PAINTED PLASTER
HEIGHT CM 101
WIDTH CM 160
18th Dynasty, Akhenaten's
reign (1350-1333 BC)

The beauty of nature,
praised in the Hymn to
Aten, is described in this
artifact unearthed by A.
Barsanti in the South Palace
at Amarna (1896).

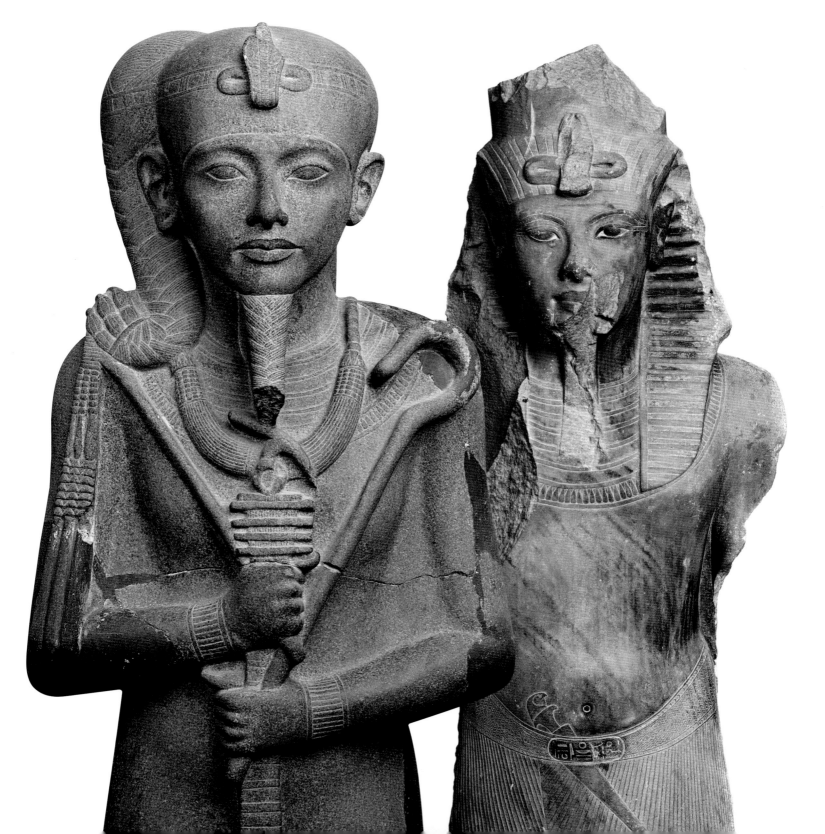

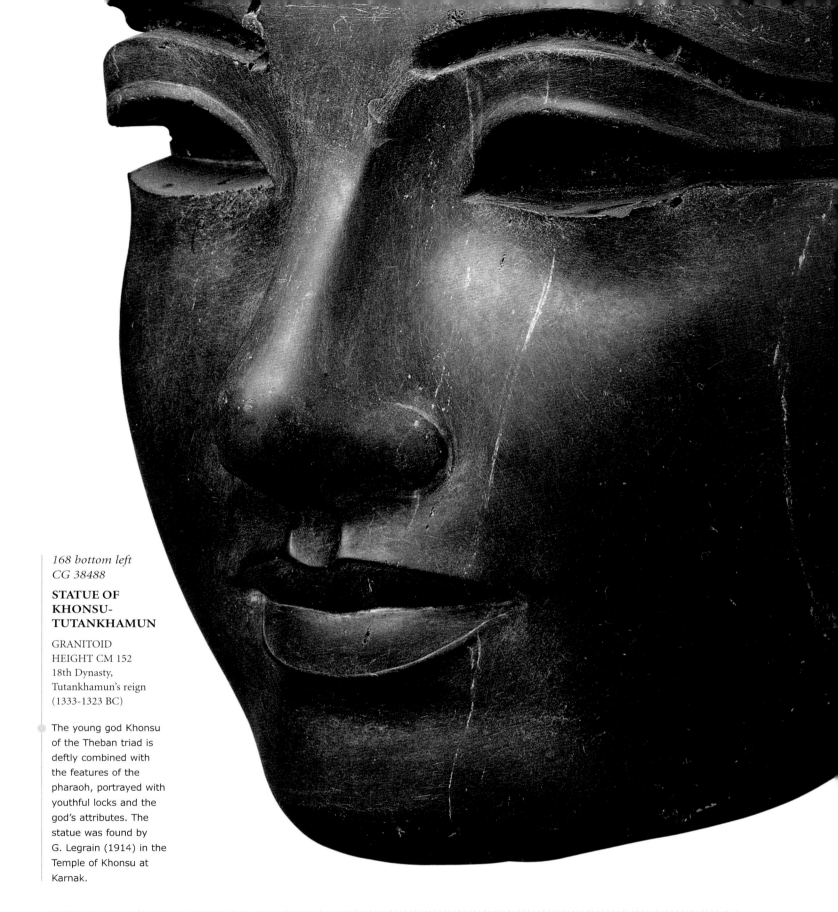

168 bottom left
CG 38488

STATUE OF KHONSU-TUTANKHAMUN

GRANITOID
HEIGHT CM 152
18th Dynasty,
Tutankhamun's reign
(1333-1323 BC)

The young god Khonsu
of the Theban triad is
deftly combined with
the features of the
pharaoh, portrayed with
youthful locks and the
god's attributes. The
statue was found by
G. Legrain (1914) in the
Temple of Khonsu at
Karnak.

168 bottom right

COLOSSUS OF TUTANKHAMUN

PINK QUARTZITE
HEIGHT CM 285
WIDTH CM 73
18th Dynasty,
Tutankhamun's reign
(1333-1323 BC)

JE 59869

The face on this
statue reflects
Amarnan features,
giving this colossus,
found at Medinet
Habu by the Oriental
Institute of Chicago, a
particularly lively
appearance (1931).

169

BUST

OBSIDIAN
HEIGHT CM 20
WIDTH CM 15
18th Dynasty (second half
of the 14th century BC)

JE 38248 = CG 42101

G. Legrain discovered
this head in the cache
at Karnak (1903-1905).
Based on its facial
features, particularly
the eyes and lips, it has
been dated to the reign
of Amenhotep III.

INNERMOST SARCOPHAGUS OF TUTANKHAMUN

SOLID GOLD, SEMIPRECIOUS
STONES, VITREOUS PASTE
HEIGHT CM 51
WIDTH CM 51.3
LENGTH CM 187
WEIGHT KG 110.4
18th Dynasty, Tutankhamun's reign
(1333-1323 BC)

The solid gold sarcophagus – the third and innermost one, which contained the body of Tutankhamun – is the most spectacular one ever found. When Howard Carter and Lord Carnarvon discovered it in the famous Tomb KV 62 in the Valley of the Kings, it was completely covered with bituminous resin (1922).

SECOND SARCOPHAGUS OF TUTANKHAMUN

GILDED WOOD, SEMIPRECIOUS
STONES, VITREOUS PASTE
HEIGHT CM 78.5
WIDTH CM 68
LENGTH CM 204
18th Dynasty, Tutankhamun's reign
(1333-1323 BC)

The second sarcophagus, featuring a rishi or feathered pattern, is equally precious and shows extraordinary workmanship. It is decorated entirely in cloisonné with sapphire, light blue and red vitreous paste.

TUTANKHAMUN'S BURIAL MASK

SOLID GOLD,
GEMSTONES, QUARTZ,
VITREOUS PASTE
HEIGHT CM 54
WEIGHT KG 11
18th Dynasty,
Tutankhamun's reign
(1333-1323 BC)

The mask was discovered on the pharaoh's intact mummy, still covered with the usual ritual objects set on and between the bandaging as protection. This is how the face of Tutankhamun appeared – in all its splendor – to its discoverer.

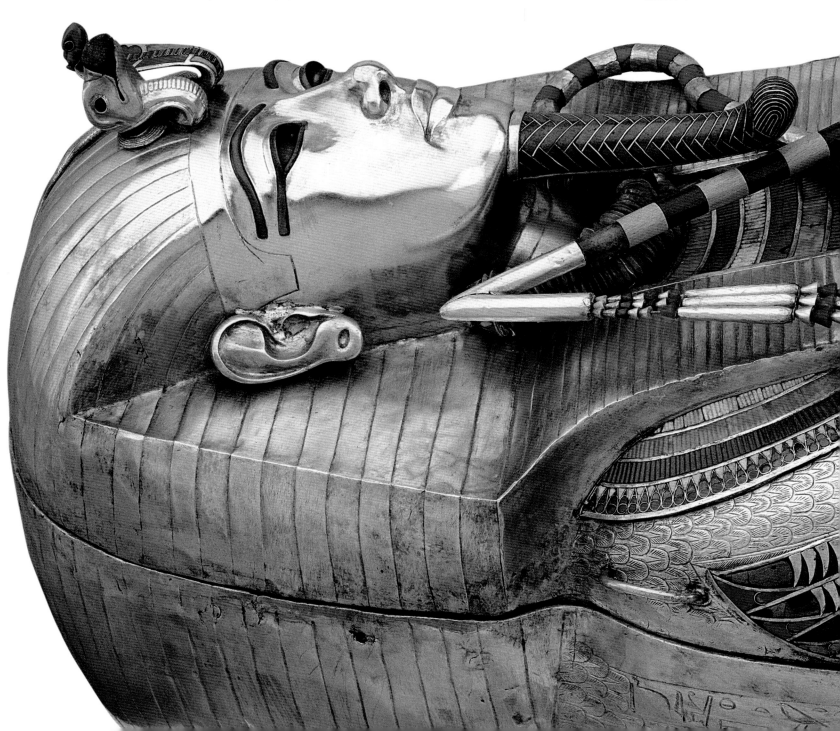

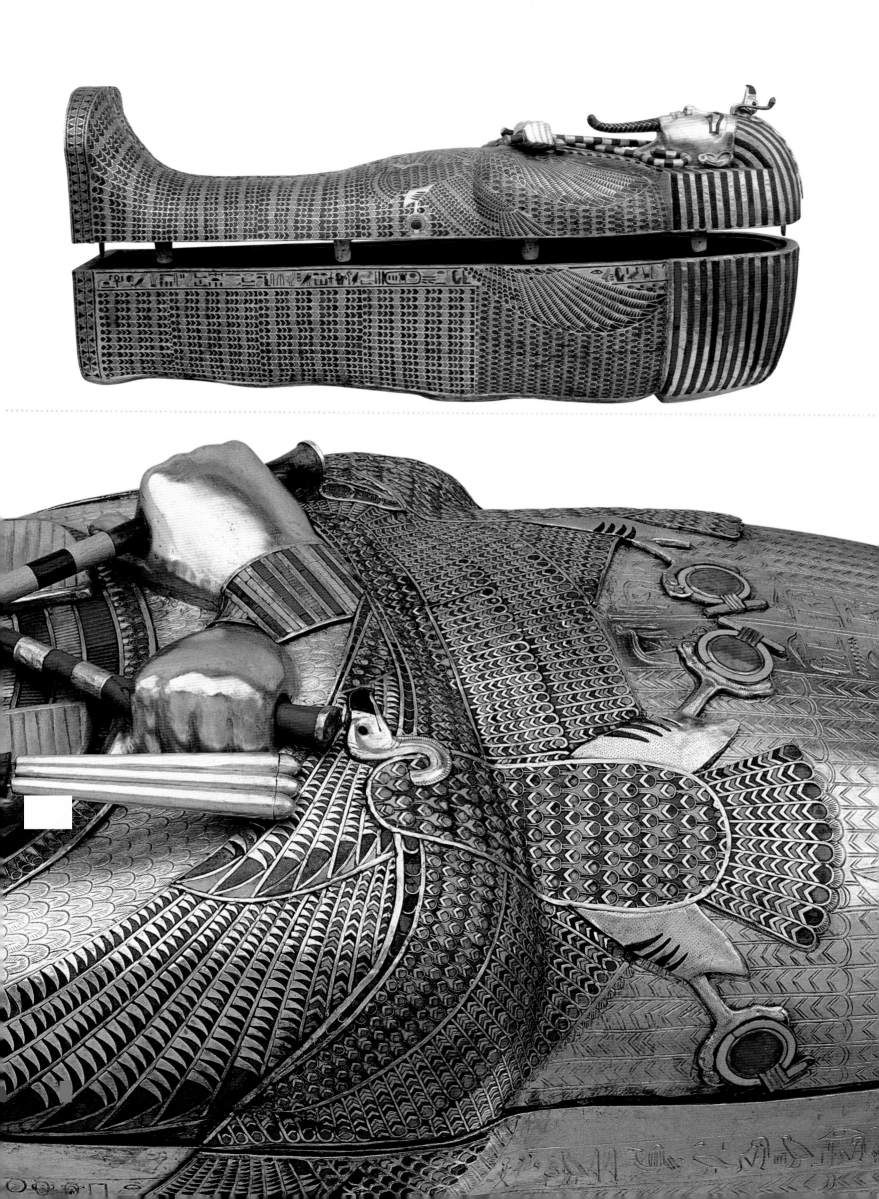

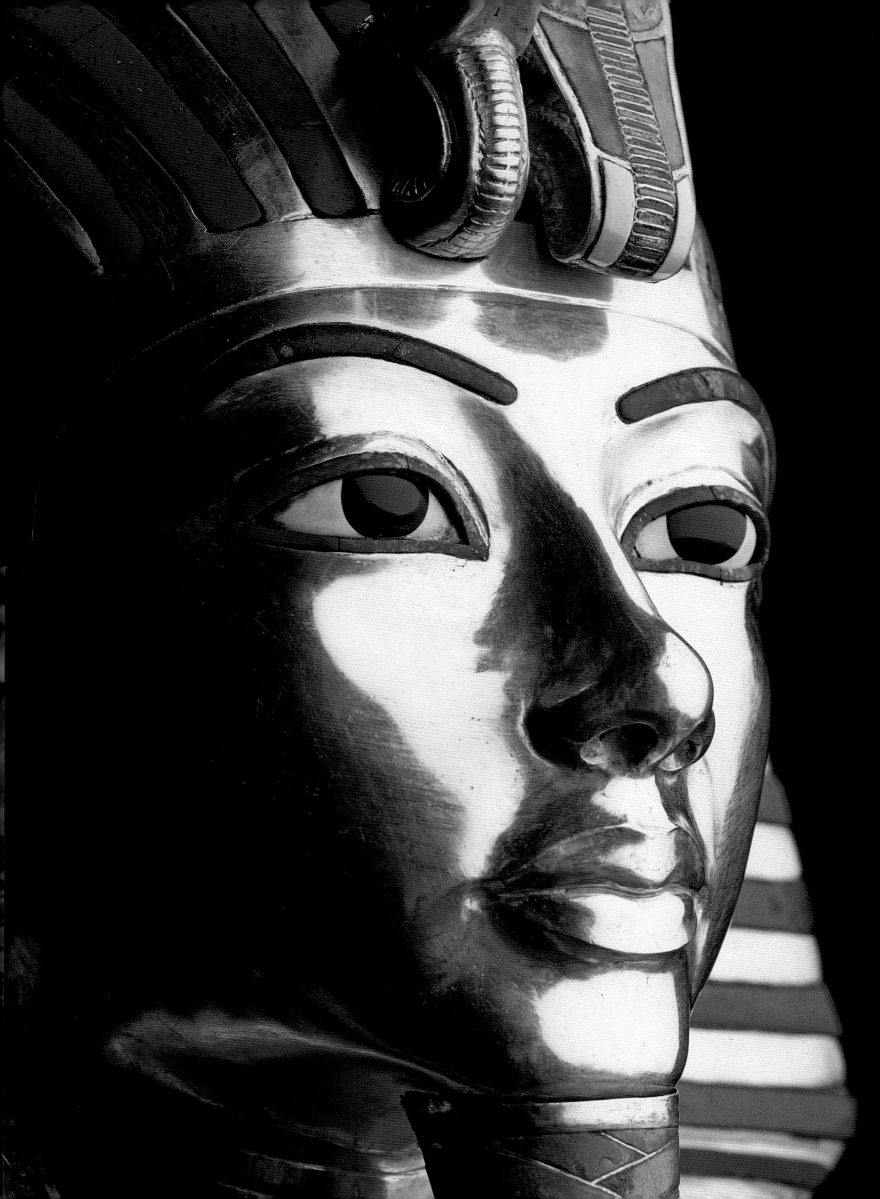

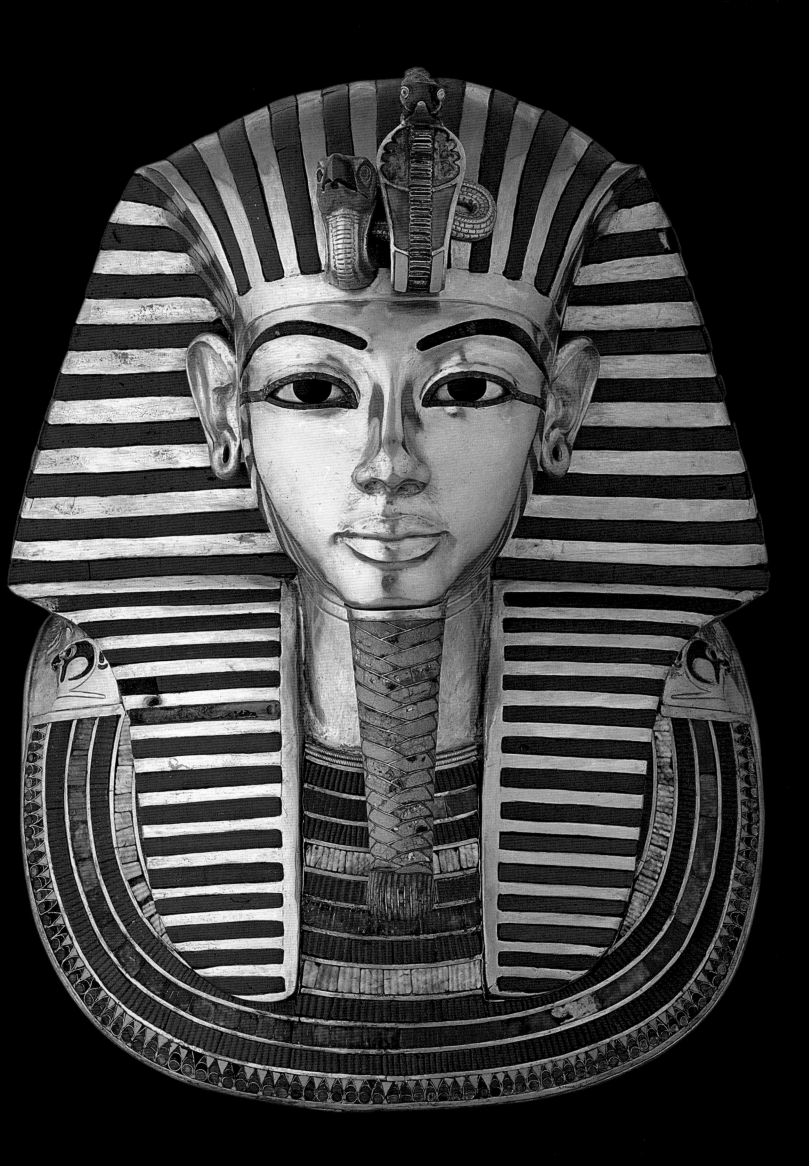

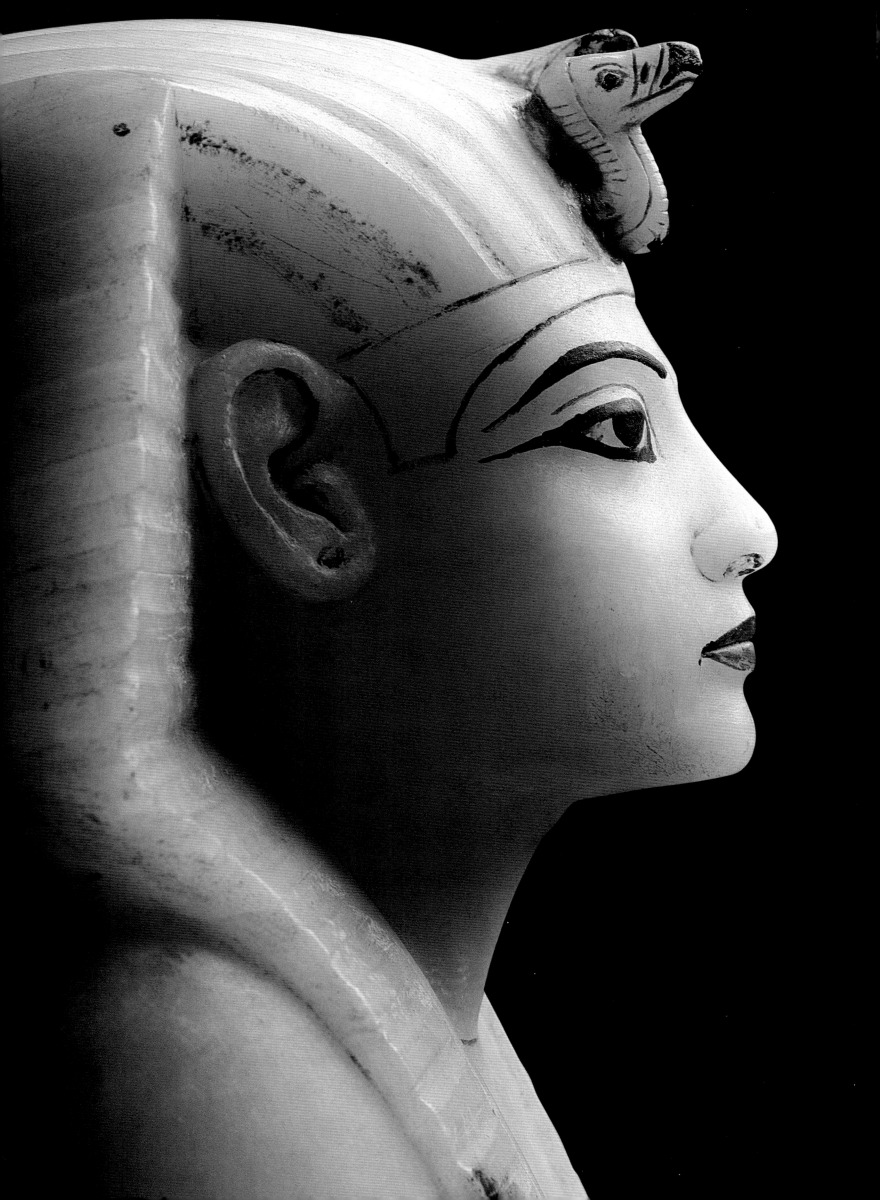

CONTAINER WITH THE CANOPIC JARS OF TUTANKHAMUN

ALABASTER
HEIGHT CM 85.5
SIDE WIDTH AT THE BASE CM 54
18th Dynasty, Tutankhamun's reign
(1333-1323 BC)

The alabaster container, with a gilded base, is set on a gilded wooden sledge and was originally covered by a linen cloth. The four jars, with lids portraying the pharaoh's head, with red lips and eyes outlined in black, are exquisitely crafted.

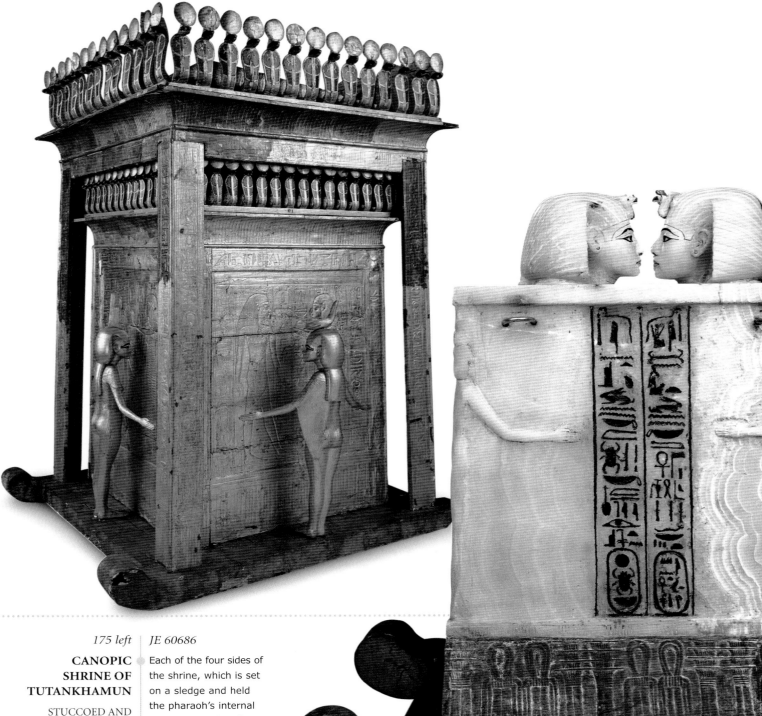

CANOPIC SHRINE OF TUTANKHAMUN

STUCCOED AND GILDED WOOD, VITREOUS PASTE, FAIENCE
HEIGHT CM 198
18th Dynasty, Tutankhamun's reign
(1333-1323 BC)

Each of the four sides of the shrine, which is set on a sledge and held the pharaoh's internal organs, was placed under the protection of breathtakingly beautiful goddesses. The deities differ only their headdresses. The goddesses on the sides of the shrine are associated with the four sons of Horus.

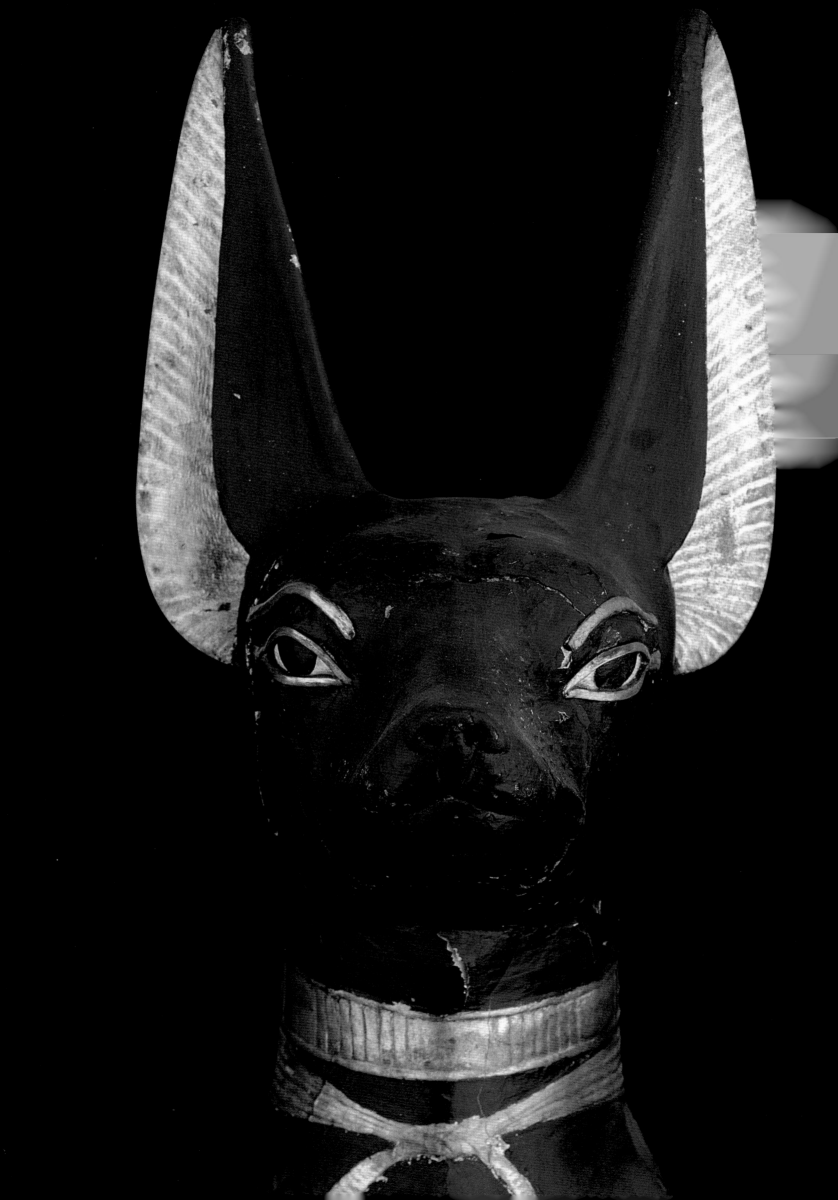

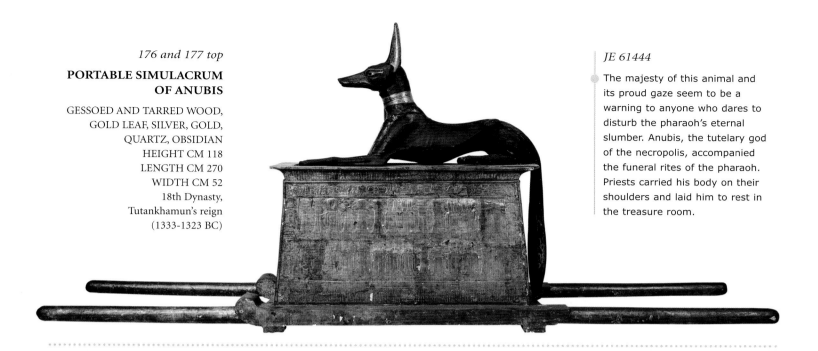

**PORTABLE SIMULACRUM
OF ANUBIS**

GESSOED AND TARRED WOOD,
GOLD LEAF, SILVER, GOLD,
QUARTZ, OBSIDIAN
HEIGHT CM 118
LENGTH CM 270
WIDTH CM 52
18th Dynasty,
Tutankhamun's reign
(1333-1323 BC)

JE 61444

The majesty of this animal and its proud gaze seem to be a warning to anyone who dares to disturb the pharaoh's eternal slumber. Anubis, the tutelary god of the necropolis, accompanied the funeral rites of the pharaoh. Priests carried his body on their shoulders and laid him to rest in the treasure room.

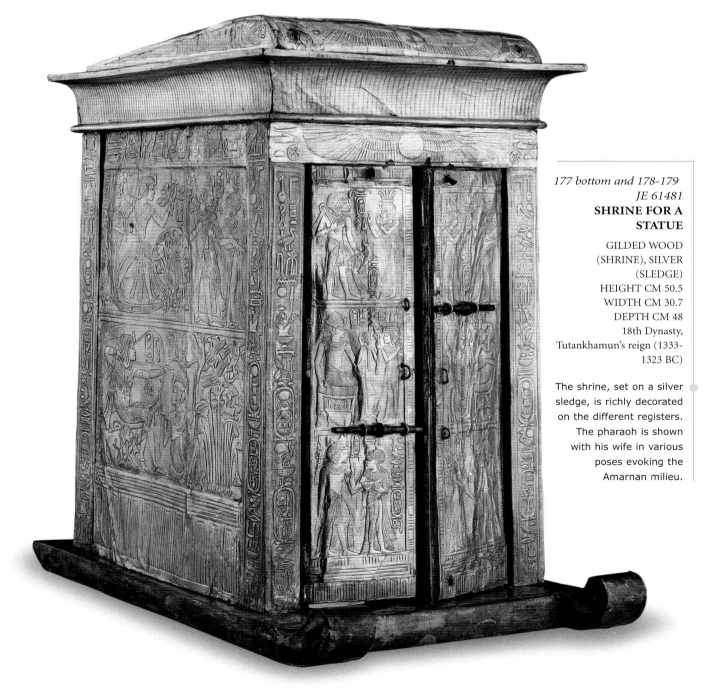

177 bottom and 178-179
JE 61481
**SHRINE FOR A
STATUE**

GILDED WOOD
(SHRINE), SILVER
(SLEDGE)
HEIGHT CM 50.5
WIDTH CM 30.7
DEPTH CM 48
18th Dynasty,
Tutankhamun's reign (1333-
1323 BC)

The shrine, set on a silver sledge, is richly decorated on the different registers. The pharaoh is shown with his wife in various poses evoking the Amarnan milieu.

The New Kingdom

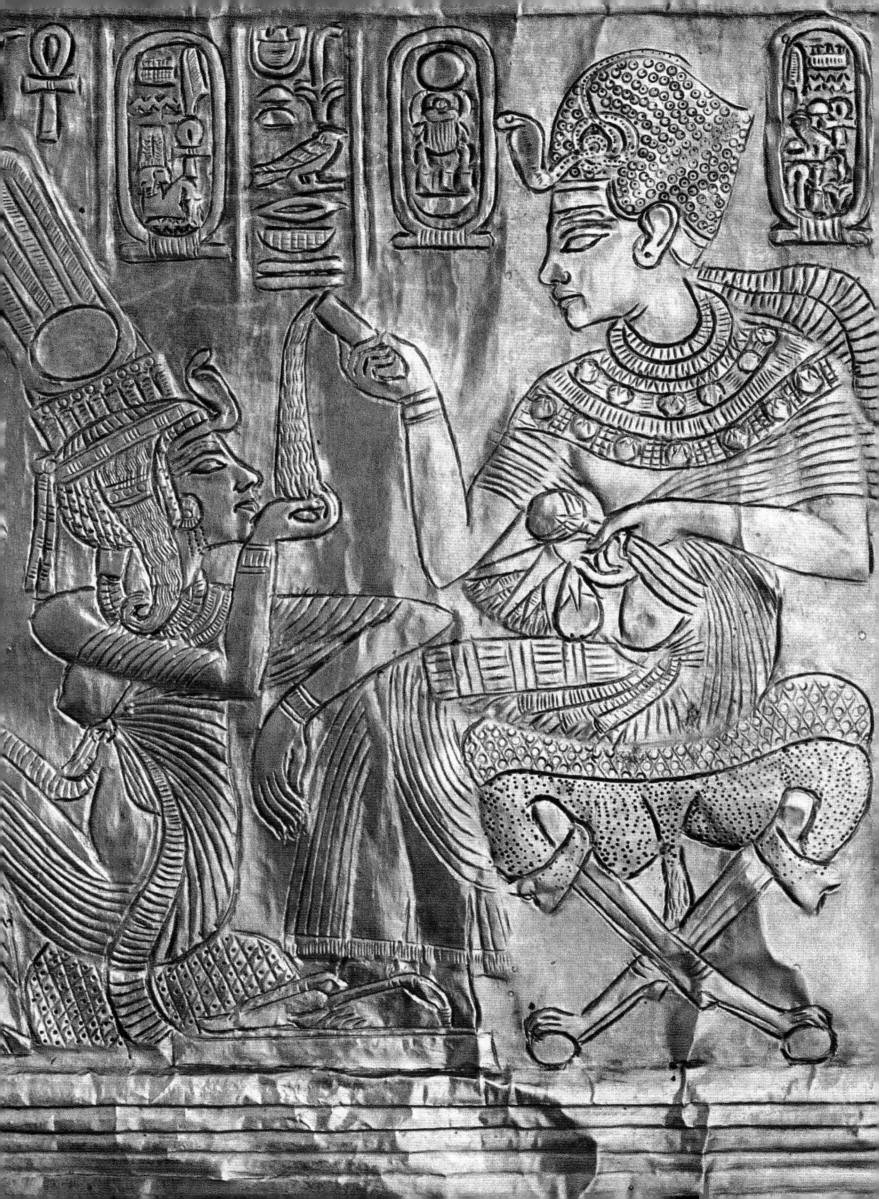

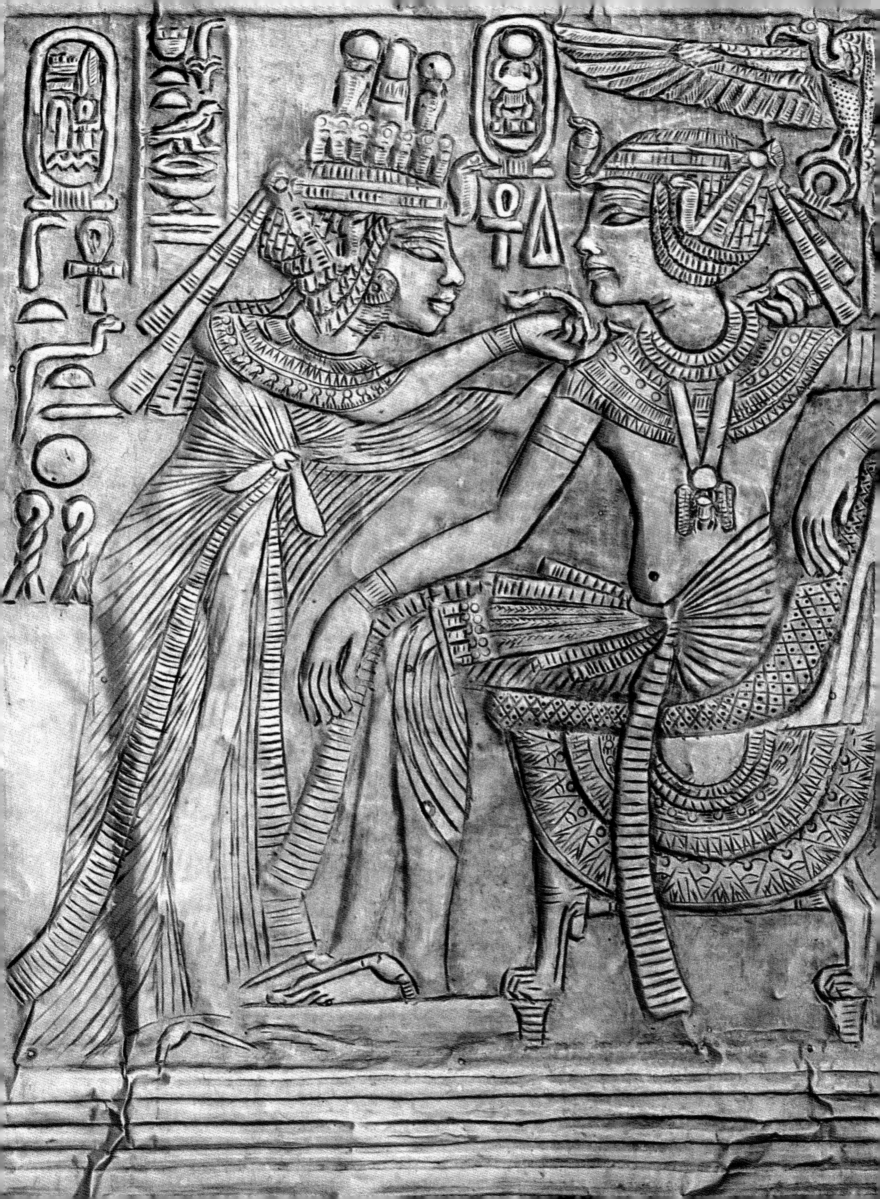

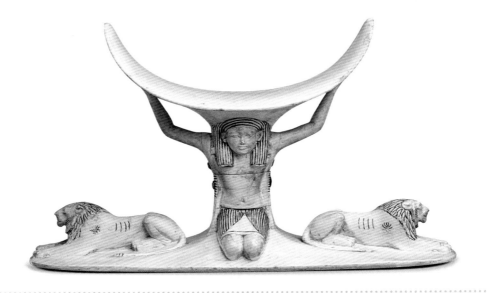

JE 62020

This headrest shows a lively composition. It is supported by the god Shu, who is lifting the heavens over the earth and sits between the two horizons of the sky, symbolized by two crouching lions.

*JE 62012
(Ammut)
JE 62011
(Mehet-Weret)
JE 62013
(Isis-Mehtet)*

These three funerary beds are from the treasure of Tutankhamun. They are decorated with a hippopotamus head, identified as the goddess Ammut, a lion that is erroneously associated with the goddess Mehet-Weret, and a cow, corresponding to the goddess Isis-Mehtet, as indicated in the inscriptions on them.

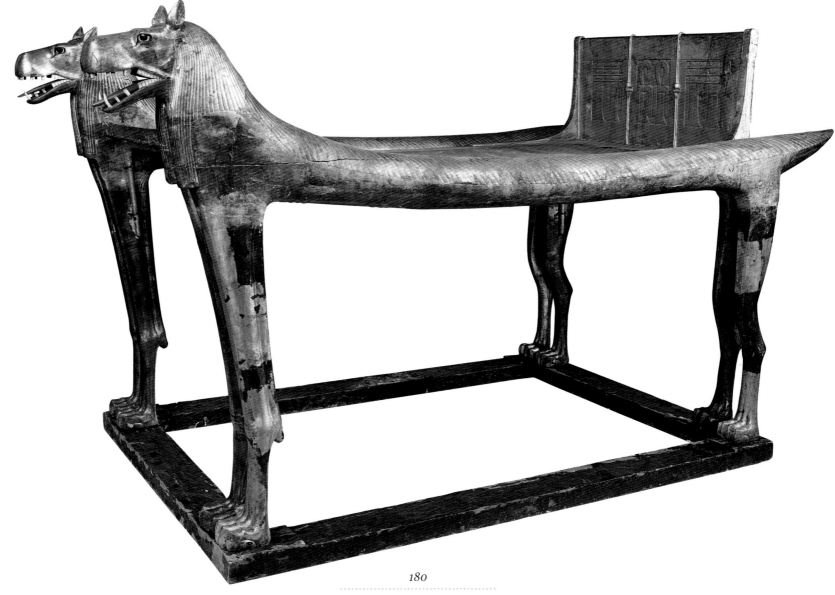

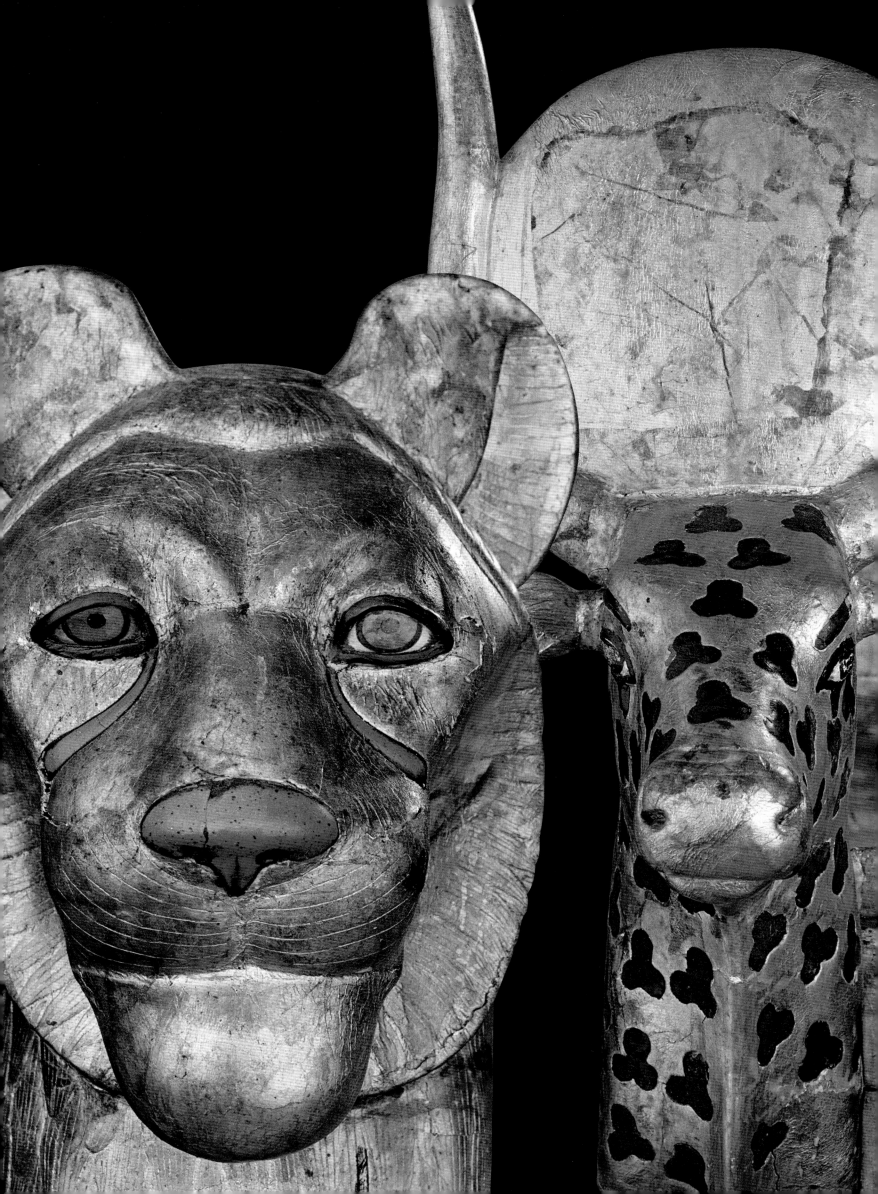

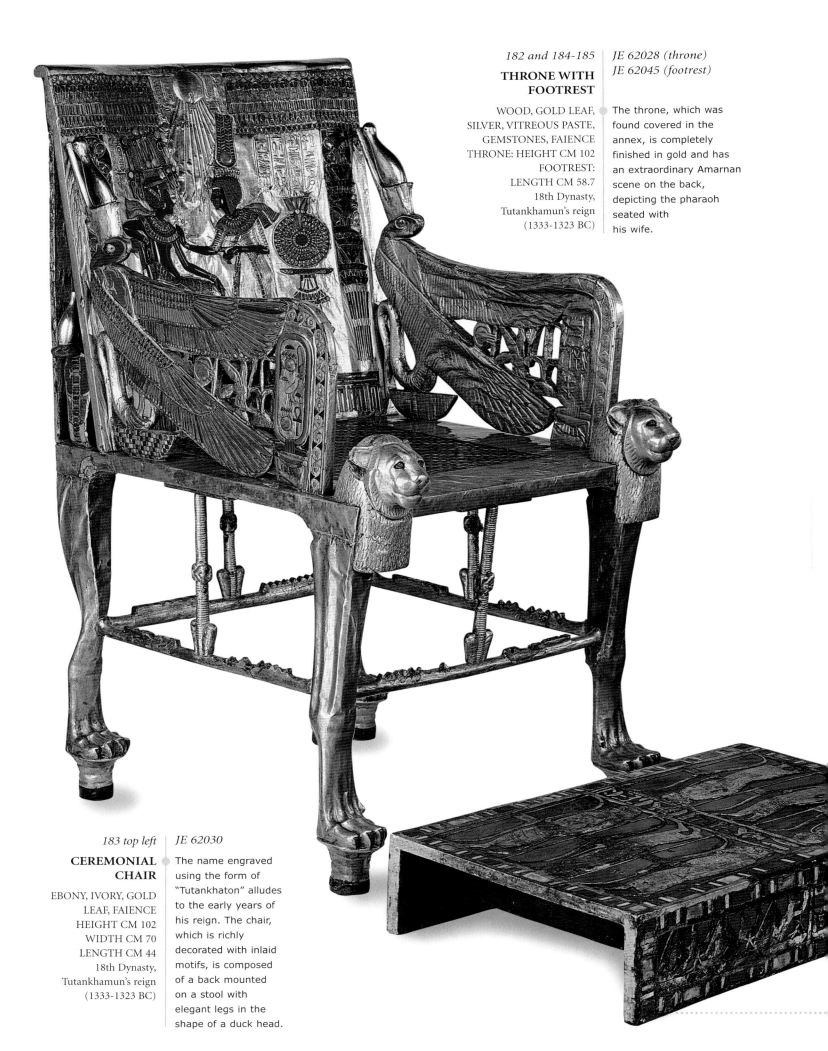

182 and 184-185

THRONE WITH FOOTREST

WOOD, GOLD LEAF,
SILVER, VITREOUS PASTE,
GEMSTONES, FAIENCE
THRONE: HEIGHT CM 102
FOOTREST:
LENGTH CM 58.7
18th Dynasty,
Tutankhamun's reign
(1333-1323 BC)

JE 62028 (throne)
JE 62045 (footrest)

The throne, which was
found covered in the
annex, is completely
finished in gold and has
an extraordinary Amarnan
scene on the back,
depicting the pharaoh
seated with
his wife.

183 top left

CEREMONIAL CHAIR

EBONY, IVORY, GOLD
LEAF, FAIENCE
HEIGHT CM 102
WIDTH CM 70
LENGTH CM 44
18th Dynasty,
Tutankhamun's reign
(1333-1323 BC)

JE 62030

The name engraved
using the form of
"Tutankhaton" alludes
to the early years of
his reign. The chair,
which is richly
decorated with inlaid
motifs, is composed
of a back mounted
on a stool with
elegant legs in the
shape of a duck head.

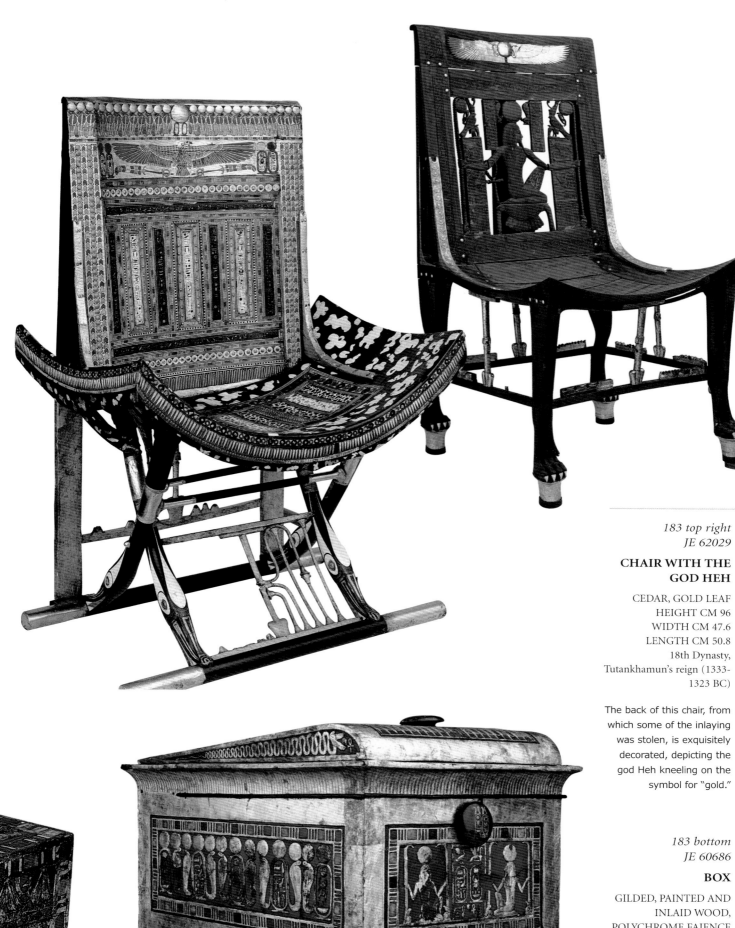

183 top right
JE 62029

**CHAIR WITH THE
GOD HEH**

CEDAR, GOLD LEAF
HEIGHT CM 96
WIDTH CM 47.6
LENGTH CM 50.8
18th Dynasty,
Tutankhamun's reign (1333-
1323 BC)

The back of this chair, from
which some of the inlaying
was stolen, is exquisitely
decorated, depicting the
god Heh kneeling on the
symbol for "gold."

183 bottom
JE 60686

BOX

GILDED, PAINTED AND
INLAID WOOD,
POLYCHROME FAIENCE
HEIGHT CM 39
18th Dynasty,
Tutankhamun's reign
(1333-1323 BC)

The box was closed by
winding a cord around
two knobs, visible
on the right.

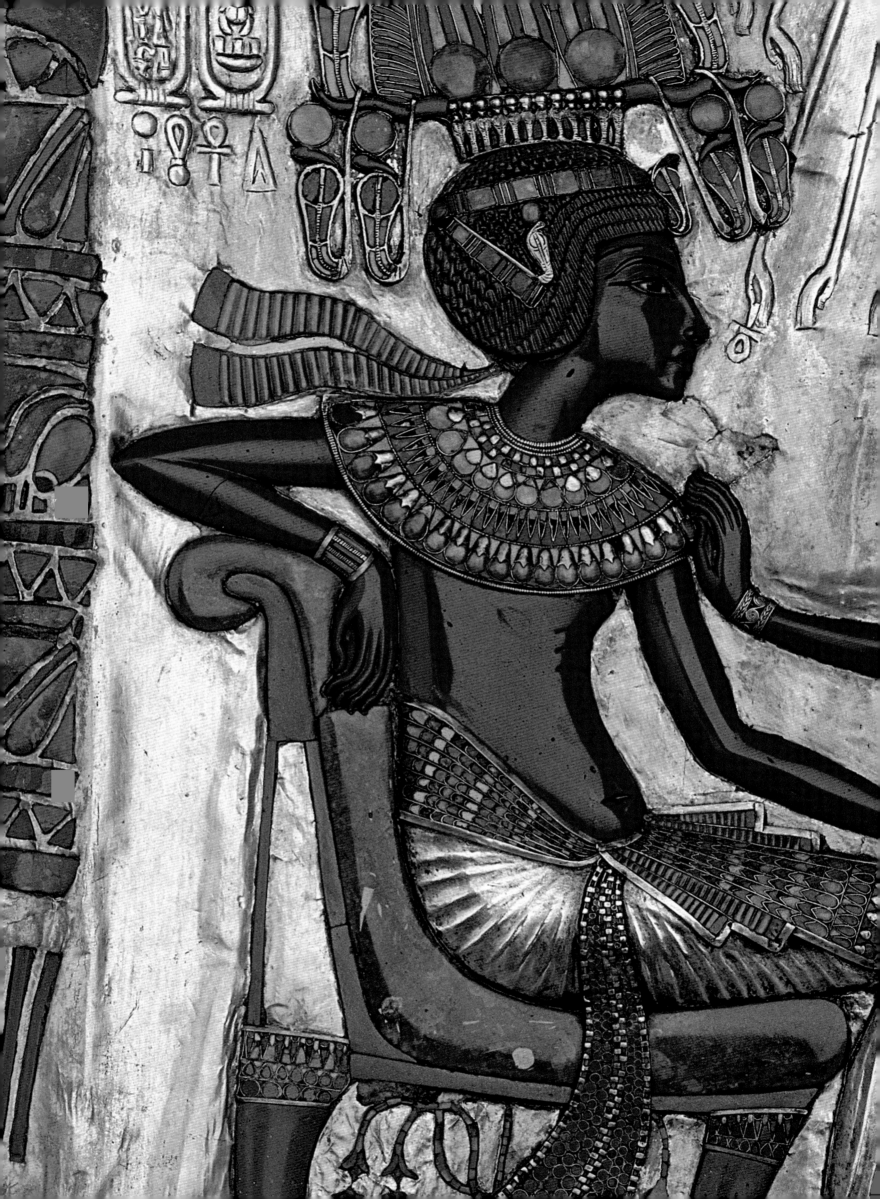

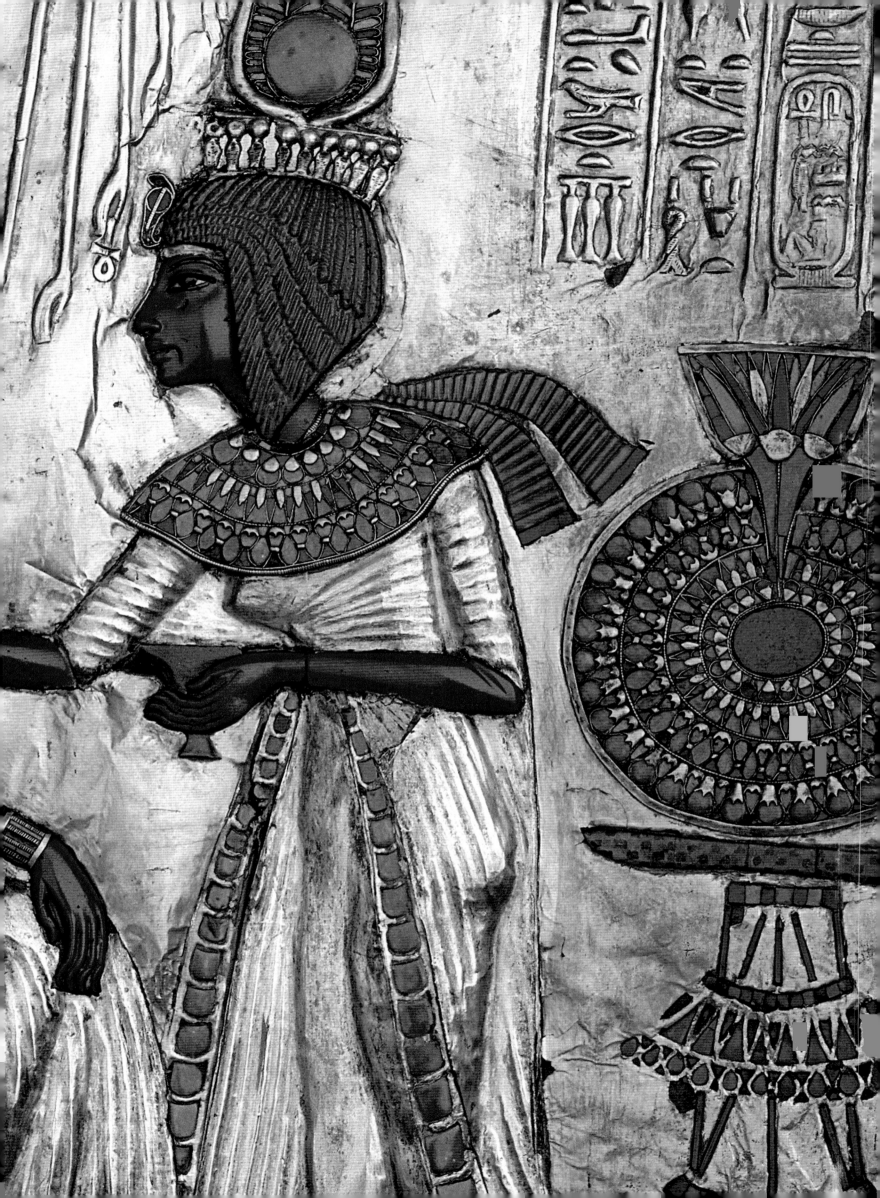

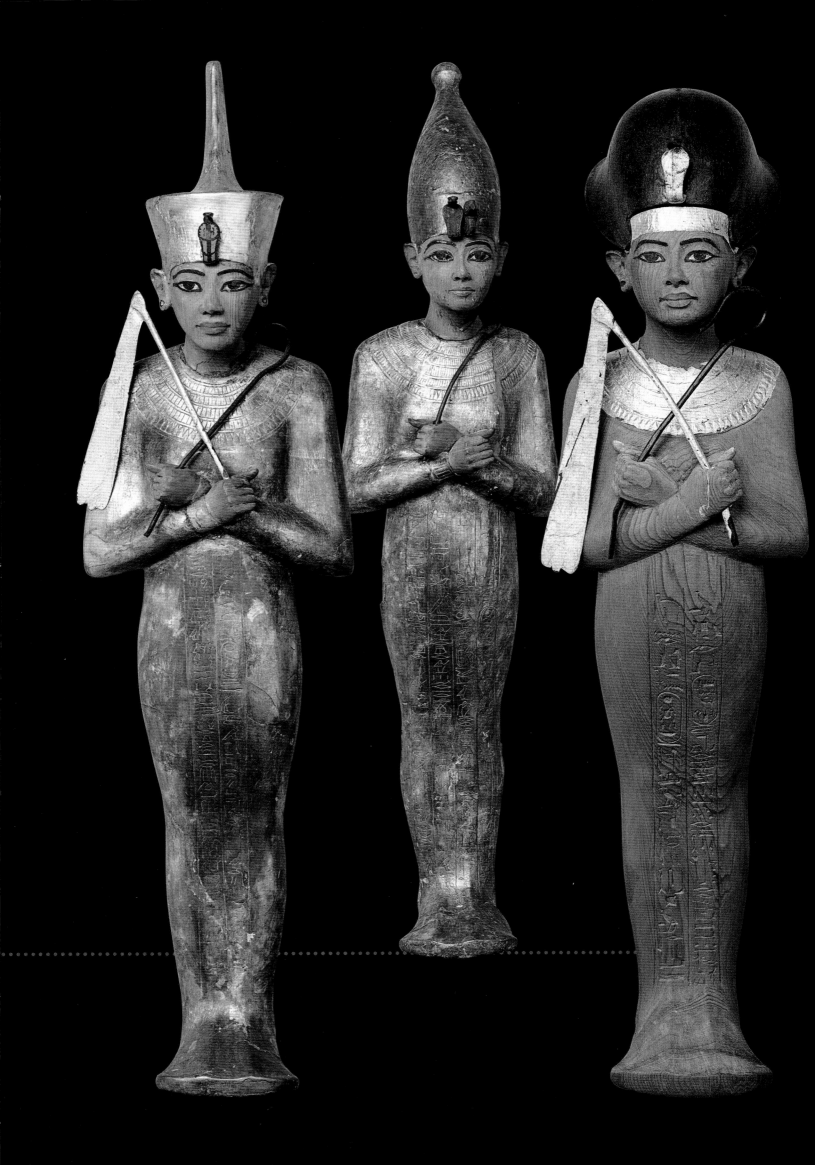

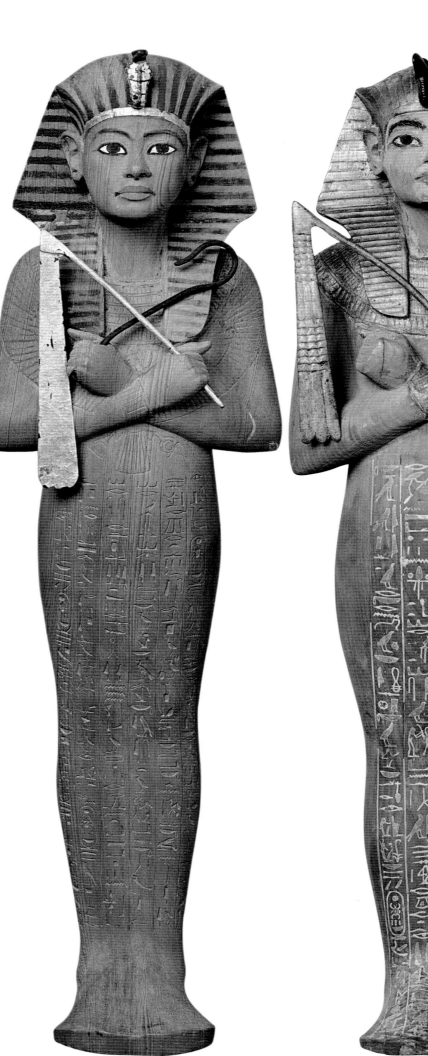

186 and 187
from left to right

JE 60823
**USHABTY WITH
RED CROWN**
PAINTED AND
GILDED WOOD,
BRONZE
HEIGHT CM 63

JE 60824A
**USHABTY WITH
WHITE CROWN**
PAINTED AND GILDED
WOOD, BRONZE
HEIGHT CM 61.5

JE 60830
**USHABTY WITH
BLUE CROWN**
WOOD, GOLD LEAF,
BRONZE
HEIGHT CM 48

JE 60828
**USHABTY GIVEN
BY GENERAL
MINNAKHTE**
PAINTED WOOD,
GOLD LEAF, BRONZE
HEIGHT CM 48

JE 60825
**USHABTY
FROM THE
ANTECHAMBER**
PAINTED WOOD,
GOLD LEAF, BRONZE
HEIGHT CM 53.6

18th Dynasty,
Tutankhamun's reign
(1333-1323 BC)

The treasure yielded 413
ushabty, whose function
was to take the place of
the deceased in the tasks
to be performed in the
afterlife.

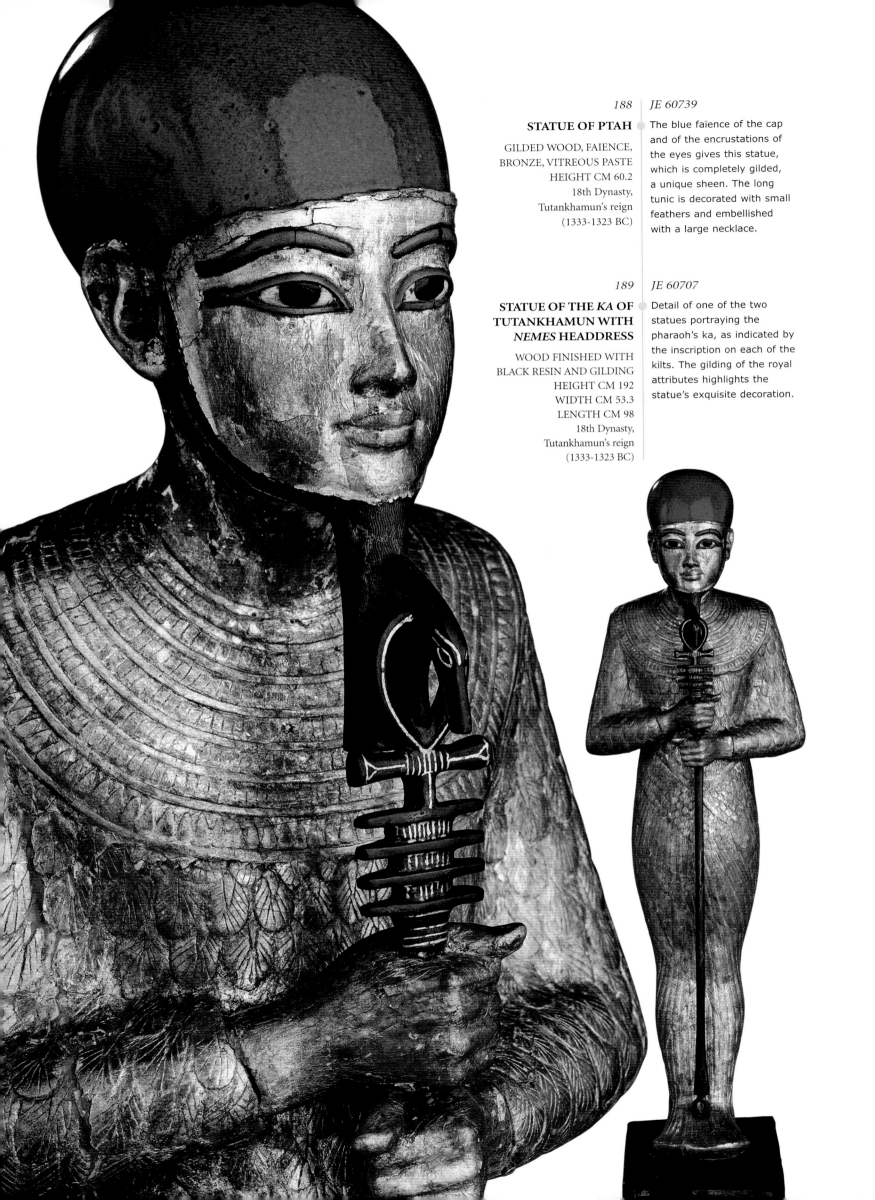

188 | *JE 60739*

STATUE OF PTAH

GILDED WOOD, FAIENCE,
BRONZE, VITREOUS PASTE
HEIGHT CM 60.2
18th Dynasty,
Tutankhamun's reign
(1333-1323 BC)

The blue faïence of the cap
and of the encrustations of
the eyes gives this statue,
which is completely gilded,
a unique sheen. The long
tunic is decorated with small
feathers and embellished
with a large necklace.

189 | *JE 60707*

**STATUE OF THE *KA* OF
TUTANKHAMUN WITH
NEMES HEADDRESS**

WOOD FINISHED WITH
BLACK RESIN AND GILDING
HEIGHT CM 192
WIDTH CM 53.3
LENGTH CM 98
18th Dynasty,
Tutankhamun's reign
(1333-1323 BC)

Detail of one of the two
statues portraying the
pharaoh's ka, as indicated by
the inscription on each of the
kilts. The gilding of the royal
attributes highlights the
statue's exquisite decoration.

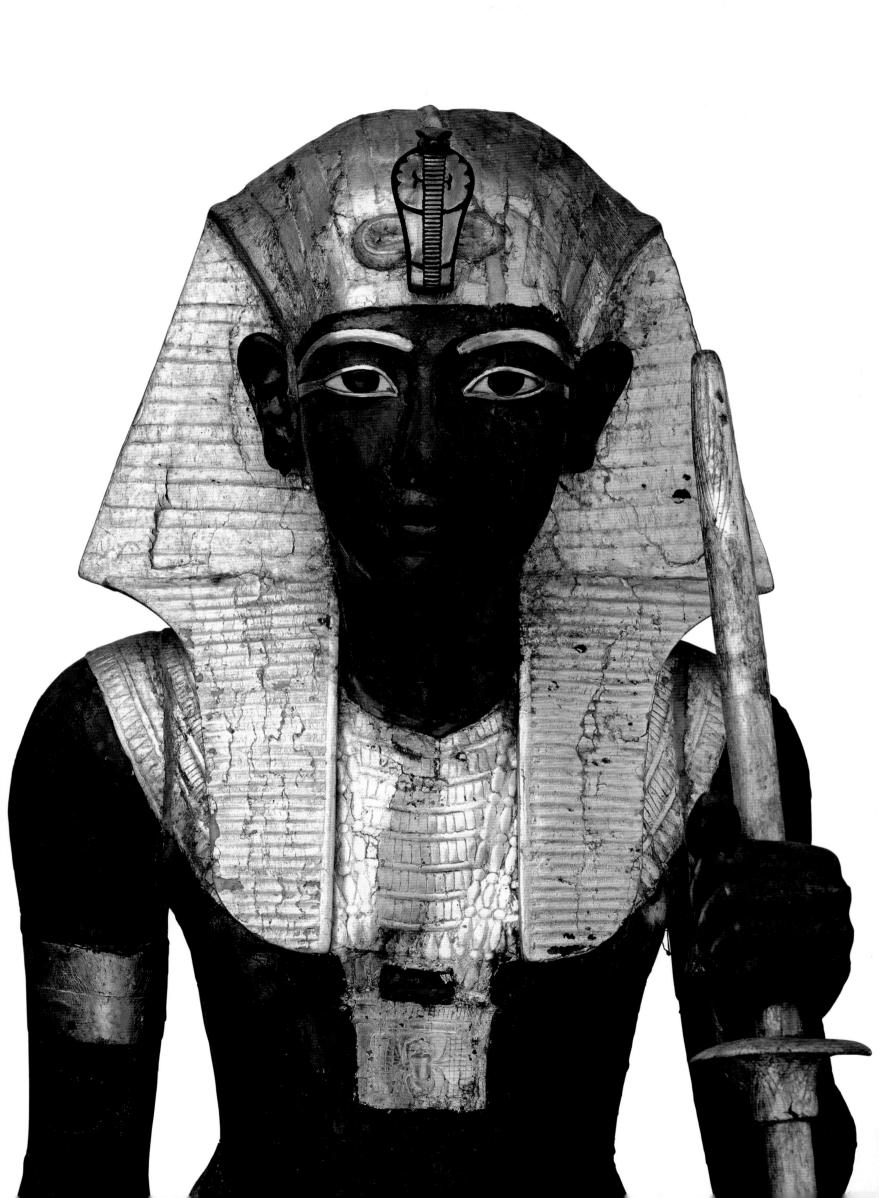

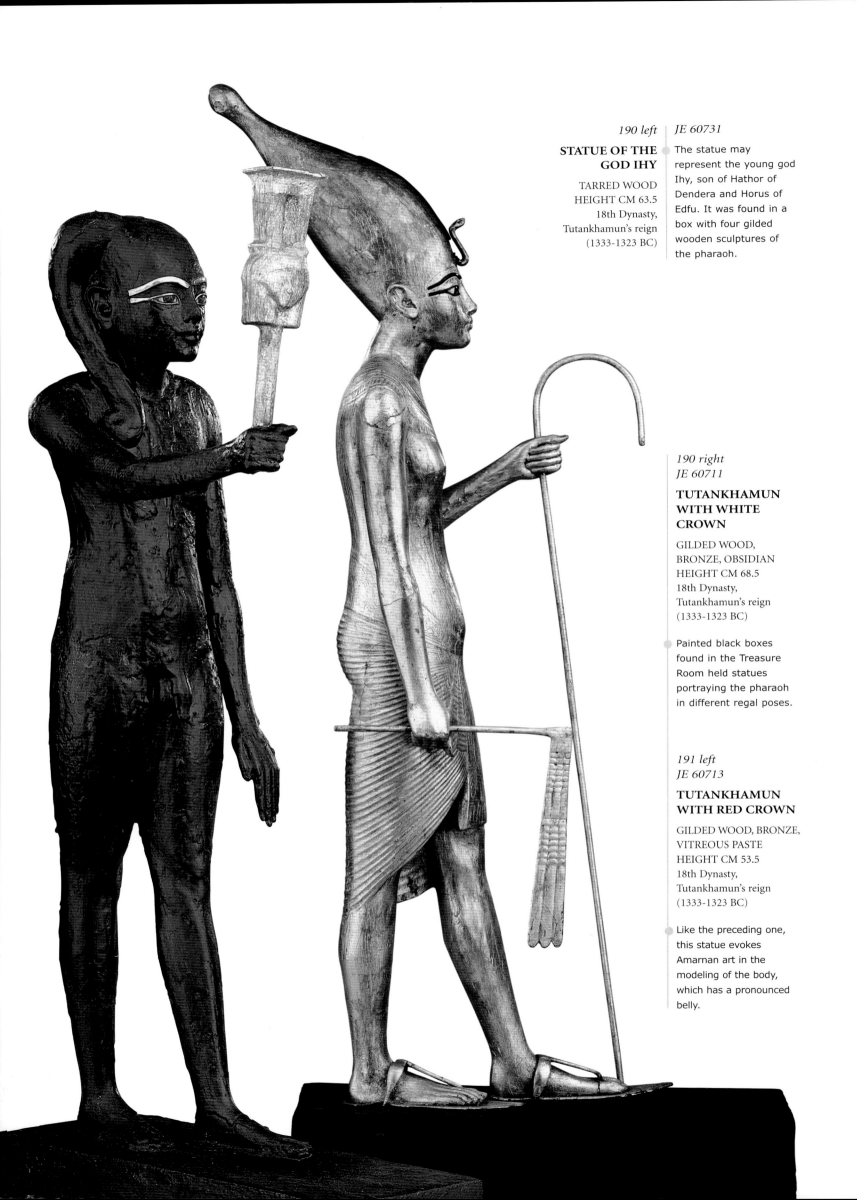

190 left | *JE 60731*

STATUE OF THE GOD IHY

TARRED WOOD
HEIGHT CM 63.5
18th Dynasty,
Tutankhamun's reign
(1333-1323 BC)

The statue may represent the young god Ihy, son of Hathor of Dendera and Horus of Edfu. It was found in a box with four gilded wooden sculptures of the pharaoh.

190 right
JE 60711

TUTANKHAMUN WITH WHITE CROWN

GILDED WOOD,
BRONZE, OBSIDIAN
HEIGHT CM 68.5
18th Dynasty,
Tutankhamun's reign
(1333-1323 BC)

Painted black boxes found in the Treasure Room held statues portraying the pharaoh in different regal poses.

191 left
JE 60713

TUTANKHAMUN WITH RED CROWN

GILDED WOOD, BRONZE,
VITREOUS PASTE
HEIGHT CM 53.5
18th Dynasty,
Tutankhamun's reign
(1333-1323 BC)

Like the preceding one, this statue evokes Amarnan art in the modeling of the body, which has a pronounced belly.

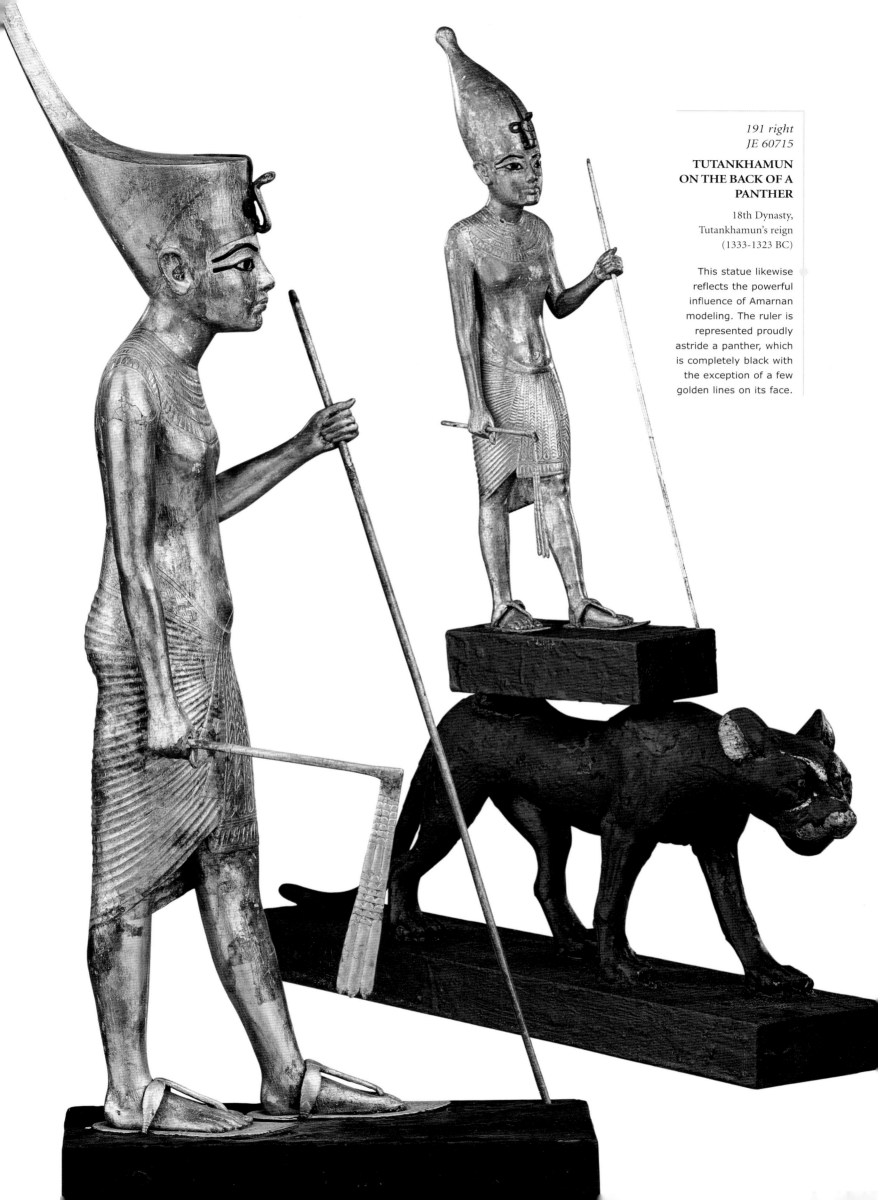

191 right
JE 60715

**TUTANKHAMUN
ON THE BACK OF A
PANTHER**

18th Dynasty,
Tutankhamun's reign
(1333-1323 BC)

This statue likewise
reflects the powerful
influence of Amarnan
modeling. The ruler is
represented proudly
astride a panther, which
is completely black with
the exception of a few
golden lines on its face.

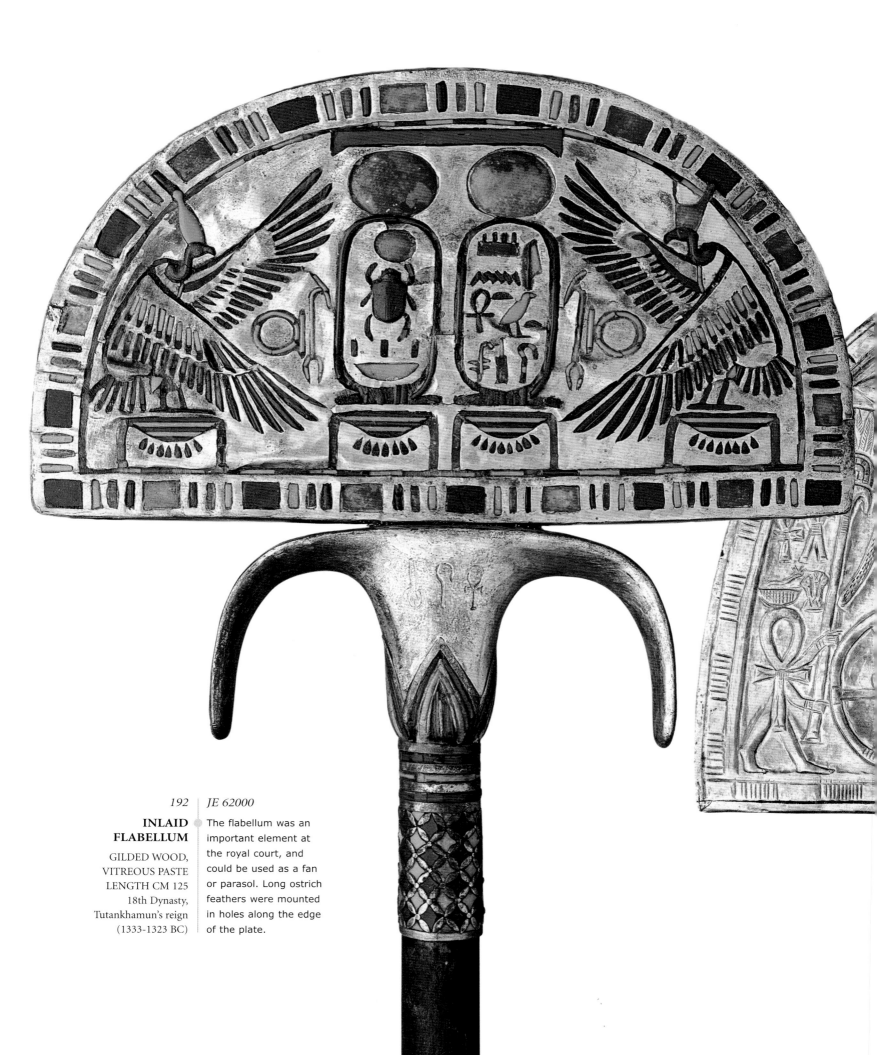

192 | JE 62000

INLAID FLABELLUM

GILDED WOOD,
VITREOUS PASTE
LENGTH CM 125
18th Dynasty,
Tutankhamun's reign
(1333-1323 BC)

The flabellum was an important element at the royal court, and could be used as a fan or parasol. Long ostrich feathers were mounted in holes along the edge of the plate.

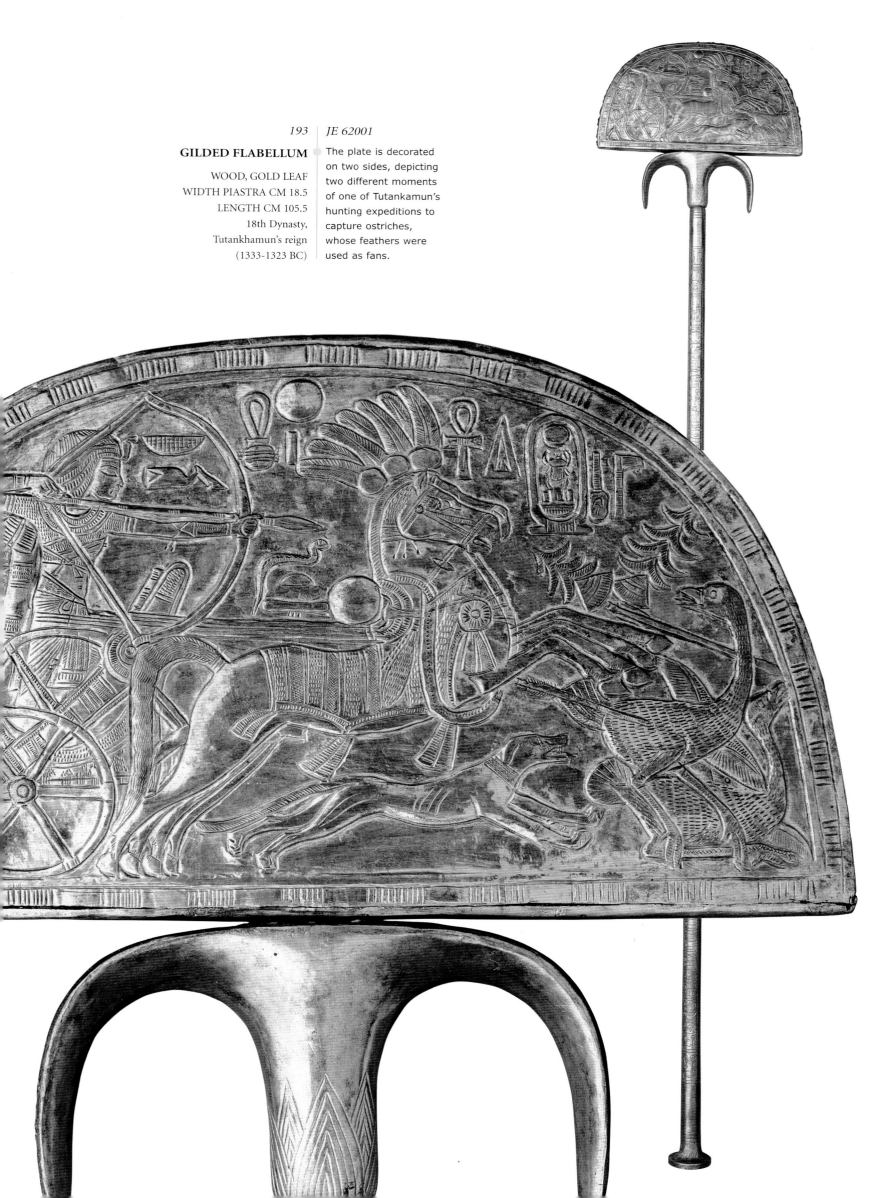

GILDED FLABELLUM

WOOD, GOLD LEAF
WIDTH PIASTRA CM 18.5
LENGTH CM 105.5
18th Dynasty,
Tutankhamun's reign
(1333-1323 BC)

The plate is decorated on two sides, depicting two different moments of one of Tutankamun's hunting expeditions to capture ostriches, whose feathers were used as fans.

GILDED FLABELLUM

WOOD, GOLD LEAF

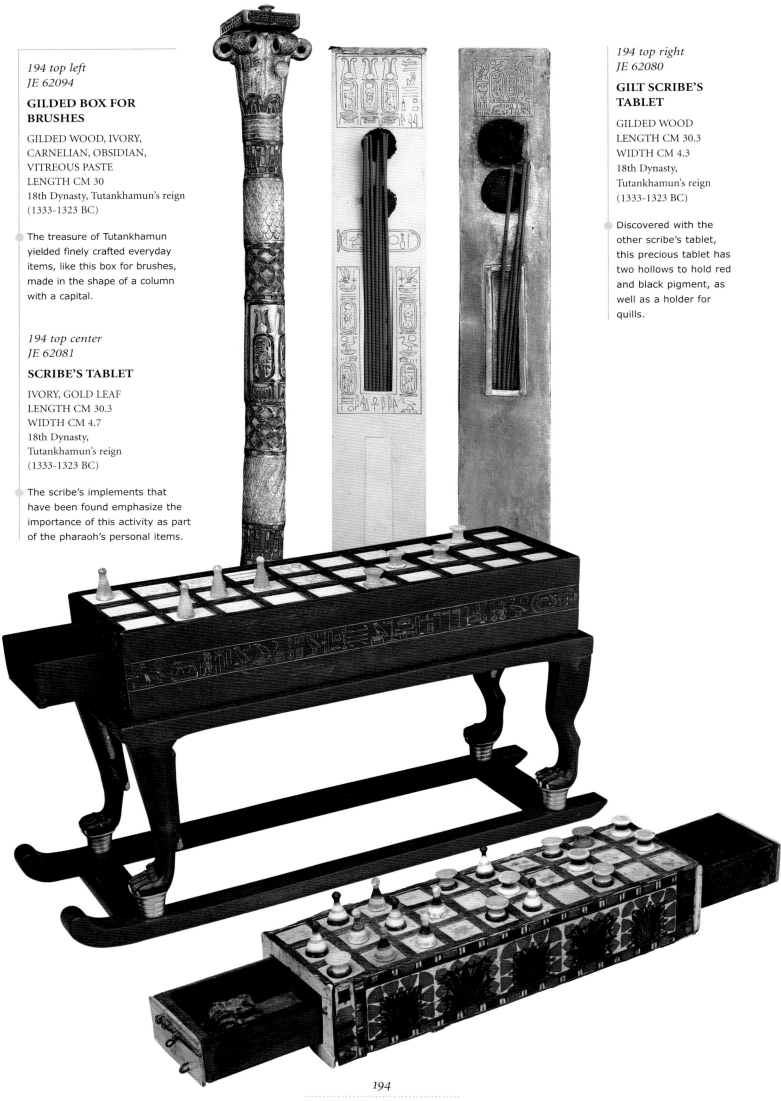

194 top left
JE 62094

GILDED BOX FOR BRUSHES

GILDED WOOD, IVORY,
CARNELIAN, OBSIDIAN,
VITREOUS PASTE
LENGTH CM 30
18th Dynasty, Tutankhamun's reign
(1333-1323 BC)

The treasure of Tutankhamun
yielded finely crafted everyday
items, like this box for brushes,
made in the shape of a column
with a capital.

194 top center
JE 62081

SCRIBE'S TABLET

IVORY, GOLD LEAF
LENGTH CM 30.3
WIDTH CM 4.7
18th Dynasty,
Tutankhamun's reign
(1333-1323 BC)

The scribe's implements that
have been found emphasize the
importance of this activity as part
of the pharaoh's personal items.

194 top right
JE 62080

GILT SCRIBE'S TABLET

GILDED WOOD
LENGTH CM 30.3
WIDTH CM 4.3
18th Dynasty,
Tutankhamun's reign
(1333-1323 BC)

Discovered with the
other scribe's tablet,
this precious tablet has
two hollows to hold red
and black pigment, as
well as a holder for
quills.

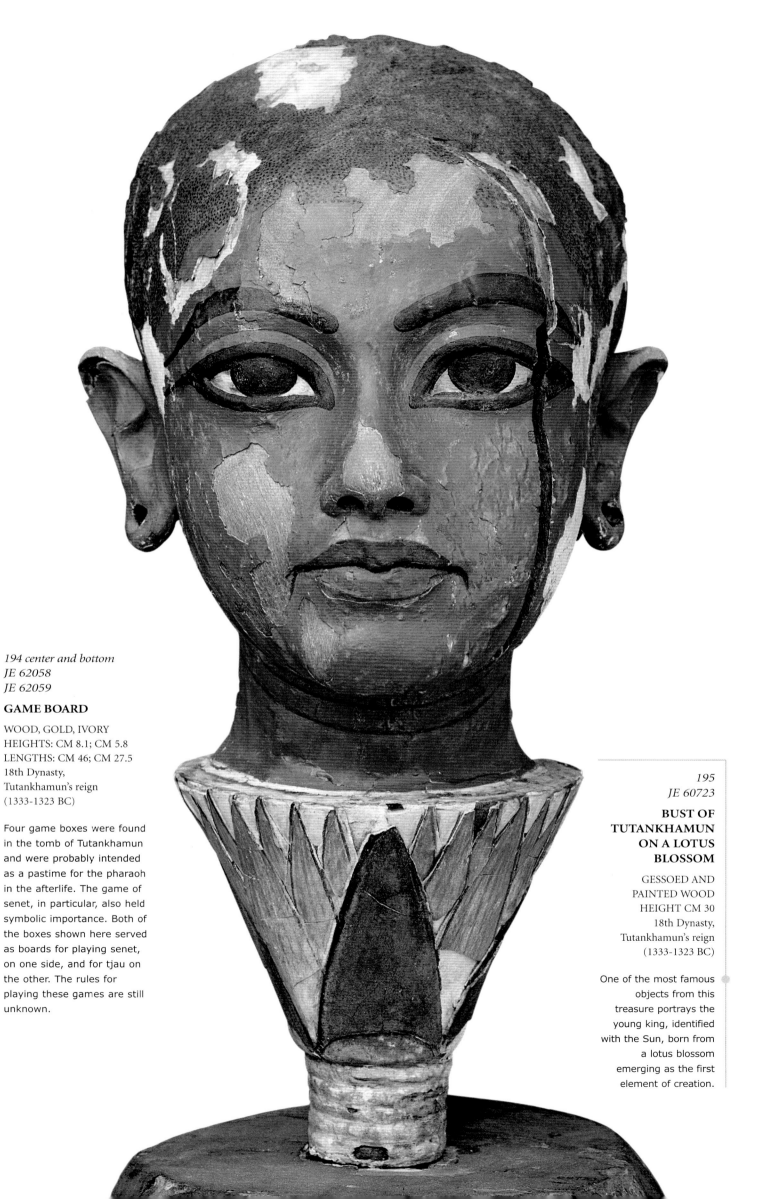

194 center and bottom
JE 62058
JE 62059

GAME BOARD

WOOD, GOLD, IVORY
HEIGHTS: CM 8.1; CM 5.8
LENGTHS: CM 46; CM 27.5
18th Dynasty,
Tutankhamun's reign
(1333-1323 BC)

Four game boxes were found
in the tomb of Tutankhamun
and were probably intended
as a pastime for the pharaoh
in the afterlife. The game of
senet, in particular, also held
symbolic importance. Both of
the boxes shown here served
as boards for playing senet,
on one side, and for tjau on
the other. The rules for
playing these games are still
unknown.

195
JE 60723

**BUST OF
TUTANKHAMUN
ON A LOTUS
BLOSSOM**

GESSOED AND
PAINTED WOOD
HEIGHT CM 30
18th Dynasty,
Tutankhamun's reign
(1333-1323 BC)

One of the most famous
objects from this
treasure portrays the
young king, identified
with the Sun, born from
a lotus blossom
emerging as the first
element of creation.

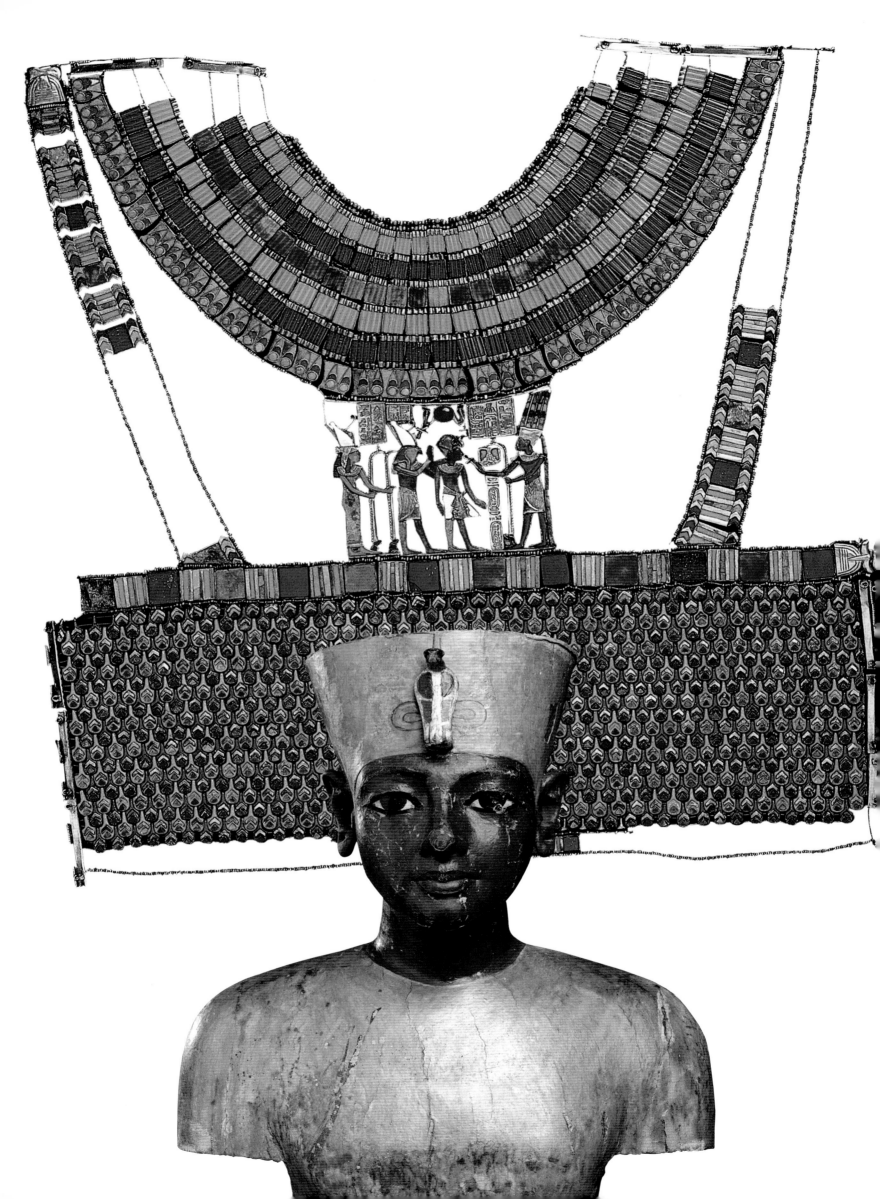

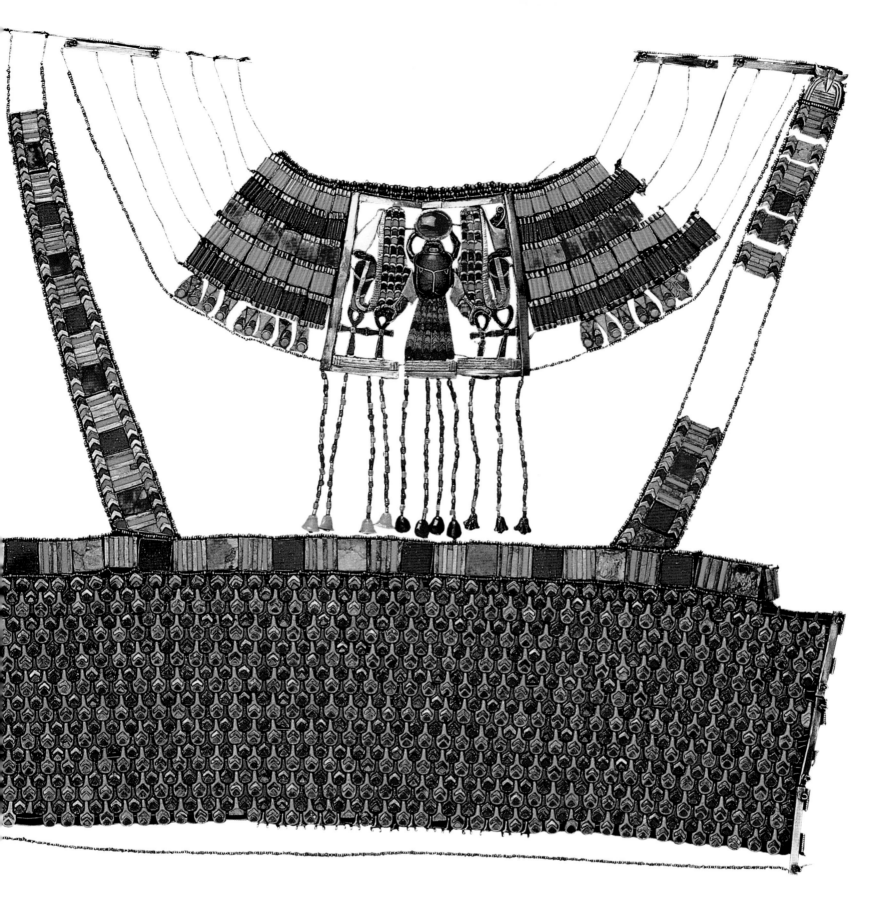

196-197	JE 62627	196 bottom	JE 60722
ROYAL CORSELET	The corselet shown here, which was found in pieces, represents the first example ever recovered of this kind of accessory. The pharaoh would wear it for certain ceremonies or in battle.	**MANNEQUIN OF TUTANKHAMUN**	This object probably served as a tailor's dummy. The statue, which has no arms or legs, is a very rare item. The face replicates the features of the young ruler, with a golden crown and uraeus on his head.
GOLD, VITREOUS PASTE, IVORY, SEMIPRECIOUS STONES HEIGHT CM 40 LENGTH CM 85 18th Dynasty, Tutankhamun's reign (1333-1323 BC)		GESSOED AND PAINTED WOOD, GOLD LEAF HEIGHT CM 76.5 18th Dynasty, Tutankhamun's reign (1333-1323 BC)	

198-199
JE 61989

CEREMONIAL CHARIOT

WOOD, GOLD, VITREOUS PASTE,
SEMIPRECIOUS STONES, LEATHER
BODY WIDTH CM 105
DEPTH CM 46
WHEEL DIAMETER CM 90
AXLE LENGTH CM 216
OVERALL LENGTH CM 250
OVERALL HEIGHT CM 118
18th Dynasty,
Tutankhamun's reign
(1333-1323 BC)

The fast two-wheel chariot was introduced to Egypt by the Hyksos. This specimen, which was probably used for parades, was found dismantled in the antechamber together with three other chariots. Finished entirely in gold leaf and polychrome encrustations, it was drawn by two horses.

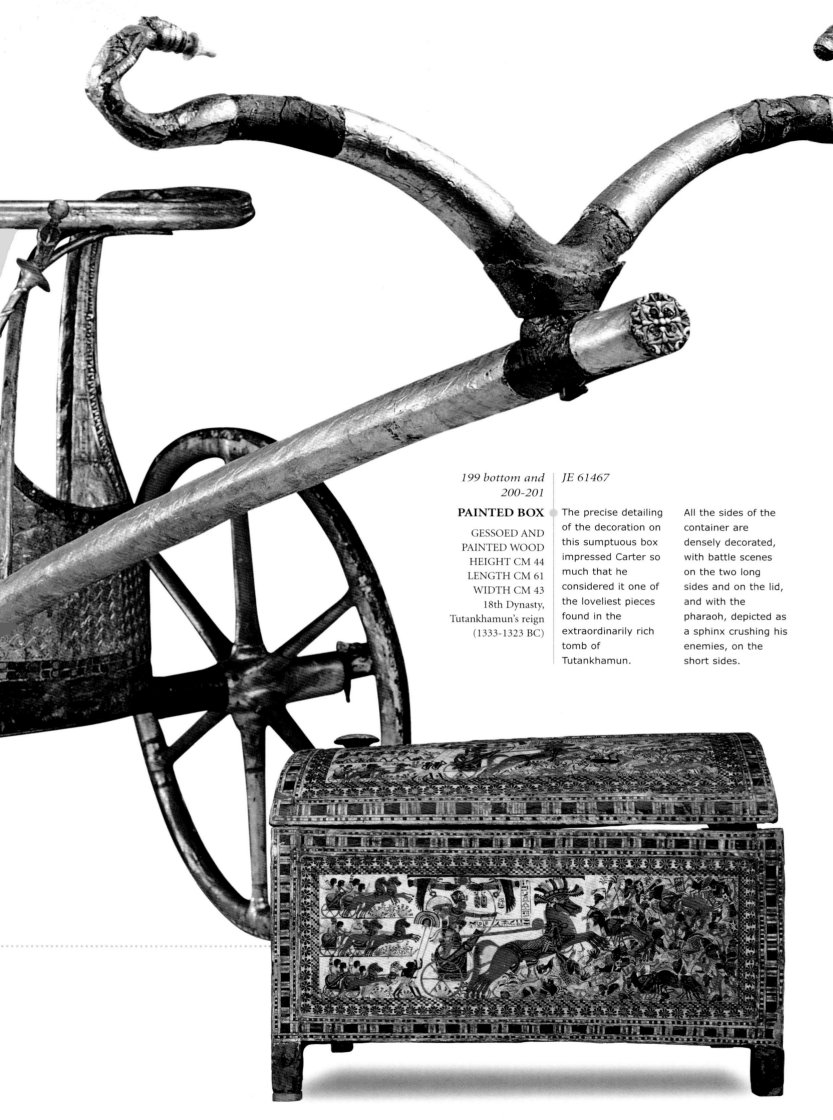

199 bottom and
200-201

PAINTED BOX

GESSOED AND
PAINTED WOOD
HEIGHT CM 44
LENGTH CM 61
WIDTH CM 43
18th Dynasty,
Tutankhamun's reign
(1333-1323 BC)

JE 61467

The precise detailing
of the decoration on
this sumptuous box
impressed Carter so
much that he
considered it one of
the loveliest pieces
found in the
extraordinarily rich
tomb of
Tutankhamun.

All the sides of the
container are
densely decorated,
with battle scenes
on the two long
sides and on the lid,
and with the
pharaoh, depicted as
a sphinx crushing his
enemies, on the
short sides.

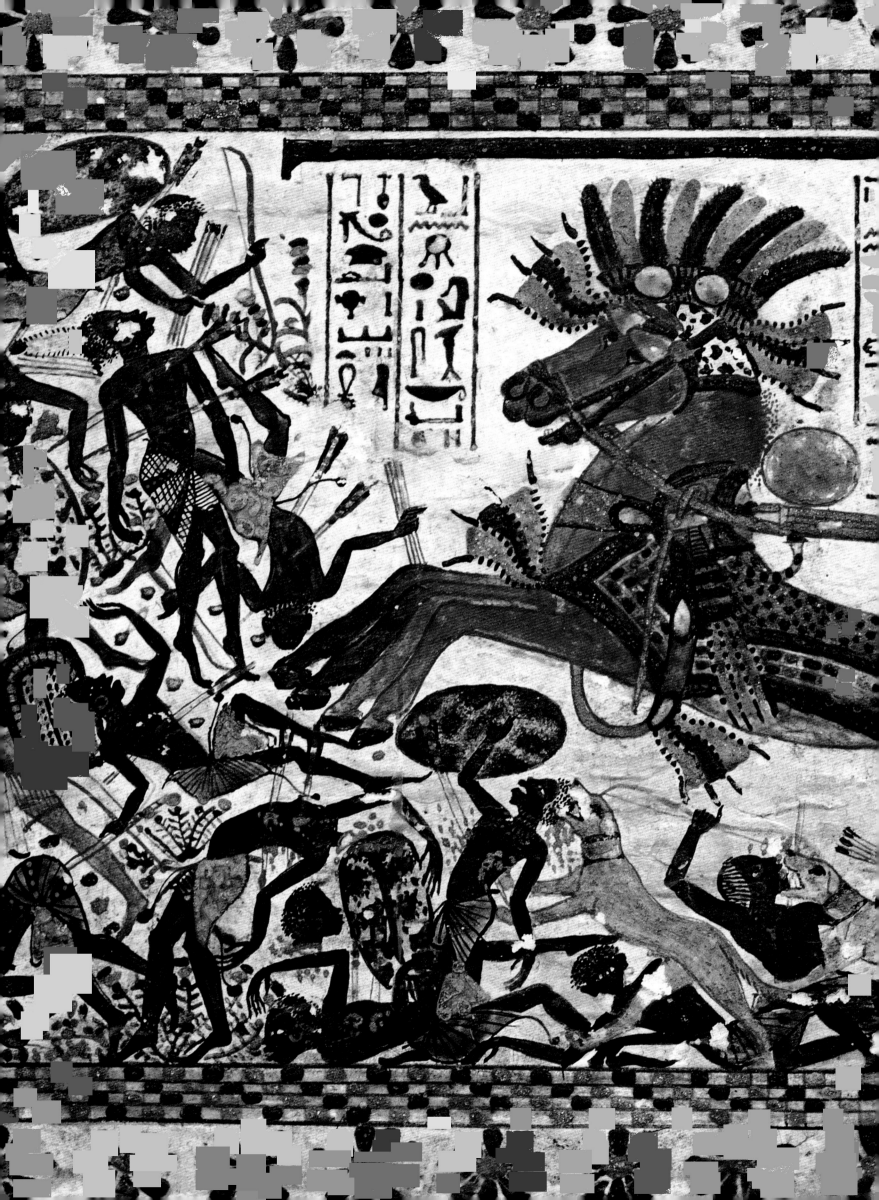

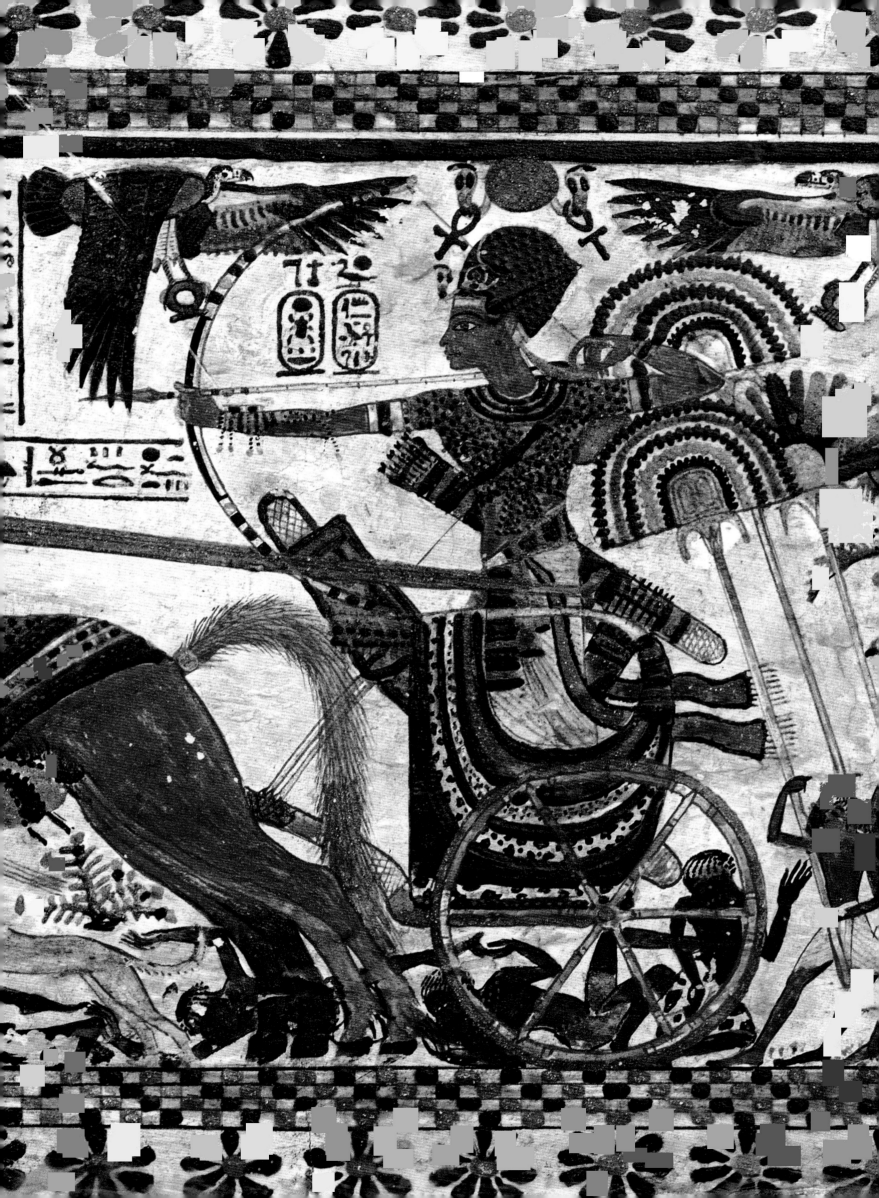

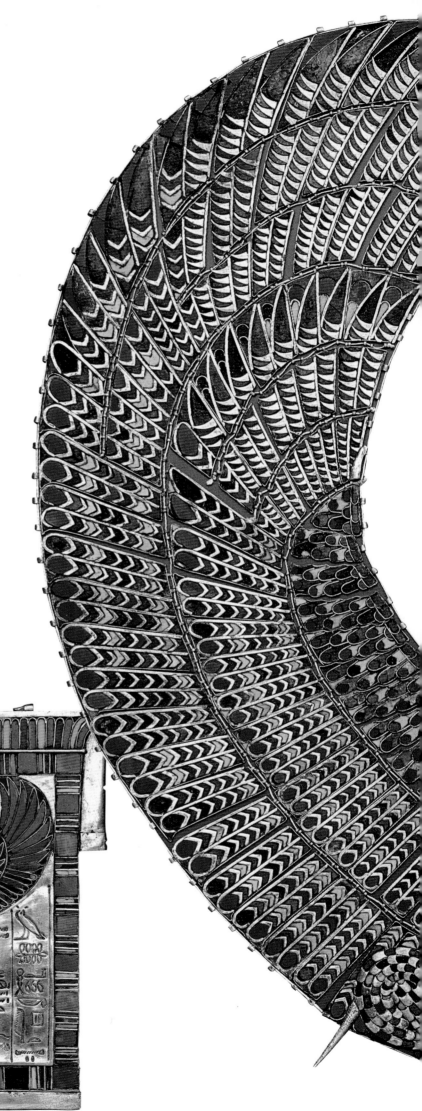

202 bottom | JE 61944

PECTORAL WITH NUT

GOLD, CARNELIAN,
VITREOUS PASTE
HEIGHT CM 12.6
WIDTH CM 14.3
18th Dynasty,
Tutankhamun's reign
(1333-1323 BC)

The pectoral, discovered inside the tabernacle protected by Anubis, depicts the goddess Nut in a polychrome frame. The eight columns of inscription on the sides of the figure invoke the goddess's protection over the pharaoh.

202-203 | JE 61875

NECKLACE OF THE TWO LADIES

GOLD, VITREOUS PASTE,
OBSIDIAN
WIDTH CM 48.7
18th Dynasty,
Tutankhamun's reign
(1333-1323 BC)

Made using the *cloisonné* technique, this spectacular necklace, which was found amidst the mummy's bandages, extends like the two wings of the goddess Nekhbet, depicted in the center with the goddess Wadjet.

203 center | JE 61899

PECTORAL WITH SCARAB AND URAEI

GOLD, LAPIS LAZULI,
CARNELIAN, CALCITE
HEIGHT CM 7.8
WIDTH CM 8.7
18th Dynasty,
Tutankhamun's reign
(1333-1323 BC)

Finely carved in every detail, a lapis lazuli scarab, holding the pharaoh's cartouche above and the shen symbol below, is the central element of this magnificent pectoral.

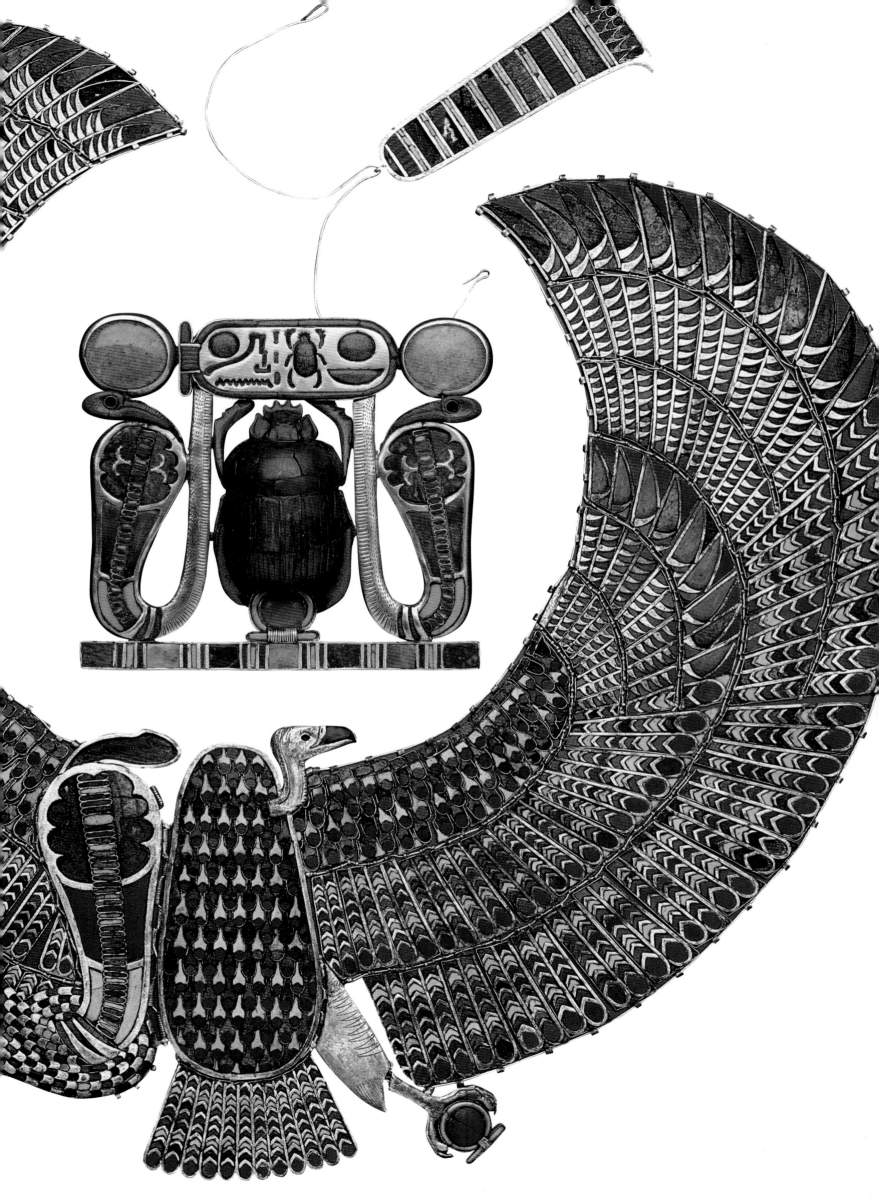

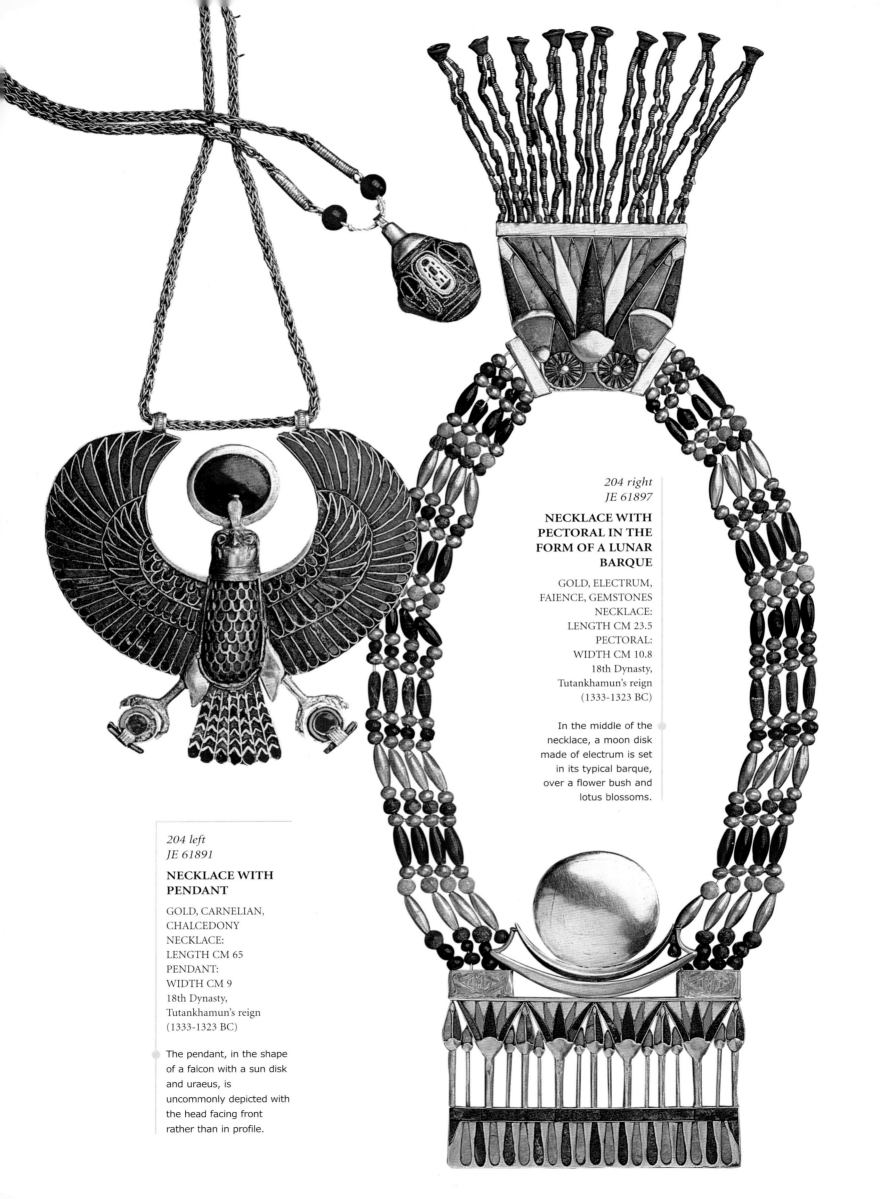

204 right
JE 61897

NECKLACE WITH PECTORAL IN THE FORM OF A LUNAR BARQUE

GOLD, ELECTRUM, FAIENCE, GEMSTONES
NECKLACE: LENGTH CM 23.5
PECTORAL: WIDTH CM 10.8
18th Dynasty, Tutankhamun's reign (1333-1323 BC)

In the middle of the necklace, a moon disk made of electrum is set in its typical barque, over a flower bush and lotus blossoms.

204 left
JE 61891

NECKLACE WITH PENDANT

GOLD, CARNELIAN, CHALCEDONY
NECKLACE: LENGTH CM 65
PENDANT: WIDTH CM 9
18th Dynasty, Tutankhamun's reign (1333-1323 BC)

The pendant, in the shape of a falcon with a sun disk and uraeus, is uncommonly depicted with the head facing front rather than in profile.

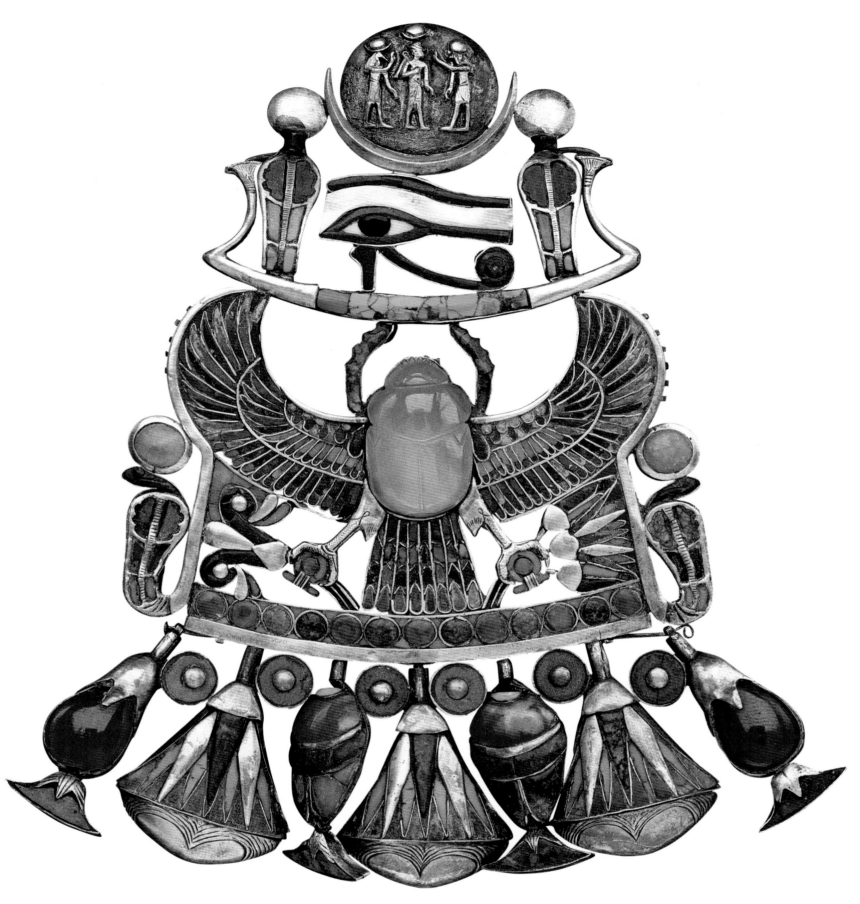

205	JE 61884	206-207	JE 61945
PECTORAL WITH WINGED SCARAB	The wing and front legs of the scarab in the middle of the pectoral, carved in chalcedony, sustain the lunar barque represented by the udjat eye it is carrying. On top, in the moon disk, Thoth and Ra-Harakhty stand next to Tutankhamun.	**PECTORAL WITH ISIS AND NEPHTHYS**	Isis on the right and Nephthys on the left – the two tutelary deities of the deceased – stretch their wings to protect the Djed pillar with the sun disk between crowned uraei. The group is set in an aedicule with polychrome inlays. This jewel was in the tabernacle protected by Anubis.
GOLD, SILVER, VITREOUS PASTE, SEMIPRECIOUS STONES HEIGHT CM 14.9 WIDTH CM 14.5 18th Dynasty, Tutankhamun's reign (1333-1323 BC)		GOLD, VITREOUS PASTE, QUARTZ HEIGHT CM 12 WIDTH CM 16.3 18th Dynasty, Tutankhamun's reign (1333-1323 BC)	

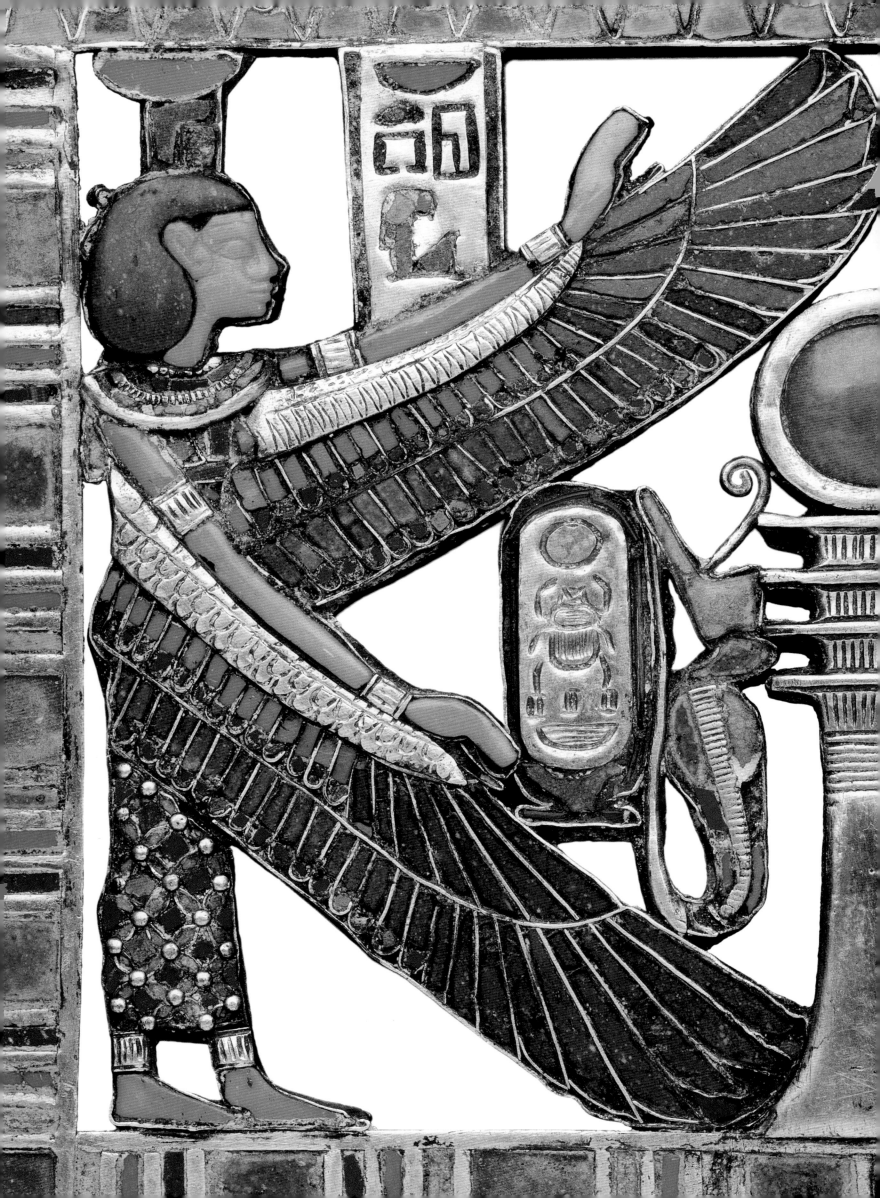

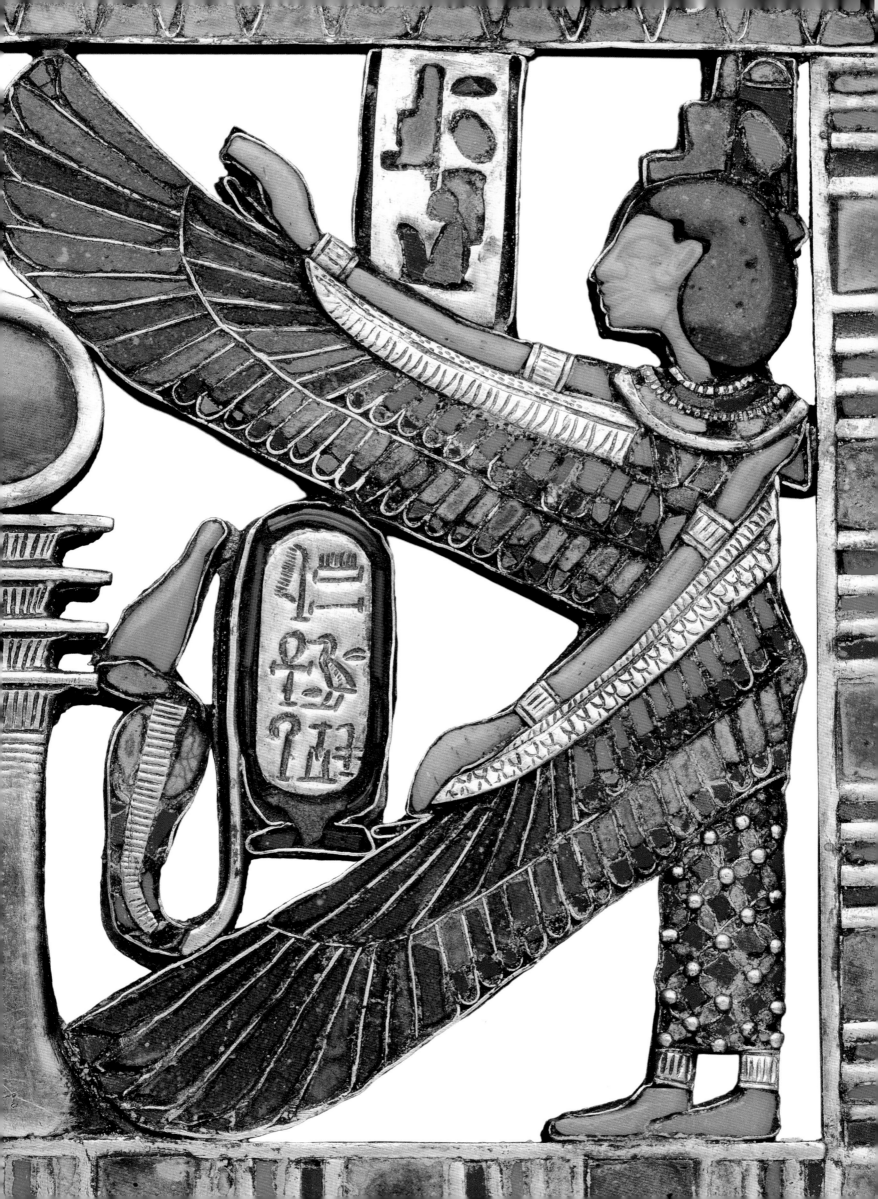

208 left | JE 62111

CHALICE-SHAPED LAMP

ALABASTER
HEIGHT CM 51.4
WIDTH CM 28.8
18th Dynasty,
Tutankhamun's reign
(1333-1323 BC)

The extraordinary skill of the artisans of the era is demonstrated in the decoration of this alabaster chalice. Tutankhamun and his wife only become visible when the chalice is illuminated from the inside.

209 | JE 62114

PERFUME VASE

ALABASTER, GOLD,
VITREOUS PASTE, FAIENCE
HEIGHT CM 70
WIDTH CM 36.8
18th Dynasty,
Tutankhamun's reign
(1333-1323 BC)

Two water and heraldic deities hold lily and papyrus plants; emerging from them is a perfume jar in the shape of a sema symbol, celebrating the Unification of the Two Lands by the pharaoh.

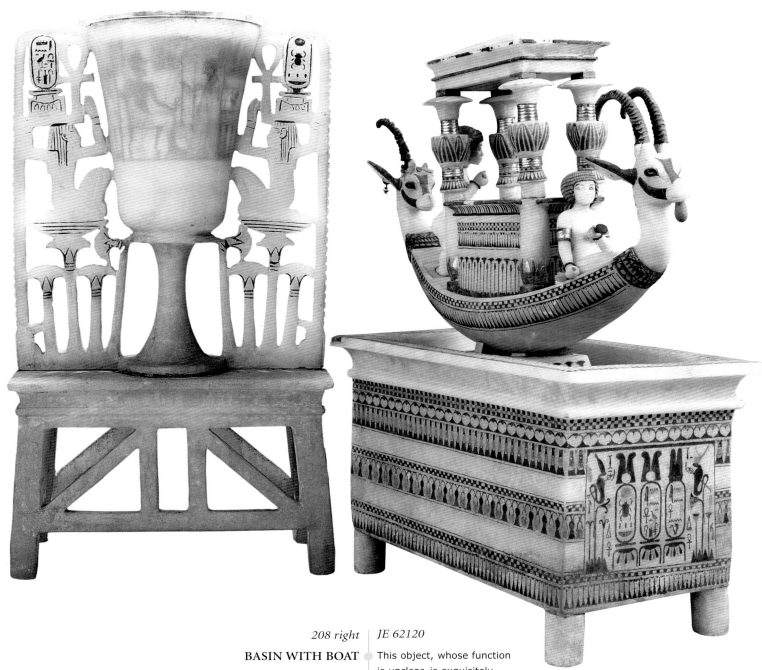

208 right | JE 62120

BASIN WITH BOAT

ALABASTER, GOLD,
GEMSTONES, IVORY,
VITREOUS PASTE
HEIGHT CM 37
18th Dynasty,
Tutankhamun's reign
(1333-1323 BC)

This object, whose function is unclear, is exquisitely crafted from fine alabaster. The boat, with a kiosk on it, seems to sail lightly over the water placed in a basin under it.

The New Kingdom

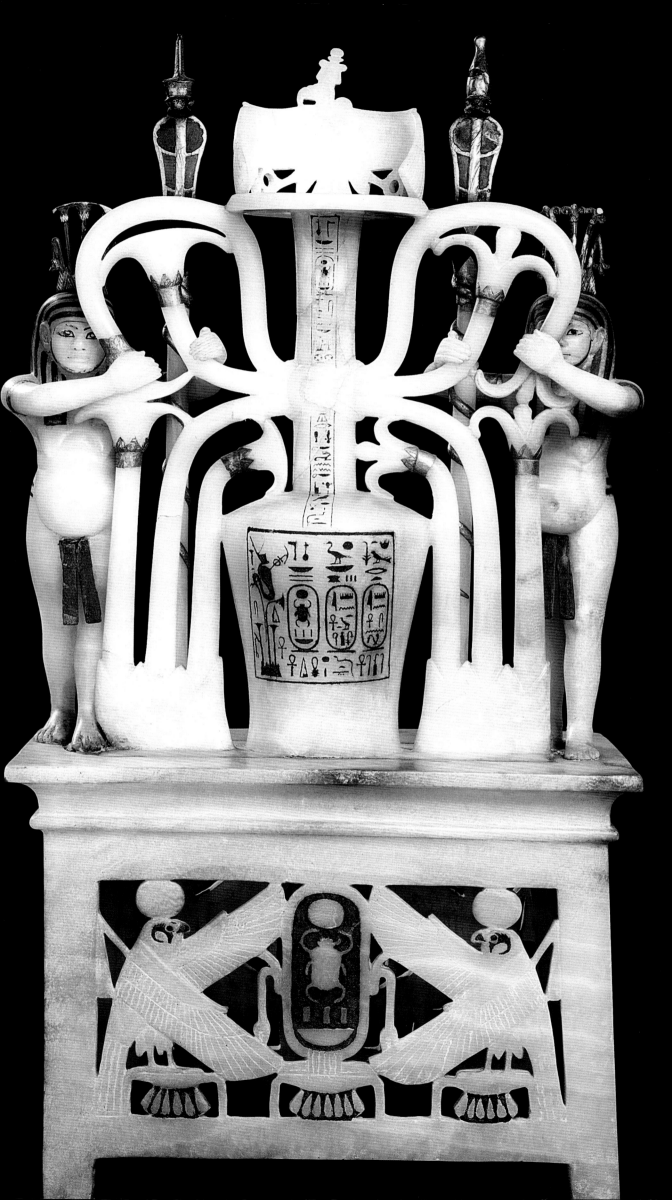

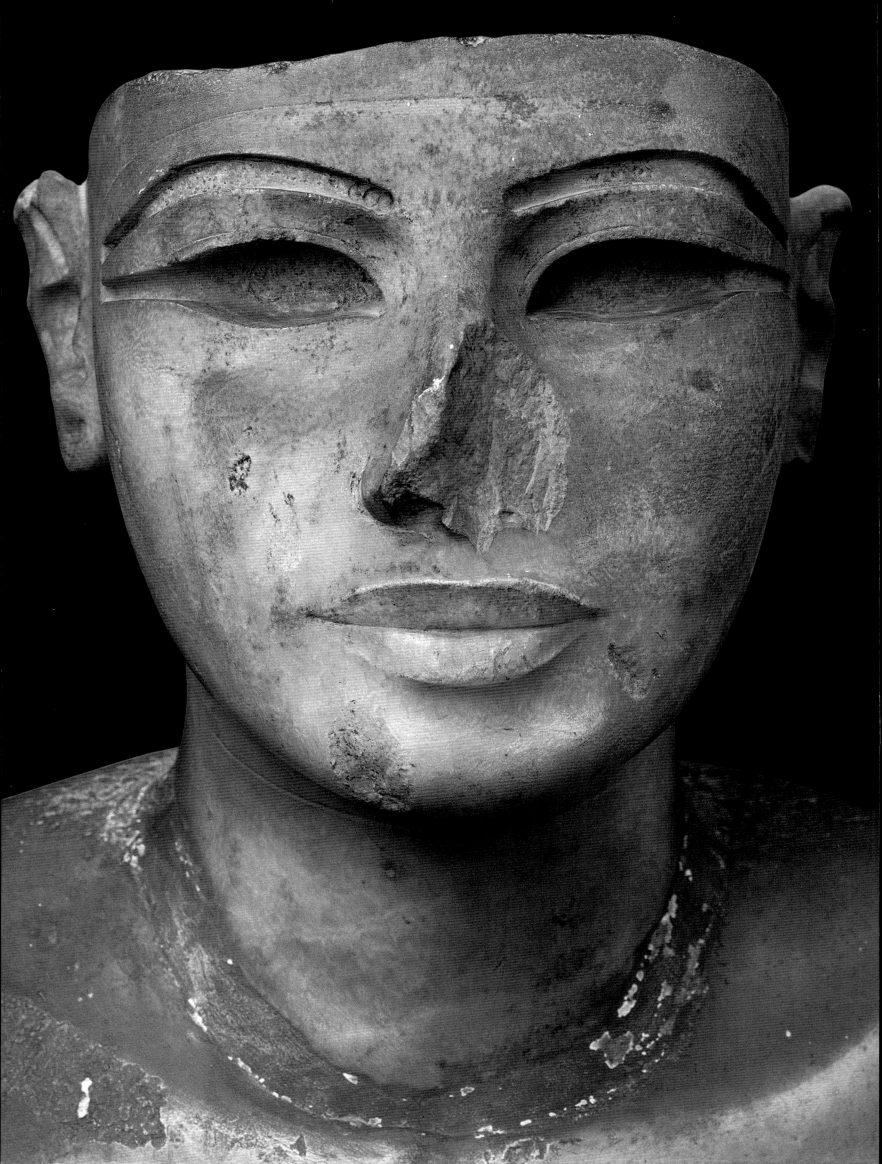

| 210 and 211 left | JE 36692 = CG 42139 | 211 right | JE 64735 |

COLOSSAL STATUE OF SETI I

ALABASTER
HEIGHT CM 238
19th Dynasty,
reign of Seti I
(1289-1279 BC)

This statue, which evokes the statuary art of the end of the Eighteenth Dynasty, may have been appropriated by Seti I, who had his name placed on the dorsal pillar. G. Legrain discovered the sculpture in the cache at Karnak (1904-1905).

STATUE OF THE BOY RAMESSES II WITH THE GOD HORUN

GRAY GRANITE, LIMESTONE
HEIGHT CM 231
19th Dynasty,
reign of Ramesses II
(1279-1212 BC)

This colossal statue is a pun on the name of Ramesses, "Ra generated him" (Ra = sun disk; mes = boy; su = reed), placed under the protection of the falcon Horun, associated with the god Harmakhis personified in the Sphinx. P. Montet discovered this artifact at Tanis (1934).

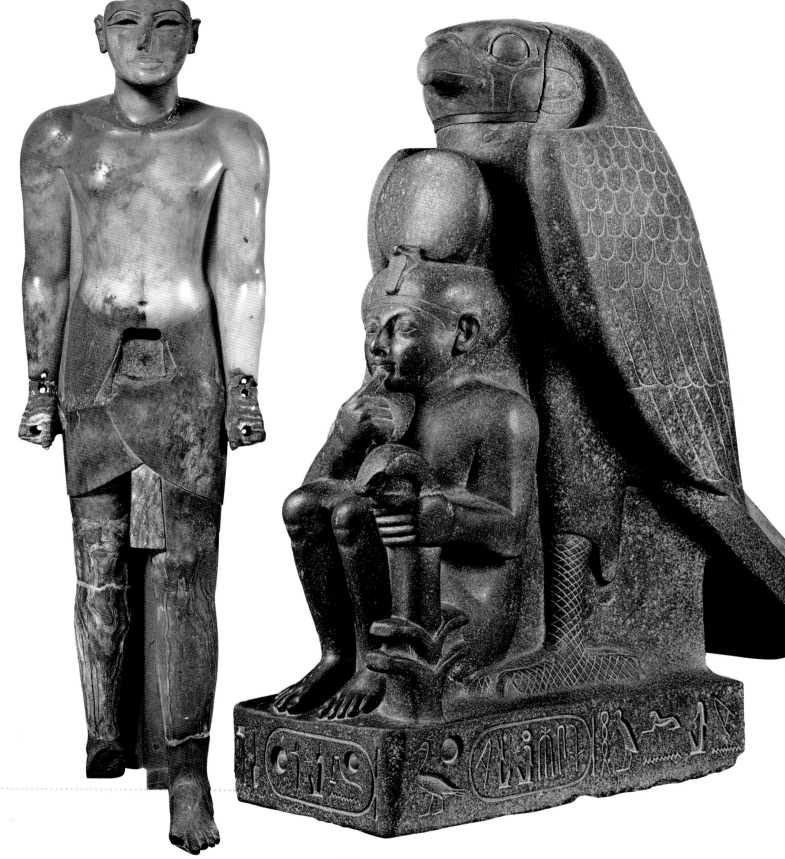

211

The New Kingdom

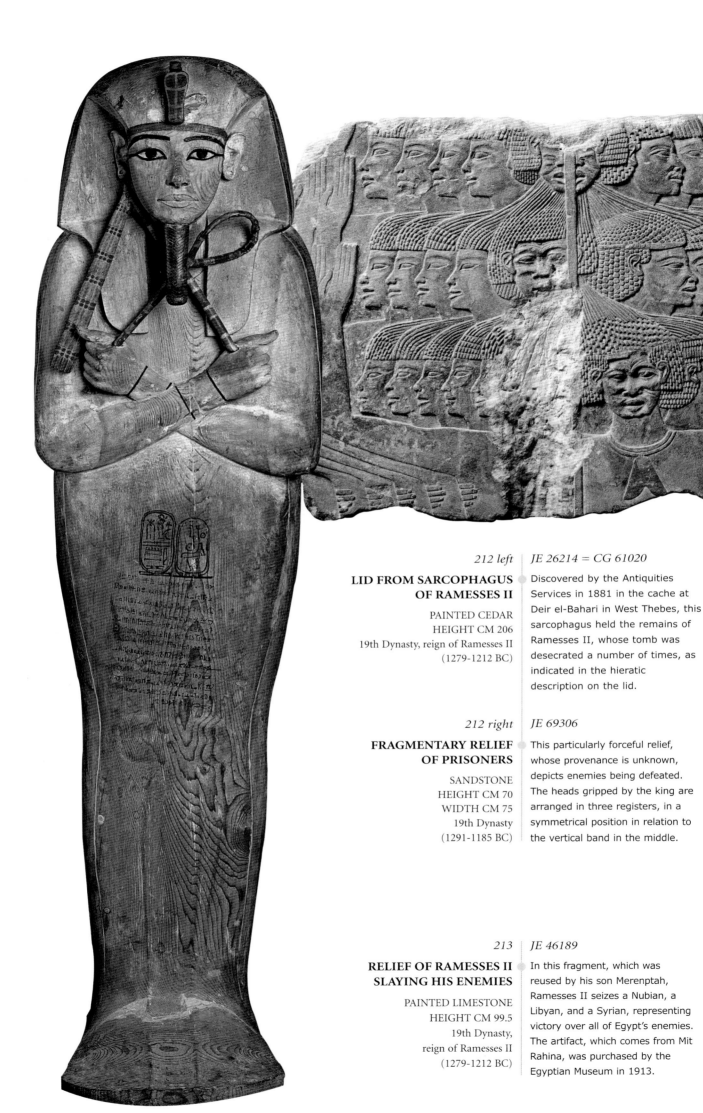

212 left | JE 26214 = CG 61020

LID FROM SARCOPHAGUS OF RAMESSES II

PAINTED CEDAR
HEIGHT CM 206
19th Dynasty, reign of Ramesses II
(1279-1212 BC)

Discovered by the Antiquities Services in 1881 in the cache at Deir el-Bahari in West Thebes, this sarcophagus held the remains of Ramesses II, whose tomb was desecrated a number of times, as indicated in the hieratic description on the lid.

212 right | JE 69306

FRAGMENTARY RELIEF OF PRISONERS

SANDSTONE
HEIGHT CM 70
WIDTH CM 75
19th Dynasty
(1291-1185 BC)

This particularly forceful relief, whose provenance is unknown, depicts enemies being defeated. The heads gripped by the king are arranged in three registers, in a symmetrical position in relation to the vertical band in the middle.

213 | JE 46189

RELIEF OF RAMESSES II SLAYING HIS ENEMIES

PAINTED LIMESTONE
HEIGHT CM 99.5
19th Dynasty,
reign of Ramesses II
(1279-1212 BC)

In this fragment, which was reused by his son Merenptah, Ramesses II seizes a Nubian, a Libyan, and a Syrian, representing victory over all of Egypt's enemies. The artifact, which comes from Mit Rahina, was purchased by the Egyptian Museum in 1913.

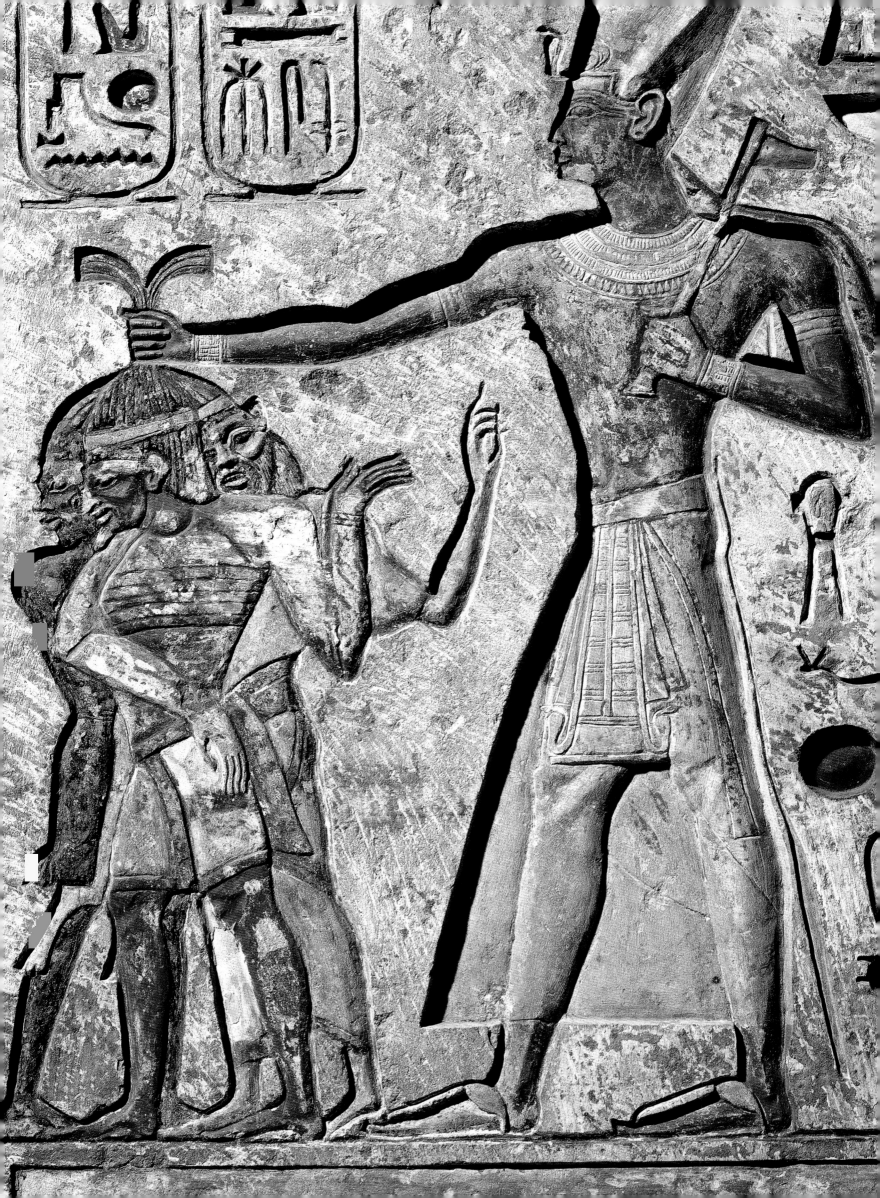

214 left
JE 39873 =
CG 52575 - 52576

**BRACELETS OF
RAMESSES II**

GOLD, LAPIS LAZULI
DIAMETER CM 7.2
19th Dynasty,
reign of Ramesses II
(1279-1212 BC)

A two-headed duck with
a lapis lazuli body and a
large tail occupies the
upper portion of each
bracelet. The objects,
which were part of a
treasure discovered at
Tell Basta (Bubasti) in
1913, are crafted with
microgranules.

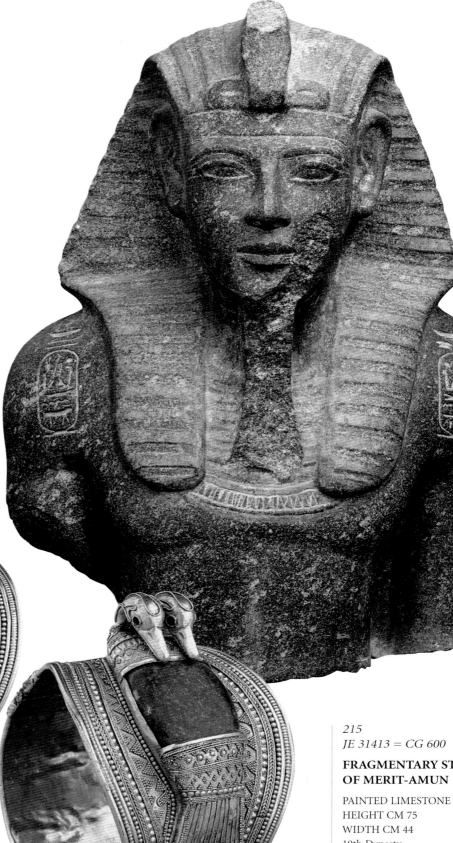

215
JE 31413 = CG 600

**FRAGMENTARY STATUE
OF MERIT-AMUN**

PAINTED LIMESTONE
HEIGHT CM 75
WIDTH CM 44
19th Dynasty,
reign of Ramesses II
(1279-1212 BC)

The queen, portrayed with a
full, youthful face, is wearing
a modium adorned with uraei
and sun disks. This fragment
is from the shrine named for
Merit-Amun, in the
Ramesseum, where it was
discovered by W.M.F. Petrie
(1896).

214 right

**FRAGMENTARY
STATUE OF
MERENPTAH**

PAINTED GRANITE
HEIGHT CM 91
19th Dynasty,
reign of Merenptah
(1212-1202 BC)

JE 31414 = CG 607

In 1896, W.M.F. Petrie
discovered this statue
of the pharaoh in the
mortuary temple of
Merenptah, the son and
successor of Ramesses
II, in West Thebes.
Merenptah, the oldest
of the princes who
survived Ramesses,
was about 50 when he
rose to the throne.

The New Kingdom

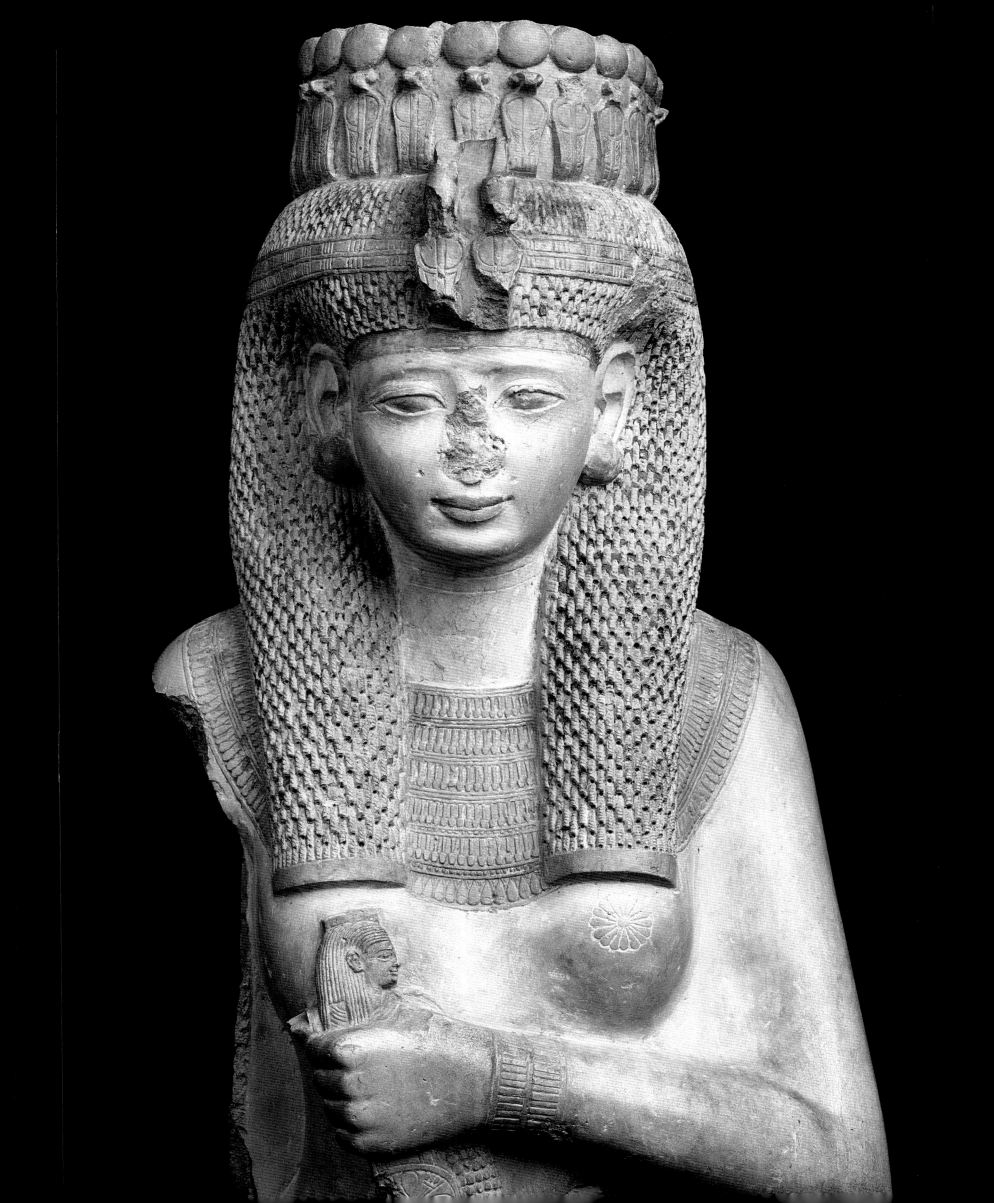

216 top
SR 4166

**BOX FOR THE
USHABTY OF
KHONSU**

GESSOED AND
PAINTED WOOD
HEIGHT CM 35.6
WIDTH CM 12.5
LENGTH CM 20
19th Dynasty,
reign of Ramesses II
(1279-1212 BC)

The box was part of the
furnishings of Khonsu,
who was buried with his
father Sennedjem and
other family members
in a tomb that the
Antiquities Service
discovered intact in the
village of Deir al-Medina
(1886).

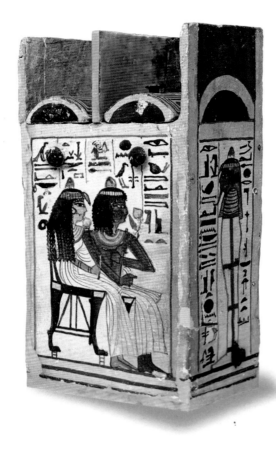

216 bottom | JE 27303

**DOOR FROM
SENNEDJEM'S
TOMB**

GESSOED AND
PAINTED WOOD
HEIGHT CM 135
WIDTH CM 117
19th Dynasty,
reign of Ramesses II
(1279-1212 BC)

Left, Sennedjem,
sitting with his wife, is
playing senet and
wagering on his future.
Right, the man is
shown in divine
adoration with his wife
and daughter (above)
and his sons (below).
The doors, discovered
at Deir al-Medina by
the Antiquities Service
(1886), are from the
tomb of Sennedjem.

217 | JE 27299

**SARCOPHAGUS
OF SENNEDJEM**

GESSOED AND
PAINTED WOOD
HEIGHT CM 184.5
WIDTH CM 50
DEPTH CM 31
19th Dynasty,
reign of Ramesses II
(1279-1212 BC)

The inviolate tomb of
the workman
Sennedjem, at Deir
al-Medina, also yielded
the man's mummy,
which was inside this
beautifully crafted
anthropomorphic
sarcophagus.

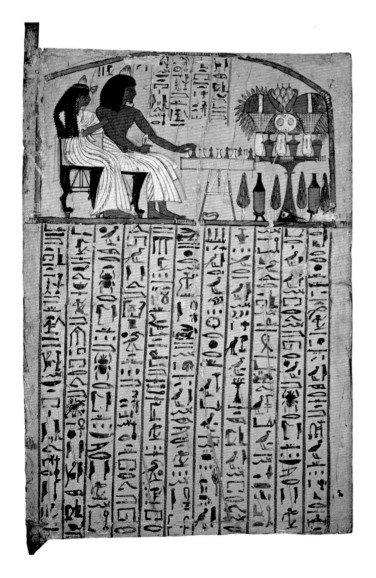

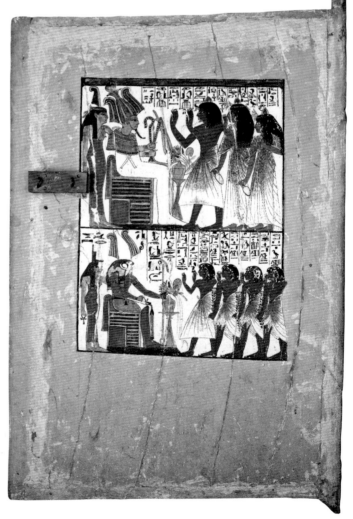

216

The New Kingdom

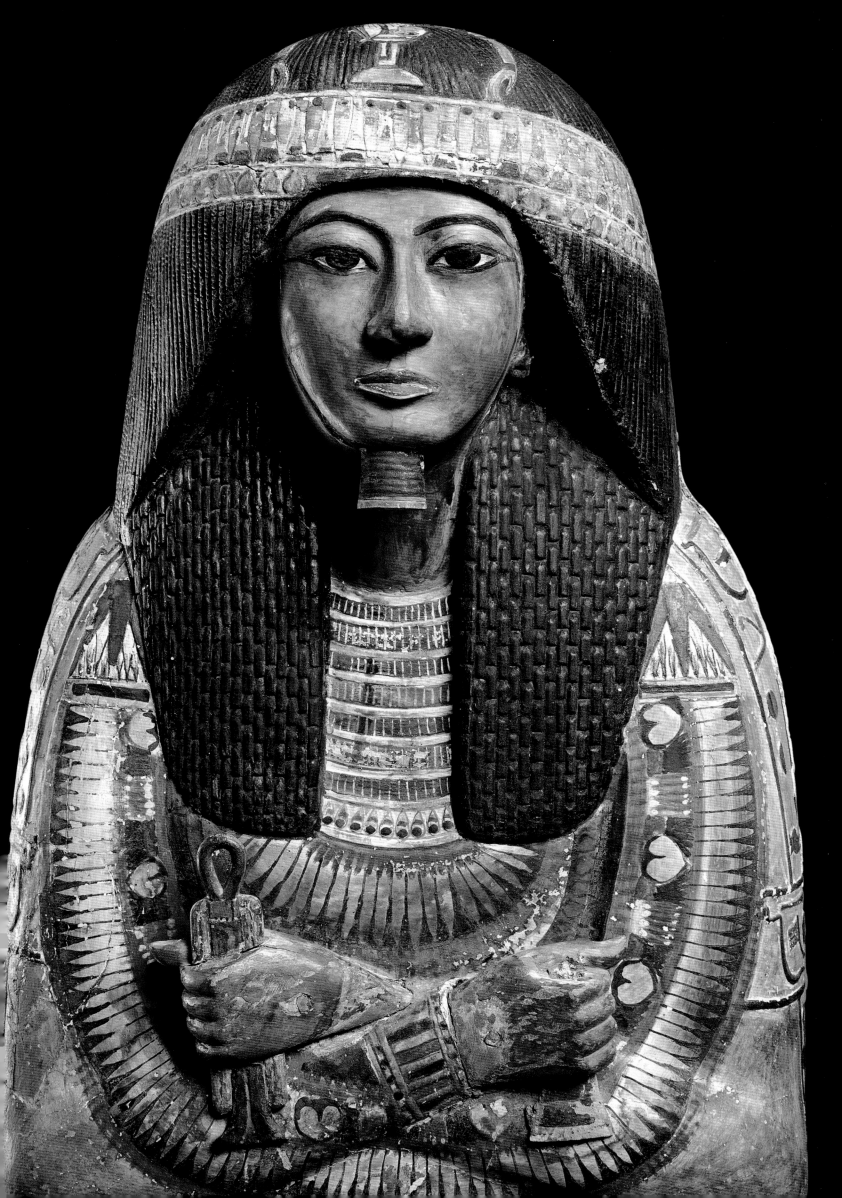

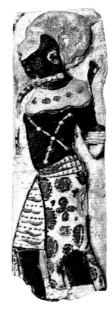
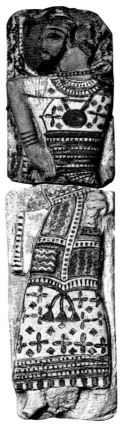
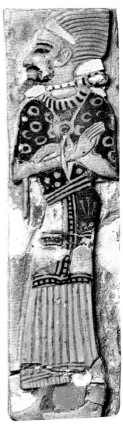

218
*JE 36457 and following
- CG 27525*

**TILES WITH
FIGURES OF
PRISONERS**

DECORATED FAÏENCE
HEIGHT CM 25-26
20th Dynasty,
reign of Ramesses III
(1184-1153 BC)

Supposedly, Ramesses
III magically subjugated
the enemies depicted on
these tiles (Syrians,
Nubians, Libyans,
Bedouins and Hittites),
which were discovered
by the Antiquities
Service (1910) in the
royal palace annexed to
the pharaoh's mortuary
temple at Medinet Habu.

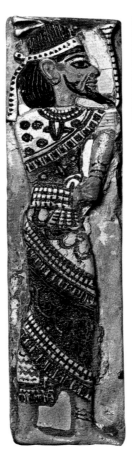
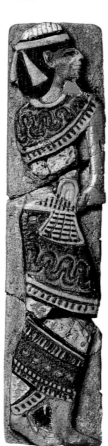
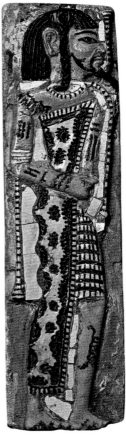
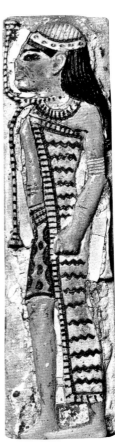
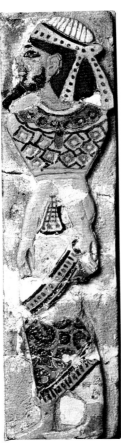

219 | *JE 38682 = CG 42150*

**STATUE OF RAMESSES III
AS A STANDARD BEARER**

GRANODIORITE
HEIGHT CM 140
20th Dynasty,
reign of Ramesses III
(1184-1153 BC)

This type of statue, depicting the
pharaoh as the standard bearer of
one of the gods (Amun-Ra in this
case, identified by the ram's head),
ensures the ruler's long-lasting
presence in the temple. G. Legrain
discovered the sculpture in the
cache at Karnak (1905).

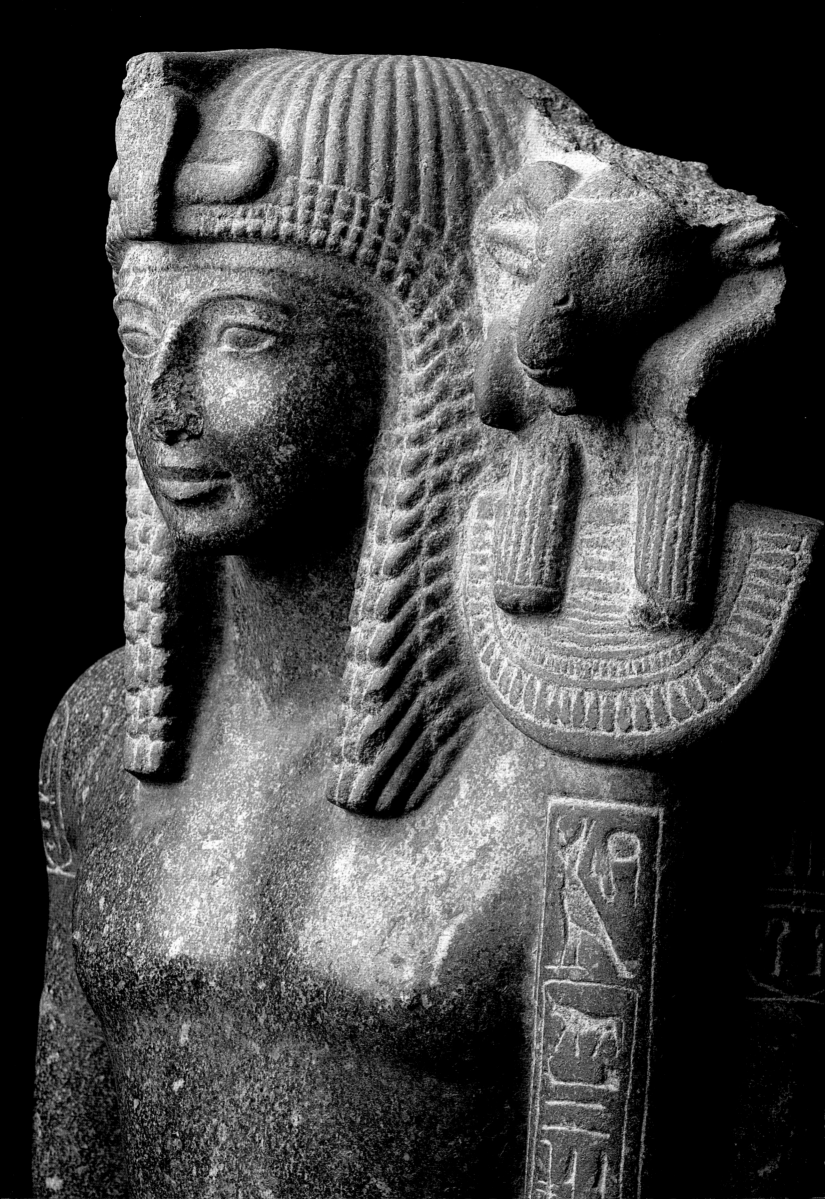

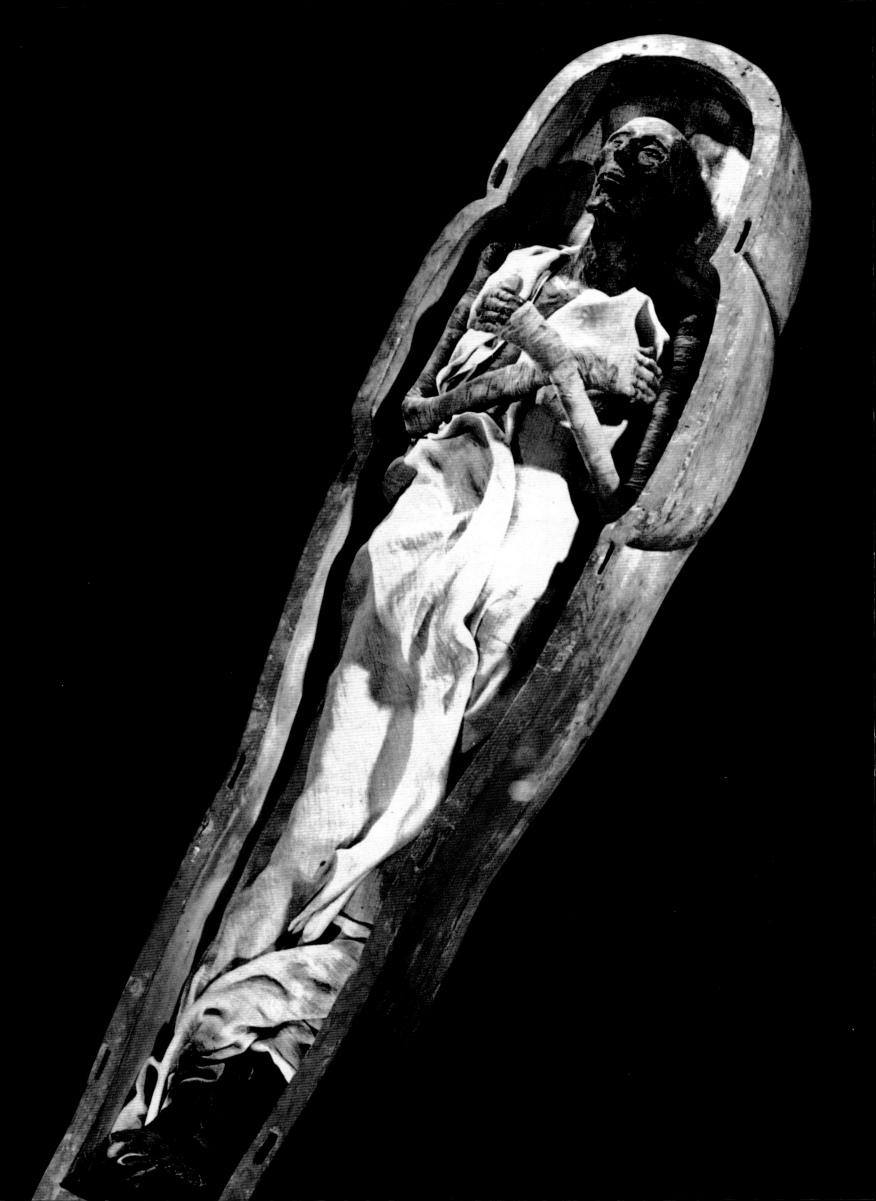

The Egyptian Museum in Cairo is the final resting place for some of Ancient Egypt's

most important pharaohs, men whose bodies were preserved through the infinite devotion of the priests of the Twenty-First Dynasty. The dramatic events that marked the end of the New Kingdom, and the ensuing economic crisis, led to pillaging of the treasures of the necropolis in the Valley of the Kings. Numerous papyruses dating to the late Ramesside Period report the trials of pillagers and substantiate the tomb-robbing incidents, which also involved several important local government officials. It seems that, in many cases, the thieves were in touch with merchants from the east bank of the Nile at Thebes, who were willing to sell off the stolen goods.

Significant attempts were made to save the pharaohs' mummies from being plundered because of the religious belief that destruction of the body would make it impossible for the spirit to enter the afterlife. Most of the royal mummies were brought to two hiding places, the tomb of Amenhotep II in the Valley of the Kings (KV 35) and a tomb at the necropolis of Deir al-Bahari (TT 320). The attribution of the latter is dubious, and it is now referred to as the Deir al-Bahari cache. Unfortunately, the mummies of several pharaohs, such as Horemheb, Ay, and Thutmose I, have not been found.

In 1881, on behalf of the Antiquities Services and in the name of Gaston Maspero, its director at the time, Émile Brugsch became the first person to enter TT 320. This was possible through the help of a member of the local family of Abd al-Rassul, who had discovered the tomb in 1875 and gradually looted it. The arrival of royal objects on the antiquarian market was precisely what tipped off the Antiquities Services, which opened an investigation. The cache was emptied in just two days and the mummies were sent to Cairo by river, attracting large crowds to the riverbanks in order to bid a final farewell to their most illustrious rulers.

In 1898, French Egyptologist Victor Loret discovered the tomb of Amenhotep II and, to his surprise, he also found the remains of other pharaohs lined up in two annexes. These bodies were also sent to Cairo, with the exception of Amenhotep II. His mummy was left in his coffin and tomb, because he was one of the few pharaohs to have been found in his original burial place. However, after the tomb was raided—once again by member of Abd al-Rassul's family—his mummy was also removed for safekeeping in 1901.

Most of the mummies, as well as the coffins in which they were placed after they were moved, have a label bearing a hieratic text. In some cases, the label lists only the name of

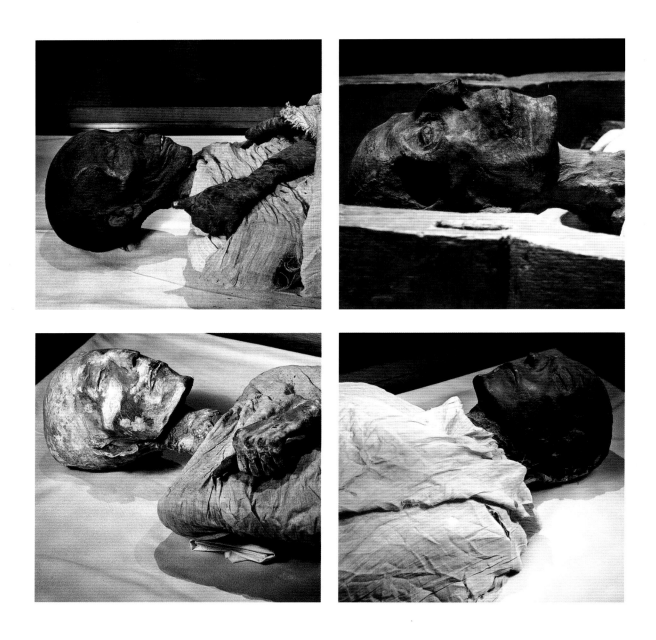
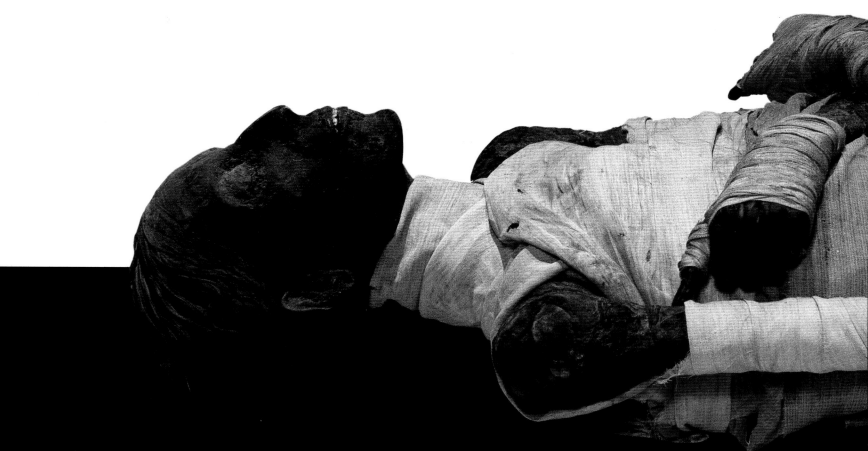

the deceased, but in others it provides more detailed information about the dates the bodies were moved and the people involved. The mummies were evidently rewrapped and restored, in some cases at a number of different sites, as indicated by graffiti and other documents. These events also involved the reuse of royal funerary accoutrements during the Third Intermediate Period, and it was possible to verify this in many cases.

In 1912, the mummies were scientifically examined for the first time. This work was done by G. Elliot Smith, who published his study in the book *The Royal Mummies*, in which he stated that radiological exams were also essential. However, it was not until 1967 that, following a radiographic study of Nubian populations from the Second Cataract, the University of Michigan, working with the University of Alexandria in Egypt, X-rayed all the mummies at the Egyptian Museum, from the Middle Kingdom to the Greco-Roman Period.

This led to the compilation of an atlas of the royal mummies from the New Kingdom, totaling 34 mummies and including 31 complete skeletons. The study revealed post-mortem traumas on many of the bodies. In some cases, limbs had been amputated by looters in search of valuable jewelry and amulets, which were generally concealed within the bandages. This systematic X-ray study made it possible to learn about the many diseases that afflicted the people of the era, and to gain better insight into how the pharaohs were embalmed. During the New Kingdom, this technique achieved its highest level of specialization, largely confirming what was reported by Herodotus, who cited thirteen phases from death to burial.

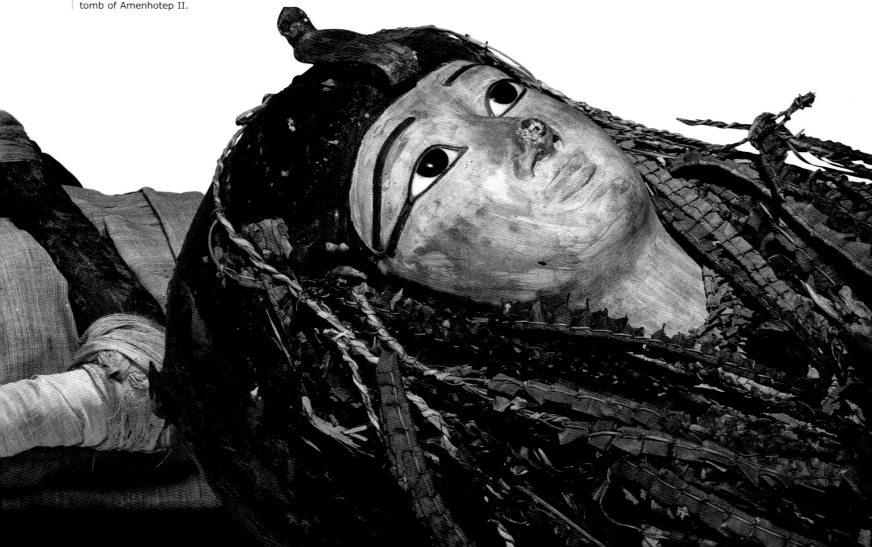

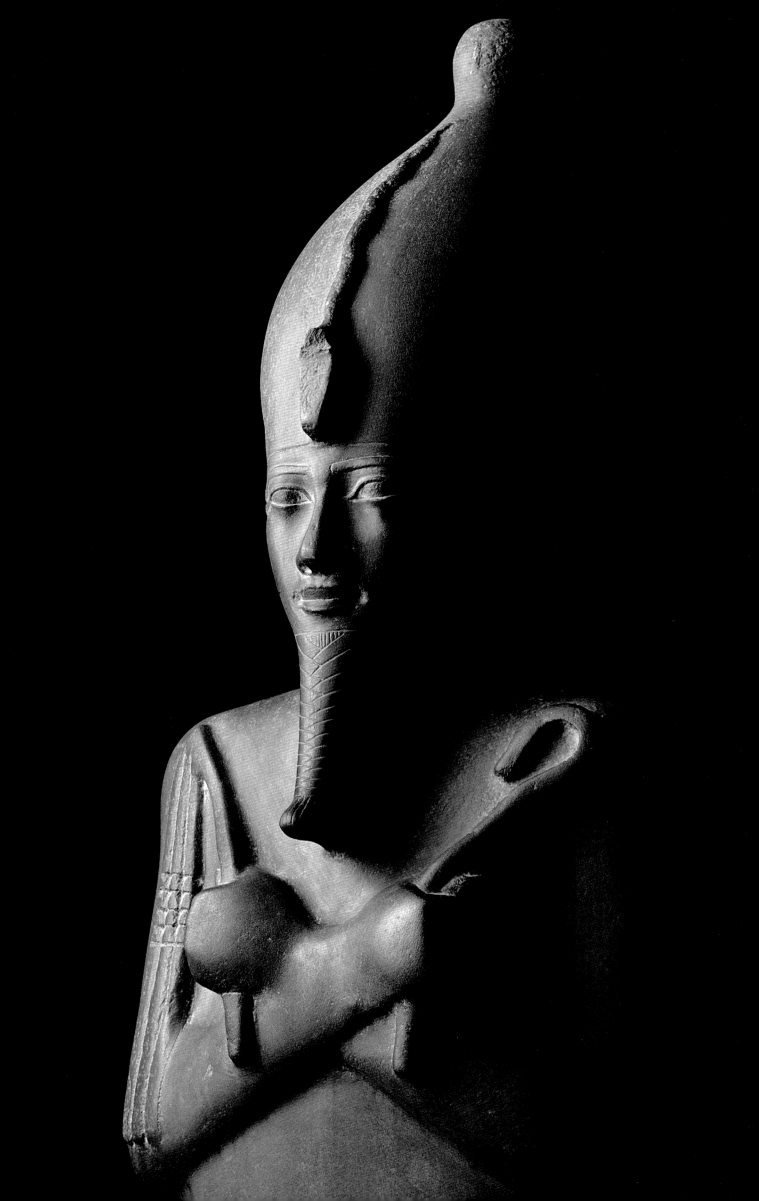

THE THIRD INTERMEDIATE PERIOD AND THE LATE PERIOD

A SHRINKING EMPIRE, THE

GROWING POWER OF THE

THEBAN PRIESTHOOD AND,

WITH THE TWENTY-SIXTH

DYNASTY, THE RETURN

TO A POWERFUL STATE ARE

THE KEY ELEMENTS FOR

UNDERSTANDING A

HISTORIC PHASE THAT,

THOUGH UNCERTAIN,

WAS NOT A DARK ONE.

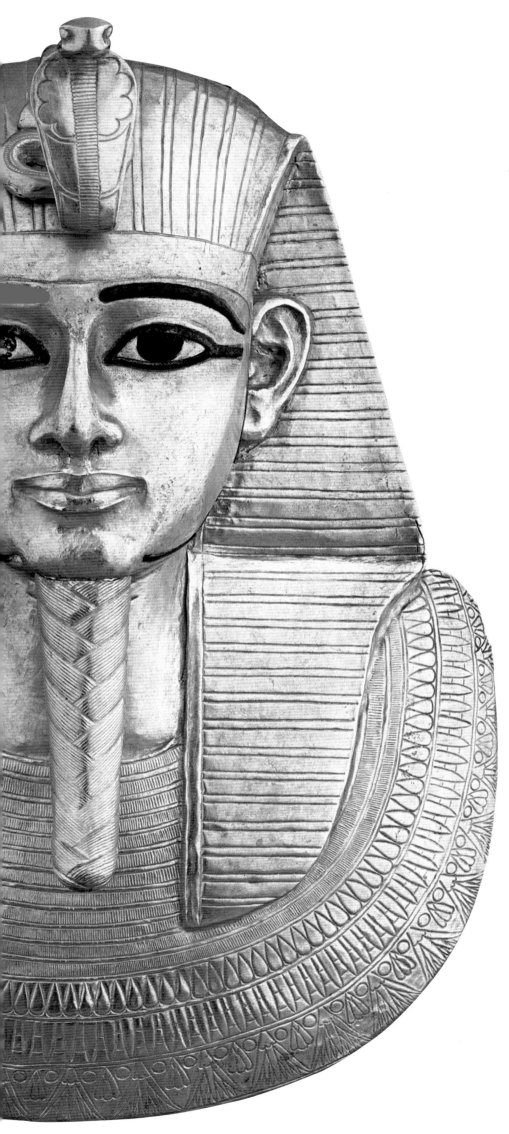

The proclamation of uhem-mesut (or rebirth) in Year 19 of the reign of Ramesses XI,

(Twentieth Dynasty) testifies to the country's need for stability during the era of great chaos that closed the Ramesside Period. In fact, a 'renaissance' had already been proclaimed twice in the past, during periods of restoration following great weakening of the central power, i.e., at the beginning of the Middle Kingdom with Amenemhat I following the First Intermediate Period, and during the New Kingdom with Seti I following the Amarna heresy.

A severe economic crisis, famine in Upper Egypt, and civil war in the Theban area had undermined the central power, allowing a powerful family of priests of Amun to rise at Karnak. These priests gradually represented themselves as rulers and held enormous power in the southern part of the country. Thus, the death of the last Ramesses and the rise to power of the rulers of the Twenty-first Dynasty, which opened with Smendes, an administrative official who ruled only Lower Egypt from the new capital, Tanis, was opposed by the 'dynasty' of Herihor, the High Priest of Amun, in Upper Egypt, whose power was also strengthened by the Oracle of Amun at Karnak. The great influence of the priesthood of Amun was already reflected in the architecture of the city of Tanis, designed to resemble the city of Thebes and even referred to as the "Thebes of Lower Egypt."

This turmoil was also reflected in the necropolises of the Valleys of the Kings and the Queens, with frenetic activity that, on the one hand, was marked by scandals and continuous trials against predators, and on the other led to the dismantling of the royal tombs of the New

224

STANDING STATUE OF OSIRIS

BASALT
HEIGHT CM 150
BASE: WIDTH CM 24.5
LENGTH CM 43
26th Dynasty, reign of Psammetik I
(664-610 BC)

JE 30097 = CG 38231

This statue, made of polished basalt, offers a splendid image of Osiris, king of the afterlife. The sculpture was found in front of the mortuary temple of Ramesses III at Medinet Habu (1895).

Kingdom. As a result, these mummies were concealed to ensure the eternal life of the dead pharaohs. A series of papyrus documents from the late Ramesside Period, known also as the "papyruses of the tomb robberies," illustrate the tragic situation of the great necropolises of Thebes, where inspections were ordered on a regular basis to check the condition of the various tombs and prevent their profanation. These documents reveal widespread corruption in the state administration, which often abetted these thefts, as well as an unspoken agreement between the tomb robbers on the west bank and merchants on the east bank, who would then sell the stolen treasures and split up the proceeds.

In addition to dealing with the deeds of these unscrupulous predators, out of devotion to their deceased rulers the priests worked frantically to remove the bodies of the pharaohs from their tombs to ensure their afterlife. Information about these movements was accurately recorded directly on the royal mummies of the New Kingdom, which often required new bandages, found inside two specific hiding places, namely Theban Tomb no. 320 at Deir al-Bahari and the tomb of Amenhotep II in the Valley of the Kings (KV 35). The bodies of these glorious rulers are exhibited at the Egyptian Museum in Cairo in special rooms reserved exclusively for them.

The west bank of Thebes continued to be used for private burials throughout the Twenty-second Dynasty, using royal and other tombs, or digging graves inside great temple enclosures such as the Ramesseum and Medinet Habu. The latter, in particular, was consecrated for burying important dignitaries. Subsequently, with the Twenty-fifth and Twenty-sixth Dynasties, once again an important necropolis was created at the foot of the Theban mountains, concentrated in particular near the Temple of Hatshepsut at Deir al-Bahari.

The Twenty-second Dynasty, under Libyan princes, brought a period of renewed splendor not only within the country but also in its outside relations. These rulers, warriors who undertook successful military campaigns, were equally skilled at establishing good relations with the cities and countries of the Syrian-Lebanese coast. Egypt's well-being can also be noted through the important construction and restoration work done in the temple enclosures of Karnak, Tanis, and the new capital city of Bubastis.

An era as controversial as the Third Intermediate Period became the focus of renewed attention, and the treasures from the royal tombs of Tanis (Twenty-first–Twenty-second Dynasties), many of which were intact when Pierre Montet discovered them in 1939, contributed enormous amounts of information. As was the case with the Theban necropolis, this royal necropolis was also redone many times. Various tombs were reutilized, and they were subject to plundering and profanation. Thus, the

225
JE 85788 - 85799

PENDANT OF PSUSENNES I

GOLD, GEMSTONES, VITREOUS PASTE
HEIGHT CM 10.5
WIDTH CM 12.5
21st Dynasty,
reign of Psusennes I
(1045-994 BC)

Attached to a gold necklace, this refined pendant in the shape of a winged scarab was discovered by P. Montet on the pharaoh's mummy, in the crypt of his tomb at Tanis (1940).

226
JE 85913

MASK OF PSUSENNES I

GOLD, LAPIS LAZULI, VITREOUS PASTE
HEIGHT CM 48
WIDTH CM 38
21st Dynasty, reign of Psusennes I (1045-994 BC)

Among the furnishings of Psusennes I, which Montet found intact in the pharaoh's tomb inside the enclosure of the Temple of Amun at Tanis, this burial mask stands out because of its striking workmanship.

bodies were moved from one tomb to another, and mummies were concealed here as well. The priceless funerary furnishings from Tanis and the jewelry found there are exhibited in a special room at the Egyptian Museum.

The tombs at Tanis were dug inside the temple enclosure of Amun-Ra, thereby placing them under divine protection, hidden and protected by the massive walls of the temple. This type of burial "in the courtyard of a divine temple" continued for over 500 years, until the Saite Period (Twenty-sixth Dynasty). The necropolises of the Divine Votaresses, buried in the enclosure of the Ramesseum during the Third Intermediate Period and in that of Medinet Habu, near the Temple of Amun, during the Late Period, are likewise tombs in the courtyard of a divine temple.

The figure of the Divine Votaress, who is also the 'wife' and 'hand' of Amun, became increasingly powerful during the Third Intermediate Period and particularly during the Late Period. Starting with Pharaoh Osorkon III (Twenty-second Dynasty)—he had named his daughter Shepenupet (I) the Divine Votaress and made one of his sons the High Priest of Amun—each ruler bestowed this title on one of his daughters, and this became an inherited role. The Divine Votaress thus came to be considered the true Lady of Thebes; her name was written in the cartouche and preceded by royal appellatives. She was represented in the act of making offerings to the gods or participating in rituals that were traditionally reserved for royalty. She also owned extensive properties that continued to grow through donations from the pharaoh, and she had her own administration with a 'High Steward' as part of her retinue. These priestesses were particularly important during the Twenty-fifth or 'black' Dynasty, which exploited the severe disorders at the end of the Libyan period. One of the first moves of the Nubian king Piankhy was to decree that the power of the Divine Votaress Shepenupet I should go to his sister Amenirdis, so he could rely on the temporal power of the god Amun and gain control of Upper Egypt. There is a splendid statue of Amenirdis, in all her magnificence, at the Egyptian Museum in Cairo.

Though the Nubian Dynasty propagated itself as a line of true pharaohs, these rulers were nevertheless forced to deal with great internal resistance. Local lords who had gained power, taking advantage of the anarchic state left by the Libyan Dynasty, continuously attempted to drive out the Nubian kings in the south. To do this, they also sought help from outside Egypt, particularly from the Assyrians. With the help of the latter, the Nubians were finally driven from Nile Valley.

At the same time, the powerful lords from the city of Sais in the north managed to rise up and reunite the Delta populations, and even the Assyrians acknowledged them as rulers of the entire country. This ushered in the last period of great splendor of Pharaonic Egypt. Psammetik I, who founded the Saite Dynasty, sought recognition in Thebes, which continued to be the undisputed religious capital of Egypt, by having his youngest daughter Nitocris adopted by the Divine Votaress Amenirdis II, daughter of the Nubian king Taharqa. This event is commemorated on a famous stele found at the triple chapel of Seti II at Karnak in 1897 and now preserved in Cairo.

Today, the terms 'renaissance' or 'archaism' are generally used to refer to the Saite Period to indicate a phase evoking Egypt's glorious past. An evident archaizing tendency—which had already commenced with the Twenty-fifth Dynasty—developed during the Twenty-sixth Dynasty, and it affected

The Late Period

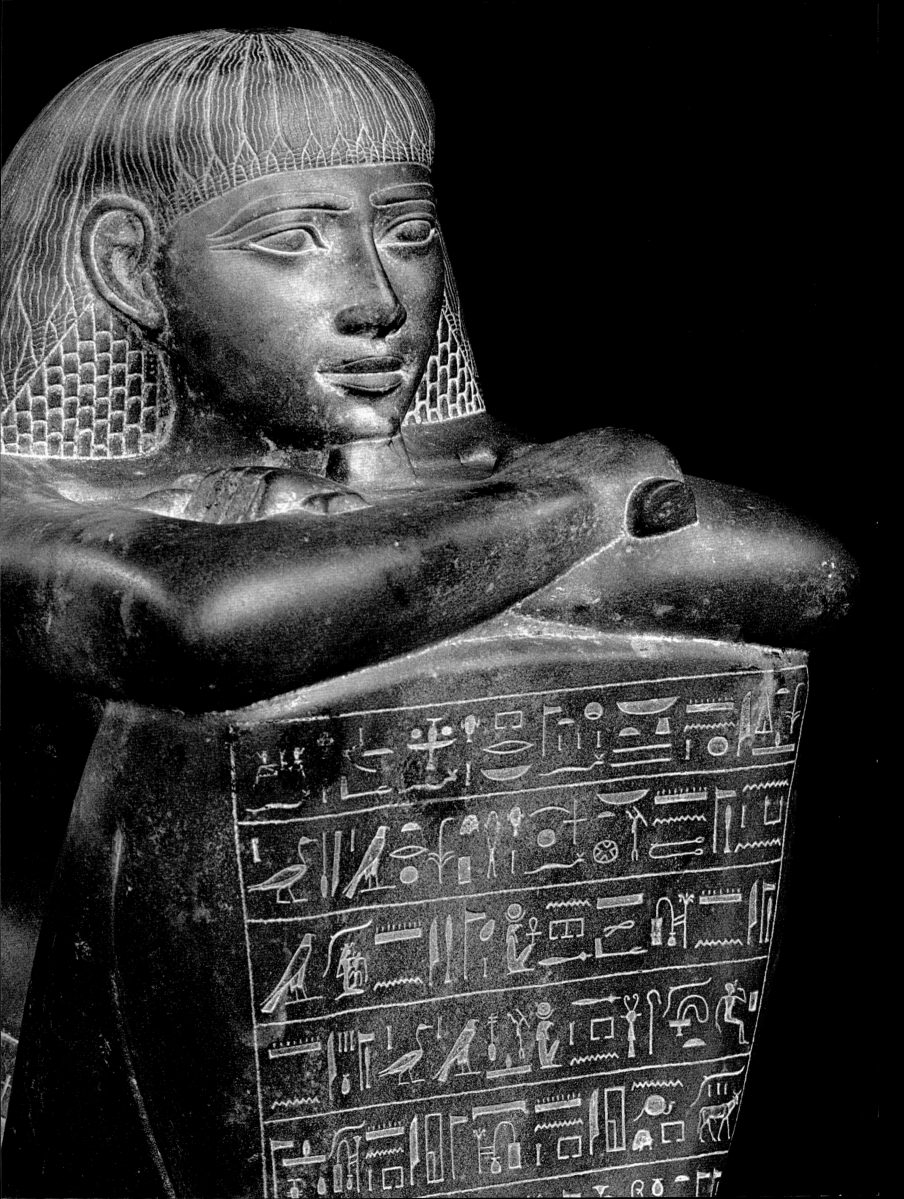

every area of the pharaonic culture, from religion to art, writing, architecture, language, and fashion. Over the course of Egyptian history, this approach was always accompanied by the search for legitimacy by the sovereign and his family, particularly during the chaotic periods that followed weakening of the central power. Nevertheless, this was never as evident as it was during the Saite Period. The reasons for this phenomenon continue to be debated by scholars even today. It is likely that contemporary events and the tangible threat of foreign populations—the Nubians and Assyrians in particular—stimulated the desire for a stronger national identity, exalting Egypt's millenary traditions while also fueling xenophobic attitudes. Nevertheless, this did not involve mere 'copying' but intelligent reconsideration that could create new forms of expression by drawing on Egypt's extended and potent cultural memory. Added to this was an 'antiquarian' interest, a taste for documenting and preserving the monuments and works of the past, and this sensitivity was plainly evident in previous periods as well, such as the striking case of Khaemwese, son of the great Ramesses II.

It was Egypt's openness toward the outside that ultimately and inevitably undermined its cultural identity. Time and again, the essentially peaceful penetration of colonies of mercenaries and merchants—Carians, Greeks, Phoenicians, and Semites—was countered by the organized armies of the Assyrians, the Persians, and the Macedonians. The victory of Alexander the Great in 332 BC inexorably marked the end of Egypt's independence.

Several rooms on the ground floor of the Museum are devoted exclusively to the Third Intermediate Period and the Late Period. The itinerary starts in Room 20 with the remarkable limestone statuette of King Osorkon III (Twenty-second Dynasty), portrayed as he is pushing the sacred boat of Amun. It continues in Room 25 with the fragmentary head of the statue of the 'black' king Shabaka (Twenty-fifth Dynasty), the statue group of Montuemhat with his son Nesptah, and the cube statue of Ahmes. The next area, Room 24, holds an array of interesting sculptures: a statue of Isis, a statue of Osiris, and a statue of the cow-goddess Hathor with the head scribe Psammetik, all of which from the tomb of this official at Saqqara. This room also holds the statue of the vizier Hori in an unusual pose, the statue of the vizier Nespaqashuty posing as a scribe, the quartzite statue of the scribe Petamenofi, the standing statue of Montuemhat, the statue of Ahmes, and two striking statues of deities, one of Osiris and the other of the hippopotamus-goddess Teweret. Displayed in the next area, Room 30, are the splendid alabaster statue of the Divine Votaress Amenirdis and the famous stele of King Piankhy (Twenty-fifth Dynasty). The itinerary continues on the upper floor in Room 24, devoted to papyruses and ostraca, and the Book of the Dead of Pinedjem I is also here. Room 19 nearby has numerous valuable statues of deities from this era, notably a bronze statue of Osiris encrusted with gold and silver, a bronze statuette of the falcon Horus inlaid with gold, a set of bronze statues portraying Nefertem, Neith, the cow-goddess Hathor, and Ptah, and a shield made of bronze and gold. After this is Room 2, devoted entirely to the treasures discovered at the royal necropolis of Tanis. Among the rooms exhibiting funerary furnishings, Room 12 houses the ushabty of Queen Henuttawy. A series of richly decorated wooden coffins can be seen in Rooms 31, 46, and 48.

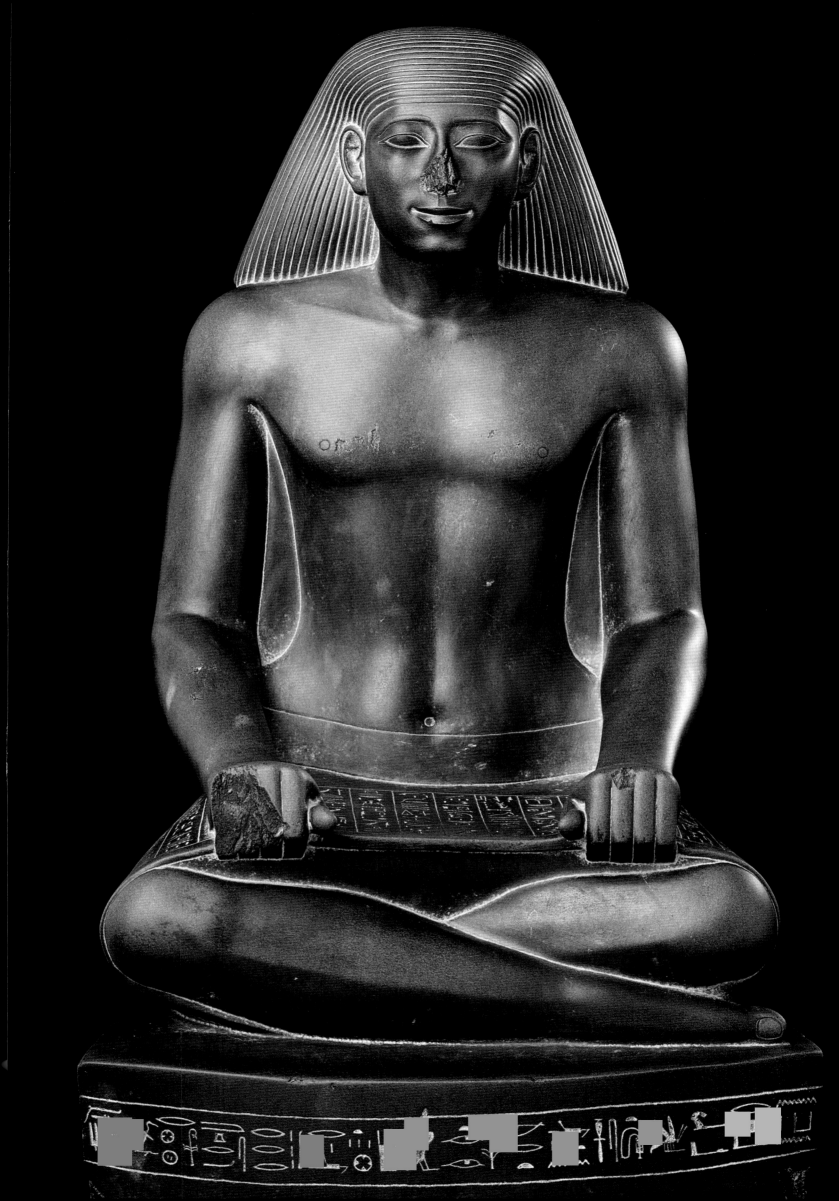

SARCOPHAGUS OF PAKHAR

PAINTED WOOD
HEIGHT CM 189
WIDTH CM 59
Middle of the 21st Dynasty
(late 21st century BC)

The cache at Bab al-Gasus yielded 153 sarcophaguses (two-thirds of which were double, like the one shown here), which belonged to priests of Amun at Karnak, from the Twenty-first Dynasty. They were discovered by G. Daressy (1891).

SARCOPHAGUS OF MAATKARA

PAINTED WOOD, GOLD LEAF
HEIGHT CM 223
21st Dynasty, reign of Pinodjem I
(1075-945 BC)

During the excavation work conducted by the Antiquities Service (1881), the cache at Deir al-Bahari yielded 14 sarcophaguses, one of which belonged to the Divine Votaress Maatkara, portrayed with her face framed by a light blue wig.

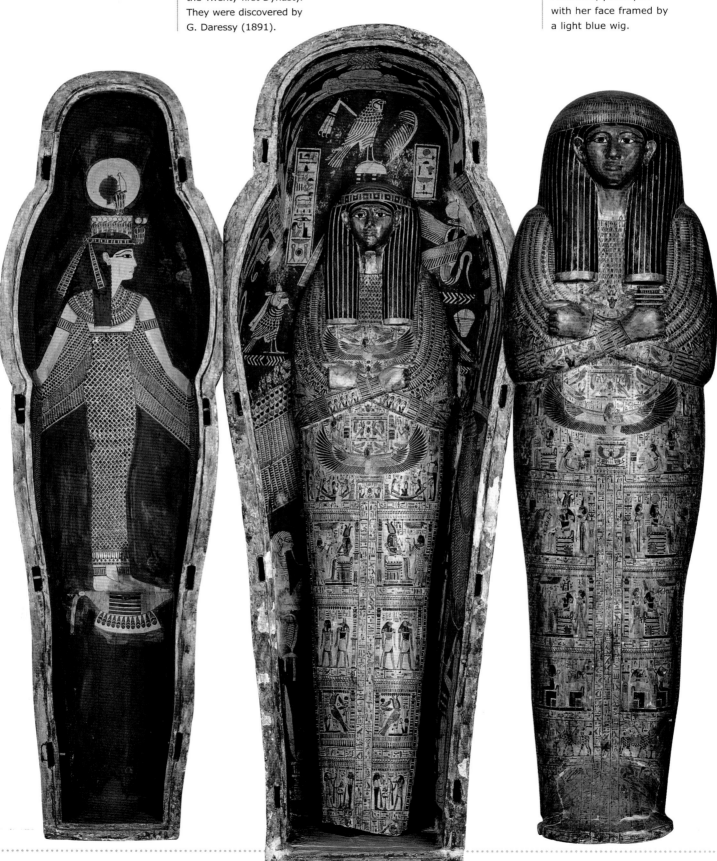

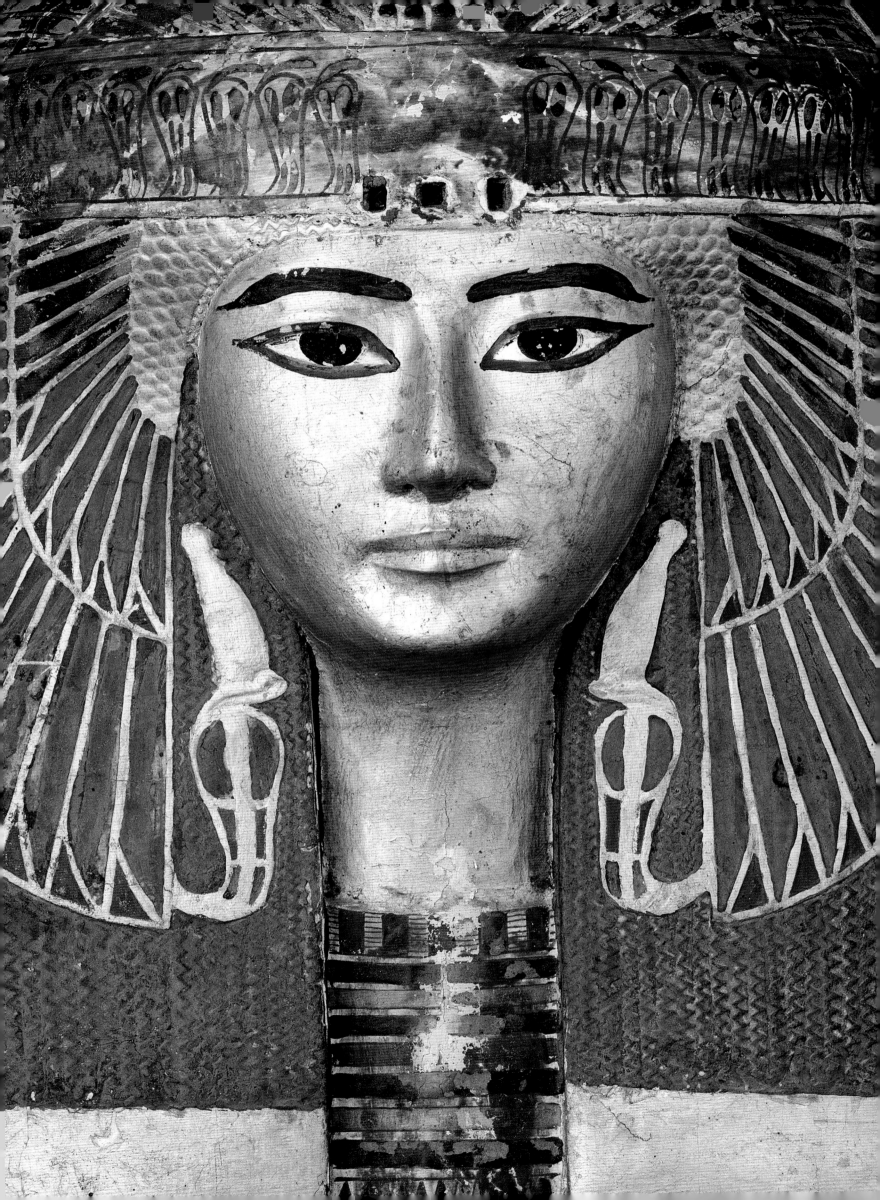

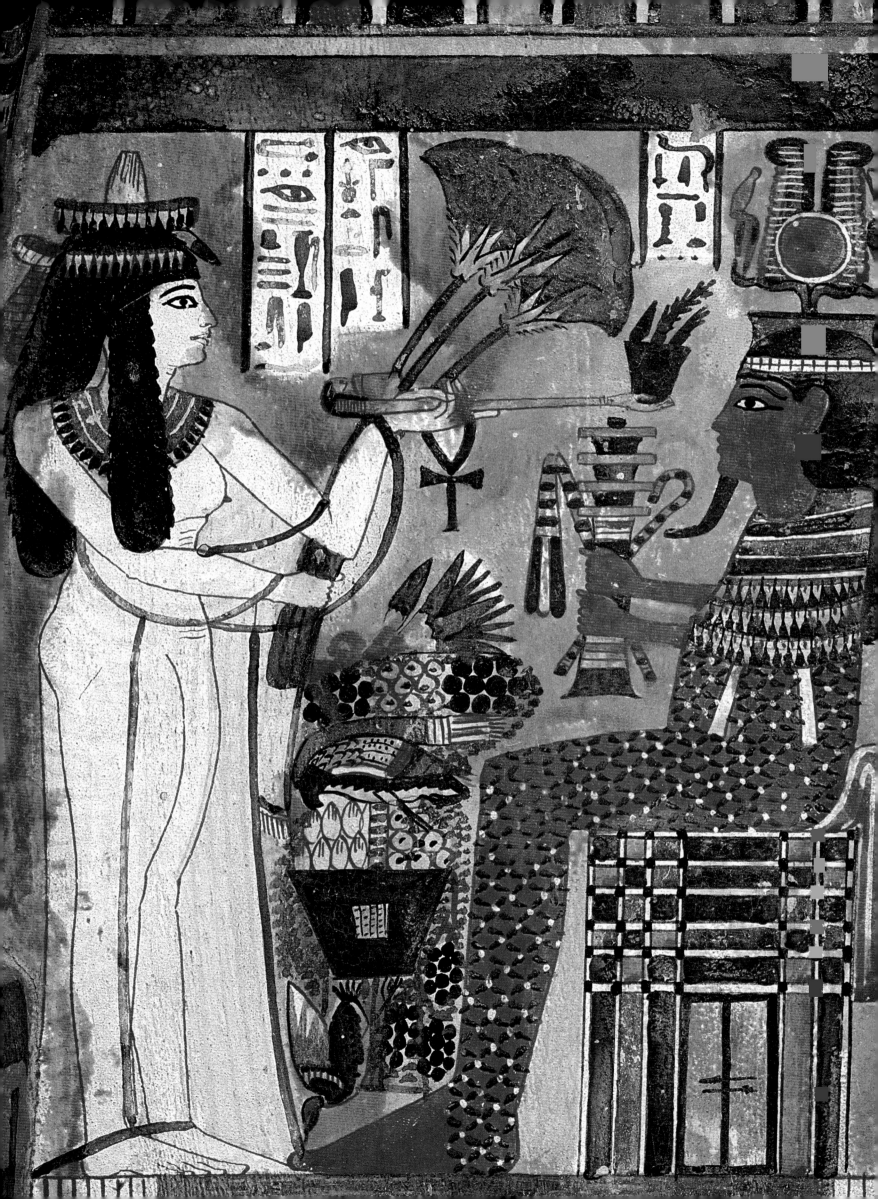

234 and 235

SARCOPHAGUS OF DJEDHOREFANKH

PAINTED WOOD
HEIGHT CM 203
WIDTH CM 61
Early 22nd Dynasty,
reign of Shoshonq I or Osorkon I
(945-899 BC)

TR 23.11.16.2

The intent of the rich decoration on the coffins from the Third Intermediate Period was to compensate for the lack of representations on the tomb walls. The sarcophagus of Djedhorefankh (whose lid has been lost) is a splendid example. It is decorated on several registers with scenes connected with burial rites. T. Davis discovered this magnificent object at Qurna (1916).

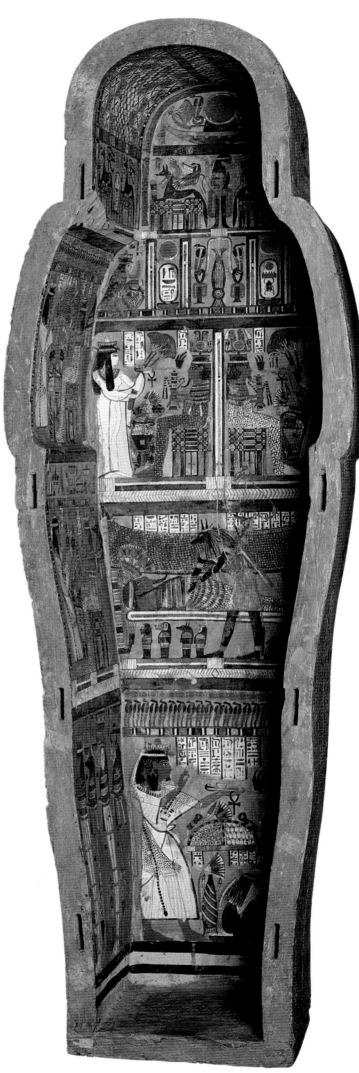

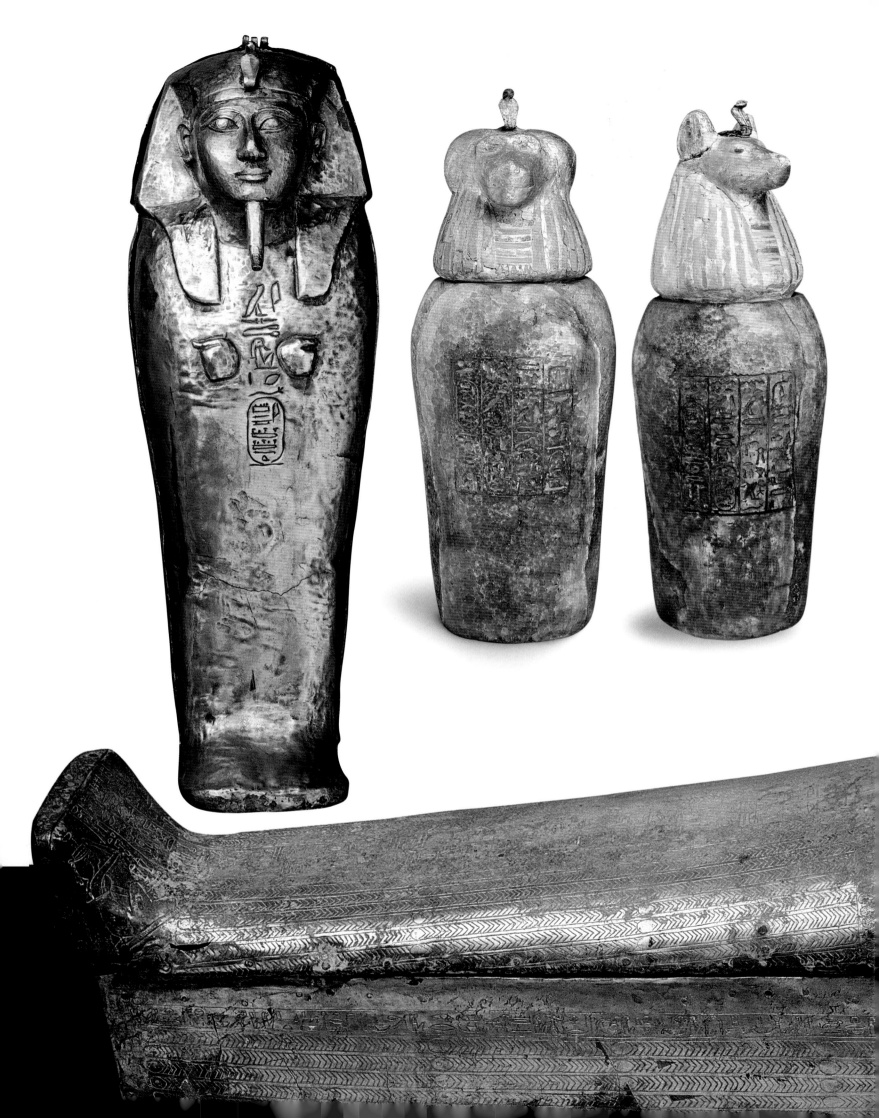

236 left | *JE 72159*

CONTAINER FOR THE ORGANS OF SHESHONQ II

SILVER
LENGTH CM 25
22nd Dynasty,
reign of Sheshonq II
(circa 890 BC)

The tomb of Psusennes I at Tanis held the burials or furnishings of later rulers, including Sheshonq II. This miniature sarcophagus, discovered by P. Montet (1940), was actually a canopic jar.

236-237 top | *JE 85917 - 85915 - 85916 - 85914*

CANOPIC JARS OF PSUSENNES I

ALABASTER, GOLD LEAF, BRONZE
HEIGHTS: CM 39; 41; 38; 43
21st Dynasty, reign of Psusennes I
(1045-994 BC)

P. Montet discovered these canopic jars – without an enclosure – in front of the sarcophagus of Psusennes I. The lids of these alabaster jars are painted and covered in gold leaf, with bronze uraei on the heads.

236-237 bottom | *JE 85912*

SILVER SARCOPHAGUS OF PSUSENNES I

SILVER, GOLD
LENGTH CM 185
21st Dynasty, reign of Psusennes I
(1045-994 BC)

This priceless sarcophagus, which was also discovered at Tanis, held the ruler's remains. The feathered decoration is finely engraved and embellished with gold.

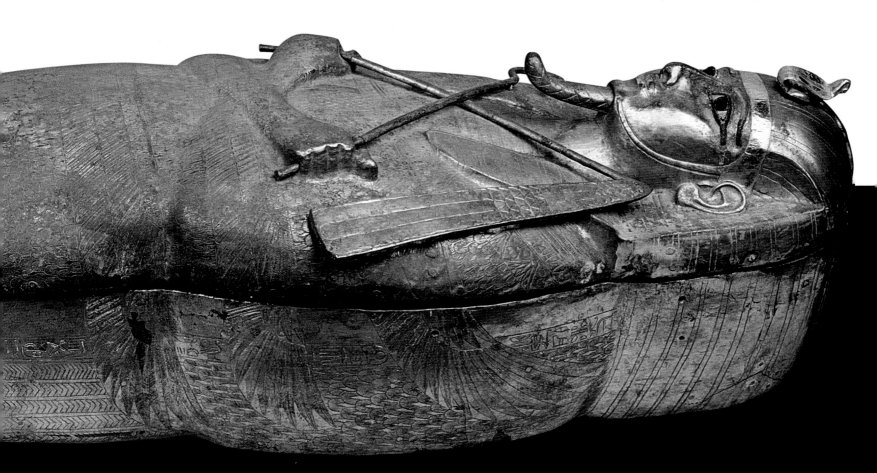

238 top | JE 85893 - 85892

BASIN AND EWER OF PSUSENNES I

GOLD
BASIN: HEIGHT CM 17
EDGE DIAMETER CM 20.9
EWER: HEIGHT CM 39
21st Dynasty, reign of Psusennes I
(1045-994 BC)

P. Montet's excavations at Tanis (1940) yielded everyday ware made of precious materials, unlike the treasure of Tutankhamun. These two specimens present light incisions with the ruler's cartouche.

238 bottom | JE 85842

SANDALS OF PSUSENNES I

GOLD
LENGTH CM 23.3
21st Dynasty, reign of Psusennes I
(1045-994 BC)

These funerary sandals, which were placed on the mummy's feet, are exact replicas of the kind used in daily life. They were also part of the treasure that P. Montet discovered at Tanis (1940).

239
JE 85911

SARCOPHAGUS OF PSUSENNES I

BLACK GRANITE
LENGTH CM 220
WIDTH CM 65
21st Dynasty, reign of
Psusennes I (1045-994 BC)

Of the three coffins in which P. Montet discovered the mummy of Psusennes I, the anthropomorphic one shown here – made of stone – was the middle one. It seems to be an older one that was appropriated for the pharaoh, given the figure's lack of regal attributes.

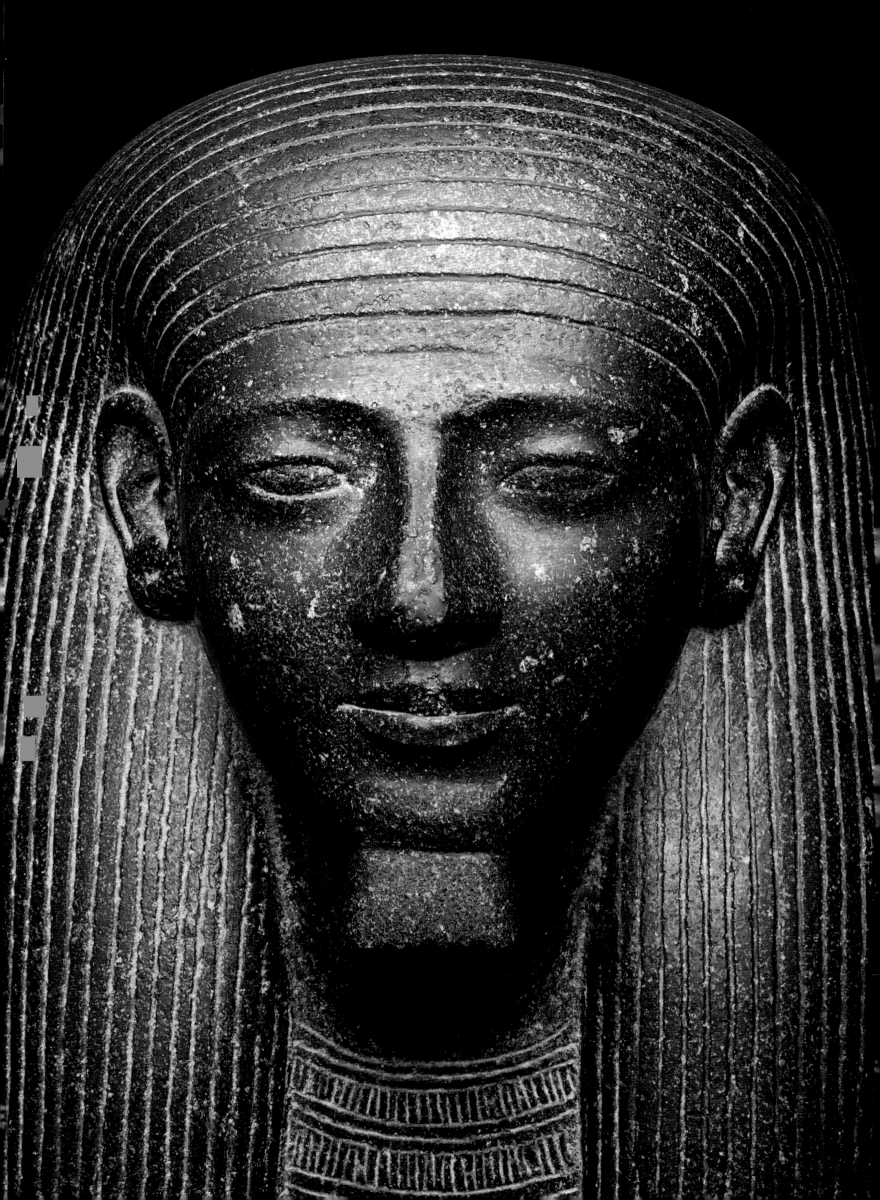

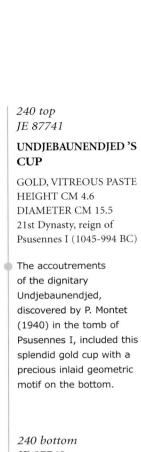

240 top
JE 87741

UNDJEBAUNENDJED'S CUP

GOLD, VITREOUS PASTE
HEIGHT CM 4.6
DIAMETER CM 15.5
21st Dynasty, reign of
Psusennes I (1045-994 BC)

The accoutrements
of the dignitary
Undjebaunendjed,
discovered by P. Montet
(1940) in the tomb of
Psusennes I, included this
splendid gold cup with a
precious inlaid geometric
motif on the bottom.

240 bottom
JE 87740

**LOBED CUP OF
UNDJEBAUNENDJED**

GOLD, ELECTRUM
HEIGHT CM 5.5
DIAMETER CM 13.3
21st Dynasty, reign of
Psusennes I (1045-994 BC)

Undjebaunendjed, who
had the honor of being
buried with his king at
Tanis, was also the
owner of this elegant cup
with alternating gold and
electrum lobes.

241 top | *JE 87742*

**PATERA OF THE
SWIMMERS**

GOLD, SILVER
HEIGHT CM 2.5
DIAMETER CM 18.4
21st Dynasty,
reign of Psusennes I
(1045-994 BC)

The pharaoh's gift to
his general
Undjebaunendjed,
this patera is
engraved with a
scene evoking earlier
compositions, with
swimmers amidst
plants and fish.

241 bottom
JE 85821

**PLAQUE OF
PSUSENNES I**

GOLD
HEIGHT CM 16.6
WIDTH CM 9.9
THICKNESS CM 0.07
21st Dynasty, reign of
Psusennes I (1045-994 BC)

The udjat eye, a
powerful amulet that
ensured the integrity
of the body, dominates
the center of this gold
plaque found by
P. Montet (1940) on the
mummy of Psusennes I.

The Late Period

242 | *JE 86027 - 86028*

BRACELETS OF PSUSENNES

GOLD, LAPIS LAZULI, CARNELIAN,
GREEN FELDSPAR
HEIGHT CM 7
DIAMETER CM 8
21st Dynasty, reign of Psusennes I
(1045-994 BC)

P. Montet (1940) found
numerous bracelets on
the mummy of
Psusennes I at Tanis
(1940). These two gold
bracelets are decorated
with winged scarabs,
with the sun disk
between the front legs
and the shen symbol
between the hind ones.
The cloisonné technique
was used for the
encrusted decorations.

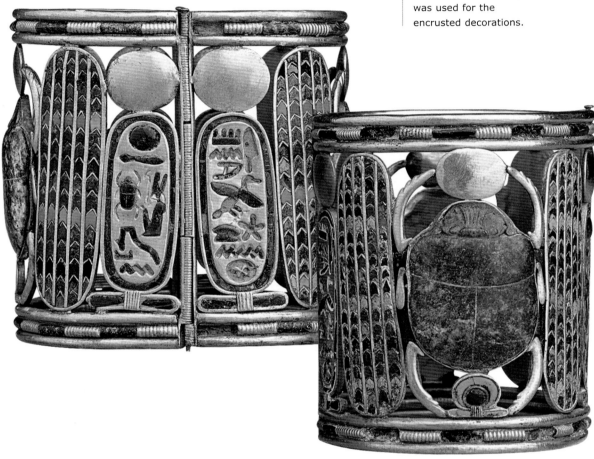

243 left | *JE 85751*

**NECKLACE OF
PSUSENNES I**

GOLD, LAPIS LAZULI
NECKLACE: LENGTH CM 64.5
DIAMETER CM 30
CLASP: HEIGHT CM 6.2
21st Dynasty,
reign of Psusennes I
(1045-994 BC)

This gold masterpiece
is one of the most
splendid necklaces
found on the
pharaoh's mummy.
Seven rows of rings
are held by a central
clasp. Dozens of
tassels of different
lengths hang from the
clasp and end in
overturned bellflowers.

243 right | *JE 85781*

**ANKLE BRACELET
OF PSUSENNES I**

GOLD, LAPIS LAZULI,
CARNELIAN
HEIGHT CM 5.5
DIAMETER CM 6.6
21st Dynasty,
reign of Psusennes I
(1045-994 BC)

The mummy of
Psusennes I also had
two ankle bracelets,
made of gold and
lapis lazuli. The scarab
or kheper, which
symbolizes
regeneration, is
depicted on the
central part of the
bracelet.

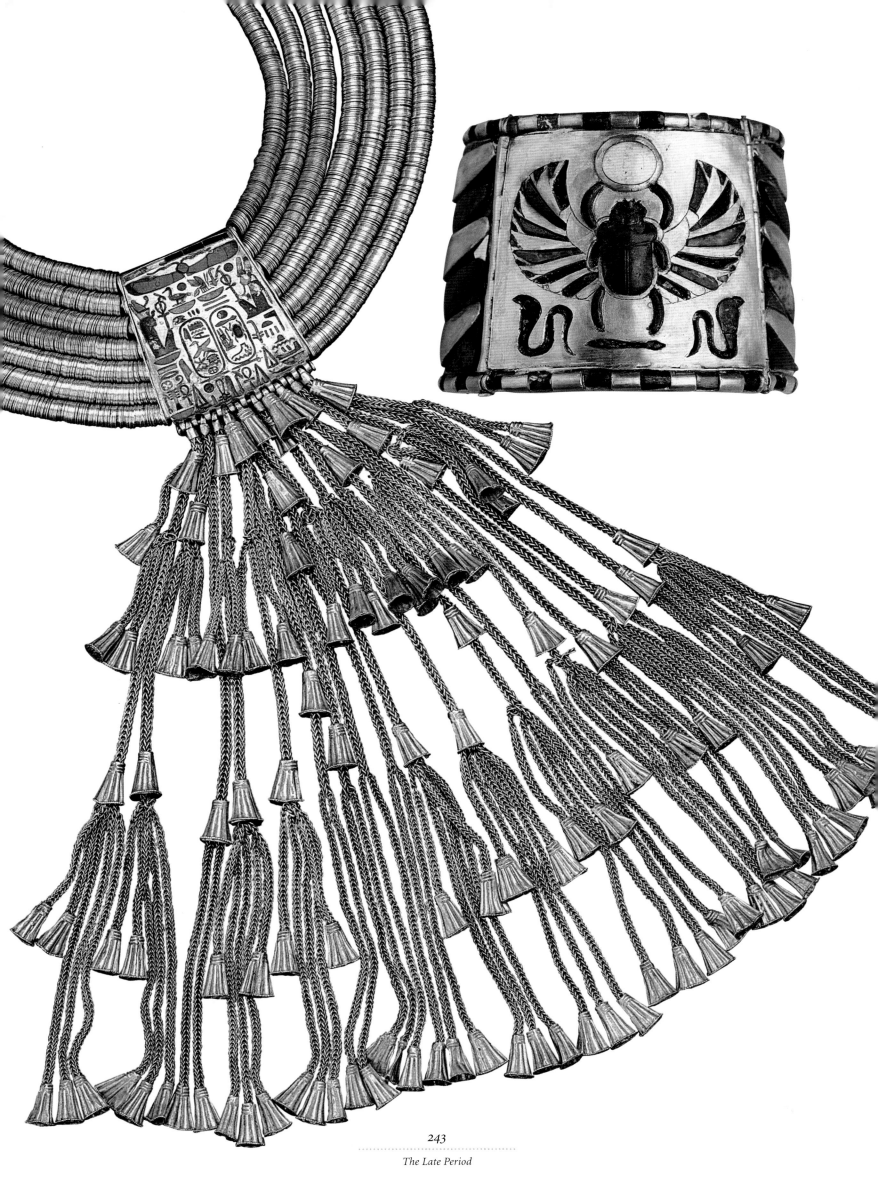

The Late Period

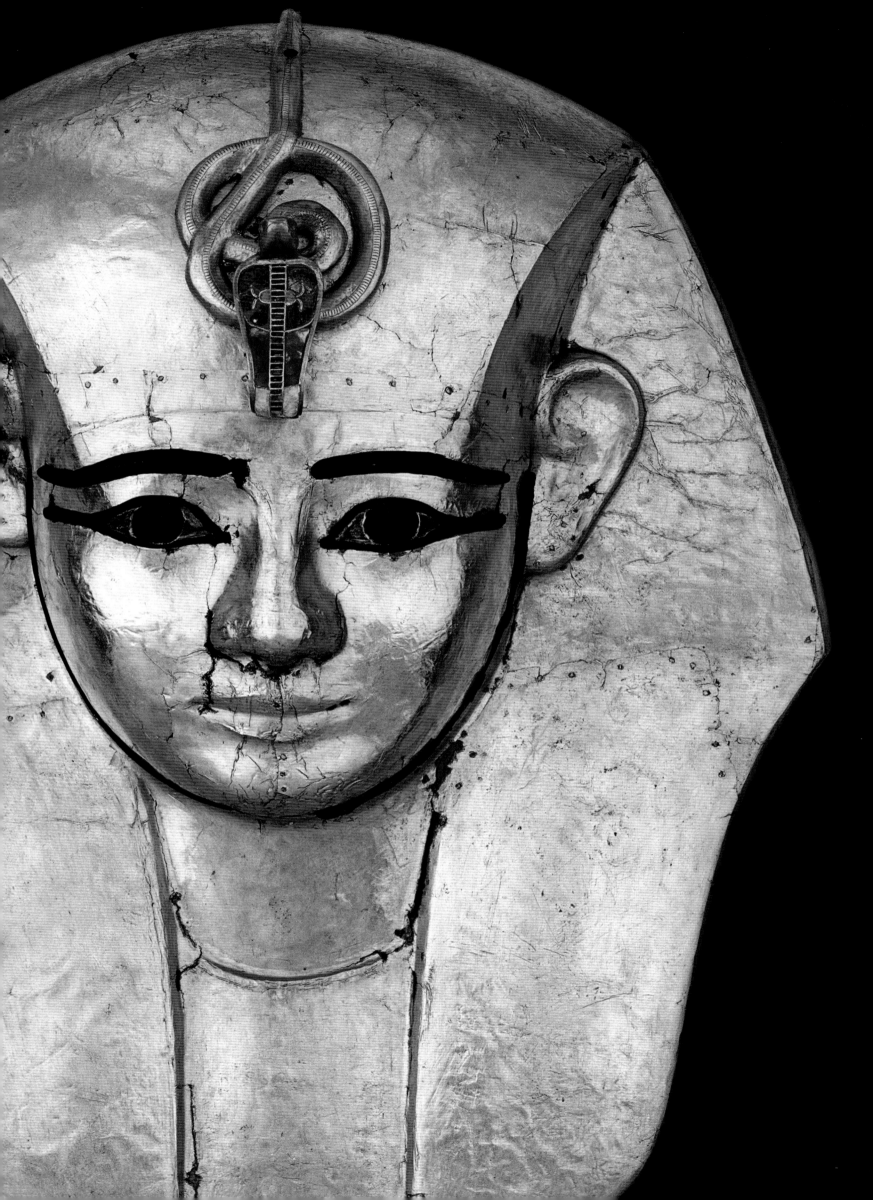

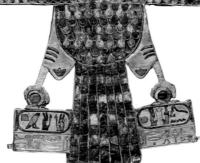

244	JE 86059

AMENEMOPE'S BURIAL MASK

WOOD, GOLD LEAF, GEMSTONESE
HEIGHT CM 30
21st Dynasty,
reign of Amenemope
(997-985 BC)

Amenemope was buried in the tomb of Psusennes I, appropriating a room that was originally dedicated to Psusennes' wife Mutnedjemet. The tomb was discovered by P. Montet at Tanis (1940). The mask was part of the lost wooden coffin.

245 top	JE 86036

AMENEMOPE'S PENDANT

GOLD, VITREOUS PASTE
WIDTH CM 37.5
21st Dynasty,
reign of Amenemope
(997-985 BC)

This striking pendant in the form of a falcon with outspread wings, found on the mummy's chest, is one of the few objects left among the furnishings of Amenemope, whose tomb was probably plundered.

245 bottom	JE 72171

PECTORAL OF SHESHONQ I

GOLD, LAPIS LAZULI, VITREOUS PASTE
HEIGHT CM 7.8
22nd Dynasty, reign of Sheshonq I
(circa 945-924 BC)

The pectoral, found on the mummy of Sheshonq II, belonged to a "head of the Meshuesh" by the same name, perhaps Sheshonq I. The object, found by P. Montet in the tomb of Psusennes I (1939), depicts the solar boat between the earth and the sky.

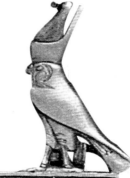

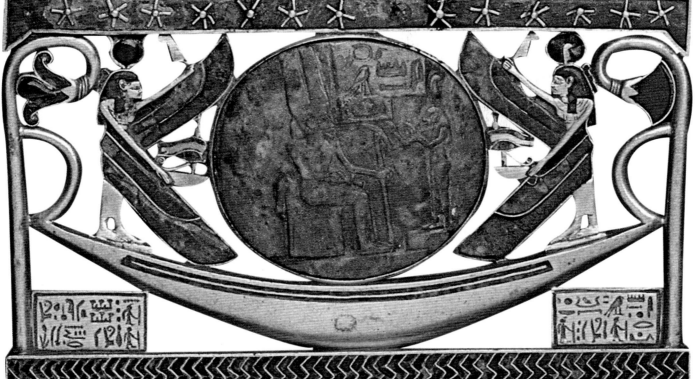

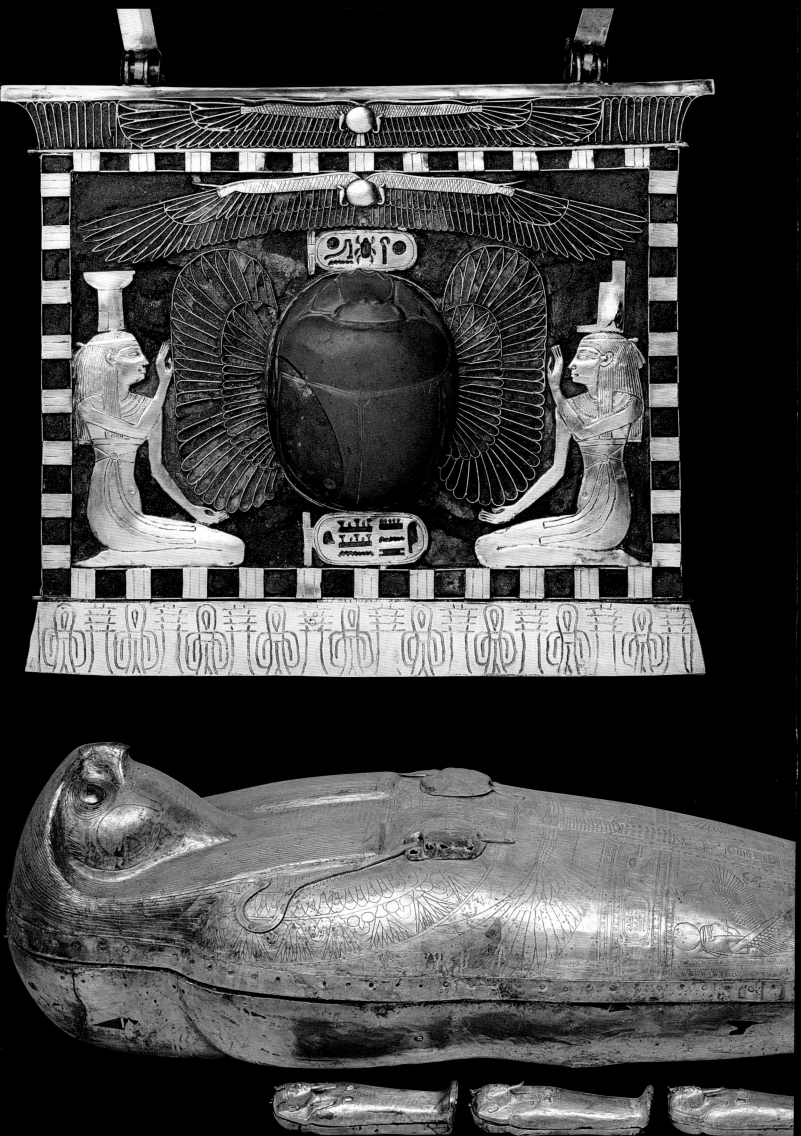

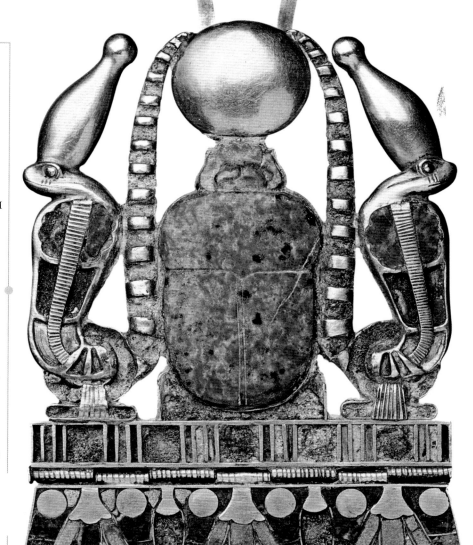

246 top
72170

PECTORAL OF SHESHONQ II, WITH WINGED SCARAB

GOLD, VITREOUS PASTE, GEMSTONES
HEIGHT CM 15.6
LENGTH NECKLACE CM 75
22nd Dynasty,
reign of Sheshonq II
(circa 890 BC)

The sun-scarab, the symbol of eternal regeneration, is reborn between Isis and Nephthys; it was discovered on the mummy's neck. Chapter 30 of the *Book of the Dead* is engraved at the base of the scarab. The pectoral was discovered by P. Montet in the tomb of Psusennes I (1940).

246 bottom
JE 72154

SARCOPHAGUS AND CONTAINERS FOR INTERNAL ORGANS

SILVER
SARCOPHAGUS:
HEIGHT CM 190
CONTAINERS:
HEIGHT CM 25
22nd Dynasty,
reign of Sheshonq II
(circa 890 BC)

In the tomb of Psusennes I, Montet found the sarcophagus of Sheshonq II (whose falcon head represents the funerary deity Ptah-Sokar-Osiris) and four coffins, consecrated to the sons of Horus and used to hold the pharaoh's internal organs.

247 top
JE 72172

PENDANT OF SHESHONQ II

OLD, LAPIS LAZULI, COLORED FAIENCE
HEIGHT CM 7
WIDTH CM 5
22nd Dynasty,
reign of Sheshonq II
(circa 890 BC).

This scarab, framed by uraei and a crown, was on the pharaoh's mummy and is from P. Montet's excavations at Tanis (1939).

247 bottom

BRACELET OF SHESHONQ I

GOLD, LAPIS LAZULI, CARNELIAN, WHITE FAIENCE
HEIGHT CM 4.6
DIAMETER CM 7
22nd Dynasty,
reign of Sheshonq I
(circa 945-924 BC)

JE 72184B

The color contrast created by blue lapis lazuli, red carnelian and gold makes this jewel particularly dazzling. P. Montet found it on the mummy of Sheshonq I with six other bracelets (1939).

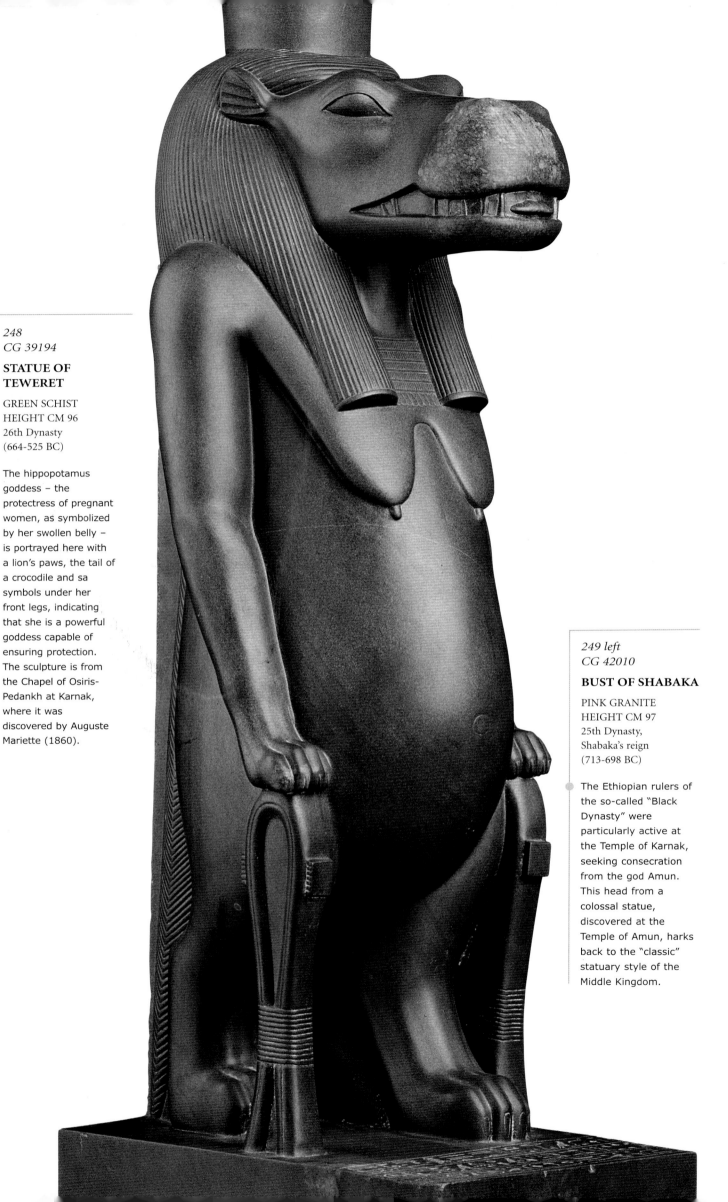

The hippopotamus goddess – the protectress of pregnant women, as symbolized by her swollen belly – is portrayed here with a lion's paws, the tail of a crocodile and sa symbols under her front legs, indicating that she is a powerful goddess capable of ensuring protection. The sculpture is from the Chapel of Osiris-Pedankh at Karnak, where it was discovered by Auguste Mariette (1860).

The Ethiopian rulers of the so-called "Black Dynasty" were particularly active at the Temple of Karnak, seeking consecration from the god Amun. This head from a colossal statue, discovered at the Temple of Amun, harks back to the "classic" statuary style of the Middle Kingdom.

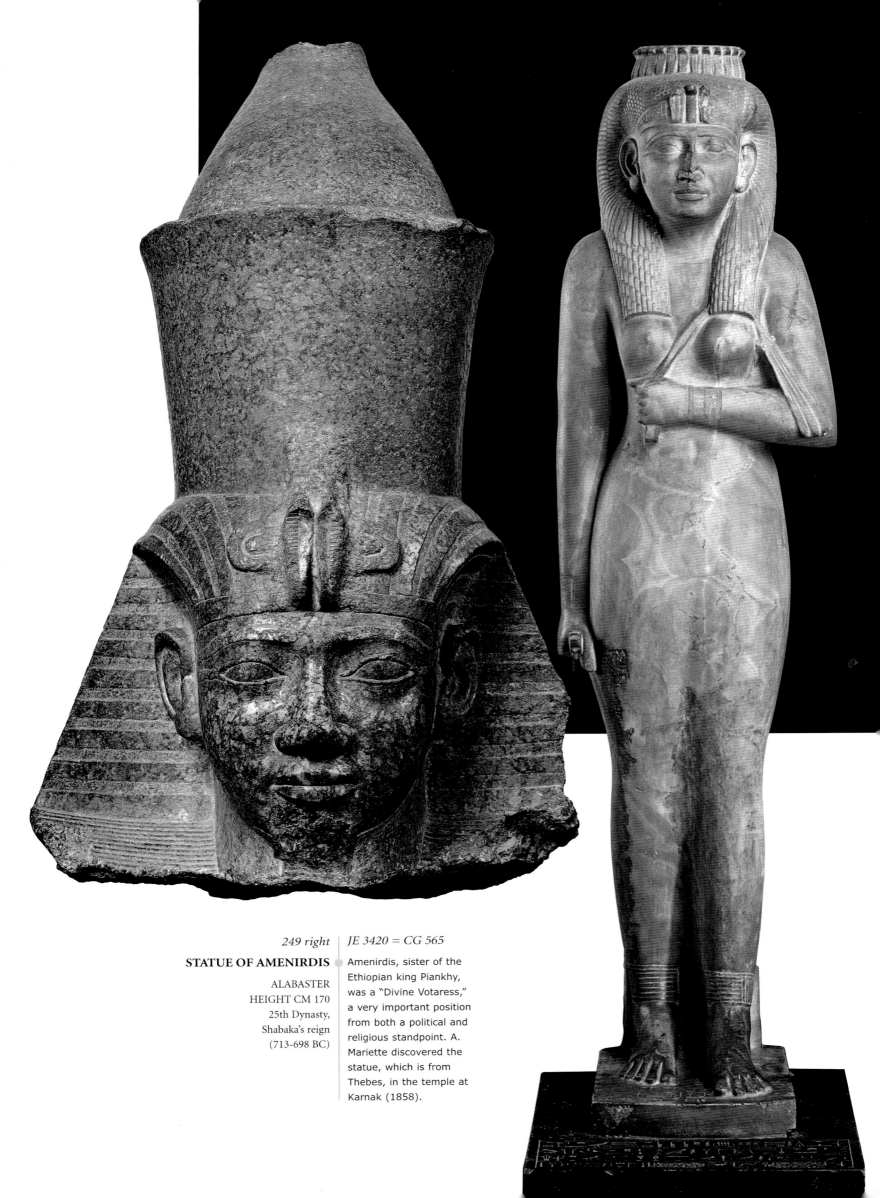

249 right

STATUE OF AMENIRDIS

ALABASTER
HEIGHT CM 170
25th Dynasty,
Shabaka's reign
(713-698 BC)

JE 3420 = CG 565

Amenirdis, sister of the Ethiopian king Piankhy, was a "Divine Votaress," a very important position from both a political and religious standpoint. A. Mariette discovered the statue, which is from Thebes, in the temple at Karnak (1858).

**STATUE OF HATHOR
WITH PSAMMETIK**

SCHIST
HEIGHT CM 96

CG 38358
STATUE OF OSIRIS

SCHIST
HEIGHT CM 89.5

CG 38884
STATUE OF ISIS

SCHIST
HEIGHT CM 90

Late 26th Dynasty (first half
of the 6th century BC)

In the tomb of the
scribe Psammetik,
at Saqqara,
Mariette uncovered
a splendid set of
schist statues
(1863). The
softness of the
curves and the
polished finish of
the stone denote
the Saite style. The
statue of Hathor
with the deceased,
in particular, shown
evident references
to older statuary.

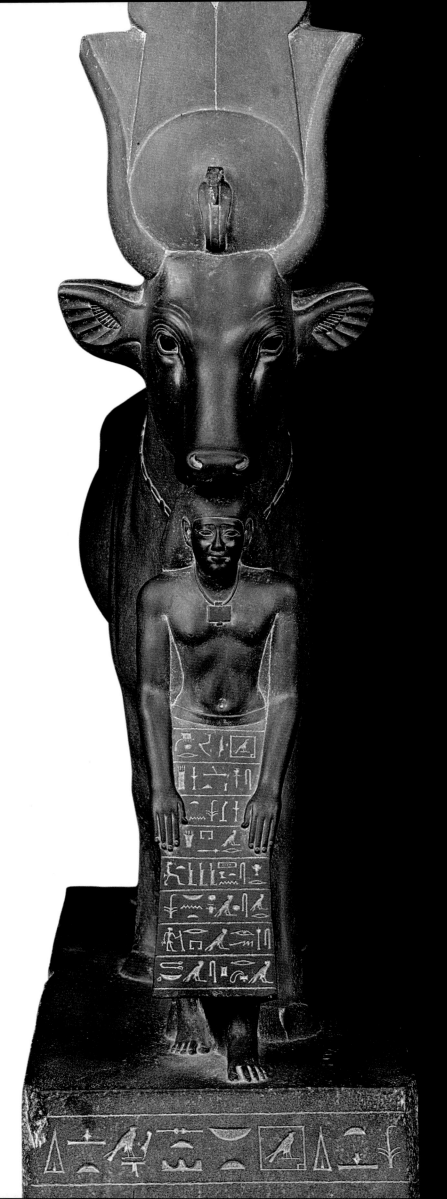

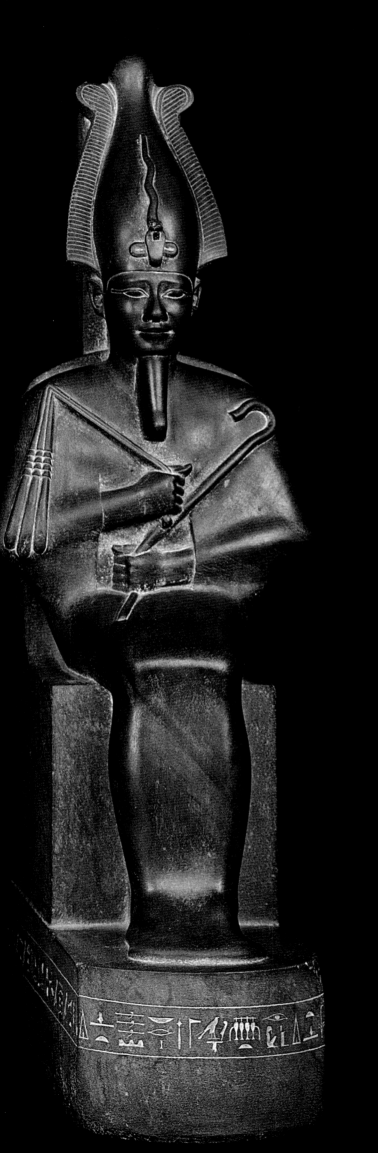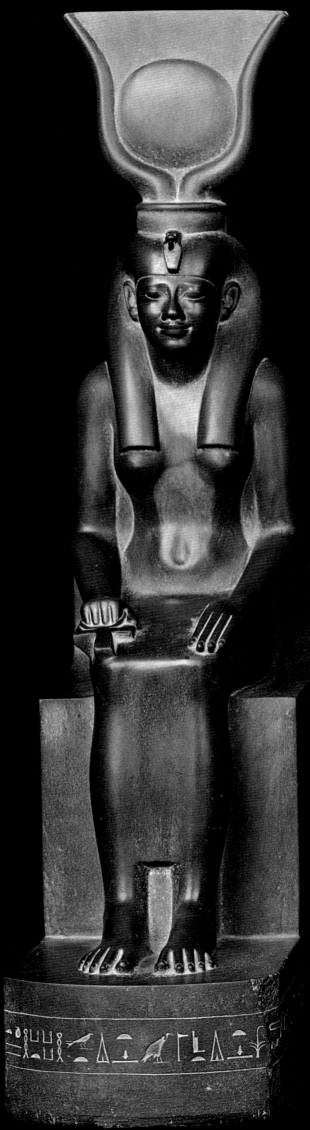

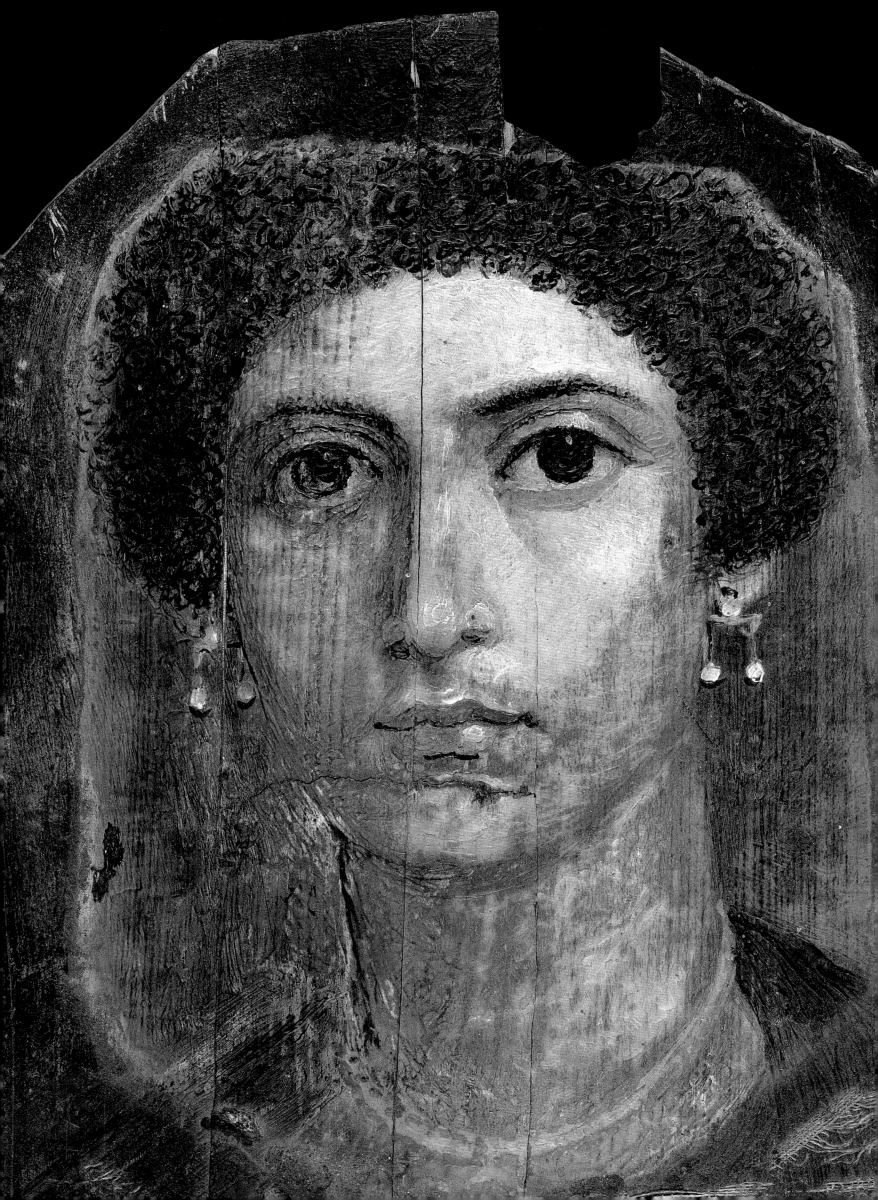

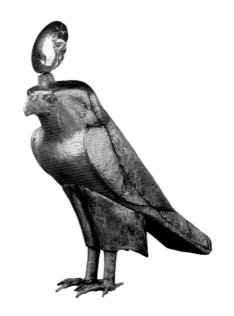

THE
GRECO-ROMAN ERA

THE GREEK INFLUENCE,
FOLLOWED BY THAT OF THE
ROMANS, SPARKED NEW
CULTURAL ELEMENTS THAT
DEVELOPED INNOVATIVE
AESTHETIC AND FORMAL
CONCEPTS. HOWEVER, THE
HERITAGE OF THE MILLENARY
CULTURE OF THE PHARAOHS
WAS JEALOUSLY SAFEGUARDED IN
THE DEPTHS OF THE TEMPLES.

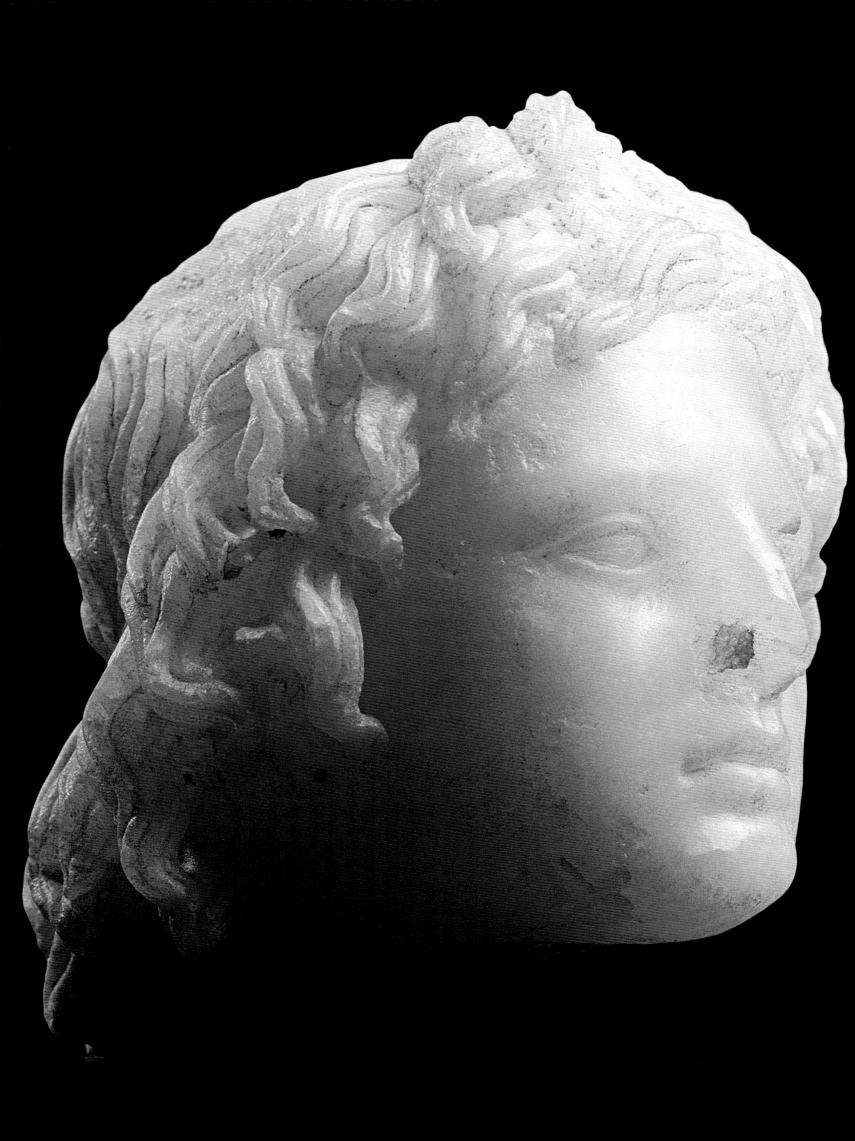

**PORTRAIT OF A
YOUNG WOMAN**

ENCAUSTIC PAINTING ON WOOD
HEIGHT CM 31
WIDTH CM 22
Roman period (late 1st century AD)

CG 33244

In the first centuries of
the Christian era, in the
Fayum area there
appeared a type of
funerary tablet with a
portrait. The paintings
were inserted into the
bandaging and set on
the mummy's face.

Following his victory in 332 BC, Alexander the Great felt impelled to legitimize his power in Egypt by visiting the Oracle of Amun

at the oasis of Siwa. According to the legend of the Alexander Romance, the Egyptian god declared that he was the father of the Macedonian leader, connecting Alexander's life with the mystery of 'divine birth' in the pharaonic era, as the Pharaohs Hatshepsut and Amenhotep III were celebrated as the children of the god Amun. It was also said that the god himself chose the site for the new capital, to be named Alexandria in honor of the Macedonian leader. With its two ports, it gradually developed into the most important city for all Mediterranean trade. However, Alexandria was also very active from a cultural standpoint. Famous for its legendary library and its circle of intellectuals, it continued to be a point of reference for centuries. With the death of Alexander, the quest to legitimize the Ptolemaic/Lagos Dynasty (Lagos was Ptolemy's father), which officially ruled Egypt starting in 305 BC after the great Macedonian Empire was divided, was manifested through a policy of great respect for the local culture, above all with regard to the deities and priesthood. At the Egyptian temples, the new rulers took over the role of pharaoh, the leader who correctly carried out the divine cult and 'achieved Maat,' assuring world order. At the same time, however, they were also sovereigns in the Greek style, presenting themselves as the incarnation of all virtues and ultimately acquiring a divine connotation. The Ptolemies effectively set up a 'Greek-style' monarchy, institutionalizing the cults bestowed on their dead ancestors and on the ruler present on earth, who appeared as a full-fledged god to his people. The aim of this type of policy was to govern different populations—Greeks and Egyptians—under a single power, as the latter were already accustomed to sacralized royal power and thus accepted this model of royalty. The ruling Greek elite effectively predominated over the Egyptian one. Likewise, Greek became the official language, though it was used alongside the demotic one in official documents. Hieroglyphics were confined to temples, the repositories and guardians of the millenarian culture of the pharaohs.

The Ptolemies took important religious—and political—action by introducing the cult of the god Serapis, the fusion of two typical Egyptian deities, Osiris and Apis. The spread of this cult has been attributed to Ptolemy I (though several scholars attribute this to his immediate successors), and it was intended to protect the new capital, Alexandria. According to several recent studies, it catered mainly to the Greek or Hellenized populations in Egypt rather than the local inhabitants. This 'invention' was so successful that numerous sanctuaries dedicated to Serapis and his wife Isis were built around the Mediterranean. In this era, there was a vast production of bronze statuettes of the gods, used for devotional purposes for the great necropolises of sacred animals, which attracted numerous followers and were honored with impressive funerary cults.

253
JE 46351

**FALCON
SARCOPHAGUS**

GOLD, SILVER
HEIGHT CM 60
LENGTH CM 88
Ptolemaic Period
(305-30 BC)

The custom of
embalming animals
developed particularly in
the Late Period. This
valuable artifact from
the Treasure of Dendera
must have held a falcon
mummy.

254
CG 27476

**BUST OF
ALEXANDER
THE GREAT**

ALABASTER
HEIGHT CM 10
Hellenistic period
(332-30 BC)

Based on iconographic
elements, this fragment
seems attributable to
Alexander the Great. The
bust is from al-Yauta,
west of Birqet Qurun.
Notably, the band around
the head (tenia)
suggests a royal figure.

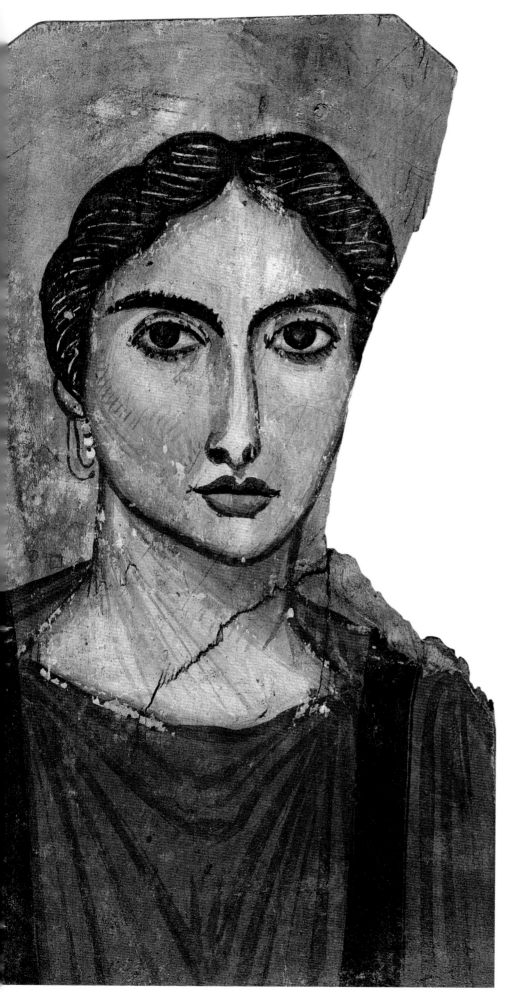

The coexistence of Greeks and Egyptians led to the creation of figures of Egyptian deities with Greek features, as reflected by the iconography of 'Osiris-Canopis' and of Isis in Greek garb, with a finely modeled body or even nude.

The enormous respect shown by the Ptolemies toward the Egyptian culture—at least on a formal level—defines it as the last 'independent dynasty' of the Nile Valley, which fell definitively under Roman power in 30 BC following the Battle of Actium. Egypt thus became a province of the Roman Empire and the country's internal situation changed radically. The powerful Egyptian priest class was effectively transformed into a clergy 'with its hands tied.' It was divested of its possessions, deprived of its independence and kept under strict control in order to weaken its strong influence of the local population, which was thus slowly deprived of its cultural memory. The local Egyptian population was also considered inferior and was subject to heavier taxes. Nonetheless, the Roman emperor was presented as the 'living Horus' on earth whose power was also legitimated at Egyptian temples. Moreover, the Romans never accepted the zoomorphic character of the Egyptian pantheon, and this seems to be demonstrated by the decrease in the production of bronze votive figures noted above. The political and cultural upheaval of Roman Egypt is also visible in art. The figure of the Ptolemaic ruler, which was proposed iconographically as a pharaoh, was gradually replaced by more realistic sculpture that yielded true classical masterpieces in Egypt. In turn, the evolution of religious beliefs is reflected in the funerary furnishings of the Greco–Roman period. In particular, the typically Egyptian practice of embalming spread, supplanting cremation among the Romans, as did the use of cartonnage. The gilded burial mask was replaced by types painted in bright colors, with eyes made of vitreous paste and elaborate headdresses. Along these lines, the 'Fayum portraits' are especially intrigu-

ing. Named after the Oasis of Fayum, where they were discovered, these encaustic paintings done on wood panels were inserted over the faces of the deceased in place of the burial mask. These highly expressive portraits have permitted a detailed reconstruction of the fashions of the period. One of the most interesting aspects of Greco–Roman Egypt lies in the opportunity it provides to analyze the coexistence of different cultures in a traditionally independent and closed territory like Pharaonic Egypt, which nonetheless continued to thrive despite foreign domination. From a religious standpoint, during both the Ptolemaic and Roman eras this coexistence was manifested in the osmosis between the Egyptian and Greco–Roman gods. This osmosis led to the creation of hybrid deities as well as the worship of deities 'foreign' to Egyptian and Greco–Roman populations alike, but without triggering any conflict whatsoever. This osmotic process can also be noted in the burial cult, which created formulas that serenely blended Egyptian and Greek elements, accompanied by the figure of Osiris set alongside the Greek gods. Likewise, the inscriptions adorning cartonnage were written in both hieroglyphics and Greek. In terms of architecture, Ptolemaic and Roman policies continued with the restoration and expansion of Egyptian temples, also increasing the construction of buildings in the classic style for both religious and civic purposes. The edicts of Emperor Theodosius in AD 391 and 392, which officially marked the end of paganism, coupled with the forced closing of the last pagan temples and bulwarks, inexorably and formally signaled the end of the ancient Egyptian culture.

Material from the Greco–Roman era is collected in several rooms on the ground floor. This itinerary starts in Room 25 with a limestone statue of a Ptolemaic queen with traces of paint still visible on it, and a singular wooden cube statue. In Room 35 has a small bronze statue of a kneeling pharaoh, making an offering to Maat. Room 34 nearby has a series of lovely portraits, among which Alexander the Great and Septimius Severus are recognizable. This room also holds a painted and gilded limestone stele dedicated to the bull Buchis by Ptolemy V, and a very interesting painting from the necropolis of Tuna al-Gebel with mythological scenes portraying Oedipus. Portraits from the Roman era can be viewed in Room 50, along with a granite statue of a Ptolemaic ruler. The itinerary ends in Room 49 with the exquisite wooden coffin of Petosiris, inlaid with multicolored vitreous paste.

On the upper floor, Rooms 39 and 44 house statuettes of gods and beautiful glass vases. This itinerary continues in Room 19 with a series of bronze statuettes, some of which are inlaid with gold, portraying the gods. In this series, Pantheon Amun, a beautiful winged Isis and the god Imhotep can be recognized. This room also features the stele of "Horus on crocodiles," which was considered a potent talisman against the poison of scorpions and snakes. Nearby Room 14 features the 'Fayum portraits' and several burial masks made of painted plaster and cartonnage (in which the body was wrapped in bandages arranged in lozenge shapes, tightened with strips of papyrus or fabric, stuccoed and then painted). In Room 4, which is dedicated to jewelry, is a series of exquisitely crafted gold items, such as a bracelet with gold grape leaves and agates from the Hadrianic period, and a gold diadem with Serapis enthroned, discovered at Dush. As far as the collection of coffins is concerned, the sycamore one adorned with polychrome terracotta motifs, exhibited in Room 21, is striking. The rooms dedicated to funerary accouterments have several beautiful items from the Greco–Roman era, including a naos with a falcon, made of stuccoed and painted wood, in Room 22.

256
CG 33248

**PORTRAIT
OF A WOMAN**

TEMPERA ON WOOD
HEIGHT CM 35
WIDTH CM 19.5
Roman Period
(first quarter of the
4th century AD)

The lack of attributes makes it impossible to date this portrait with any certainty. In fact, jewelry and hairstyles are used to help date these works, which are generally found out of their original context. This painting, which comes from el-Rubayat, was purchased by the Egyptian Museum in 1893.

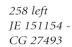

**BUST OF
PANEMERIT**

BASALT
HEIGHT CM 30
Late Ptolemaic Period
(80-50 BC)

Marked, severe
features characterize
the face of the
governor Panemerit,
discovered at Tanis by
A. Mariette (1861).

258-259
JE 46341

**MAGIC STATUE
OF DJED-HOR**

BLACK GRANITE
STATUE:
HEIGHT CM 78
BASE:
HEIGHT CM 38
Ptolemaic Period
(305-30 BC)

The formulas engraved
on magic statues were
intended to protect
against the bites of
dangerous animals.
The statue shown
here, which is one of
the most famous, by
discovered at Tell Atrib
(1918).

259 right
JE 38582

**STATUE OF
PTOLEMAIC
QUEEN**

PAINTED LIMESTONE,
GILDING
HEIGHT CM 47.5
Ptolemaic Period
(305-30 BC)

The attributes seem to
indicate that the person
portrayed in the statue
was a Ptolemaic queen.
The gilding of certain
parts and the traces of
color give the statue a
very intense appearance.
G. Legrain discovered
the work in the cache at
Karnak (1904).

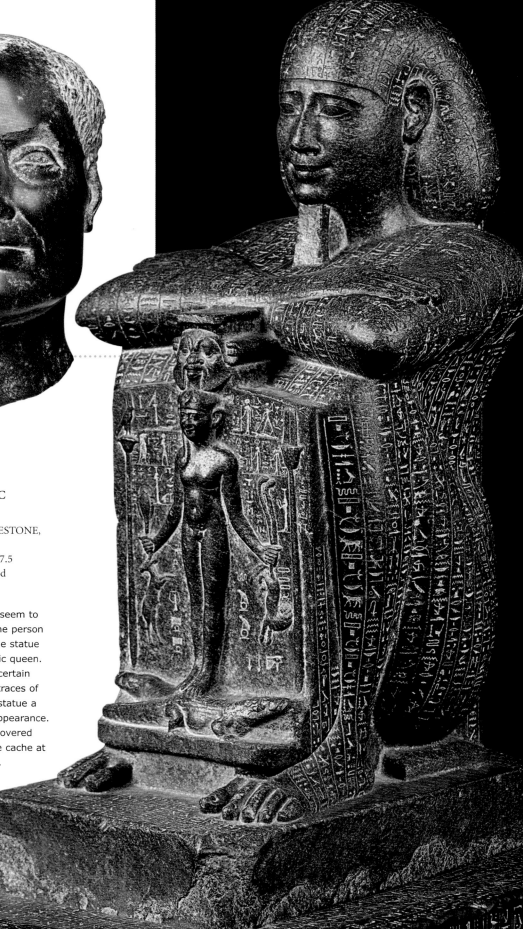

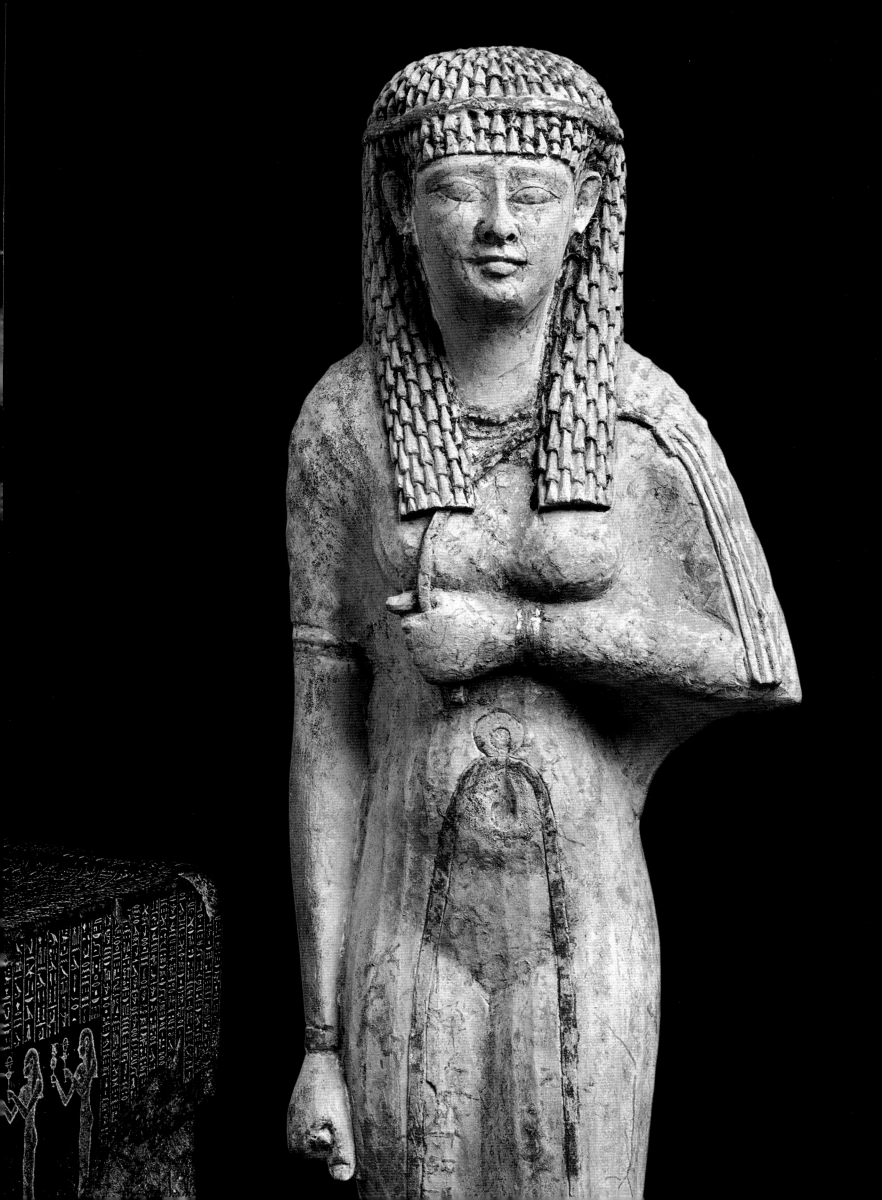

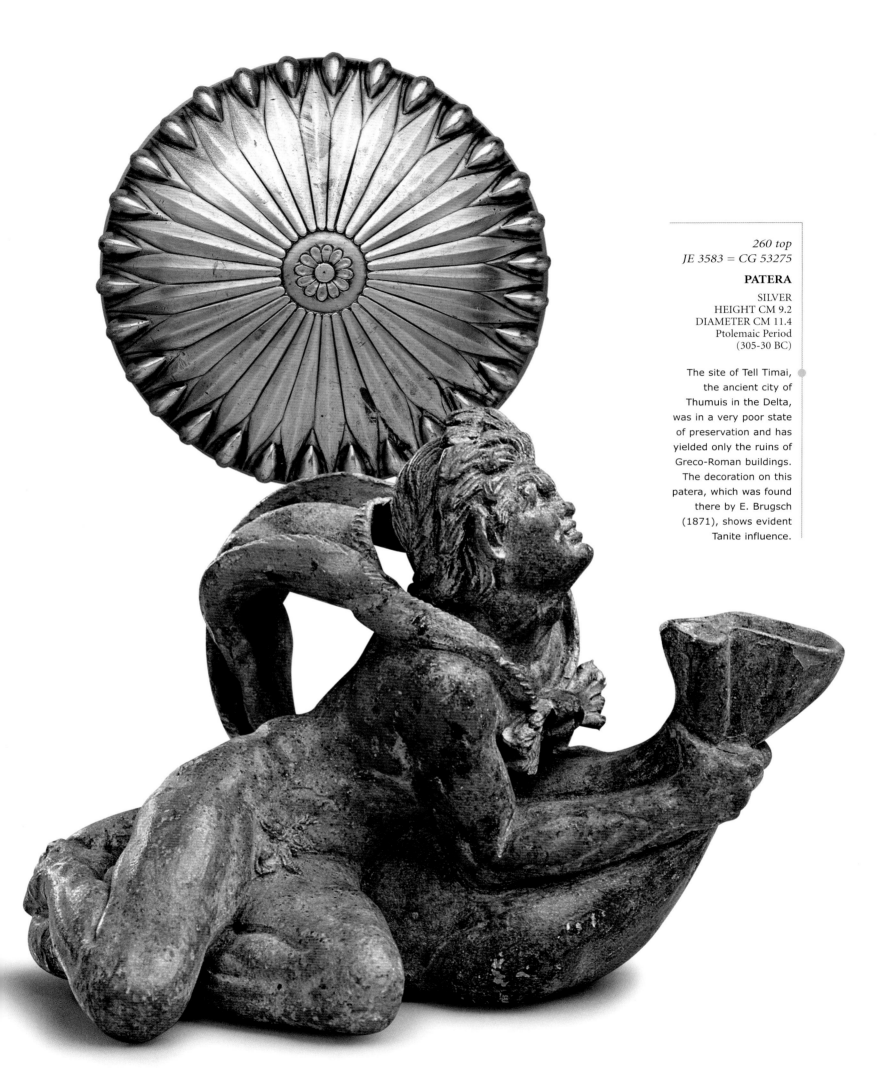

260 top
JE 3583 = CG 53275

PATERA
SILVER
HEIGHT CM 9.2
DIAMETER CM 11.4
Ptolemaic Period
(305-30 BC)

The site of Tell Timai,
the ancient city of
Thumuis in the Delta,
was in a very poor state
of preservation and has
yielded only the ruins of
Greco-Roman buildings.
The decoration on this
patera, which was found
there by E. Brugsch
(1871), shows evident
Tanite influence.

VASE WITH RELIEF DECORATION

TERRACOTTA
HEIGHT CM 14
Ptolemaic Period
(2nd-1st century BC)

This artifact, from Memphis, presents rich moulded decorations covering the entire belly of the vase. In the central band, a portrayal of Harpocrates, with the curly locks characterizing this figure, is juxtaposed with a lotiform capital.

260 bottom
JE 6102 = CG 26752

SATYR WITH WINESKIN

TERRACOTTA
HEIGHT CM 8.5
PTOLEMAIC PERIOD
(305-30 BC)

During the Greco-Roman period, there was an enormous production of terracotta statuettes. This one, with a cape, pointy ears and windswept hair, is holding a wineskin. Thus, some scholars have identified the figure as Aeolus. The artifact is from the Delta area.

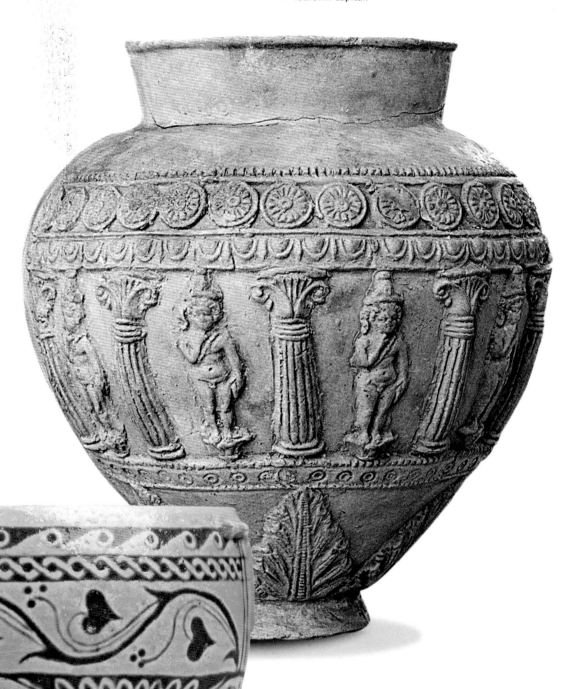

261 bottom | *JE 49802*

FAÏENCE VASE

FAÏENCE
HEIGHT CM 7.2
Ptolemaic Period
(2nd century BC)

The decoration on this vase from Abydos, with geometric bands, is animated by the contrast of the brilliant hues of the faience, used in place of more costly gemstones.

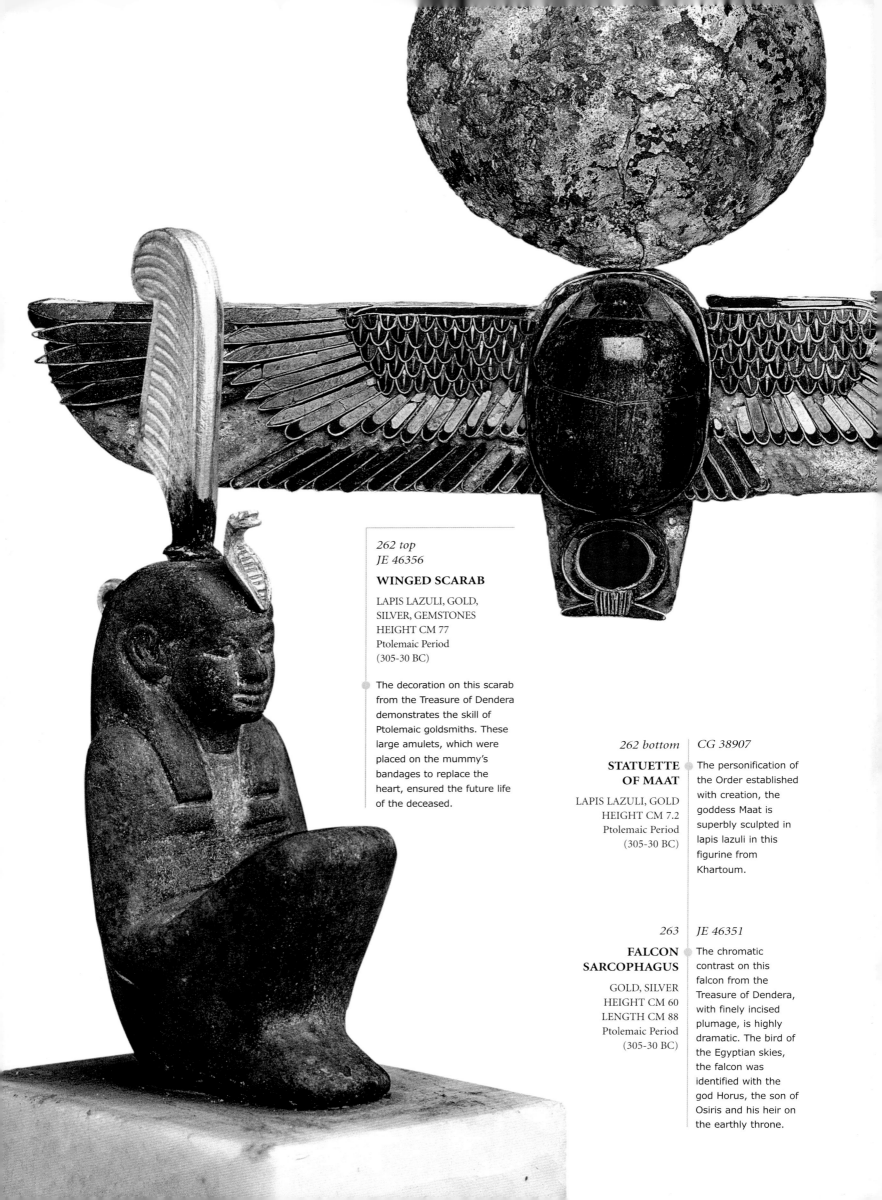

262 top
JE 46356

WINGED SCARAB

LAPIS LAZULI, GOLD,
SILVER, GEMSTONES
HEIGHT CM 77
Ptolemaic Period
(305-30 BC)

The decoration on this scarab
from the Treasure of Dendera
demonstrates the skill of
Ptolemaic goldsmiths. These
large amulets, which were
placed on the mummy's
bandages to replace the
heart, ensured the future life
of the deceased.

262 bottom

**STATUETTE
OF MAAT**

LAPIS LAZULI, GOLD
HEIGHT CM 7.2
Ptolemaic Period
(305-30 BC)

CG 38907

The personification of
the Order established
with creation, the
goddess Maat is
superbly sculpted in
lapis lazuli in this
figurine from
Khartoum.

263

**FALCON
SARCOPHAGUS**

GOLD, SILVER
HEIGHT CM 60
LENGTH CM 88
Ptolemaic Period
(305-30 BC)

JE 46351

The chromatic
contrast on this
falcon from the
Treasure of Dendera,
with finely incised
plumage, is highly
dramatic. The bird of
the Egyptian skies,
the falcon was
identified with the
god Horus, the son of
Osiris and his heir on
the earthly throne.

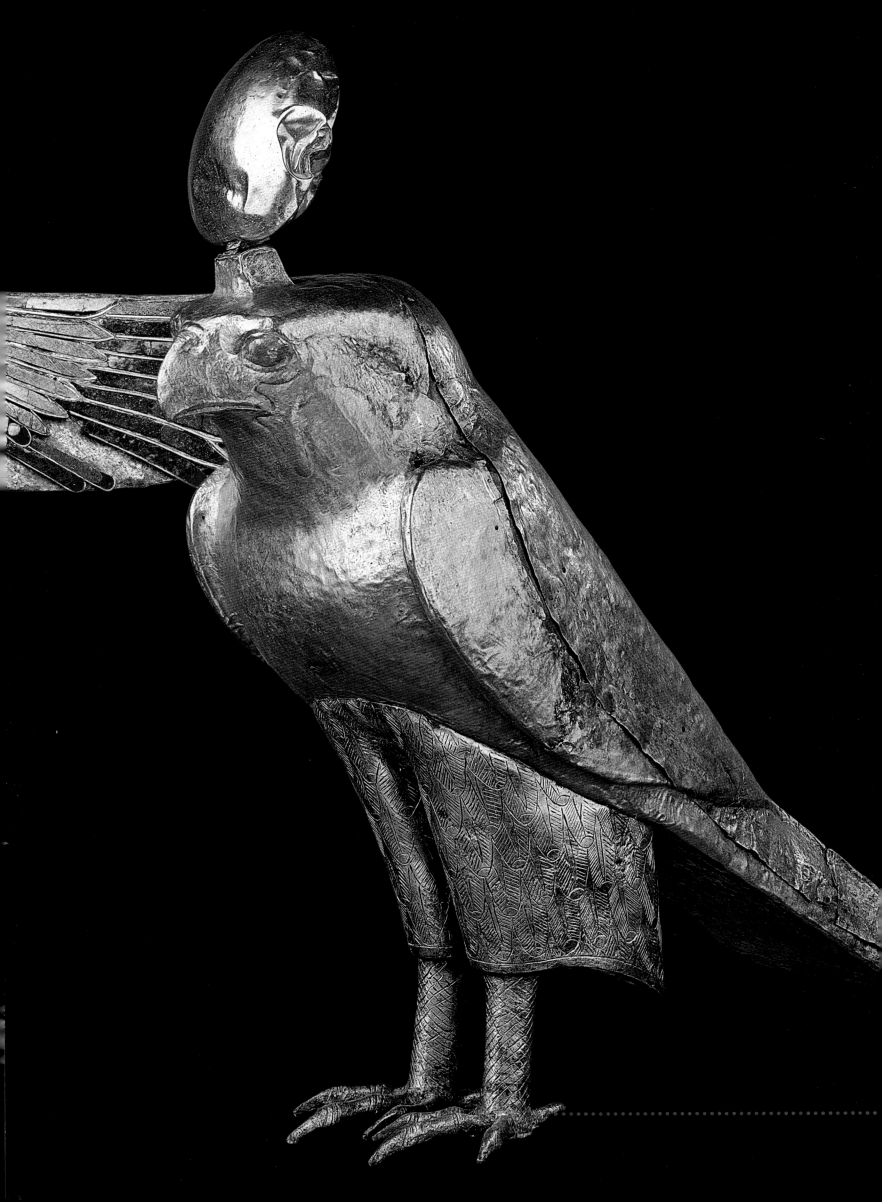

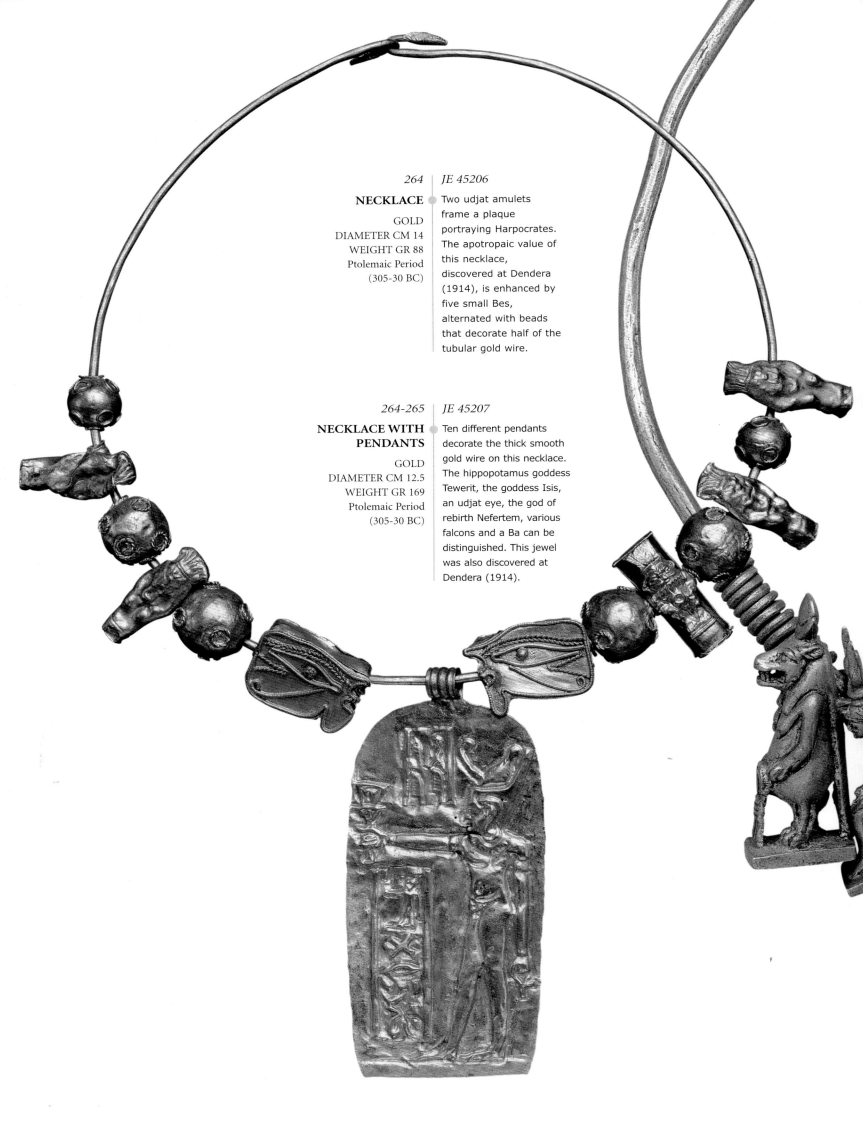

264 | JE 45206

NECKLACE

GOLD
DIAMETER CM 14
WEIGHT GR 88
Ptolemaic Period
(305-30 BC)

Two udjat amulets frame a plaque portraying Harpocrates. The apotropaic value of this necklace, discovered at Dendera (1914), is enhanced by five small Bes, alternated with beads that decorate half of the tubular gold wire.

264-265 | JE 45207

NECKLACE WITH PENDANTS

GOLD
DIAMETER CM 12.5
WEIGHT GR 169
Ptolemaic Period
(305-30 BC)

Ten different pendants decorate the thick smooth gold wire on this necklace. The hippopotamus goddess Tewerit, the goddess Isis, an udjat eye, the god of rebirth Nefertem, various falcons and a Ba can be distinguished. This jewel was also discovered at Dendera (1914).